T0247766

ON THE ROAD TO
ABANDONED
MANITOBA

I dedicate this book to my family,
Maria, Stefanie, and Josef, and apologize
for all the time that I missed spending with you
as I explored the back roads of Manitoba.

ON THE ROAD TO
ABANDONED
MANITOBA

Taking the scenic route through historic places

GORDON GOLDSBOROUGH

GREAT PLAINS
PRESS

Great Plains Press
320 Rosedale Ave
Winnipeg, MB R3L 1L8
www.greatplainspress.ca

Great Plains Press gratefully acknowledges the financial support provided for its publishing
program by the Government of Canada through the Canada Book Fund; the Canada Council
for the Arts; the Province of Manitoba through the Book Publishing Tax Credit and the Book
Publisher Marketing Assistance Program; and the Manitoba Arts Council.

Design & Typography by Relish New Brand Experience
Printed in Canada by Friesens

LIBRARY AND ARCHIVES CANADA CATALOGUING IN PUBLICATION

Title: On the road to abandoned Manitoba : taking the scenic route through historic places /
 Gordon Goldsborough.
Names: Goldsborough, Gordon, 1959- author.
Description: Includes index.
Identifiers: Canadiana 20230466346 | ISBN 9781773371078 (softcover)
Subjects: LCSH: Historic sites—Manitoba—Guidebooks. | LCSH: Manitoba—
 Guidebooks. | LCGFT: Guidebooks.
Classification: LCC FC3357 .G65 2023 | DDC 917.12704/4—dc23

Canadä

Contents

The author in his "pandemic beard" descends into a Fallout
Reporting Post near Beaver Creek Provincial Park in the Interlake.
CHRISTINE LOFF

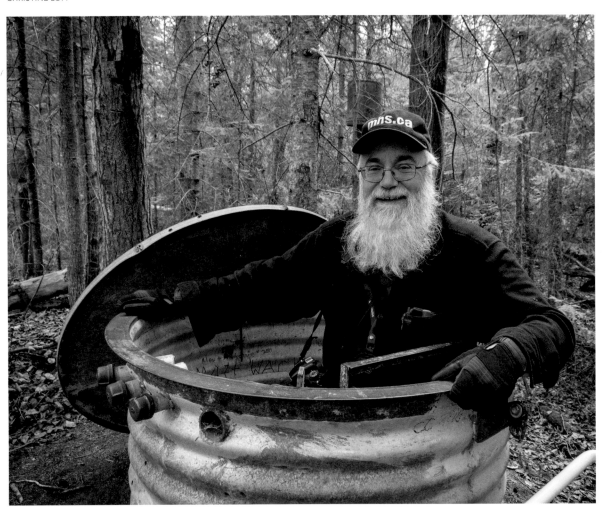

Foreword

In your hands you hold the third volume of Gordon Goldsborough's *Abandoned Manitoba* series. That is, "abandoned" in the sense of a site not serving its original purpose. Gord has found these sites during his travels throughout the province, dug into the tales that lie behind them, and offers them now as glimpses into a world no longer with us. In this collection, the sites include not just buildings, but also a road, a bridge, a dump, a fire tower, a ship, and many other oddities that have an interesting story behind them.

Gord has limitless energy for projects related to Manitoba's past. His charming anecdotes may be communicated in print but they come across as enthusiastic, engaging conversation. In one of our chats in the Archives of Manitoba, he told me that he was surprised by the popularity of his *Abandoned Manitoba* books. I'm not. They entertain us well. And they communicate the remarkable energy of their author.

Like its two partner volumes, this third version of *Abandoned Manitoba* celebrates the history of the province. How can you use it? Take an excursion, by car, canoe, bicycle, or mind's eye. Use the geographical coordinates to line up your destinations. Or treat the stories as a springboard into further exploration on the website—thousands of biographies, buildings, books, elections, and more (10 billion bytes)—that Gord and his allies created for the Manitoba Historical Society, at www.mhs.mb.ca. The Society also publishes the magazine *Prairie History* for those who would like regular supplements of the vitamins and minerals and inspiration provided by stories of the past.

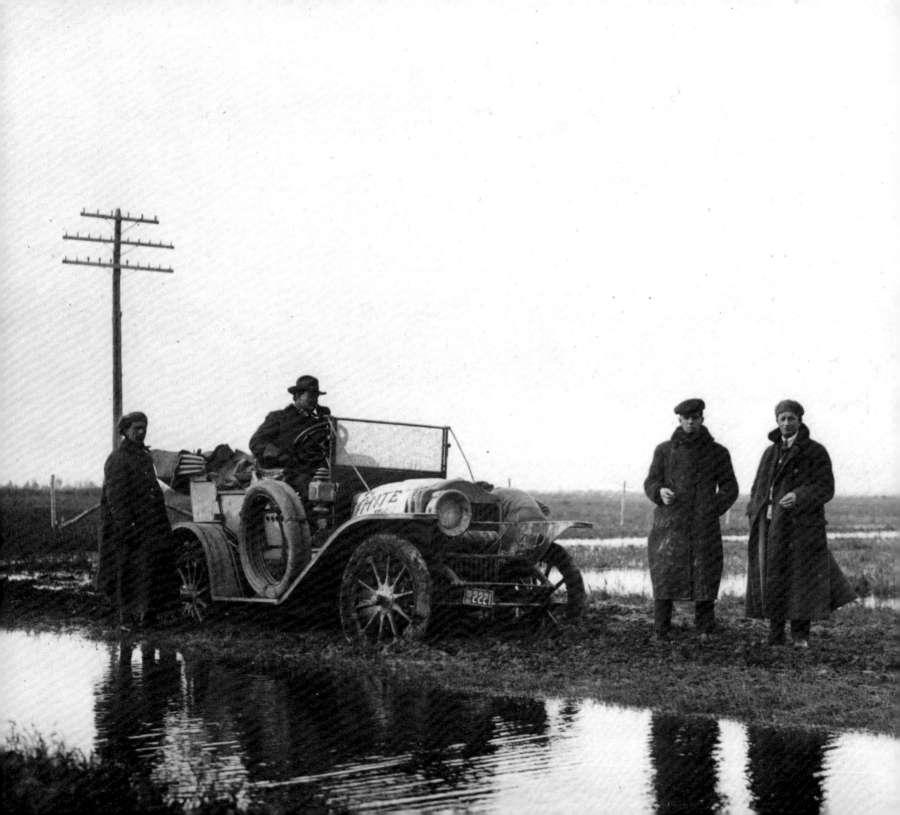

An automobile stuck on Ace Emmett's "Blue Route" between Winnipeg and Souris, 1912. ARCHIVES OF MANITOBA, TRANSPORTATION – ROADS & HIGHWAYS 6

In the spirit of reconciliation that is so much a part of Canadian preoccupations today, several Indigenous sites appear in the following pages. Their inclusion is a reminder that what is called "built heritage" by students of Manitoba history focuses almost exclusively on the nineteenth and twentieth centuries. Memorable sites also existed in the previous thousands of years of human habitation, as Gord has noted in volumes one and two, but many of them have been eclipsed or erased during subsequent generations of settlement.

Like its two partner volumes, this third version of *Abandoned Manitoba* celebrates the history of the province. Expect the quirky and the unusual. Why was this place or structure once an obvious destination? Why did it convey something meaningful? And why has its purpose disappeared? Or has it? Gord prompts us and he provokes us. Enjoy the ride.

Gerald Friesen
Department of History
St. John's College, University of Manitoba

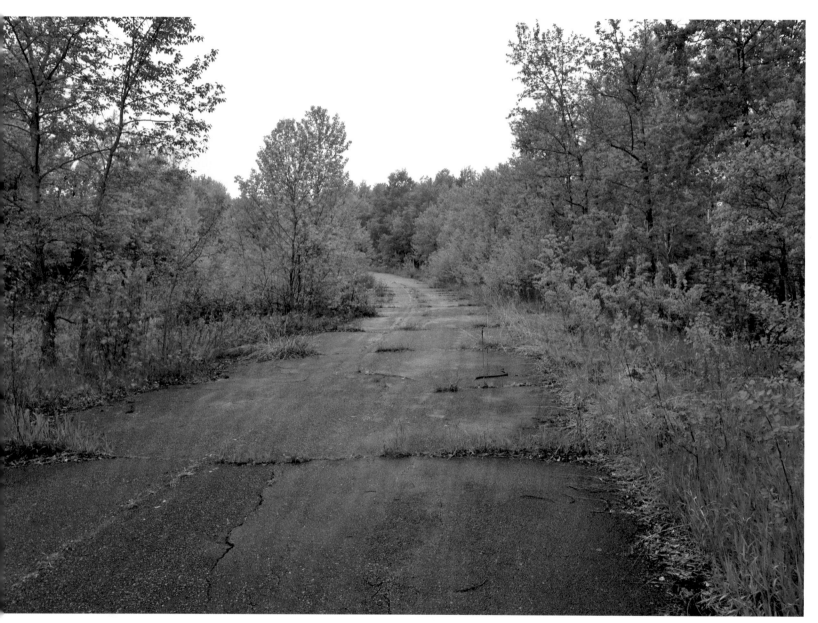

An abandoned portion of the Trans-Canada Highway near the Manitoba-Ontario border, June 2019. GORDON GOLDSBOROUGH

Introduction

One More Time

Here we go again. This is the third—and, I am pretty sure, final—installment in the *Abandoned Manitoba* series. When *Abandoned Manitoba* was published in 2016, I was certain that few would want to read a book about abandoned places around the province. Yet, it sold enough copies to warrant a sequel, *More Abandoned Manitoba*, two years later. Now, five years later and a global pandemic behind us, I confess that I am still a little perplexed that people find interest in my stories about travels around Manitoba in search of abandonment. I suppose, if I had to offer an explanation, it is that my books illustrate how, and why, Manitoba has changed over its 153 years of existence. I am fascinated by the ways in which the day-to-day aspects of our lives—the mundane and often unknown places and services on which we depend—have come about, changed and, in some cases, ended. At its core, *Abandoned Manitoba* is about daily life in Manitoba, warts and all, and how we have ended up where we are today.

Updates

Before we delve into new stories of Manitoba abandonment, I thought you might be interested to know how some of the places mentioned in the two preceding books have fared in the years since their stories were told. Some of those dozens of places are, to the best of my knowledge, essentially unchanged. It is possible that changes have occurred, but because my ability to travel has been somewhat constrained over the past few years and my network of contacts around the province is imperfect, I do not know about the present status for all of them. What I do know follows.

I can truthfully say that I had visited every place featured in these books … except for two. I did not visit Port Nelson before writing about it (but see below) and, to date, I have not seen the wreck of the steamboat *Alpha* buried in the bank of the Assiniboine River in Spruce Woods Provincial Park. It was not for lack of trying. The only time the shipwreck can be seen is when the river is so

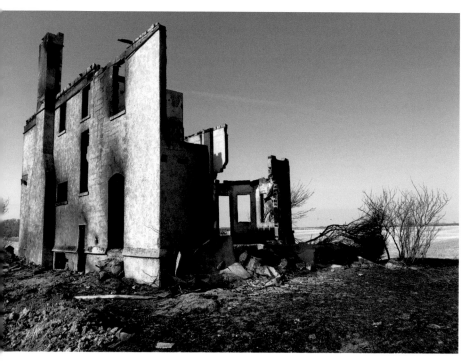

The former Atkinson House, near Hamiota, following a fire that destroyed all but its exterior brick walls. TERRI DELLER

farthest western extent of where we believed the *Alpha* to lie then began working our way back along the riverbank. It was clear that considerable erosion had occurred during the flood on the Assiniboine in 2011 because much of the soil visible in satellite imagery from 2009 was gone. We went 2,500 feet eastward, all the way back to an exposed shoal and found nothing. I was disappointed but not surprised. I concluded that the remains of the *Alpha* were probably washed away during the flood. So, you might imagine my surprise, and frustration, when I was contacted four months later by another explorer who had found it. The wreck was located barely 1,000 feet to the west of where we had started our search. We were so close! It is now on my bucket list for the next time that river levels are sufficiently low as to reveal the wreck.

In *Abandoned Manitoba*, I talked about the Atkinson House, a large two-storey residence near Hamiota that was built in 1913 by local farmer Arthur Atkinson. It featured many more conveniences than it was typical for a rural farmhouse to have in those days, including central heating, running water, and telephone service. Unfortunately, it lacked the wall and ceiling insulation that would have made the building comfortable in winter. Its last occupants, the Gray family, moved out in the fall of 1960 and it had stood vacant ever since. After the book was published, I was contacted by a member of that last family, who shared with me some photos taken inside the house, a couple of years before they moved out. Compared to how it looked when I first visited it in 2014, the old

low that the remains of its wooden hull are above water. To write about it in *Abandoned Manitoba*, I depended on my friend Ken Storie, who photographed the *Alpha* in 2003. So, I was really looking forward to seeing it myself in May 2021. The conditions were ideal. Water levels on the Assiniboine were low that year, so any remnants of the hull would be readily visible. Ken and I met near the site, or at least as close to it as Ken's memory permitted. I carried my trusty GPS receiver so I could see where we walked over the course of a few hours. We went to the

house had deteriorated badly under the combined impacts of weather and vandals. But those changes were nothing compared to what happened in May 2019. The "official story" is that a local farmer was burning crop residue on a nearby field and the fire got out of hand. It is remarkable, then, that the fire seemed to have been confined to the Atkinson House and its immediate surroundings. An Atkinson descendant visited soon after the fire was extinguished and shared some photos with me, one of which is shown here.

Fires are a common means by which historic structures—especially those made from wood—are lost. I assumed that would be the fate of two old grain elevators in the village of Elva that I described in *More Abandoned Manitoba*. My research had shown that one of them, built in 1897 by the Lake of the Woods Milling Company, was the oldest "standard plan" elevator in Manitoba, and probably all of Canada. Abandoned for many years, the elevator had deteriorated to such a degree that it was no longer useful for grain storage. That's why I was excited to learn, in early 2022, that a local entrepreneur, Troy Angus, was going to dismantle the elevator carefully so as much as 70 percent of its wooden and metal parts could be reused. Troy made a good start at taking the old elevator apart, removing its exterior metal panels, some of the interior wooden timbers, and other miscellaneous parts. Unfortunately, while using a nearby ditch to burn old lumber that was too badly rotted for salvage, a wayward spark found its way inside the elevator. Within minutes,

the entire elevator was aflame, and it was gone within an hour. The other old elevator at Elva, dating from 1916, was undamaged, so Troy was able to disassemble it fully. But the loss of grain elevators—once a ubiquitous symbol of prairie Canada—continues unabated. I estimated there were 133 surviving elevators when *More Abandoned Manitoba* was published in 2018. Now, five years later, there are 120 elevators still standing and I anticipate that several more will come down in 2023.

A highlight of my travels in 2022 was an opportunity to revisit Port Nelson, an intended seaport partially built between 1912 and 1917 at the mouth of the Nelson River

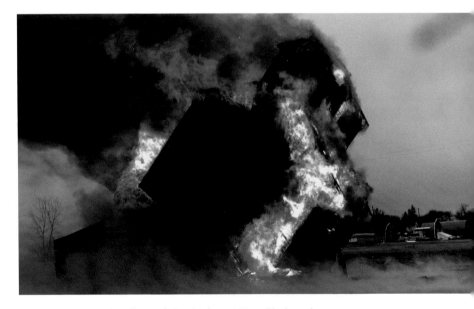

A grain elevator in the village of Elva, built in 1897 and believed to be the oldest surviving one in Canada, was destroyed by fire in April 2022 while it was being dismantled so its wood and other parts could be reused. TROY ANGUS

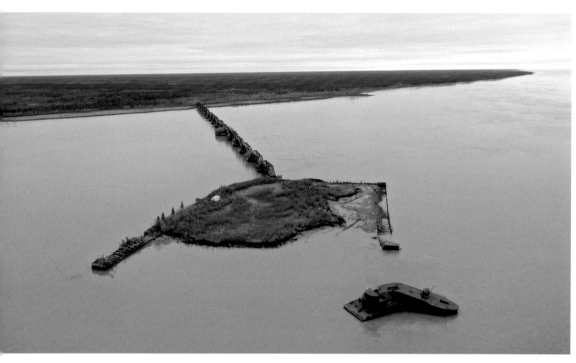

An aerial view of the artificial island at Port Nelson, with the 17-span railway bridge connecting it to the mainland in the background, and the twisted remains of the dredge in the foreground. GORDON GOLDSBOROUGH

more time at Port Nelson. I wanted to see a small ship (called a lighter) that was beached on the south shore of the river, opposite the island and bridge. The lighter had been used to ferry construction materials from ocean-going vessels whose draught was too deep to allow them to reach the construction site. I also wanted to see the remains of buildings on the mainland, and a narrow-gauge railway that shunted supplies around the site. And I always regretted that the windy, sleeting conditions during my first visit had prevented me from flying my drone, so that I could not take any aerial photos or video.

As I made plans for a return visit to Port Nelson, I heard from people who shared information about the site. One person clarified for me that a small shack on the railway bridge—that I thought looked like an outhouse and might have been used for that purpose—was, in fact, a shelter for water-level monitoring equipment built in 1980 by Manitoba Hydro as part of its work in preparing to construct the later-cancelled

on Hudson Bay that has been abandoned for over a century. Although I described it in *Abandoned Manitoba*, I was only able to visit it for the first time in 2017 when, for a few hours, I explored an artificial island that had been constructed about a half-mile offshore—where a grain terminal was intended to be built—and connected to the mainland by a seventeen-span railway bridge. The island had been built with a dredge brought to the site from southern Canada at exorbitant cost, then abandoned when a storm lifted it atop the island's seawall, from which it could not be removed. Over the years, the old dredge had sagged and been torn apart, but was still explorable when low tide made it possible to walk out to it. Since that short visit, I have been pining to go back and spend

Conawapa Generating Station. In time, they had found the site on the bridge not well suited for measuring water levels because it was often affected badly by storms and intense water currents in the river below the bridge. So, the equipment was moved into a room in the dredge and the shack on the bridge was abandoned. Meanwhile, an historian who was writing an article about shipwrecks along the coast of Hudson Bay in Ontario contacted me about a pair of bottom-dump barges that local people had found about halfway between Fort Severn and the Manitoba border, between the mouths of the Pipowatin and Niskibi rivers. He believed the two barges had been used, along with the dredge, to construct the artificial island but they were washed away, perhaps in a storm, and deposited on the shore about 190 miles to the southeast of Port Nelson.

Finally, in June 2022, a group of friends and I boarded the same high-speed jetboat that had taken me to Port Nelson five years earlier. Our plan was for me to be dropped off at the artificial island with a canoe, which would enable me to paddle to the mainland to check out the buildings there and also to cross the Nelson River to the beached lighter. While I was exploring Port Nelson, my friends would go out into Hudson Bay, travel along the coast to the Hayes River, then upriver to the former fur trade post of York Factory. Unfortunately, the plan was dashed when the water intakes of the boat's two jet engines became plugged with stones as the boat came close to shore to drop me off. The stones prevented the

jetboat from reaching anything close to its maximum speed and, at the slow speed of the plugged engines, we would not have enough fuel to get home. The only way to fix the problem was to remove the stones, and the only way to do that was to beach the jetboat, wait until the tide went out, then climb under the hull and dig out the stones. While waiting for the tide to come back up—which ultimately forced us to spend the night on the island, some of us crammed into a tiny, emergency shelter built by Manitoba Hydro for its field staff and some of us aboard the jetboat—I was able to get a thorough look at the sagging remains of the dredge and fly my drone around the island and over to the mainland. The same water currents that posed problems for Manitoba Hydro's

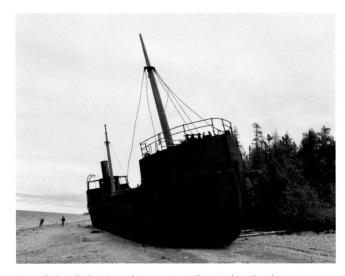

A small ship (lighter) used to construct Port Nelson has been beached on the south shore of the Nelson River for over a century.
GORDON GOLDSBOROUGH

equipment thwarted my plans to paddle the canoe, but we were able to putt-putt across the Nelson River with the incapacitated jetboat. I was able to climb aboard the lighter and get a good, close look. By comparing the photos and video that I took at Port Nelson, I was able to detect marked deterioration in the artificial island's wooden seawall during the five years between my two visits. Large segments of it had broken loose and floated away. One piece was beached on the south side of the river, not far from the lighter. Another piece floated

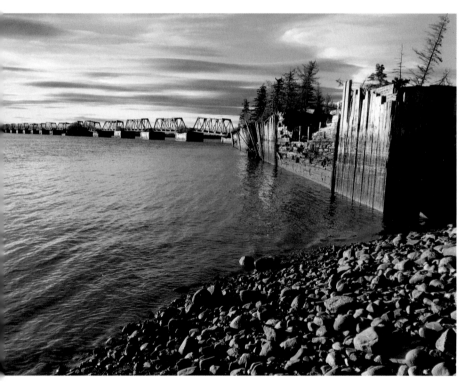

A view of the wooden seawall and railway bridge at Port Nelson. GORDON GOLDSBOROUGH

northward in the Bay and ended up in the mouth of the Churchill River. Meanwhile, the seventeen spans of the railway bridge were still intact, sort of. Several spans were more skewed and twisted than they had been five years earlier. At the rate the spans seem to be moving, I expect to see some of them lying in Hudson Bay within the next few years.

Fortunately, the updates do not all entail bad news. I am cautiously hopeful about the future of Mallard Lodge. Featured in *Abandoned Manitoba*, it is a hunting lodge overlooking Lake Manitoba, built in 1932 by Winnipeg businessman and hockey star Donald H. "Dan" Bain, and used as a teaching and research facility by the University of Manitoba for nearly 50 years before closing in 2010. Its abandonment was especially sad for me, as I had taught university courses and done environmental research at the facility for decades and was its administrator for fourteen years. The building has been vacant for about a decade and, not surprisingly, it has been the target of vandals who broke nearly every glass window in the place and did lots of other willful damage. The provincial government, which owned the building, did not foresee any productive use for it, so they called for proposals to demolish the lodge. While clarifying the scope of the demolition work, and to determine the presence or absence of asbestos, numerous holes were cut in its interior walls. But, so far, the demolition has not happened, and it now looks like it won't. Some local folks want to restore the lodge to its former glory for use as a venue for meetings and other

activities. The building will require some investment to reverse the vandalism it has sustained since being abandoned by the University, and to address maintenance that a building of its age necessarily requires. But I am now much more hopeful about its future than I was a year ago.

A couple of vacant buildings that I described in the previous books are not only still standing but have been, or soon will be, put to new uses. The Manitoba College of Pharmacy Building on Notre Dame Avenue in Winnipeg, built in 1899 as a facility to train pharmacists and later turned into a brush and broom factory, was standing empty when I wrote about it in *Abandoned Manitoba*. A new owner had just cut down the mature trees in front of the building, and I took that as a sign of imminent demolition. Fortunately, I was wrong. After a period of thorough renovations, in which its mechanical, electrical, and plumbing systems were upgraded, in late 2019 the building was offered for lease as office space. A cooperative realtor gave me a tour of the interior and I was impressed with the degree to which the owner had made the building compliant with modern building codes while still retaining some vestiges of its history. A building that I felt certain would soon be gone is now hopefully going to have a prolonged useful life.

Meanwhile, on Brandon's North Hill, a large brick building at the former Brandon Mental Health Centre, now a campus of Assiniboine Community College, stands poised to be renovated back into usefulness. The Valleyview Building was a revolutionary building, opened in 1925 with the goal of treating mentally ill people and eventually reintegrating them into general society, rather than considering them as prisoners to be confined forever. It was closed in 1992, and I suspected the building would soon be demolished. An urban explorer shared some photos of its interior taken in 2014 and 2015. They revealed a lot of superficial damage, but nothing seemed so bad that it could not be repaired. Inevitably, some remedial work is needed—such as to remove asbestos-based flooring and insulation—on which basis College officials denied me permission to tour the building. But they assure me that the day is not far off when the Valleyview will be turned into a state-of-the-art teaching and research facility.

A final update relates to two of my sources in *More Abandoned Manitoba*. Former Winnipeg police officer Danny Hutch, who was my main source for the chapter on Crabby Steve's Dance Hall and, more generally, on liquor bootlegging and who told me great stories from his personal experience, died in December 2022. When I met Danny during research for the book, he did not want his identity revealed so I referred to him in the text as "James". Now, I can set the record straight. Were it not for Danny and his excellent research on sites of illegal liquor distillation—research that was made possible by his police connections— we would not have this rare glimpse into a widely-known but almost

completely unstudied facet of Manitoba's history. On another front, Peter Boychuk died in March 2023. He had been my major source for a sidebar on the Orbit roadside trash receptacles that he had designed while working as a technical engineer with the Province of Manitoba. Peter also designed many of Manitoba's highway signs and in retirement invented an innovative cake pan made of wood.

On the Road … To Abandoned Manitoba

"The known universe ends at the Perimeter Highway." I don't know if any Winnipegger has ever actually said this, but this is what most of them think, if you believe people living *outside* of Manitoba's capital city. It is a widely held view by rural Manitobans that most Winnipeggers have no idea what lies beyond the city boundaries and are quite happy for it to stay that way. As a Manitoban with rural roots, I can empathize with the sentiment, but I am not so sure that it is a fair depiction of the majority. I think that Winnipeggers, like Manitobans everywhere, are interested in their home province and need only be given a small nudge to get out and see it for themselves. If this book can play some small role in giving that push, all the better.

Whenever I am out exploring the province, I purposely take roads that I have never travelled before, in hopes of discovering new places that I would have not otherwise seen. I have experienced first-hand with my small car the diversity of roads in Manitoba, from paved, multi-lane highways to dirt tracks that barely deserve the name "road". There was the time, for instance, when I drove down a country road in the Red River valley. Despite a firm foot on the accelerator, I found myself going slower and slower. When I finally made it to a paved road, my car was barely moving. I found that its wheel wells were almost completely packed with sticky, wet clay for which the region is legendary. If anything, though, those experiences on muddy roads have made me more appreciative of the great roads we enjoy today in Manitoba, relative to those of not so long ago.

At first, Manitoba's roads were barely more than an unmarked track across virgin prairie. As automobiles grew in popularity, more people hit the road and began pushing for improvements. In 1909, the Manitoba Good Roads Association was established to promote the development of a good road network throughout the province. Three years later, 1912, the ongoing demand for improvements in provincial roads led the Manitoba government to pass two important Acts. The Good Roads Act committed funds to assist municipalities around Manitoba in building and improving roads. The provincial government would pay two-thirds of the cost to a municipality to build a "main public highway" through its jurisdiction and the province would further guarantee the debentures that a municipality would issue to raise its one-third share. Meanwhile, the Highways Improvement Act would provide a provincial guarantee on debentures for the construction of *any* road that a municipality would wish to make within its boundaries. The demand for roads was so high that these

two Acts were found to be inadequate within just two years. They were repealed in 1914 and replaced by a new Good Roads Act that entailed cost-sharing of expenses to build and maintain "market roads" (local roads intended to help farmers bring their produce to market) and "main highways". The new Act created a three-person Good Roads Board led by Manitoba's first highway commissioner, Archibald McGillivray (for whom Winnipeg's McGillivray Boulevard was later named), along with former Winnipeg mayor Thomas Deacon and Virden-area farmer and municipal reeve Charles Ivens. One of the Board's first actions, in April 1914, was to hire Manson A. Lyons as its chief engineer. A native Nova Scotian, Lyons came to Manitoba in 1912 to design bridges for the government, and he would go on to succeed McGillivray as Highway Commissioner and, still later, was Deputy Minister of Public Works.

Bridges over rivers were an essential ingredient of the growing

In July 1926, when this photo was taken, the Trans-Canada Highway near Carberry was little more than a dirt track across the prairie. ARCHIVES OF MANITOBA, HIGHWAYS COLLECTION R17-5

provincial road network. Soon after Manson Lyons was hired, bridge construction in rural Manitoba kicked into high gear, limited somewhat by shortages of materials and labour during the First World War. Seventy-nine bridges were built in 1916 and 90 more were built in 1918. By the end of 1919, the Good Roads Board had overseen the construction of 64 bridges around the province, bringing the total to

384 bridges built in the five years since it was established.

Road construction was a major post-war priority. By 1923, there were some 22,000 miles of "passable roads"—only 1,000 of which were gravelled; the rest were dirt—and a gasoline tax had been levied so that motorists would contribute to the cost of road building in proportion to their use of them. In 1925, the provincial government assumed

The Hecla Island Ferry

Prior to initiation of a public ferry, people crossed over to Hecla Island—the largest island in Lake Winnipeg—by fishing boat or on the ice in winter. The first Hecla Island Ferry began operating in the Fall of 1953. It was a modest vessel, capable of carrying just four automobiles across about 1¼ miles of open water, with a one-way fare costing 50 cents. A local commercial fisherman named Grimsi Grimolfson was put in charge. Just five years after it began operating, the ferry was replaced by a larger vessel with a capacity for eight automobiles. In July 1959, the ferry set a record of 70 people on a single trip when it carried its first tour bus, along with five cars, over to the island.

A one-way trip took fifteen to twenty minutes, and the ferry operated every hour from 8 a.m. to 11 p.m.. Unfortunately, this was still not ideal, especially as tourism to the island continued to grow. Ferry users were at the mercy of its schedule. If you arrived a few minutes late and the ferry had already left, you had to wait up to an hour. If there were more than eight cars waiting, exceeding the capacity of the ferry, you had to wait for it to return. The water at the ferry site is not especially deep, and I found references in historical newspapers to the ferry running aground, sometimes forcing people in their cars to spend the night in them, awaiting rescue. Occasionally, when the ferryman was ill and a replacement could not be found, there was no ferry at all. In short, ferries were not nearly as convenient as a permanent connection to the mainland which, of course, is what happened at Hecla.

A rock causeway between the island and the mainland was built between 1970 and 1971, in an instant making Hecla Island much more accessible to carloads of tourists. In an ironic little twist, in 2011 the connection that had made the ferry obsolete was named the "Capt. Grimsi Grimolfson Causeway" for the man who had operated the ferry for its eighteen-year lifespan. Today, the approaches to the Hecla Island Ferry on the mainland and on the south end of the island are still present, albeit in rough shape having been unused since the early 1970s. The old Hecla Island Ferry was renamed the *MV Edgar Wood*, lengthened by 30 feet (50% of its total length) and turned into a cargo carrier. It continued in use on the Winnipeg River and in Lake Winnipeg until 2015 when it was abandoned in Selkirk. Captain Grimolfson's son is advocating to have the former ferry moved back to the Island to be preserved as an important part of Hecla's past.

responsibility for ongoing development of 1,700 miles of municipal roads, turning them into "Provincial Trunk Highways" and making it a priority to gravel them. A provincial report in 1939 noted that:

> It was believed that this class of surface was all our relatively meagre population could afford and a gravel surface was considered sufficient to keep our wheels free of that tenacious substance known to motorists as Manitoba mud. However, the growing volume and weight of motor-vehicle traffic very soon compelled consideration of various methods of surface treatment which, while being economical, would fortify the gravel surface. After considerable experimental work, we adopted various methods of bituminous surface treatment.

By 1936, a total of 1,578 bridges, the majority made of durable steel or concrete, had been built by the Good Roads Board. Important as bridges were, they were not always

feasible over larger water crossings. For these places, there were ferries. A highway map of Manitoba from 1931, for instance, showed seven ferry crossings along the Assiniboine River and six ferries along the Red River. On the Winnipeg River, there was a ferry at St-Georges. On lakes, there was a ferry that shuttled people across Lake Manitoba at The Narrows and a ferry to connect Hecla Island in Lake Winnipeg to the mainland. These lake ferries were eventually replaced by a bridge (1968) and a causeway (1971), respectively.

As the size and complexity of Manitoba highway network grew, so too did the need for an efficient system of navigation. Initially, the Manitoba Motor League had offered booklets of turn-by-turn instructions on a series of standard routes. Early automobiling advocate Arthur Coates "Ace" Emmett designated driving routes by colour before realizing that a better system was to number the various highways. He proposed the idea at a 1920 meeting of the Canadian Automobile Association, but Manitoba was beaten to the punch by the state of Wisconsin and did not introduce highway numbers until 1926.

Many of the early numbered highways retain the same numbers today. But someone looking at a map of Manitoba from the early 1930s would see some notable differences. Highway 10, which today runs northward from the US border all the way to Flin Flon, used to be #25 from Boissevain to Brandon and #26 from Brandon to Minnedosa, where it met Highway 4 going in an east-west direction. That highway, today's

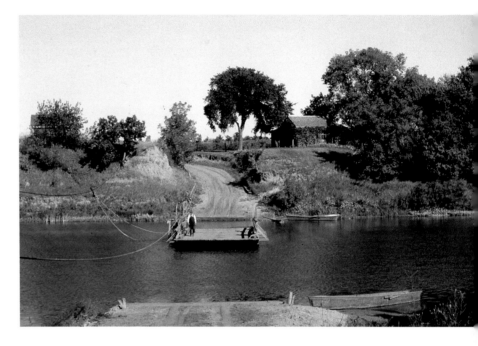

Where there were no bridges, there were ferries. This pastoral photo from August 1941, taken by naturalist Ralph D. Bird, shows the ferry that operated on the Assiniboine River near the village of Treebank from 1898 to 1989. CHARLES D. BIRD

Yellowhead Highway (#16), had been #4 before being renumbered in 1979 so it would be the same across the four western provinces. Anthony Wlock, a now-retired provincial highways official, told me that his director instructed him to order new signs for the renumbered highway. Seeking to reduce the cost, Wlock suggested (facetiously) adding a small sticker bearing the number 2 to the existing signs, making them 4 raised to the power 2, or 16. His director was not amused. Today, all Provincial Trunk Highways have one- or two-digit numbers, except

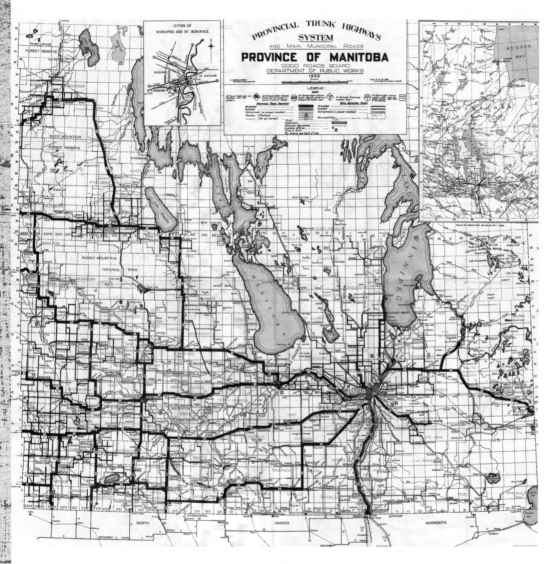

Manitoba's highway network as of 1933, the first year that the Trans-Canada Highway was fully open from the Ontario to Saskatchewan borders. MANITOBA TRANSPORTATION AND INFRASTRUCTURE

The Trans-Canada Highway

On 1 July 1932, a group of officials met at the border between Manitoba and Ontario to unveil a twelve-ton boulder bearing a brass plaque, flanked by flags of the two provinces. It marked the official opening of a new road linking the two provinces as part of the Trans-Canada Highway. Construction of the highway, by men employed by government relief programs during the Great Depression, had been completed just a month earlier. Measuring 145½ miles long, the highway started at the corner of Portage and Main in Winnipeg and ran northeast to Beausejour, east to Whitemouth, then through the boreal forest through Rennie to West Hawk Lake. The road followed the contours of the land, so it twisted and turned as it passed large rock outcrops of the Canadian Shield, with just two lanes (one each way, twelve feet wide), and no shoulders. There were numerous blind corners. Travellers were told to allow a full day for the trip that, today, takes about 2½ hours. Four days after the official opening, the first hitchhikers, a pair of fifteen-year-old boys from Winnipeg, headed to Kenora on the new highway, allowing themselves two weeks for the return trip.

The roadway, initially graveled, was paved (with "bituminous" paving—akin to asphalt) in 1937. Through time, its

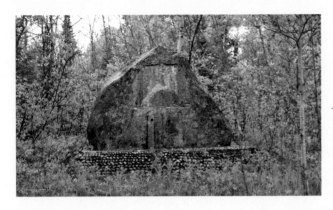

The original Trans-Canada Highway monument, unveiled at the border of Manitoba and Ontario in July 1932, as it appeared in June 2019.
GORDON GOLDSBOROUGH

width increased from the original twenty-four feet to something varying between thirty-two and forty-four feet. Between 1952 and 1954, the winding route (today's Highway 44) was replaced by the shorter, more direct route that it follows today. At the same time, the Trans-Canada Highway west of Winnipeg also took a new route, abandoning the original one north of the Assiniboine River (Highway 26) to use a former railway right-of-way, south of the river, in an almost ramrod-straight drive to Portage la Prairie. The route west of Portage was also much straighter. Rather than following a zig-zag path along country "mile roads" that passed through numerous towns along the way, the new route of the Trans-Canada bypassed towns in the name of high-speed travel.

Today, you can still drive portions of the original Trans-Canada Highway in Manitoba, as I will show you in the conclusion to this book. Some of them are still active highways. Along Highway 44,

there are numerous short sections where the old Trans-Canada can be seen, including a two-mile-long stretch paralleling the modern highway, about five miles east of Whitemouth. Most parts are not drivable; the pavement is cracked and disintegrating, with vegetation poking through but, in some cases, the old traffic markings are still visible. If you drive along the present-day highway near the Manitoba-Ontario border, there is a turnoff that brings you to an abandoned portion of the original Trans-Canada. If you know where to look, you can stop and walk a short distance into the forest. There, overgrown and forgotten, is the boulder from that opening ceremony in 1932. Its plaque is long gone, having been moved to a visitor information bureau a few miles to the west. But the abandoned monument is a reminder of a time when we did not take for granted the ability to get into our cars and drive to most any place we wanted.

for 100 and 101 encircling Winnipeg, 110 bypassing Brandon, and 190 for the CentrePort Canada Way. Provincial Roads have three digits with odd numbers going generally east-west and even numbers north-south. New Provincial Roads are assigned numbers from a pool of unused ones. Wlock recalls receiving a request to purchase twelve new signs for Provincial Road 420, to replace ones that had been stolen. He approved the purchase but then, a few weeks later, received another order for the same signs, because they had been stolen again. Only then did he investigate the reason for the inordinately frequent sign thefts: 420 is slang for the consumption of cannabis and the signs were apparently popular as collectibles among marijuana fans. Recognizing the futility of keeping the 420 signs in place, the government instead renumbered the road as 426.

From the late 1940s into the 1960s, governments across Canada worked to replace the gravel on major roads with pavement, and

In 1948, the Manitoba government published a guide showing the dimensions, design, and colours for standard road signs in the province. Informational signs such as this one, to denote a Provincial Trunk Highway, had black lettering on a white background whereas signs requiring motorist attention were yellow-orange with black. Red was used much more sparingly than today, and signs were smaller than we have come to expect for maximum visibility. ANTHONY WLOCK

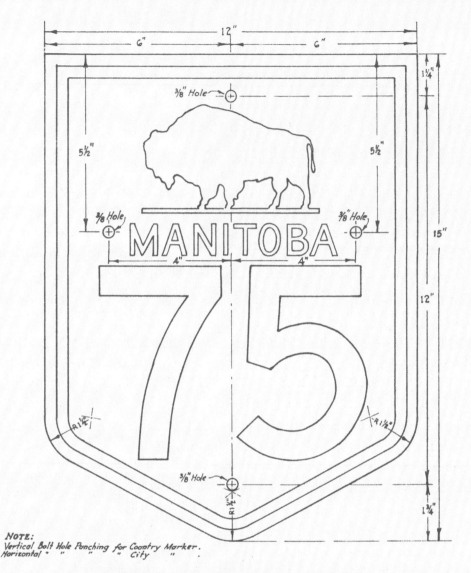

NOTE:
Vertical Bolt Hole Punching for Country Marker.
Horizontal " " " " City " .

STANDARD ROUTE MARKER
SIGN 12"x 15"

BORDER- BLACK (Embossed)
BACKGROUND-WHITE
SYMBOL- BLACK SCOTCHLITE (Embossed).
LETTERS- 1"SERIES"D" BLACK.
NUMERALS- 6"SERIES"D".
 BLACK SCOTCHLITE (Embossed).

DEPT. OF PUBLIC WORKS
HIGHWAYS BRANCH DESIGN OFFICE
PROVINCE OF MANITOBA
MAY 1949

H.S.148

to interconnect provincial networks. These changes stimulated trade and tourism, and therefore vehicular traffic. There is a downside, however, to roads becoming better. By making it easier for people to travel from place to place, good roads make it easier for people to commute to and from large communities offering more services than smaller communities. The result is that fewer people are willing to live in small towns and they become ghosts. As the population wanes, a negative feedback loop causes businesses and organizations to lose the participants that justify their operation. Depopulation—the growth of a few large cities and towns at the expense of many smaller ones—is rampant in rural Manitoba and it is a direct result of road development.

That is why this book is called *On the Road to Abandoned Manitoba*. One can see a lot of abandonment by driving the roads and backroads of the province. But there is another, more positive basis for the title. We can learn a lot about Manitoba from a casual drive along its roads. As we drive and ask ourselves the questions "What is that thing over there? Who put it there? Why? Why was it abandoned?", we naturally lead to stories in the answers we find. Most of the stories in this book come from the research I did about a place that I found during my own drives. I do admit that some of the places are not situated on a road, but it is worth remembering that roads can be more than earth, gravel, and concrete; for millennia, people have used rivers and lakes as roads too. By the end, I hope you will agree that there is much to learn and enjoy if you are willing to take the "road less travelled" and be a keen observer along the way, always with an open and inquisitive mind. Let's go.

Directions

In each of the following chapters, you will find geographic coordinates (latitude and longitude) to reach the subjects of the chapter. Enter the coordinates into a GPS receiver or a smartphone app, and you're on your way! For example, you can find the abandoned Trans-Canada Monument at N49.74080 W95.15349. Accompanying each chapter is a road sign that would have been familiar to Manitoba motorists in the 1930s and 1940s. I obtained the sign designs (and coloured them in the way they would have looked) from a book on Manitoba road sign specifications lent to me by retired highways official Anthony Wlock.

ACKNOWLEDGEMENTS

I thank Jean-Luc Pilon and Jeff Chalmers for sharing information on the beached barges from Port Nelson and the instrument "outhouse" on the railway trestle, respectively. Terri Deller shared her photos of the Atkinson House in the aftermath of the fire that destroyed it. Clint Sawchuk of Nelson River Adventures got me to Port Nelson and, after a worrisome night sleeping aboard his jetboat beached on the artificial island, brought me back. A couple of fine gentlemen who used to work at the Manitoba Highways Branch, Anthony Wlock and Chuck Lund, enabled me to learn a lot more about provincial highways than I would have been able to do on my own. A wonderful pair of books about the history of the Trans-Canada Highway are Clint Cannon's *Exploring the Old Trans-Canada East* and J. Clark Saunders' *Exploring Old Highway No. 1 West*, both of which cover the portion in Manitoba.

Buller
Monument

W here do we go when we die? This is a question to which there are no certain answers. In one sense, however, we know where the remains of a person are put when their life ends. In some cases, they are buried in the ground. But not always. Here, I want to tell you about a person whose remains have arguably been abandoned in a quite unusual place: inside a monument on the University of Manitoba's main campus in south Winnipeg. Those remains, of one of the University's first science professors, inform us about the origins of advanced education and scientific research in our province, and how our attitudes about the treatment of the dead have changed through the years.

In 2023, the University of Manitoba celebrates its 146th anniversary, making it the oldest university in western Canada. What is perhaps not as well known is that the early University was operated very differently from today. Rather than offer classes taught by its own professors, the University of Manitoba existed only to confer degrees on students taught by its three founding colleges, all of which were affiliated with religious faiths: St. Boniface College (Roman Catholic, today's Université de Saint-Boniface), St. John's College (Anglican), and Manitoba College (Presbyterian). Wesley College (Methodist, today's University of Winnipeg) joined the University consortium eleven years later, in 1888.

The monument on the University of Manitoba's campus in south Winnipeg that contains the abandoned remains of Reginald Buller, April 2018. GORDON GOLDSBOROUGH

The University of Manitoba as we know it today started to take shape in 1901 when the first building solely dedicated to university teaching was built at the present-day site of Memorial Park, north of the provincial Legislative Building. This new building motivated Reverend George Bryce—whose teaching load included lecturing in Astronomy, Botany, Geology, and Zoology at Manitoba College—to begin fundraising to hire specialists to teach these subjects. In 1904, he persuaded Donald Smith (Lord Strathcona) of the Canadian Pacific Railway to contribute the princely sum of $20,000 (about $570,000 in today's dollars) to hire six full-time professors. Job advertisements were sent all over the world and, later that year, what I call the "Original Six" were introduced to the public: Frank Allen (who taught Physics), Gordon Bell (Bacteriology), Matthew Parker (Chemistry), Robert Cochrane (Mathematics), Swale Vincent (Physiology and Zoology), and Reginald Buller (Botany and Geology). Three were Canadians (Allen, Bell, Cochrane) and the other three were from Great Britain.

For over forty years, I have been fascinated by Reginald Buller, partly because he had founded the University's Department of Botany where I received my professional training, and partly because he was so colourfully eccentric. In 2004, I was able to delve deeply into Buller's life when the University's Faculty of Science was celebrating its 100th anniversary. Jim Jamieson, the Dean of Science at the time, convened a committee to plan activities for the anniversary and, knowing my interest

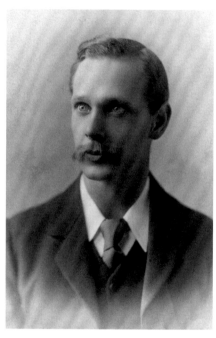

Arthur Henry Reginald Buller (1874–1944), one of the first full-time science professors hired by the University of Manitoba, as he appeared soon after arriving at Winnipeg in 1904. UNIVERSITY OF MANITOBA ARCHIVES & SPECIAL COLLECTIONS

in history, he invited me to join it. When he asked for suggestions on what we should do for these activities, I proposed that we invite Buller to reminisce about the early days. Of course, I did not expect Buller to rise from the dead; rather, I suggested that we hire one of my actor friends to portray Buller. Dean Jamieson loved the idea and authorized me to write the actor's script. I quickly discovered that it is one thing to offer an idea like this and quite another to follow through on it.

To write a factually accurate and detailed memoir for the ersatz Buller to speak, I would have to learn far more about the real Buller than I knew. One of my University colleagues mentioned that Buller's personal papers were in the library of the Agriculture Canada building on the University campus. Thinking they would be a useful source of information, I went there and found an odd collection of his books, photographs, and a few documents. The bulk of his papers were missing. A librarian told me

they had been transferred to the care of the national archives years earlier. I dutifully contacted the archives and found, to my excitement, that they had not been moved to Ottawa, as I had feared, but to a dormant records storage facility in Winnipeg. I visited the facility and learned that I was the first person to ever seek access to Buller's papers. The archivists retrieved several cartloads of dusty, disorganized boxes from storage, and I spent several months perusing every scrap of paper in them. They included his correspondence with people all over the world, his voluminous notes, and documents relating to his university work; essentially, it was his entire collection of day-to-day papers from his forty-year residence in Winnipeg. It was a daunting task, and, in retrospect, it was a lot more work than Dean Jamieson or I had anticipated. However, in the process, I learned so much about Buller that I felt I knew him personally, though he died fifteen years before I was born.

Birmingham-born Arthur Henry Reginald Buller arrived in Winnipeg in late 1904, at the age of thirty, and checked into the Vendome Hotel on Fort Street, south of Portage Avenue. The Vendome still exists today. He lived there until 1913. One of the people that he met there was a journalist named Ruth Collie. Despite what you may think, Buller's interest in her was decidedly unromantic. Collie was married and, for his part, Buller never married. (Despite rumours to the contrary, I found no evidence that Buller was gay.) Instead, he believed that Mrs. Collie was telepathic and could project her thoughts over great distances. As a trained scientist, Buller was fascinated by this capability. He carried out experiments to test her telepathic powers and, in 1912, he said in an address to his university colleagues: "In my opinion, telepathy by means of overwhelming evidence has been established as a fact … telepathy teaches us how little we yet know of our own minds and how much there is yet to be discovered of human personality."

Each year, Buller lived in the Vendome Hotel from the fall, when university classes resumed, to the following spring, when he would go home to spend his summer in England. (He crossed the Atlantic Ocean by ship sixty-five times, every year at least once, until his death.)

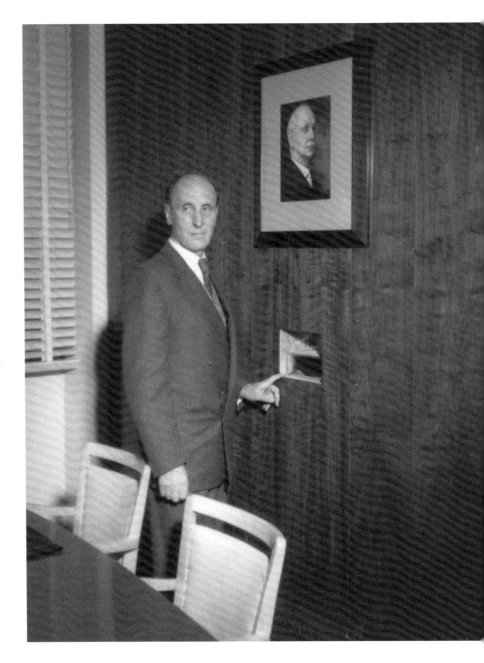

In 1958, William Hanna, one of Reginald Buller's former graduate students, inserted a box containing Buller's cremains in a wall cavity in the library inside the now-demolished Agriculture Canada building at the University of Manitoba. They remained there until 2013 when they were transferred to the care of the University of Manitoba Archives & Special Collections. UNIVERSITY OF MANITOBA ARCHIVES & SPECIAL COLLECTIONS

Cremation of the Dead

Reginald Buller was a trailblazer in more ways than one. Not only did he pioneer the practice of science in Manitoba, but he also led the way when he died in 1944. His will had specified that his remains should be cremated. There was no crematorium in Manitoba, so the cremation was done in Minneapolis.

Interest in having a crematorium in Manitoba goes back to at least 1900 when the City of Winnipeg passed a bylaw to permit the construction of one. But nothing came of it. Some religious faiths opposed cremation on grounds that it violated their beliefs, for example, in the resurrection of the body after death. However, in 1920, the mayor of Winnipeg announced that he was wholly in favour of building a crematorium here and, indeed, that his mother had been cremated. From the 1920s to 1940s, periodic proposals to build a crematorium would encounter fierce opposition. In the late 1940s, a plan to build a crematorium at the Brookside Cemetery was opposed by a fellow named Jaroslaw "Slaw" Rebchuk, who would later serve on the city council, and is now commemorated by a bridge.

By the early 1950s, there was still no crematorium in Manitoba—the nearest ones in Canada being in Calgary and Toronto—and cremation was still not a widely chosen option. In the USA, in 1958, only about 4% of all funerals involved cremation. But everything changed in June 1958 when the town council in Fort Garry (at that time still independent from Winnipeg) approved the construction of Manitoba's first crematorium. Not surprisingly, public reaction was mixed. Over fifty angry neighbours of the proposed site appeared before the council to demand that it withdraw the approval, arguing that they did not want to see smoke rising from the crematorium to continually remind them of death. But the council was undeterred, and construction of the crematorium went ahead. In March 1959, the Pineview Memorial Gardens and Crematorium opened officially, on Waverley Street, and members of the public were invited in for tours.

I have not been able to find data on the number of early cremations at Pineview. However, I did find annual reports for the Manitoba Vital Statistics Agency that present a revealing picture. From essentially no cremations in 1959, the number had risen to 39% by 1994. Over a twenty-seven-year period, from 1994 to 2020, the percentage of deaths involving cremation rose to 68%; in other words, over two-thirds of deaths now involve cremation. In speaking to a local funeral director, I learned that the proportion of cremations today varies from place to place, depending on ethnicity and religion. At a funeral home in south Winnipeg, the percentage is between 70 and 80 percent. And the trend is an almost perfect straight line upward, increasing at a rate of slightly more than one percent per year. If we extrapolate, from the present rate, the number of deaths involving cremation will be 100 percent by 2044, just over twenty years from now. Of course, there will always be people who oppose cremation, so the percentage will not truly be 100 percent. But I find it remarkable that the method of handling the dead has changed so fundamentally in such a short span of time; that a cultural practice that was the norm a century ago would be all but abandoned in such a short time.

Why are more people being cremated? Cremation uses less land for burial. But the space-saving is mostly relevant in places where there is a shortage of land, which is definitely not the case in Manitoba. I think the main benefit of cremation is that it is cheaper than a traditional burial, not requiring an expensive coffin, and this appeals to legendarily frugal Manitobans. But cremation may not be an ideal solution. Cremation creates carbon dioxide, a greenhouse gas, that contributes to global climate change. There is growing interest in "green burials" that return to the practice of burying intact bodies with minimal use of toxic embalming chemicals. A green burial is probably something that would have appealed to a botanist like Reginald Buller.

In other words, Buller never really became a permanent resident of Manitoba. His entire forty-year residence in Winnipeg was spent in hotels. In 1913, he moved into the McLaren Hotel that still stands at the corner of Main Street and Rupert Avenue. Unlike the Vendome, which had communal bathrooms, the McLaren offered the luxury of suites with private amenities. It was Buller's "home away from home" for the next thirty-one years.

From the early days, the Original Six professors gave public lectures in an attempt to make Manitobans aware of science in general, and their academic specialties in particular. In one lecture series, Allen spoke about the physics of soap bubbles while Parker described the chemistry of air. Vincent talked about how humans digested their dinner and Buller told the story of a grain of wheat. One of Buller's later, more contentious lectures was entitled "The case for sterilization" in which he advocated that people who he described as "feeble-minded" or "congenitally defective" should be sterilized to prevent them from having children, arguing that "no animal or plant breeder would breed from his worst stock." Known as eugenics, this philosophy became the basis for some of the practices of Nazi Germany, which sought to create a "Master Aryan Race" by selecting only certain men and women with desirable qualities to have children. Horrified as we are by such practices today, Buller's eugenic views were common at the time, especially among Manitoba's intellectual elite, including noted suffragist Nellie McClung.

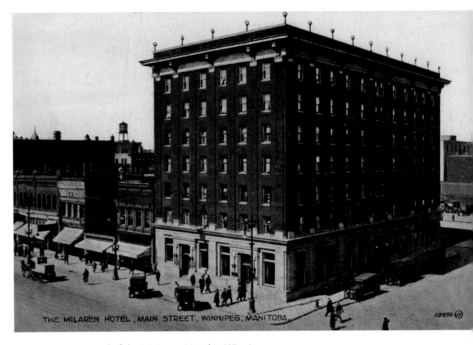

An antique postcard of the McLaren Hotel in Winnipeg, Reginald Buller's home for most of his forty years in Manitoba.
GORDON GOLDSBOROUGH

Unlike George Bryce and the other lecturers from the religious colleges, Buller felt it was fundamentally important for university professors to carry out original scientific research, thereby expanding human knowledge. Within a month of his 1904 arrival in Winnipeg, Buller got underway: "There was a woodpile on a vacant lot north of us here on Portage Avenue … so I went right over and gathered some fungi and started my investigations." In the newly built Science Building, Buller settled into a spacious workspace that consisted of a lecture theatre,

Winter Vaults

Some might think that a "winter vault" is used to store cold, hard cash. But it is actually a building used to hold human bodies during the winter when digging a grave in frozen soil is difficult. There are several other names for a winter vault, including dead house, mort house, corpse house, charnel house, and receiving vault.

The history of these vaults goes back centuries, especially in northern European countries where gravediggers had to resort to all sorts of methods to bury the dead during the winter. The most common approach was to build a bonfire at the burial site, to thaw the ground sufficiently to allow digging. Today, some cemeteries dig graves in the fall to be ready for winter burials. Where burial must occur in a specific plot, they use jackhammers, backhoes, and other mechanical means to dig a grave in the winter so there is no longer any need for winter vaults. Yet at least three vaults survive in Manitoba today.

The second oldest of the three vaults was built in 1908 in the cemetery about a mile west of Melita. It has two levels and is built on the side of a small hill. The upper level, with a main entrance door from the cemetery, was intended as a chapel where funeral services could be held. A trap door in the floor of the chapel leads to the lower level which also has an exterior door at the bottom of the hill, presumably where coffins could be carried inside for storage on a series of racks. And it is a *very* solid little building. Its lower level is made of solid concrete and the upper level is made from red bricks with decorative buttresses at the corners, and two small windows on each side. The main door is made of wood but entirely clad in metal.

Interestingly, the solidness of the building is a legal requirement for such buildings. The Manitoba's Cemeteries Act contains a lot of details about the construction of winter vaults. The exterior walls must be made of stone, brick, or a mixture of stone and brick. The doors must be iron, or wood encased in iron sheeting. Windows and other openings in the vault must be protected by iron-sheeted shutters. The only reason that I can think of, to explain the robustness of winter vaults, is to make them difficult to break into (by animals and vandals) or to damage by fire.

The other two winter vaults are in Winnipeg. The oldest one in Manitoba, as far as I know, is in St. Mary's Cemetery on Osborne Street. That vault dates from 1906. Its construction is similar to the one at Melita. It is a little larger and more ornate but still consists of two levels: a chapel above a vault that is partially below ground. It is made of yellow bricks with decorative buttresses at the corners and along the sides, with several small windows on each side. The other Winnipeg winter vault is in the Transcona Cemetery on Dugald Road. The cemetery was established in 1914 and the vault is the newest of the three, built in 1932 using yellow bricks salvaged from a nearby Presbyterian Church that had closed. Like the other two, it has a chapel on the main level and a vault partially below ground. Its chapel is still mostly intact, having hardwood wainscotting around its walls and other wooden millwork so that I wonder if it was salvaged from the church too. Downstairs, the vault had space for up to forty coffins. Following the law, all its windows are covered in metal bars and its main entrance door is clad in metal. An exterior door into the vault at the back of the building has been closed permanently so the only way into the basement is via a small door under the chapel entrance, or from a trap door inside the chapel.

None of the three winter vaults is used actively. A groundskeeper at

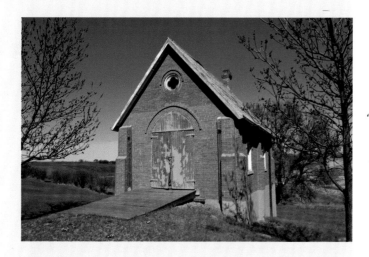

A winter vault in the Melita Cemetery, built in 1907 and seen in this photo from May 2019, used to store coffins during the winter, is now used mostly for storage of groundskeeping equipment.
GORDON GOLDSBOROUGH

Melita told me the vault there is still used occasionally, but it appeared to me that the main use was to store lawnmowers. The St. Mary's vault has conspicuous holes in its roof, numerous cracks in its brick walls, and I was told by a groundskeeper that the lower-level vault floods frequently. The Catholic parish that owns the vault has looked into demolishing it, but the cost will be considerable. An alternative is to convert the vault into a columbarium for the storage of cremation urns. The Transcona vault also has numerous cracks in its walls and, although it used to be used to store groundskeeping equipment, a new, larger building elsewhere in the cemetery has replaced it. Like the St. Mary's vault, it is also subject to frequent flooding, and the building has suffered quite a lot of shifting through the years. The vault has not been used in many years; its floor is badly buckled and cracked, probably as a result of flooding. I was told by a cemetery worker that the City of Winnipeg plans to demolish it, but no timeline has been given.

professor's office, a laboratory with one room dedicated to plant physiology, a second to morphology, and a third for "museum purposes," a small greenhouse, and a photographic dark room. A grant enabled Buller to purchase "botanical models, diagrams, physiological apparatus, glassware, and general laboratory supplies" although he was horrified by the absence of a good scientific library because "without works of reference and access to current scientific literature it is impossible for either teacher or student to keep in touch with scientific progress." Buller contributed substantially to this progress through a series of six books that he called *Researches on Fungi*. They described his observations and experiments through the years, including descriptions of the effects from eating hallucinogenic mushrooms. Curiously, Buller shared pieces of these mushrooms with his friends and acquaintances, including his laboratory assistant Rudolph Hiebert, a brother of University chemist Paul Hiebert whose published works included the award-winning humorous book, *Sarah Binks*.

In addition to his teaching and research at the University, Buller was involved in other facets of community life. He wrote frequent letters to local newspapers whenever he thought the public discourse required his lofty scientific input. For instance, he believed firmly in Darwin's theory of evolution and sparred about its implications with local theologians in newspaper columns. He helped to co-found the Scientific Club of Winnipeg where learned men (and *only* men, although Buller

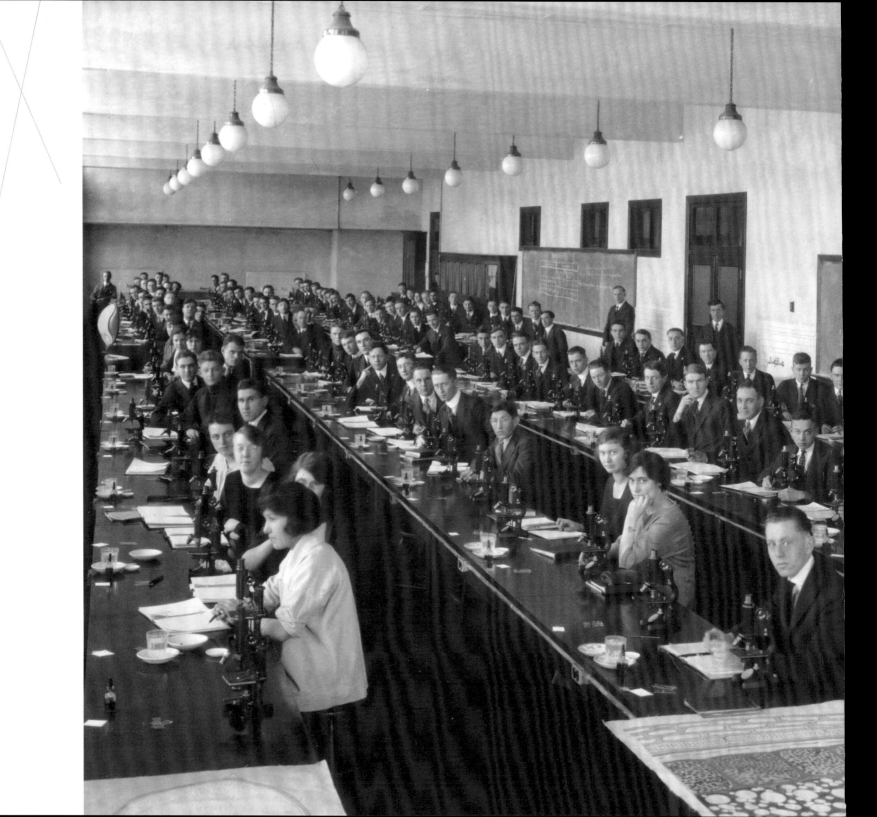

Classroom in the University of Manitoba where rows of formally dressed students (a stark contrast to today's informally dressed ones) examined tiny specimens with microscopes. Buller and his laboratory assistants can be seen standing at the back of the classroom. UNIVERSITY OF MANITOBA ARCHIVES & SPECIAL COLLECTIONS

himself appears to have had progressive views about the equality of women) from the realms of science, medicine, engineering, and related fields met to discuss weighty topics of the day. At one particularly heated club meeting in 1923, where the merits of Einstein's theory of relativity were being discussed, Buller offered a limerick that he had written on the relationship of velocity and time. It would become his most well-known writing:

> There was a young lady named Bright,
> Whose speed was far faster than light.
> She set out one day, In a relative way,
> And returned home the previous night.

Like many well-educated men of his day, Buller fancied himself a poet and his papers are littered with examples of his creative work. Most of them are atrocious. For example, in the early twentieth century, automobile owners began offering rides to anyone willing to pay (something like modern-day Uber) at a rate of five cents per ride. An early nickname for the five-cent coin was "Jitney" so these cars became known as Jitneys. Buller so loved the fresh air of riding in an open-topped Jitney, compared to the stuffiness of a streetcar, that he wrote the poetic ode, "To a Jitney:"

> Hail to thee, Jitney!
> Of thy cheapness and speed
> The good folks of Winnipeg
> Long have had need.

Hail to thee, Jitney!
May thy tyres ne'er wear through.
May thy spark-plug keep sparking and
Ever spark true.

So many people began taking Jitneys that ridership on the city-run streetcars began to wane and the city council banned them, after which Buller penned:

Good-bye, dearest Jitney!
Thy loss is a blow,
And oft think I of thee
As homeward I go,
The air very stuffy
With microbes filled thick,
And stop! Oh dear oh!
Thou always wert quick.

In 1942, after Buller had retired from day-to-day teaching at the University, he was kicked out of the office in the Science Building that he had occupied since his arrival in 1904. He boxed up years of accumulated files (that I would later peruse) and stored them in a series of temporary spaces. In January 1944, he was diagnosed with a terminal brain tumour and died that July, at the age of 69. Buller's will called for him to be cremated and his ashes were put in a sealed copper box. Due to his lingering resentment at having been evicted from the University, he is said to have decreed that none of his papers, books, and other effects should ever go to the University. Consequently, they were all taken, along with Buller's remains, to the "Dominion Rust Laboratory," a federal government research facility on the University's campus where some of Buller's former students worked. The remains sat there until the 1950s when a new building, to be used by research scientists working for Agriculture Canada, was constructed. The library in that building was named the Buller Memorial Library and a special cubby-hole in the wall of the library was made as a home for Buller's ashes. Eventually, the librarians decided that the large number of boxes of Buller's papers did not have any useful purpose there, so most of them were shipped to the dormant records facility where I found them years later.

After spending months ploughing through Buller's papers, I realized how important they were to documenting the history of the University in the early twentieth century. Knowing the rumour about Buller's deathbed decree, I located a copy of Buller's will among court records at the provincial archives. There was not a word about the supposed prohibition. So, I suggested to Shelley Sweeney, the

University Archivist, that we ask the national archives to donate the papers back to the University. The national archivists were receptive, and the transfer was duly done as part of the Faculty of Science's anniversary celebrations in 2004. The remaining materials at the Agriculture Canada building were later given to the University and, when it was decided that the building would be demolished, Buller's ashes were removed from the hole in the library wall and given to the University too. After some deliberation, Sweeney decided that the best place for Buller to rest was near the building that today bears his name, built in 1932 as the University's first dedicated science building at the Fort Garry campus. In 2013, Buller's ashes were put inside a monument on a sidewalk in front of the building. So, today, when people walk past the Buller Building and its monument, they should doff their hats to the quirky Englishman entombed inside. He helped, in a tangible way, to convert the University of Manitoba from what it had been, a mere degree-granting non-entity, into the world-recognized institution for higher learning and research that it is today. If you are interested in knowing more about Reginald Buller, a much more detailed biography that I wrote can be found on the website of the Manitoba Historical Society. It also contains more samples of his awful poetry.

Directions

Enter these coordinates into a GPS receiver or a map app on your smartphone.

Historic Site	Latitude	Longitude
Reginald Buller's Cremains	N49.81037	W97.13340
Manitoba's First Crematorium	N49.82291	W97.18110
Melita Winter Vault	N49.26700	W101.01801
St. Mary's Winter Vault	N49.86727	W97.13427
Transcona Winter Vault	N49.88508	W96.96237

ACKNOWLEDGEMENTS

My excavations in the extensive Buller papers back in 2004 were made possible by David Horky at the Winnipeg office of Library and Archives Canada and Mike Malyk, then at the now-demolished Buller Memorial Library of Agriculture Canada. I am grateful to Shelley Sweeney, now-retired Head Archivist at the University of Manitoba Archives & Special Collections, for her enthusiastic efforts to repatriate this incredible collection to its rightful University home.

BEGIN DETOUR 400 FT

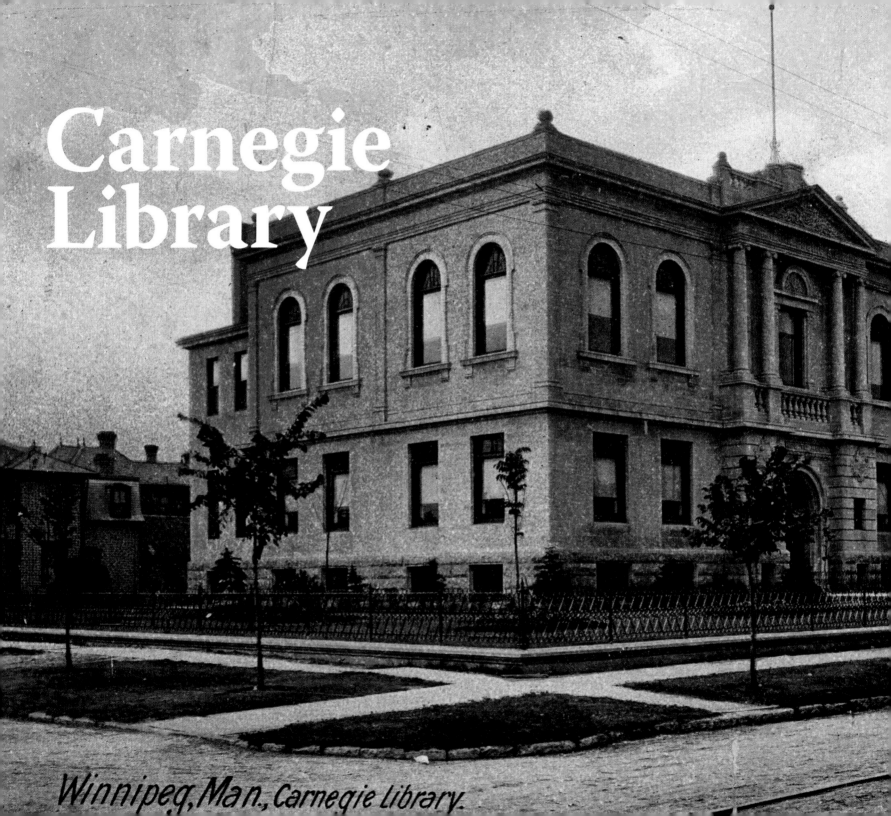

Carnegie Library

Winnipeg, Man., Carnegie Library.

I admit it—I am a bibliophile. As far back as I can remember, I have loved books. I love everything about them: the way they look, feel, smell (I especially love the aroma of a really *old* book) and, of course, read. So, it follows that I also love libraries, as places where there are lots of books. We tend to assume that libraries have always existed in Manitoba but, in fact, the City of Winnipeg was not served with a public library for its first thirty-two years of existence. It was 1905 when the now-vacant Carnegie Library on William Avenue became Manitoba's first public library. For the next seventy years, it was the "flagship"—a centre of humanity's collected knowledge—in a network of libraries around the city.

In truth, the library that opened in 1905 was not the first library in Manitoba. A Red River Library existed in the Red River Settlement between 1848 and 1871, with books donated by explorer Peter Fidler and several retired fur traders. The first lending library in Winnipeg was operated by the Historical and Scientific Society of Manitoba (today's Manitoba Historical Society; MHS). As of 1888, the collection was housed in the City Hall on Main Street, managed by a joint committee of the MHS and the City. A juvenile section, opened in 1899, caused a marked increase in book circulation. Dedicated

An historical postcard of the Carnegie Library on Winnipeg's William Avenue. In the background at right, across Ellen Street from the library, was Victoria School and its twin, Albert School, sat farther back. ROB MCINNES

library space was needed. In 1901, provincial librarian John Robertson wrote to American philanthropist Andrew Carnegie (pronounced car-nuh-gie by purists, not car-nee-gie) to request a grant for the construction of a new library building.

Scottish-born Carnegie made a fortune in the steel industry and, later in his life, became passionately engaged in public philanthropy. He is reported to have said that "the man who dies rich, dies disgraced" and he lived by this mantra, endowing a wide range of institutions. Most notably, Carnegie is commemorated by Carnegie Hall in New York City and Carnegie Mellon University in Pittsburgh. Among his other works were public libraries throughout the English-speaking world, in the United States, Britain, Ireland, Australia, New Zealand, South Africa, and Canada. In total, Carnegie paid for the construction of some 3,000 libraries world-wide and 125 libraries across Canada. Winnipeg was just one of 142 cities that Carnegie approved for a library grant in 1901. Other Canadian cities approved that year were Collingwood, Cornwall, Guelph, Ottawa, St. Catharines, Sault Ste. Marie, Stratford, and Windsor in Ontario, and Vancouver and Victoria in British Columbia.

Carnegie's offer of $75,000 was contingent on the city government approving an annual allocation of one-tenth of this sum for operating costs. An additional $25,000 from city coffers would be used to acquire and landscape the grounds. Designed by local architect Samuel Hooper, construction of the two-storey building of limestone

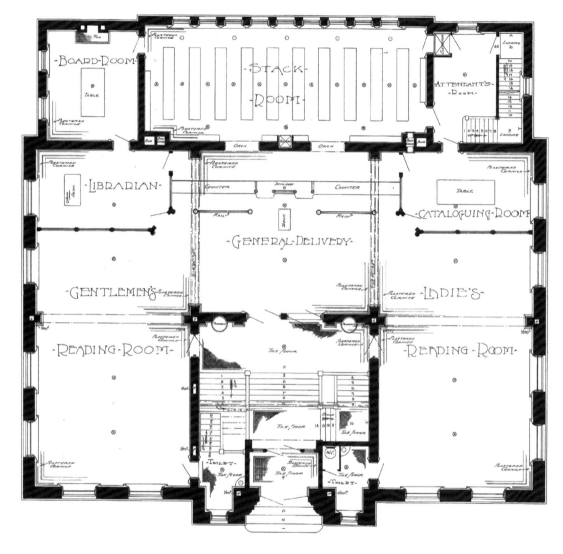

The floor plans for Winnipeg's new Carnegie Library, circa 1904. CITY OF WINNIPEG ARCHIVES

veneer over a brick core took from 1903 to 1905. It was (and is) an impressive building. Walking up steps leading into the building, you entered a small lobby, then through a second set of doors into another lobby, then up a set of six marble steps. From here, you could take a second staircase to the second floor or proceed ahead onto the main floor, where there was a wide desk staffed by librarians. Behind them, through a pair of arched doorways, were the stacks—closely positioned shelves jammed with some 30,000 books transferred from the old City Hall library. The stacks were "closed" in the sense that you could not simply browse the contents of the shelves in search of a particular book. Instead, you asked a librarian to retrieve the book from the stacks then, according to your gender, you turned left to enter the Gentlemen's Reading Room or right for an equal-sized Ladies' Reading Room. There, gentlemen (but, it appears, not ladies) were offered a selection of current newspapers and magazines

from across Canada, the United States, and Great Britain. On the second floor were book stacks with 30,000 more books (and a small elevator to transport books between floors), an impressive skylight to flood the area with natural sunlight, as well as public rooms with oak bookcases, tables, and chairs. The plastered white walls with natural oak woodwork would later feature a collection of artwork. An assembly room on the second floor was used for regular Saturday afternoon lectures. Down in the basement were mechanical systems for heating—but not cooling—the building, meeting rooms (used through the years, for example, by the Manitoba Camera Club and the Beta Sigma Phi Business Girls Sorority), and storage space (more on this later). The grounds surrounding the building, under the control of the Winnipeg Parks Board, were grassed and enclosed with a cast iron fence.

As finishing touches were put to the library, a search commenced to find a *male* librarian to lead it. (There was no consideration whatsoever of the possibility that a *female* librarian might be able to do the job.) In due course, James McCarthy was selected (by a 6-5 vote of council) as the city's first Chief Librarian. Ontario-born, McCarthy had come to Manitoba in 1888 and taught school at Portage la Prairie then moved to Winnipeg where he was the principal of Carlton School on Carlton Street—the present-day site of the True North Square. He sold life insurance and served on the city council before finding another principalship at Pinkham School on Pacific Avenue.

The new Carnegie Library was opened officially by the Governor General in October 1905. Under McCarthy's administration, the first children's room of any library in Canada was opened, in January 1907, followed a few months later by a reference library that catered to those seeking specific facts and figures—in modern parlance, an early version of Google. Expansion of the library network began less than five years after the main Carnegie Library was built, with the opening of "branch and extension libraries" in public spaces, including a pharmacy on Grosvenor Avenue at Stafford Street, in the Stella Avenue branch of the All Peoples Mission, at the YWCA, General Hospital, and several local schools (Clifton, Strathcona, Lord Selkirk, Cecil Rhodes, and King Edward). McCarthy also oversaw the construction of an addition on the south side of the original building, in 1908, using a second $39,000 grant provided by the Carnegie Corporation. This was not the end of Carnegie's largesse toward Winnipeg. In 1913, the city council approached him for $70,000 to construct two libraries away from the city's core: St. John's Library in the North End and the Cornish Library near the Misericordia Hospital. Constructed in 1914, these one-storey buildings, modest compared to the main library, opened to the public in 1915. Unlike their predecessor, the newer Carnegie libraries in Winnipeg are in active use today. Although Winnipeg received three Carnegie libraries, only one other Manitoba community received one; a $10,000 grant in January 1908 went to Selkirk. (That library was demolished in 1960 to

To those who did not return books to the library on time, a penalty of two cents a day was assessed, and the transgressor was mailed a postcard reminder like this one from 1948. GORDON GOLDSBOROUGH

make way for an expansion of the Selkirk Town Hall.) In 1917, Carnegie discontinued his grant program for libraries.

The library's collection grew from an estimated 35,000 volumes in 1911 to a peak of 140,000 by 1918 before declining to around 125,000 through the 1920s then declining again to about 82,000 in the 1930s. From the 1940s onward, however, it grew consistently, reaching 405,000 volumes by 1971. The collection diversified in 1947 with the addition of a lending library of phonograph records, adding to an existing film collection and a growing number of foreign-language books. Starting initially with 700 records, mostly of classical music, they were rented out at ten cents per record per week. Statistics on the library's total annual circulation—the number of volumes lent out—show an interesting trend over time (see Figure 1). After a short-lived spike during the First World War, circulation settled down at around 800,000 volumes per year and remained more or less constant right up to the early 1950s. It climbed dramatically throughout the 1950s, and especially after 1956. I combed annual reports prepared by the chief librarian to seek an explanation for this apparently abrupt increase. There, in the 1953 Annual Report, I found it. For several years through the 1940s, the librarian had complained that the site of the main library, while centrally located when it was built, was no longer convenient for a large proportion of Winnipeggers. The city council was not responsive to requests for new library branches in some of the city's far-flung new neighbourhoods. However, in 1953, it approved the construction of a Bookmobile. A twenty-four-foot heated trailer towed by a one-ton panel truck, containing 2,500 books, the Bookmobile roamed the city, parking for periods of 2½ to four hours in service station or community centre parking

lots. In its first couple of months of operation in late 1953, the Bookmobile circulated 8,400 books, about four times as many as the Elmwood branch during the same period. By autumn 1957, a second Bookmobile—this one a larger vehicle holding 4,000 books—was added to meet the growing demand, managed along with four libraries in public schools by a new "Extension Department" under librarian Nettie Siemens. The Chief Librarian would later report:

> The two Bookmobiles last year had a circulation of 146,968 and have been almost embarrassingly popular especially with the children who line up to get in them at almost every stop.

By 1958, the Bookmobile fleet circulated 277,875 books—more than the main Carnegie Library or any of its bricks-and-mortar branches. Despite these impressive gains in readership, librarians fretted that their circulation was threatened by new technology, most notably television, which was becoming more common in Winnipeg households through the 1950s. In his 1955 Annual Report, Chief Librarian Archibald Jamieson reported that "There has been a decrease in the circulation of books in almost every department of the Library. The general opinion of the branch and department heads is that this is caused partly at least by the effect of TV." The following year, he started to come around to a view that "1956 may be remembered as the year the library recovered from television," in that TV could satisfy the demand for lighter reading

A child exits one of Winnipeg's new bookmobiles, March 1956.
UNIVERSITY OF MANITOBA ARCHIVES & SPECIAL COLLECTIONS

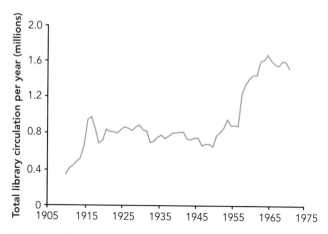

FIGURE 1 The annual book circulation from Winnipeg's libraries between 1910 and 1971 increased rapidly in the first few years then was mostly static through the 1920s, 1930s, and 1940s, rising again through the 1950s as the Bookmobiles made books available to many more Winnipeggers. Was the drop in the early 1960s due to the impact of television? MILLENNIUM LIBRARY, LOCAL HISTORY ROOM

but might stimulate interest in "more serious" books in paper form.

The main Carnegie Library closed in 1977 when the Centennial Library (today's Millennium Library) was opened. It reopened in June 1978 as the "William Avenue Branch" of the library network (remaining open until 1995) and as home for a newly established Archives and Control Branch. Intended to store inactive municipal documents such as council minutes, tax rolls, building plans and permits, and a wealth of other materials going back to 1873, as well as "various community

artifacts and historic documents," the archives arose, in effect, from a storage role that the library had served for a long time. In his 1950 Annual Report, Archibald Jamieson noted that, during flood-fighting that year, "a valuable collection of old records consisting of journals kept by Hudson's Bay Company factors at Fort William was unearthed and handed over to the Provincial Library." Some 580 volumes of bound newspapers that had been "kept in the basement of the Library for many years" were moved to safety in the Civic Auditorium.

In addition to having secure warehouse space for dormant records, Archives staff made microfilm and microfiche copies of tax rolls and other single-copy originals to save on storage space. By the mid-1990s, however, the building was said to be "full" and not well organized. A consultant concluded that:

> The 380 William facility [has] neither the equipment nor the staff to preserve or restore historical records. Similarly, there is no capacity to conduct research, develop displays and publications, and conduct presentations.

In response, the city appointed Marc Lemoine of the City Clerk's Office as its first formal City Records Manager and Archivist. A few months later, historian James Allum

was hired as his assistant. Together with other staff, they began to turn the City of Winnipeg Archives into a facility that could support the municipal government and also be a valuable resource to historians and the general public.

Appraised for insurance purposes at $4.1 million, the City of Winnipeg Archives was considered by professional archivists to have among the finest collections of municipal records in Canada. Unfortunately, the records were stored under less-than-ideal conditions in the nearly century-old Carnegie Library. Insect and rodent pests, widely erratic air temperature and humidity, and a leaky roof combined to make it a terrible environment for preserving precious old documents. In 2013, a major renovation to turn the building into a world-class archival facility, including a temperature- and humidity-controlled storage vault, was begun. These were the first major renovations since the building was underpinned with piles in 1948 and a mezzanine floor was installed and wiring was replaced between 1959 and 1963. Unfortunately, the transformation was not completed. The building sustained extensive water damage when a hole in the roof was left uncovered by contractors during two major rainstorms in June 2013. Soggy archival collections were hurriedly moved into an obscure building in an industrial park and the building has been standing empty ever since. The roof was repaired, and I have been assured the building envelope is now intact, but the interior requires considerable repairs. None of the work to create a satisfactory archival space—estimated to cost $9.2 million—was done. The city council seemed reluctant to commit those funds.

In December 2019, the City of Winnipeg initiated a study to consider the future of its archives. As is typical for such activities, consultants from outside Manitoba were hired, and stakeholders were asked about their views. The review considered the needs for preservation of the archival records, compared the situation in Winnipeg to those in other Canadian cities, and evaluated the space that would be needed to accommodate growth in the collection over a period of twenty

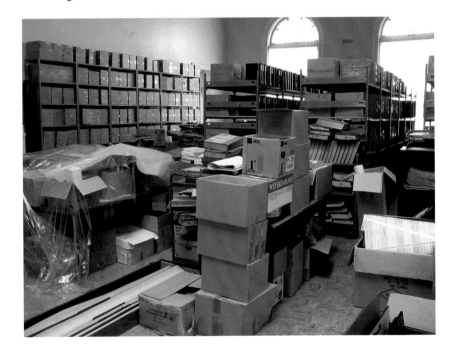

Interior of the former Carnegie Library when it was host to the somewhat disheveled-looking City of Winnipeg Archives, May 2006. GORDON GOLDSBOROUGH

years. Four options, and the associated costs, were explored. All of them would provide a climate-controlled vault for safe storage of the most precious records. One option was to construct a new purpose-built archive, with ideal specifications and sufficient space for twenty years of accumulated files, at an estimated cost of $22.3 million. A second option was to build two structures, one for storing the files and the second for accommodating staff and the public. This was the costliest option, at about $25.8 million. A third option was to build a modest new structure with provision for growth for ten years, with planned expansion in ten years, at a cost of $23.7 million. Finally, the fourth option was to return to the old Carnegie Library, with extensive upgrades, at a cost of $13.3 million. Given these cost estimates, it would seem to be a "no brainer" to choose Option 4.

In November 2021, nearly two years later, the City of Winnipeg Standing Policy Committee on Property and Development met to consider the options. And it decided to push the matter into 2023 and to solicit more reports. As I write this, the City Council has made provision for the city archives in its 2023-2024 budget, in recognition of the city's 150th birthday, so there is renewed hope among advocates for the old Carnegie building that something good may finally be happening.

The potential reopening of the Carnegie building will be received as good news by a generation of people with fond memories of trips to the Winnipeg public library. My wife and her sister remember taking out books with their parents and, if they were especially good, enjoying a chocolate bar from a vending machine in the library's lobby. Growing up in the faraway suburb of Charleswood, I did not patronize the Carnegie Library until high school, when my history teacher assigned a research project on the Second World War. I went to the library in search of old newspapers, published during the war, that were archived there. Reading those newspapers as though they were today's news made the war "come alive" for me, and I think this single experience, more than any other, sparked my life-long interest in history. In 2000, one of my most profound experiences using archival materials occurred when James Allum let me roam among piles of large, bound volumes stored on the second floor. I remember my feeling of awe as I turned each yellowed old page containing hundreds of handwritten entries for the tax bills assessed on particular properties around the city. I also remember how filthy my hands got from touching those

old volumes because dust and debris had been showering down on them from the deteriorating ceiling for years. Later, those volumes were covered by large plastic sheets to protect them from further damage, clearly showing how poor the conditions were at that time for the protection of these invaluable records.

A few years ago, I was asked for a Top-10 list of books that I have known and loved. I realized in compiling my list that several entries were not physical books at all. They were books that I had read in electronic format on my iPad. What this says, I think, is that the *format* of reading material is changing but the *practice* of reading is alive and thriving. Winnipeg's public libraries now include electronic books among their collections. So, I am doubtful of dire predictions that the Internet will eliminate books, just as librarians of the 1950s need not have worried that television would do likewise. Inevitably, future libraries will look very different from Winnipeg's Carnegie Library of 1905. I am glad to have this surviving reminder of how far we book-lovers have come in just over a century.

Directions

Enter these coordinates into a GPS receiver or a map app on your smartphone.

Historic Site	Latitude	Longitude
Carnegie Library (380 William Avenue)	N49.90051	W97.14492

ACKNOWLEDGEMENTS

The City of Winnipeg Archives, residing in an industrial warehouse since the 2013 flood, was a wonderful source of information about the Carnegie Library—and numerous other subjects—and I am grateful to archivist Sarah Ramsden for her enthusiastic help. Louis-Philippe Bujold and the other librarians at the flagship Millennium Library (successor to the Carnegie Library) have assembled an impressive collection of materials in their Local History Room for which I am most appreciative. Lewis Stubbs found excellent photos in the Tribune Collection at the University of Manitoba Archives & Special Collections. Shout-outs go to postcard collector Rob McInnes for sharing his voluminous collection that includes several views of the library, and former MLA James Allum for discussing his experiences as a city archivist. Sisters Maria and Halina Zbigniewicz talked with me about their childhood memories of trips to the Carnegie Library. An earlier version of this chapter was published in *Manitoba History*, number 88, in January 2019.

ACCIDENT STOP AHEAD

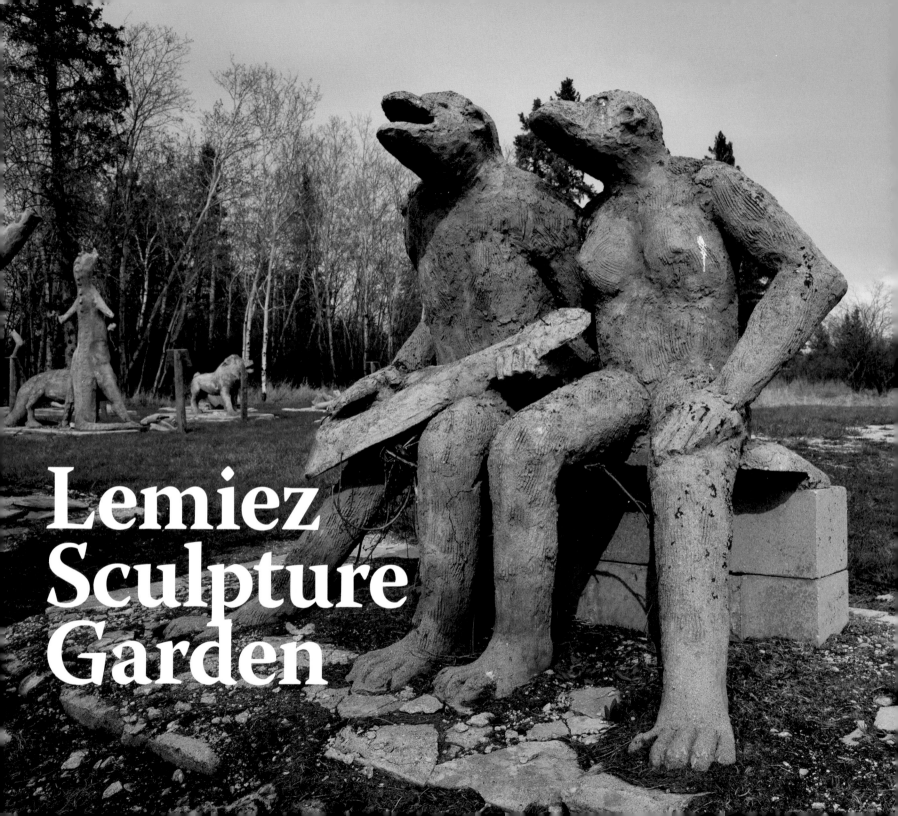

Lemiez
Sculpture
Garden

In 2021, I visited an abandoned site in the Interlake and found several people there. But all I got from them were cold, stony stares. The site contains a haunting and surreal collection of concrete sculptures created by an eccentric farmer named Armand Lemiez (pronounced "le-MEEZ"). The sculptures are mostly of people, roughly life-sized, but sometimes rendered in an exaggerated or symbolic way. There are a few animals, such as apes, serpents, and a sasquatch. Mr. Lemiez tackled such weighty themes as global politics, human evolution, and world religions. God, angels, the devil, and Adam and Eve are all represented there.

Who was Armand Lemiez? Born in Belgium in 1894, Armand and his family were abandoned by his father when little Armand was just six years old. He and his mother, along with his sister Paula, came to Canada in 1911. After working in Winnipeg to raise money, Lemiez bought 160 acres of land near the village of Grahamdale and cleared it of bush by hand and horse. He built a small house for himself and his mother, and they lived together until the end of her life, in 1945. He had a small farm and an orchard of over 100 plum trees, as well as apples and crab apples. Although he did try some experiments, such as a fish farm in a pond on his property, Lemiez was old-school in his approach to farming; he was still using a team of horses in 1974, when he was 80 years old.

Lemiez's sculpture entitled *My Father & his Girlfriend* from 1975 depicts his father, and the woman for whom he presumably abandoned his family, as apes. GORDON GOLDSBOROUGH

In addition to farming, however, Lemiez was passionate about art. He had studied the subject in high school back in Belgium but, when he first came to Canada, naturally, his attention was focused on establishing himself. He returned to art during the winter of 1927 when he was inspired by a hired hand who had studied oil painting in Germany. He took up painting. His work featured traditional landscapes, views of homesteading in Manitoba, and portraits of people. Other paintings were products of his imagination, sometimes with a blunt political message. Some related to the injustice that Lemiez felt affected him and other Manitoba farmers during the Great Depression. And he had a very dim view of US President Richard Nixon due to his actions during the Vietnam War. He painted at least one portrait of Nixon, after his election in 1969, making a victory sign while sinking in a sea of blood.

Lemiez occasionally gave away a painting as a gift, but he refused to sell them. There were over 530 paintings in his collection by the mid-1970s, by which time his interest had turned to sculpture using the unconventional medium of concrete rather than stone. He would create a metal skeleton of the sculpture then mould wet concrete onto it. Like his paintings, the themes of his sculptures were diverse, ranging from biblical scenes to overt political statements, portraits of family, and real or imaginary animals. One sculpture, for example, shows a pair of apes sitting side by side and was titled *My Father & his Girlfriend*. There is even a self-portrait cast in concrete. In the end, Lemiez created twenty-one sculptures,

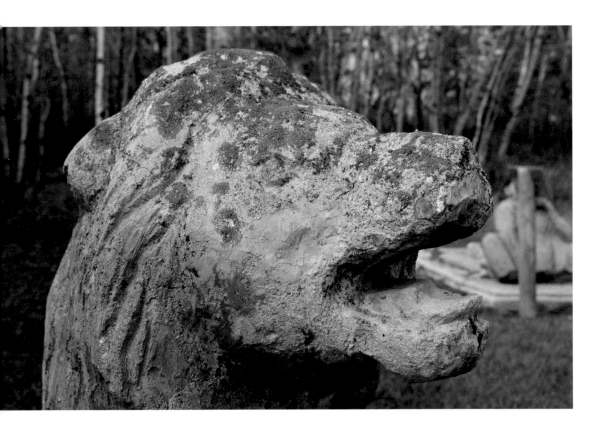

The head of Lemiez's 1967 sculpture of a lion is encrusted liberally in Xanthoria.
GORDON GOLDSBOROUGH

including one of a naked woman in repose that he sometimes referred to as his "wife".

Although Lemiez did not sell his art, he did want to share it with other people. He was happy to host visitors and schoolchildren at his farmyard. His paintings and sculptures were displayed in his home and in a small outbuilding in the yard that he called the "Pioneers Memorial Gallery". In his senior years, Lemiez lobbied the provincial government to turn his property into a public park. It did not happen. Lemiez died a bachelor in 1984, at the age of ninety, and was buried in the Grahamdale Cemetery. His home and farm buildings were in an advanced state of deterioration, so they were not well suited for ongoing use.

Lemiez' will bequeathed his property to a relative and set aside some land for the establishment of a museum to house his art. After at least two years of study, and a proposal to move the artwork to a facility at Moosehorn, the material was deemed by provincial officials to have "no cultural value" and the idea died. I found references in historical newspapers to some of his paintings, gifted to people, that were offered for sale at auction. So, some of them probably still exist in private collections. Some believe that all of Lemiez's remaining artwork has been destroyed. One of his paintings, of an Indigenous man in traditional

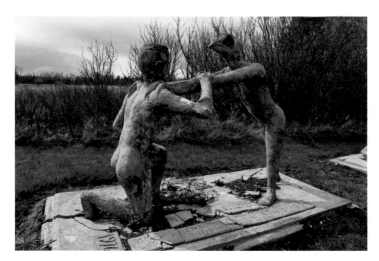

Lemiez's sculpture entitled "Nixon and the Police" from 1974 expressed his feelings about the complicity of American president Richard Nixon, the kneeling subject at left, in the Vietnam War. The bird-headed figure at right is supposed to represent the "American police". GORDON GOLDSBOROUGH

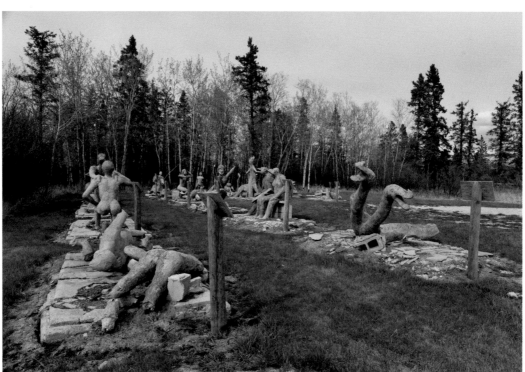

The concrete sculpture garden on the Lemiez farm near the village of Grahamdale, as it appeared during my visit in early 2021. GORDON GOLDSBOROUGH

Barone Sculptures

Armand Lemiez is not the only Manitoba sculptor known for making unusual figures with unconventional methods. Another is Giorgio "George" Barone, who came to Canada from his native Italy in 1951, at the age of thirty-five, and settled with his family in Transcona. Having trained as a sculptor in Rome, he found work designing plaques and figurines for a local firm and, later, was a set designer for CBC Television. But his true calling was sculpture and, in the early 1960s, he established a sculpture business, working in such media as wood, bronze, granite, and marble. But, in 1966, he pioneered a radically new medium for sculpture that he believed was superior to those other materials.

An aerial view of the abandoned Mount Agassiz ski hills on the eastern slopes of the Riding Mountains, site of the 1979 Canada Winter Games. The roof of the building used to house the ski patrol, now converted to a picnic shelter and the only remaining structure here, is visible in the lower left.
GORDON GOLDSBOROUGH

Barone started with a steel mesh frame in the general shape of the final sculpture. He covered the mesh with numerous layers of fiberglass cloth, then coated the fiberglass in a mixture of resin and marble dust. Barone was so confident in this medium that he claimed it was bulletproof and would last forever, unlike other sculptures made from fiberglass. For example, a large sculpture of a Hereford Steer at the entrance to the Union Stockyards in St. Boniface was made in 1967 from fiberglass and wood. In 1989, the steer was set upon by vandals and destroyed. By comparison, Barone's sculptures, although hollow, are still as strong today as when they were first unveiled. And unlike bronze and stone, that have no other colour than that of the material itself, Barone's new medium allowed for the application of coloured resins to make the final sculpture colourful in a way that never needed repainting. However, his first commission using the new material was uncoloured, for a very good reason.

In 1966, Barone was hired by the Manitoba Tourist Association, with financial support from the White Horse Distillers of Glasgow, Scotland to create a large sculpture of a white horse. It was unveiled at the junction of Highway 26 and the Trans-Canada Highway. The White Horse symbolizes an Indigenous legend about a white horse, the beautiful daughter of an Assiniboine chief, and a Cree suitor for her hand. Barone used his new method for most of his most renowned sculptures around Manitoba, including Gimli's Giant Viking (1967), the Hi Neighbour Sam on Transcona's Regent Avenue (1968), Tommy the Turtle at Boissevain (1974), Sara the Camel at Glenboro (1978), the Sharptail Grouse at Ashern (1979), and the King Miner at Thompson (1981).

There are undoubtedly other Barone sculptures in private hands. In the 1960s, he created a large fiberglass bison that he eventually sold to the provincial government. Its present whereabouts is unknown. He sculpted the "burger family" holding hamburgers and mugs of root beer for the A&W restaurant chain. There was a two-ton statue of a triceratops dinosaur, one of his first creations in the 1960s that, in 1992, sat in the yard of a house in Fort Garry. Outside Manitoba, Barone created a statue of Winnie the Pooh for the community of White River, Ontario and he sculpted a variety of works in British Columbia after moving to Kelowna in 1980. He died there in December 1992 and is commemorated by George Barone Bay, in Winnipeg.

Why am I talking about the Barone sculptures in a book about abandonment? Because at least one of them commemorates a site that has been abandoned. On the west edge of the

Giorgio Barone's 1978 fibreglass sculpture of "Alpine Archie" at McCreary reminds us of the importance of downhill skiing at that time. GORDON GOLDSBOROUGH

town of McCreary, gazing out at the eastern slopes of Riding Mountain, is a Barone sculpture entitled "Alpine Archie". Commissioned in 1978 by the Town of McCreary and the McCreary Chamber of Commerce, Archie is an 18-foot high, 3,000-pound boyish cartoon figure wearing a toque, winter clothes and boots, and holding a pair of skis. He was intended to draw attention to the fact that, the year after he was unveiled, the area hosted downhill skiing events of the 1979 Canada Winter Games. In 1961, a group of skiers opened the Mount Agassiz Ski Area west of McCreary, just inside the eastern boundary of Riding Mountain National Park. The facility got a major boost when it hosted skiers from the Winter Games. New ski runs were developed in preparation for the event, along with Manitoba's first chairlift.

Business at Mount Agassiz began to decline in the early 1990s and the operator declared bankruptcy twice, in 1995 and again in 2000. A local group hoped to take it over, but their offer was refused, apparently because a competing group involved with a ski facility in western Manitoba wanted to eliminate the competition. Consequently, the chalet and ski runs at Mount Agassiz sat abandoned for fifteen years until Parks Canada finally acted. Despite public protests in McCreary, most of the buildings were demolished in 2015. When I visited the site in 2021, the three chairlifts were gone. The ski runs were overgrown but still easily visible. I found two pieces of remaining infrastructure—a power pole containing numerous heavy cables that were presumably used to provide power for nighttime lighting and to operate snow-making equipment. A building that housed the ski patrol, known as the Buffalo Lounge, has been converted into a picnic shelter. Its doors and windows have been removed and a wood-burning stove is the only source of interior heating. Parks Canada is gradually converting the site for use by hikers, mountain bikers, picnickers, and cross-country skiers. Alpine Archie, who still stands at attention beside Highway 5, is the only tangible reminder of a once-thriving facility that attracted championship skiers from across Canada, and it is also part of the legacy of sculptor George Barone.

clothing, is held at the Archives of Manitoba, a gift of provincial librarian Clementine Combaz in 1977. But there is no explanation of how it ended up there.

However, the concrete sculptures remain in his former farmyard which, by 1999, was untended and being reclaimed by nature. A group of local residents sought to have something done to protect it. I am happy to report, based on my 2021 visit, that the Lemiez farmyard has been spruced up by the Rural Municipality of Grahamdale, with grass mowed, a gate installed, and interpretive signs posted beside each of the sculptures. They state when the sculpture was created (mostly between 1967 and 1976), what it was intended to symbolize, a few quotes from Lemiez, and with one or more photos to show what the sculpture used to look like.

Unfortunately, time has not been kind to the Lemiez sculptures. In the thirty-nine years since Lemiez died, the effects of freezing and thawing, combined with random vandalism,

Xanthoria

You have probably seen it but did not know what it was. Xanthoria (pronounced Zan-THOR-ee-ya) forms a bright yellow-orange crust on all sorts of outdoor surfaces, but especially on concrete (it appears on several of the Lemiez sculptures) and stone. It is a type of plant called a lichen in which two things, algae and fungi, live together in a way that is mutually beneficial. The name comes from the Greek word "xanthos", meaning yellow, which is apt given the lichen's appearance.

In the course of my travels around Manitoba, I have visited numerous cemeteries and, when I look at

A closeup of Xanthoria growing on concrete.
GORDON GOLDSBOROUGH

gravestones or sometimes a concrete pad that covers the gravesite, they are often bright orange due to the growth of Xanthoria. One of the most conspicuous places that I have found Xanthoria was on an abandoned concrete bridge over Plum Creek, a mile west of Souris. Its once-brilliantly white concrete arches are now almost entirely orange due to Xanthoria. A few years ago, I asked one of my University colleagues, who is an expert on lichen, about it. I described the places where I found Xanthoria, and she was not at all surprised. She said there are two reasons that Xanthoria grows well on concrete and stone. One is that such surfaces are not especially favourable to most plants, but hardy lichens are capable of growing in places where few other plants can. They thrive due to the absence of competition from other plants. The other reason is that Xanthoria prefers to grow on materials that are rich in calcium, which is the case for concrete and some kinds of stone. But what I find particularly interesting is *where* on these materials you find Xanthoria. It does not grow evenly all over the surface but mostly on the tops—rarely on sides—of these surfaces. The tops are well exposed to sunlight, which is important for an organism that depends on photosynthesis for its nutrition. And the tops are usually wetter than the sides, especially

where there are cracks and crevices, because water runs off vertical surfaces more easily than horizontal ones. There is also a chemical reason. In addition to being attracted by calcium, Xanthoria prefers sites where there is abundant nitrogen. Nitrogen levels are higher on the tops of concrete than on the sides because that is where animals such as rodents and birds tend to sit. So, that is where dung accumulates and breaks down to release nitrogen and other chemicals. In other words, Xanthoria grows best where there is a lot of animal feces. It is described by scientists as ornithocoprophilous, meaning "bird-poop loving."

Xanthoria tends to be found mostly on *old* structures. New structures are usually well-maintained so that any lichen that starts growing gets scrubbed off. More important, lichen grows very slowly compared to other plants. So, it is only on old materials where enough time has elapsed for Xanthoria to grow to a significant size. A grave in the Canadian Arctic, dating from 1848, belonging to one of the sailors from the ill-fated naval expedition of Sir John Franklin, was found to have a circular patch of Xanthoria growing on it. The patch was less than two inches in diameter and it had taken 102 years to reach that size. This is understandable because the Arctic is a hostile environment where nothing grows especially

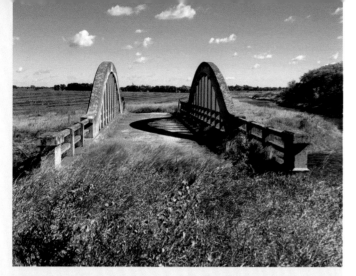

Xanthoria lichen growing on the horizontal surfaces of an abandoned bowstring arch bridge over Plum Creek near Souris gives it a colourful appearance. GORDON GOLDSBOROUGH

quickly. Xanthoria grows more rapidly in temperate climates like here in southern Manitoba so it might grow to that same size in just a few decades. The Souris bridge that I found covered in Xanthoria was built in 1921—over a century ago. But I found a photo of it at the provincial archives, taken in 1961, and the bridge had little or no Xanthoria then.

Knowing the time over which a patch of Xanthoria has grown allows us to calculate the rate at which it has grown each year or decade. This rate can have useful applications, one of which is lichenometric dating. For example, if geologists find boulders that fell in an avalanche, measuring the diameter of Xanthoria patches on the boulders, and comparing their size to the annual growth rate tells us how long the Xanthoria has been growing there, and therefore how long ago the avalanche occurred. Cemeteries are an especially good place for lichenometric dating because gravestones usually say when the person died and therefore how much time Xanthoria has had to grow on those markers. Ultimately, the story of Xanthoria tells us that there are cases in which an understanding of biology helps when one is researching the history of a place.

have wreaked havoc on many of the sculptures. Some were reasonably intact when I was there; for example, there was a lion whose head was covered in orange Xanthoria lichen. Some sculptures are missing hands or heads. Unfortunately, a few, including a larger-than-life-size statue of Lemiez himself, have been turned into little more than rubble. I encourage readers to check out the Lemiez sculptures before they are too far gone.

Directions

Enter these coordinates into a GPS receiver or a map app on your smartphone.

Historic Site	Latitude	Longitude
Lemiez Sculpture Garden	N51.38230	W98.50124
Alpine Archie	N50.76880	W99.49358
Mount Agassiz Ski Hills	N50.76167	W99.67406
Plum Creek Bridge	N49.62141	W100.29936

ACKNOWLEDGEMENTS

I thank lichen specialist Michele Piercey-Normore for telling me about the environmental preferences of Xanthoria.

Kanuchuan Generating Station

For years, I had plotted a way to explore an abandoned hydroelectric generating station on a remote river in northern Manitoba. I finally got there last summer … almost.

Manitoba derives nearly all its electricity from water flowing over a turbine that turns a generator. The majority of what we generate comes from stations on the mighty rivers of the north. If I asked you to name all the northern stations in Manitoba whose names begin with K, you would rightly answer Kelsey (completed in 1972, producing 292 megawatts of power), Kettle (1974, 1,220 MW), and Keeyask (2021, 695 MW). But you have missed the Kanuchuan station that, completed in 1935, was the first hydroelectric generating station in northern Manitoba. And it is easily the smallest, at a measly 1.4 MW. (The only one smaller was the Little Saskatchewan Generating Station, northwest of Brandon, that I described in *Abandoned Manitoba*. It was built in 1900 with a power output of just 0.6 MW.) Kanuchuan also holds the record as the shortest-lived station in Manitoba's history, having been in service for just eight years.

This tiny generating station is located on the Kanuchuan River that flows into the southern end of Gods Lake, about 330 miles (530 km) as the crow flies northeast from Winnipeg. At 444 square miles, Gods Lake is the seventh-largest lake in Manitoba. It is divided into two basins—a smaller south basin and a larger north basin—separated from one another by a constriction where the community of Gods Lake Narrows is situated. Numerous islands punctuate the lake, the largest of which is the nineteen-square-mile Elk Island.

As with a lot of places in northern Manitoba, the fur trade brought Europeans to the region. In 1824, the Hudson's Bay Company established Gods Lake House, a fur trade post at the northern end of the lake, and provisioned it by canoe from its depot at Norway House. Gods Lake House was abandoned within seven years in favour of one at Island Lake. Reopened in 1864, it was closed again in 1872, then reopened in 1888. The post relocated to the lake narrows in 1922 then to the eastern end of the lake in 1939.

The story of how a hydroelectric generating station came to be built on the Kanuchuan River starts with an engineer named William Chace. Described as having a "rugged character," Chace is significant in the engineering history of Manitoba in several ways. He first came here in 1907 to supervise construction of Manitoba's oldest operating plant, the Pointe du Bois Generating Station on the Winnipeg River. Then, after a short time in the USA, he returned as chief engineer for construction of the Shoal Lake Aqueduct, between 1913 and 1919, that provides Winnipeg with its drinking water. After living in Winnipeg into the 1930s, Chace moved to Toronto where he designed hydroelectric power plants for gold mines in northern Quebec.

During my abortive visit to the generating station in 2022, I was able to use my drone to take this view of the generator with the power channel behind it. GORDON GOLDSBOROUGH

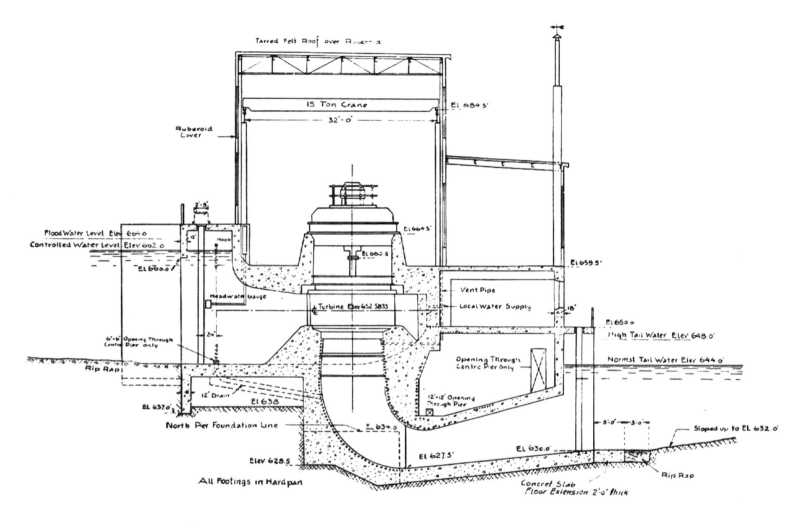

Cross-section of the Kanuchuan powerhouse as it was designed by engineer William Chace, 1934. MANITOBA HYDRO

A gold mine factors into the Kanuchuan Generating Station too. In 1932, while camped near Elk Island, prospector Robert Jowsey discovered gold. Believing the deposit to be sufficiently large for commercial exploitation, he incorporated the Gods Lake Gold Mine Limited in 1933. Its head office was in Winnipeg with Jowsey as president and Winnipeg lawyer Humphry Drummond-Hay as vice-president. Development of the mine on Elk Island began in earnest through 1933, but it needed electricity to operate the mine and the ore-processing equipment. Given the abundance of water in the region, hydroelectric power generation seemed like the

logical choice. Jowsey presumably knew about Chace and his prowess at building generating stations in remote spots, so he was hired. Chace investigated several spots along the 4½-mile-long Kanuchuan River (known at the time as the Island Lake River) connecting Beaver Hill Lake and Gods Lake and, in the end, selected the Kanuchuan Rapids. The site was about thirty-five miles southwest of the mine site.

Construction of the generating station began in the fall of 1934, with a plan to be completed within a year. Materials needed to build the facility, including two large draglines to move soil, several trucks, and a sawmill were carried in during the winter by "cat trains" from the Ilford station, 120 miles to the northwest on the Hudson's Bay Railway. The sawmill was used to cut local trees into lumber to build dormitories, a kitchen and dining hall, and an office. Timber was also needed to build forms for pouring concrete, retaining walls for an earthen dam,

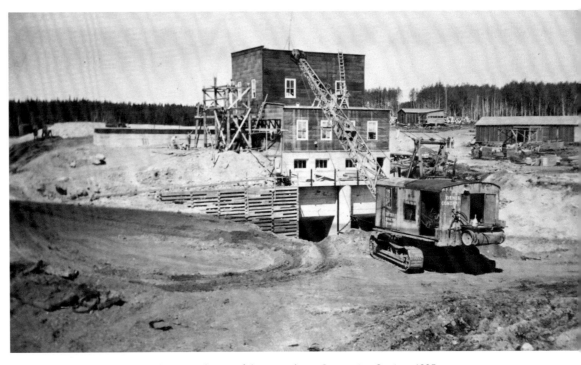

A drag-line digs an outlet from the powerhouse of the Kanuchuan Generating Station, 1935.
ARCHIVES OF MANITOBA, GODS LAKE GOLD MINE COLLECTION

and wooden sluice gates to regulate flow in the river.

Through the winter of 1934 and spring of 1935, workmen laboured to build a wood and concrete powerhouse that enclosed a turbine and generator, surrounded on each side by a fourteen-foot-high earthen dam, and to excavate a 1,100-foot-long power canal on the north bank of

the Kanuchuan River. By leaving rock and soil at the upstream and downstream ends of the canal, the powerhouse could be built and the power-generating machinery could be installed under dry conditions. When all was ready, the "plugs" were removed and water flowed through the new canal into the intake, over the turbine, and out through a

A former mineshaft on Elk Island, now capped with concrete slabs, is one of the few remnants of the former gold mine that operated there from 1935 to 1943.
GORDON GOLDSBOROUGH

tailrace canal back into the river. Station operators regulated water flow through the facility by adding or removing "stoplogs" on a wooden sluice structure at the upstream end of the intake canal and a second sluice structure on the main river channel. The powerhouse was designed to enclose up to three generators, although only one generator was ever installed. The total cost of building the facility was $540,439, or about $11 million in today's dollars.

To carry the generated electricity from Kanuchuan to the mine on Elk Island, a forty-two-mile transmission line had to be built. Trees were cleared along the route, wooden power poles were erected, and steel-reinforced aluminum power lines were installed. To carry the line from the mainland over to Elk Island, it hop-scotched over a couple of small islands. To provide the necessary height and strength at these critical points, steel transmission towers were built at each end of the water crossing.

Meanwhile, the mine on Elk Island was excavated down to a depth of 1,850 feet and, as the operation commenced, some two hundred tons of gold-bearing ore per day were loaded into small dump carts and brought to the surface for processing. A full-service town sprang up around the mine to support the miners and their families, some 300 to 400 people at its peak. The company provided houses for their employees and the Hudson's Bay Company operated a store where

all manner of goods could be purchased. With limited access to the outside world, the local population looked inward for entertainment. A Community Club built by the company contained an indoor badminton court, card room, billiards room, shower room, library, movie theatre, and camera club dark room. Club membership cost $1 per month. Nearby, there was a skating rink. A church served the spiritual needs of the residents. A school operated by the company for the miners' children had an average annual enrollment of thirty pupils and was deemed by the Manitoba Department of Education to adhere to the highest standards.

The first delivery of power from the Kanuchuan Rapids to Elk Island occurred on 7 September 1935. Testing of the plant continued over the next few months until a formal licence to operate the generating station was issued by the Manitoba government in October 1936.

As construction of the mine was completed in late 1935, the workforce diminished from a high of 346 men

to 177 in the first full year of operation in 1936. Over the next six years, the mine employed an average of 185 men. It operated year-round, but gold could be shipped out to market only during the winter when it could be loaded on cat trains and taken over a winter road constructed by the company to Ilford for shipment south by rail.

Gold production from the Elk Island mine peaked in 1939, just as the Second World War broke out. The war took a toll on the mine's operations, as miners left to enlist in military forces for service overseas. The company reported at the end of 1942 that its workplace had diminished to 127, including 30 Indigenous men from the local area, down from 205 a year earlier. With labour at a premium, the wages paid to the remaining men rose. Yet, the final blow to the mine was not a shortage of labour. Despite efforts by the company to find additional high-grade ore deposits at Knee, Oxford, Island, and Red Sucker lakes, none proved commercially viable. With its gold-bearing ore exhausted, the mine on Elk Island was closed in September 1943. Over the course of its eight years of production, the mine had produced about 11,000 pounds of gold and 2,000 pounds of silver, with a cumulative value of $5,925,844 (or about $120 million in today's money).

In the years immediately after the mine's closure, the company investigated other mineral deposits at various other places in northern Manitoba, as well as in Quebec, but could ultimately find no use for its facility on Elk Island. Anticipating that future developments

would need electrical power, the generating station at the Kanuchuan Rapids was maintained in good condition, under the supervision of a resident engineer. The mill, ore-crushing plant, and mining plant at Elk Island were left intact, anticipating some future use. Ultimately, in 1948, the whole operation—buildings, equipment, mining leases, and generating station—was sold to the Toronto-based Lingman Lake Gold Mines Limited in exchange for 500,000 shares in the company. Lingman had identified significant gold deposits in the vicinity of Lingman Lake, Ontario, about 75 miles southeast of Gods

One of the abandoned drag-lines used to excavate soil to create the power channel at the Kanuchuan Generating Station, 1988. ROBIN CLARKE

Swirling water at the bottom of this photo of the generator, taken as my drone hovered overhead, indicates that water is still flowing past the turbine. GORDON GOLDSBOROUGH

Lake, but would need to build a transmission line from the Kanuchuan Generating Station to develop a mine there. And it would need to move the mining equipment from Elk Island to the new mine. The new transmission line was supposed to have been built during the winter of 1949-1950 but it never happened, probably because the price of gold did not warrant the expense.

In the aftermath of the mine closure, Mathias "Harry" Ellgring, an employee of the Gods Lake Gold Mine who had been left to look after the Kanuchuan Generating Station, had tried to develop a sport fishing camp as an additional source of income for himself, using the station's bunkhouses and kitchen to accommodate guests who would arrive by aircraft. He wrote in 1949 to the provincial tourism department, bragging that:

> My layout has 5 three-room houses, cupboards, electric lights, electric heat, radio, private showers, an amateur radio station in camp and most of all lots of speckled trout etc etc etc and hunting.

Fishing in the area was exceptional; whitewater boating down the river rapids was an added recreational bonus for the guests. And the camp enjoyed unlimited free power that was still flowing from the mothballed generator. To his regret, however, Ellgring found that the remoteness of the camp—an aircraft visited just once a month—made it difficult to attract paying customers. He had a few guests in 1950 but, because he failed to advertise in American hunting and fishing magazines, none in 1951. Other entrepreneurs, however, saw the recreational opportunities in the region.

In 1953, American businessman Barney Lamm—who a few years earlier had established a successful sport fishing camp near Kenora, Ontario and had built a fleet of thirty aircraft and later a network of fly-in camps in the Canadian wilderness—opened a camp on Elk Island using buildings of the former gold mine in partnership with a local trader and game warden named Jim Smith (or Fred Smith according to some sources). Lamm and Smith offered a "package deal" that included flights to and from Lamm's base in Kenora, accommodation and meals, and the services of a guide familiar with the area. Smith, who had apparently succeeded Ellgring as caretaker at the Kanuchuan Generating Station, was also given the right to use company-owned buildings for tourism purposes. During summer months through the 1950s and early 1960s, Lamm brought sport fishermen, mostly from the US, to Kanuchuan.

Meanwhile, in August 1965, Manitoba Hydro sent a team of engineers to the Kanuchuan Generating Station to evaluate the feasibility of assuming control of it. Their report, unfortunately, was not favourable. Based on the expense of putting the thirty-year-old facility back in running order, Hydro concluded that Kanuchuan's power output was insufficient to merit the investment needed to transmit the power to communities and mines in the region. Instead, it supplied power to these communities using diesel-powered generators. Renewed interest during the early 1980s led Hydro to send an engineering student to the Kanuchuan River with the goal of investigating sites where a new, more efficient facility could be built to supply regional demand for power. No action was taken. Today, it is thought to be more cost-effective to build long transmission lines from huge power plants on the Nelson River than to build small local plants such as the one at Kanuchuan.

By 1966, Barney Lamm had decided to sell his two fishing camps at Gods Lake. He succeeded in selling them the following year, only to take them back in 1972 when the buyers went bankrupt. It was a bad time for Lamm. His original camp in Ontario had been forced to close as a result of high mercury levels in the fish on which his business depended. In what has been described as "one of the worst cases of environmental poisoning in Canadian history," a paper mill upstream of his camp

had contaminated the river. Facing ruin, Lamm appears to have abandoned his Manitoba camps altogether by the mid-1970s.

Other than incidental amounts of electricity used at the Lamm fishing camp, the old generating station was idle and, without routine maintenance, it deteriorated. In 1956, inspectors from General Electric and Allis Chalmers, the companies that had supplied the generator and turbine, respectively, reported to the Manitoba government that the main bearing was "about done". Yet, when Gods Lake Narrows schoolteacher Robin Clarke visited it in 1988, he took a photo of the huge metal shaft of the turbine. It was still turning. In 2001, the provincial government called for tenders to clean up around the Elk Island mine site, to remove the transmission line from Kanuchuan, and remove the transformers and additional safety work at the old generating station. One of the bidders on the tender, who visited the site to assess the scope of the project, noted that most of the river's flow was bypassing the intake canal but the powerhouse was intact. Remarkably, despite the dire prediction about the main bearing forty-five years earlier, the turbine was still spinning, albeit with a rhythmic clunking noise as it turned.

Equally remarkable, from a legal perspective, was a case brought before the Manitoba courts in 1984 by a successor to the Lingman company. Its licence to the Kanuchuan site had expired in 1975 and had not been renewed, so ownership reverted to the provincial government. The company argued that it deserved to be reimbursed for assets that it had lost as a result. The mine on Elk Island, being depleted of ore, was not especially valuable but the Kanuchuan Generating Station was still functional and, in the company's view, was worth $3.5 million when adjusted for inflation since its construction in 1935. The company also sought $300,000 for the power "stolen" from its station by Lamm's nearby fishing camp. Finding the company's claims baseless, the judge threw out the case.

After several years of pondering how I could see the old Elk Island gold mine and its Kanuchuan Generating Station, I finally found a way in 2022. I would travel by chartered aircraft to the Elk Island Lodge, a fly-in fishing camp that still operates at the site of the old gold mine on Elk Island. From there, a guide would take me by fishing boat to the mouth of the Kanuchuan River. Depending on what we found there, it would be either a short boat ride up the river to the site of the generating station or we could walk through the forest about 2½ miles. The trip was not going to be cheap, but it sounded easy.

The total visit would be about forty-eight hours spread across three days. The flight from Winnipeg was about ninety minutes and we touched down on Elk Island's gravel runway in mid-afternoon of the first day. Because the boat ride to the Kanuchuan Generating Station would take several hours, there was not enough time to go there that first day. So instead, our guide took us to see some of the remains of the former gold mine. Until about

sixteen years ago, there were open mineshafts and at least one headframe (used to lower miners and equipment into the mine) near the camp buildings. A few of the old buildings—a former Hudson's Bay Company store and some residences—were still in use by the fishing camp. But others had been demolished by a Winnipeg-based engineering company acting on behalf of the provincial government. The call for tenders in 2001 had proven unsatisfactory so the government waited for six years then tendered again. The company had demolished many of the unused buildings, capped the old mine shafts with concrete, and dismantled most of the transmission line.

Unfortunately, this meant there was not much left for me to see. Our guide had spent many years working at the camp and, as a result, he was knowledgeable about the area. He was able to show us remnants that the cleanup crew had missed, scattered throughout the forest: pipes, steel rails, vast amounts of waste rock excavated from the mine, and plenty of other debris. He showed us three dump carts that had been used to bring gold-bearing ore from deep in the ground, which were now lying in the forest, partially overgrown with moss. On a small island a short boat ride from Elk Island, we visited a cemetery containing grave markers for a couple of infants born to miners, and probably several more unmarked graves. But a highlight was on another nearby island, shown on our maps as Tower Island. It was so named because a pair of the tall steel towers that had once carried electricity from the generating station to the mine were still standing.

An eagle had made its nest at the top of an abandoned steel transmission tower on the edge of Tower Island, immediately south of Elk Island. The tower once transmitted electricity produced by the Kanuchuan Generating Station to the gold mine on Elk Island.
GORDON GOLDSBOROUGH

Eagles had built nests at the top of the towers from which they got a panoramic view of the area. Next to one tower, we found remains of the aluminum cable that had carried the power.

The trip to the generating station was planned for the second day. We knew the boat trip would take at least three hours. In fact, it was so windy that our boat (and, by extension, our bodies) took a real pounding. It ended up taking us over two hours to reach the mouth of

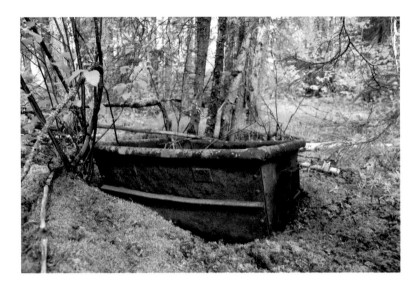

A dump cart abandoned in the woods near the former Elk Island Gold Mine was missed during the site cleanup in the 2000s. GORDON GOLDSBOROUGH

Kanuchuan River. At that point, the basis for the river's name became clear. "Kanuchuan" is an Indigenous word meaning "long current", referring to a series of rapids along its length. This is the reason, in fact, why a generating station was built there in the first place, because there was sufficient elevational change to provide "head" needed to produce power. We were able to see a pair of challenging rapids in the short distance along the river we could see, and there were undoubtedly others that we could not see. There was no way that our boats intended for sport fishing could navigate these rapids. Instead, we pulled the boats to shore. Luckily, it quickly became clear that we were not the first ones to have done this. A rusty old

tracked vehicle, probably from the 1930s, sat abandoned where we tied up our boats. Nearby, hidden by trees, was an old grader that had been used to maintain a road to the generating station. Now partially overgrown, that road was still easily walkable. So, we walked.

So far, so good. We walked for about an hour and everything was going well. Even the bugs were not too bad. We were within a half-mile of the generating station, at a spot where I knew we would have to cross a small creek, when we ran into trouble. That year, 2022, was an exceptionally wet one, so it was not a small creek anymore; it was a raging torrent. We discussed ways that we might cross the creek but decided in the end that it was simply too dangerous to try to cross it. My plans to visit the Kanuchuan Generating Station were ultimately thwarted by Mother Nature, ironically by rushing water, the kind that the old station had been designed to exploit.

But I did get to see the generating station. It was well within the range of my drone.

The cleanup crew that had removed most remnants of the mine on Elk Island had also come here. Photos from 2001 had shown a two-storey powerhouse that contained the station's generator atop the dam. The wooden walls and roof of the powerhouse were gone,

along with the steel girders inside the powerhouse that had supported a fifteen-ton crane. The generator was still there, now exposed to the elements, with small trees growing around it. As my drone hovered over the generator, I could see water swirling in the tailrace canal, telling me that water was still flowing through the station and turning its turbine. In theory, the generating station could still produce electricity. Near the powerhouse had been several wooden buildings left over from the construction back in 1934–1935 and used later by Barney Lamm's fly-in fishing camp. They were gone and the site had been completely reclaimed by the forest. One of the large metal draglines that had constructed the power canal was still there, surrounded by trees. The wooden sluice that controlled the amount of water to bypass the power canal was gone (or, at least, underwater) but three rock and timber piers of the sluice that allowed water into the power canal were still visible. A narrow strip of land separating the power canal from the main river channel was covered in mature trees. I expect that, many years from now, people will wonder about this long, narrow island in the Kanuchuan River.

As we walked back to our boats for the ride to Elk Island, I thought about how wasteful it was that a state-of-the-art hydroelectric generating station, built at enormous cost, on a remote river in northern Manitoba—the first of its kind and the forerunner of today's huge stations on the Nelson River—was used for just eight years then abandoned. The fact that it was still operable as recently as the 2001, even though it had had no maintenance in decades, is a testament to the quality of the work done by William Chace and his workers during the depths of the Great Depression.

Directions
Enter these coordinates into a GPS receiver or a map app on your smartphone.

Historic Site	Latitude	Longitude
Elk Island Gold Mine	N54.66987	W94.15528
Gold Mine Cemetery	N54.67625	W94.16299
Electrical Transmission Tower	N54.63407	W94.23311
Kanuchuan Generating Station	N54.36022	W94.84307

ACKNOWLEDGEMENTS

I dedicate this chapter to my friend Terry Little of the Garden Hill First Nation who encouraged me to visit the Kanuchuan Generating Station. Al Myska first drew my attention to it at meetings of the Heritage Committee of Engineers Geoscientists Manitoba, and Glen Cook, Doug Chapman, and John Clouston helped me to understand the facility's engineering. Robin Clarke kindly shared his photos taken during a visit to the abandoned station, before its disassembly, in 1988. I am grateful to Greg Dick and his excellent staff at the Elk Island Lodge, and especially guide Kyle Fountain, for (almost) getting us there despite fierce wind and water. Though I did not fish during my visit to one of Canada's best fishing spots, the shore lunch was fabulous!

CLOSED
TO
ALL VEHICLES
OVER
3 TONS GROSS

Fallout
Reporting
Posts

It started with a text message from one of my former students who knows my fascination with historical curiosities. "What is this thing?" she asked. Attached to her message was a photo of what looked like the inside of a large, corrugated metal pipe, roughly eight feet in diameter, closed at the end. The pipe had shelves on one side and a pair of beds hanging on chains from the wall on the other. She found the strange structure while driving along a remote highway on the west side of Lake Winnipeg, north of Grindstone Point, near Beaver Creek Provincial Park. Walking off the road a short distance, she saw what looked like a culvert, about three feet in diameter, sticking vertically out of the ground. It had a hinged door on the top that, when lifted away, revealed a metal ladder. She wanted to climb down the ladder but, worried there might be no oxygen at the bottom, she dropped a lit match to see if it remained burning. It went out. Undeterred, she held her breath and climbed down the ladder, eight to ten feet, to take the photo that she sent to me.

I was perplexed. It seemed to fit my stereotypical image of a bomb shelter from the 1960s. Two details made me think it was not a bomb shelter. First, the structure was too remote. There were no buildings or developments of any kind near the structure, or any evidence that there

A view from the bottom of the stairs of the FRP at an undisclosed location in Manitoba. The three pipes to the right of the ladder carried electrical lines to a bank of batteries (or perhaps a generator) that supplied the FRP. GORDON GOLDSBOROUGH

ever was any such building in the past. The site is far from the nearest town. Why would someone build a bomb shelter in such a remote place? Second, it is too small. If there are only two beds, it is intended for use by only two people. During the Cold War, Manitobans were encouraged to build bomb shelters in their basements to protect the occupants of the house. Again, this outdoor shelter was not associated with any residence.

Seeing my student's photo twigged an old memory. Another friend of mine, a caver, had explored an underground structure near Devil's Lake along Highway #6 south of Grand Rapids. It had the same basic layout, but it was made of smooth, not corrugated, metal. I wondered if they could have the same origin and function.

The crucial clue came when I found a scholarly article published in 2011 by military historian Andrew Burtch, of the Canadian War Museum in Ottawa. Dr. Burtch's research specialty is the history of the Cold War, that tense period of years after the end of the Second World War when the United States and the Soviet Union threatened each other with extinction using nuclear weapons. Burtch's article described a Canadian government program that operated between 1959 and 1963 to monitor radioactive fallout across Canada. At the height of the Cold War, politicians worried that if a nuclear bomb was somehow detonated on Canadian soil, or nearby in the USA, fallout would drift across the country and have disastrous consequences. There might have to be mass evacuations of entire cities involving vast numbers

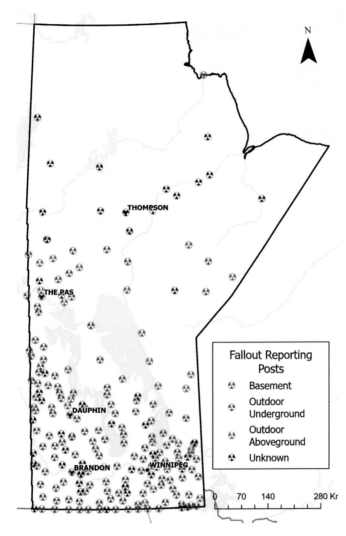

This map shows the locations of 192 Fallout Reporting Posts believed to have been constructed in Manitoba. PAIGE KOWAL AND GORDON GOLDSBOROUGH USING DATA PROVIDED BY ANDREW BURTCH

Fallout Reporting Posts

☢ Basement

☢ Outdoor Underground

☢ Outdoor Aboveground

☢ Unknown

of people. The logistics of such evacuations would be daunting, not to mention the potential for massive loss of life. So, starting in 1961 and continuing into 1962, the Canadian military began to build the Nuclear Detonation and Fallout Reporting System (NDFRS). It consisted of a network of about two thousand facilities called "Fallout Reporting Posts" (FRPs) spread all over the nation, but more concentrated in the populous areas. Each post was intended to be staffed by one or two people who would take measurements of airborne radioactivity in their vicinity and transmit them to a central reporting station, or "Filter Centre", where the data would be collected, analyzed, and presented to government officials and military commanders so they could make informed decisions.

Of the two thousand FRPs that were supposed to be built across Canada, one-tenth were earmarked for Manitoba. By lucky coincidence, Burtch's paper included a map showing the locations of the Manitoba FRPs. Lo and behold, two points on his map corresponded exactly to the locations of the two curious underground structures found by my friends. I was now certain they were FRPs. But I still wanted to know more.

What forms did the FRPs take? Were they all underground metal tubes like these two? My research started at the Winnipeg branch of Library and Archives Canada, where I found a collection of blueprints for the construction of FRPs. There had been at least two types, depending on their location. Wherever an FRP was to be situated in a town with government-controlled buildings,

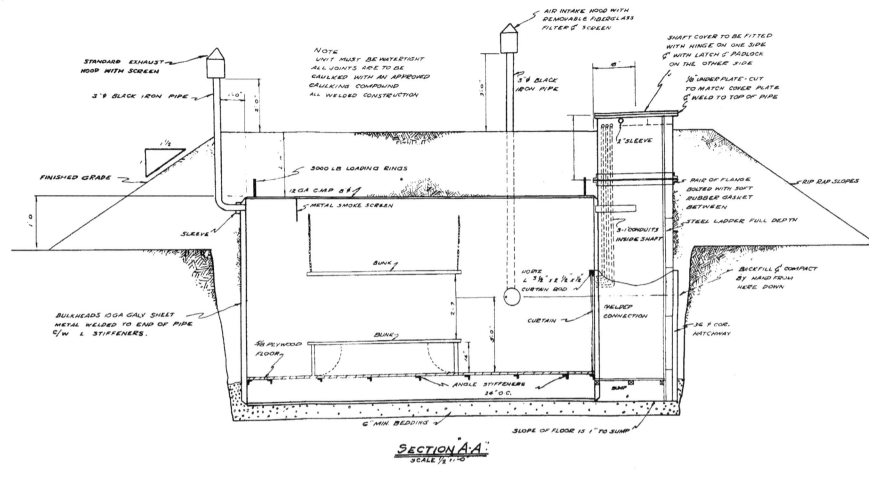

This architectural drawing shows specifications of the FRP buried underground near the provincial conservation office at Big Whiteshell Lake. It is nearly identical to ones shown on pages 6, 68, and 77. LIBRARY AND ARCHIVES CANADA, NDFRS - REPORTING POSTS & FILTER CENTRES, ACCOMMODATION AGREEMENTS, PROVINCE OF MANITOBA

such as offices and RCMP stations (CN and CP railway stations were also used), it would occupy a bricked-off area in the basement, typically against an exterior wall. The walls were made of eight-inch-thick, hollow-core cinder blocks filled with sand to increase their absorption of radiation. A couple of blocks on the wall facing into the basement would be placed sideways to serve as vents for a chemical toilet and a ventilation hood inside the FRP. Most indoor FRPs had a baffle entrance, with or without a door, to reduce the exposure of the people inside to radiation. The ceiling was made with pre-cast concrete bars, the sides of which

were beveled so there were no vertical straight-line gaps through which radiation could penetrate.

An FRP was not at all spacious; a typical one had outside dimensions of 14 feet by 8 feet, or about 90 square feet of interior space, and was clearly meant to be occupied by two people. (Remember the two beds?) Power for interior light and heat, as well as to cook meals, was provided by the building's supply. To communicate radiation measurements to a Filter Centre, these FRPs used a telephone or private radio networks maintained by the railways, RCMP, and provincial government.

Unfortunately, the archival records in Winnipeg told me nothing about the FRPs that were not situated anywhere near a town, or where there was no basement in which to build them. Finding out about these FRPs

Postcard view of the former CBC radio transmitter building in Carman which, in the early 1960s, housed a Fallout Reporting Post, and supposedly also a Nuclear Detonation Reporting Post, in its basement. It has since been demolished. GORDON GOLDSBOROUGH

required a trip to Ottawa, to the main facility of Library and Archives Canada. There, I was presented with boxes and boxes of files that, at one time, had been closely guarded secrets of the federal government. Over the course of two days, I pored over those boxes to find vast amounts of information on the FRPs specifically, and the NDFRS more generally, much more than I can relate here.

I learned that, of the 192 FRPs built in Manitoba, 45% were in basements (see Table 1), 23% were outdoors underground to gain the benefit of radiation absorption by the soil, and 15% were outdoors aboveground. No type was given for 17% of them. Although sites for FRPs were selected in northern Manitoba, in the end, the federal government decided not to build any above 55° N latitude, perhaps because the population density there was deemed too low to be worth the expense of transporting construction supplies.

As opposed to the indoor FRPs, which seem to have been individually designed by a government architect to fit the chosen space in a building, the outdoor FRPs were designed according to one of at least two standard specifications. One was built with flat metal plates; the other used corrugated metal. Otherwise, the basic dimensions were the same. The main working area was a cylinder measuring eight feet in diameter and 14½ feet long, with a ⅝-inch plywood floor that reduced the headroom to seven feet. On one end was a vertical access tunnel: a metal pipe three feet in diameter and 10½ feet tall. All

TABLE 1: Indoor Fallout Reporting Posts built in government buildings in Manitoba.

RCMP Station		Post Office/Customs Office	Railway Station	Prov Govt Office	Other / Unknown
Amaranth	Minnedosa	Cartwright	Belmont	Bissett	Cowan
Beausejour	Morden	Coulter	Brandon	Boggy Creek	Dauphin
Boissevain	Reston	Crystal City	Elkhorn	Dauphin	Fairford
Brandon	Rossburn	Deloraine	Elm Creek	Falcon Lake	Gods Lake Narrows
Carberry	Russell	Goodlands	Glenboro	Garland	Ochre River
Crystal City	Ste. Rose	Gretna	Hartney	Grand Rapids	Portage la Prairie
Dauphin	Selkirk	Haskett	MacGregor	Grandview	Steinbach
Elphinstone	Shoal Lake	Lena	Oakbank	Gypsumville	
Emerson	Souris	Middlebro	Morris	Hadashville	
Ethelbert	Steinbach	Tolstoi	Pine Falls	Hodgson	
Gimli	Stonewall	Windygates	Rivers	Marchand	
Gladstone	Swan River		Ste. Anne	Oak Point	
Hamiota	Teulon		Somerset	Piney	
Killarney	Treherne		Vivian	Rennie	
Lac du Bonnet	Virden			Richer	
Lundar	Wasagaming			Snow Lake	
Manitou	Whitemouth			Sprague	
Melita	Winnipegosis			The Pas	

parts were to be welded together and, to make the FRP watertight, all joints were to be sealed with an approved caulking compound. Kerosene lanterns provided interior light, although a series of conduit pipes running down the access tunnel were presumably intended, in some cases, to carry electrical wiring from a generator or battery bank outside the FRP. The depth at which the FRP would be buried in the ground depended on the depth of soil and the proximity of impenetrable bedrock. In general, the deeper it was buried, the better. The spec called for at least three feet of soil covering the FRP, with two vertical metal pipes for ventilation extending from the FRP's interior above the soil cover. A pipe at the rear was the exhaust while an intake pipe near the front had a fibreglass filter to block access by radioactive particles, with a hand-cranked blower attached inside the FRP to clear accumulated debris that might clog the filter. Because the underground FRPs were mostly in remote locations, communication was by radio.

As I was flipping through archival documents at the Ottawa archives, I was surprised to find an architectural drawing of the Beaver Creek FRP that had instigated my investigation in the first place. The drawing showed that, although today there is nothing but the FRP at the site, in the 1960s there had been a forestry cabin, storage shed, and fire lookout tower. The FRP was to be installed six feet below grade with about four feet of soil on top. It was one of seven FRPs built in mid-1962 by a contractor from

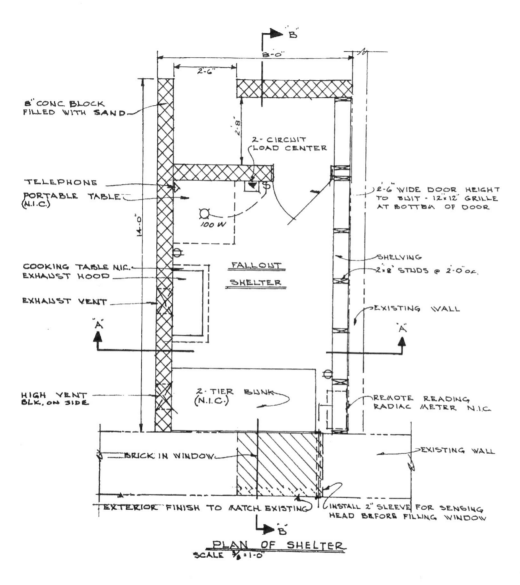

Within the drawing:

B

8'-0"

2'-6"

8" CONC. BLOCK
FILLED WITH SAND

2'-8"

2- CIRCUIT
LOAD CENTER

TELEPHONE
PORTABLE TABLE
(N.I.C.)

2'-6" WIDE DOOR HEIGHT
TO SUIT - 12"×12" GRILLE
AT BOTTOM OF DOOR

14'-0"

100 W

COOKING TABLE N.I.C.
EXHAUST HOOD

FALLOUT
SHELTER

SHELVING
2"×8" STUDS @ 2'-0" o.c.

EXHAUST VENT

EXISTING WALL

A

A

HIGH VENT
BLK. ON SIDE

2- TIER BUNK
(N.I.C.)

REMOTE READING
RADIAC METER N.I.C.

BRICK IN WINDOW

EXISTING WALL

EXTERIOR FINISH TO MATCH EXISTING

INSTALL 2" SLEEVE FOR SENSING
HEAD BEFORE FILLING WINDOW

B

PLAN OF SHELTER
SCALE 3/8"=1'-0"

This architectural drawing shows the indoor FRP designed for the basement of the RCMP headquarters in Brandon, November 1961. LIBRARY AND ARCHIVES CANADA, RG11 - PUBLIC WORKS, EMERGENCY MEASURES ORGANIZATION - FALL-OUT SHELTER SURVEY

Garson at a total cost of just under $11,000, or about $1,500 each.

In addition to information about FRP design, the Ottawa files contained sobering statistics on the amount of radioactive fallout expected at each FRP site, given its location relative to potential nuclear strikes. There was uncertainty in the location and amount of radiation that would occur, so the numbers were statistical probabilities: the ten-percent chance that fallout would be greater than a specific value, measured in rads (radiation absorbed dose). Ten percent of the FRPs might be exposed to 2000-5000 rad, 8% to 1000-2000 rad, 4% to 500-1000 rad, 8% to 200-500 rad, 10% to 100-200 rad, and 25% to 25-100 rad. An exposure to less than 100 rad was generally believed to have minimal human impact, while values over 1,000 rad were expected to be fatal. In other words, many of the people who operated FRPs faced a significant health risk.

In the event of massive evacuations after a nuclear blast, who were

the unlucky souls who would be left behind to monitor radiation at the FRPs? Thirty percent were provincial government employees—mostly conservation officers and the like—working at the most remote FRP sites. Twenty-two percent were RCMP officers. The rest were railway workers (18%), federal civil servants (16%), postal workers (5%), Manitoba Hydro employees (3%), private citizens (2%), Hudson's Bay Company workers (1%), and the CBC (1%). The remaining 2% were military personnel, an interestingly small number given that the Canadian military developed the NDFRS system and supervised construction of the FRPs. I suppose, in the event of a full-blown nuclear war, the military would have bigger problems than protecting the civilian population and would need every person they could muster.

Archival documents provided details on how the FRPs would have been equipped (see Table 2). The consumable supplies included fourteen days of military rations for two people, but the presence of an exhaust hood in the indoor FRPs suggests to me that occupants could use a cooktop to heat their meals or augment the austere rations with freshly cooked food. The close confines of an FRP mean that living there for two weeks (presumably, the time it would take for radiative particles from a blast to dissipate) would not have been pleasurable, with two single bunks for sleeping, perhaps a chair or two to sit. The main job would be to measure and report levels of radiation, and perhaps to make short sojourns outside the FRP to observe radiation impacts on the surrounding

TABLE 2: Supplies provided to a Fallout Reporting Post	
Radiation meter (1)	Kerosene safety can, 5 gallon (1)
Kerosene lantern (2)	Kerosene stove, 1 burner (1)
Bed springs (2)	Plastic bags, 15 x 14 inches (48)
Bedsteads (2)	First-aid kit (1)
Folding table, 36 x 24 inches (1)	Fire extinguisher, dry chemical (1)
Mattresses (2)	Paper towels, rolls (20)
Mattress covers (2)	Rations, 14 days, 2 persons (28)
Tin funnel (1)	

This "Radiac" radiation meter was issued by the Canadian military in a stout wooden box for deployment in FRPs across the nation. It consisted of a sensor that would be placed outside the FRP, a meter inside the FRP, and a length of cable to connect them. I bought this specimen from a militaria dealer in California. I have no idea how it found its way there. HOLLY THORNE

environment. To take the radiation measurements, each was equipped with a military-issue "Radiac" meter. It says so on the architectural drawings for indoor FRPs. Interestingly, I know first-hand what these meters looked like because I own one. Early in my research for this story, I did an online search for "Radiac" and was surprised to see several meters for sale on auction websites. I bought one from a seller in California. Ironically, although the meter originated in Canada, I could not get it shipped back "home" at a reasonable cost, so I had it delivered to my brother, who lives in the US, and he brought it across the line.

The Radiac meter came in a nicely built wood box with spongy material inside to protect its delicate electrical components. I took the meter to a friend who is knowledgeable about old-school instrument electronics, to see if it might still be in working order. He found, perhaps not surprisingly due to its military heritage, that the device required a weird type of battery that my he'd never seen. Given its age, I would be surprised if it still worked but, who knows? I plan to donate the Radiac meter to a museum if any of the FRPs ever ends up at one.

The large number of FRPs that were built, and the millions of dollars spent to build them, begs the question, "were they ever used?". As far as I could determine, the FRPs in Manitoba were used just once, for a training exercise in mid-April 1962, the first test of its kind in Canada. The plan was to radio the results from about a hundred FRPs in eastern and northern Manitoba to a simulated

Filter Centre in the Pine Falls Armoury. From there, in theory, teams of women in the Canadian Women's Army Corps would summarize and pass on the data to one of four Nuclear Detonation Reporting Posts (NUDET), located at the air force bases at Portage la Prairie and Gimli, in the basement of a CBC transmitter building in Carman, and in Manitoba Hydro's hydroelectric generating system at Great Falls. NUDET personnel would use data on the heat and light generated by a blast to determine, by triangulation, the "ground zero" of a nuclear explosion and its fallout yield. This information would be transmitted to the Regional Emergency Government Headquarters (REGHQ) at the military's Camp Shilo in western Manitoba.

At Shilo, the federal government had built a two-storey underground bunker that was intended, in the event of a nuclear attack, to provide emergency accommodation for up to two hundred senior civil servants, politicians, and military officers for up to two weeks. Similar in concept to the "Diefenbunker" outside Ottawa (nicknamed for Prime Minister John Diefenbaker, under whose administration the shelters were constructed), several of these structures were built across Canada. My friend Brad Moorehead, who lives near Shilo, told me that its Diefenbunker was situated just south of the present-day golf course. He says it was mothballed in the 1990s, filled with water to dissuade "urban explorers" who might try to get inside, and its doors were sealed. All that remains visible is a mound of soil at the site.

It appears that none of the NUDET posts were constructed to replace the simulated one at Pine Falls used in the April 1962 test. Although many of the FRPs were built, a newspaper story from August 1962 reported that many were non-operational or had limited capability because they lacked communication equipment or Radiac meters. The military did not equip the FRPs because it could not afford to do so. Completion of the FRP network was "temporarily" shelved due to an estimated $86 million cut in defence spending by the federal government. Despite having been billed as a "survival plan" for Canadians in the aftermath of a nuclear catastrophe, there seems to have been little or no public outrage over its cancellation. Perhaps it was because the nuclear threat never materialized. In any case, the FRPs already built were all but abandoned by mid-1963. Through the years that followed, some of the indoor FRPs were dismantled but some were turned to other uses, such as storerooms. The underground FRP at Devil's Lake was used by the family of the conservation officer posted there as cold storage for their preserves and vegetables. Most FRPs, I suspect, were simply ignored and gradually lost to memory.

My final question about FRPs could not be answered by archival documents. How many of the ones that were built are still out there? Andrew Burtch did not know but he generously shared with me a file that he had compiled containing the approximate geographic coordinates (latitude and longitude) for all of them. My search was on. And I was not alone.

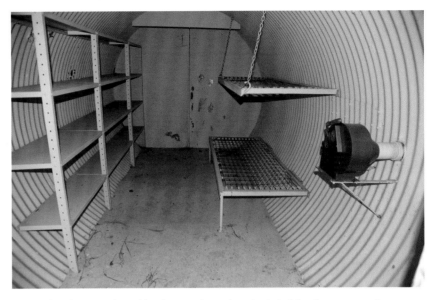

A typical underground FRP like the one shown here had shelving for storage of emergency supplies, food, and water; beds for the two people who manned the FRP; and a hand-cranked blower at right to push air out a covered intake pipe that protruded above the soil covering the FRP. A chemical toilet at the back of the FRP, near a radiation meter, vented fumes out through the top. Everything was metal except for a 5/8-inch plywood floor. GORDON GOLDSBOROUGH

In 2021, after a newspaper article revealed the presence of an FRP near Moose Lake in southeastern Manitoba, the provincial government—worried about the possible liability if someone visiting an FRP were hurt or worse—sent one of its workers out on a search for more of them. This fellow kept me apprised of his findings and, over the course of a few weeks with help from conservation officers around Manitoba, he located several underground FRPs. Some were readily accessible (or a padlock on their access hatch could be defeated easily with a bolt-cutter) while others had been sealed in other ways. The FRP at Devil's

Lake, being close to a major highway and therefore far too tempting, had its access hatch welded shut. Another had a huge boulder set atop its hatch. The FRP at Moose Lake was subject to so many breaches—replacing lost padlocks became a regular job for park staff—that the government intends to excavate and move it to a museum or, failing that, to fill it with sand to prevent anyone from going inside.

At the time that I write this story in early 2023, we have located

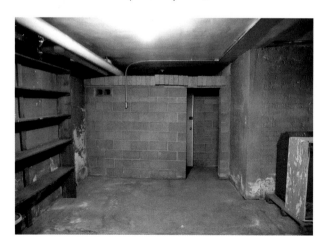

An indoor FRP in the basement of the post office at Deloraine is still present. When it was constructed in early 1962, a basement window in the thirty-two-year-old building was bricked over except for a metal pipe through which the sensor of a radiation meter was placed. GORDON GOLDSBOROUGH

22 FRPs in Manitoba and I have personally been inside three of the underground types and two of the basement ones. (By the way, they are not at all radioactive.) I visited the Beaver Creek FRP in early 2021. The hinges on the cover to its access hatch had been broken, perhaps by someone who thwarted an effort to keep them out. A friend and I lifted the cover to reveal the top of the ladder. There was a faint whiff of something foul emanating from the hatch, but I was undeterred. With my camera slung over my back, I swung my legs over the top of the access tunnel and slowly climbed down, rung by rung. The smell got stronger as I reached the bottom, and I immediately discovered the source. My former student's photo of the FRP interior had shown mattresses on the two bunks but, since her original visit, someone had tried to light them on fire. My guess is that the fire never completed its burn because the access cover had been replaced and the fire was extinguished by lack of oxygen. The walls of the FRP were

liberally covered in graffiti and there were abandoned snack food wrappers and pop cans littering the floor. Clearly, many people had visited this FRP before me. Although it was disappointing to see the willful damage that had been inflicted by vandals, I was able to obtain useful measurements and observations about it to compare to the Moose Lake FRP that I had visited a few days earlier. That one was in much better condition, with nothing inside to burn and no graffiti. The hand-cranked blower on the intake ventilation pipe, absent in the Beaver Creek FRP, was still present. On the same trip, accompanied by provincial forestry officials, I was able to see an FRP in a house in the village of Piney. The house was used to accommodate forest firefighters and the walled-off corner of its basement, next to exercise gear for the young people who lived there, was used as an equipment storeroom. It followed the same basic design specification as I had seen at the Winnipeg archives, but its entrance had only a simple

curtain rather than a solid door. Inside, the metal range hood was still present, along with wooden shelving, but the two bunks were gone. By comparison, an indoor FRP that I visited in the basement of the post office at Deloraine was remarkably intact. Like the one in Piney, its walls were cinder blocks and its ceiling was made of interlocking, precast concrete bars. It had a wooden door at its entrance, lockable from the inside. Two bunks made of lumber and plywood, wooden storage shelving, and a metal range hood made the interior seem quite claustrophobic. A window in the basement wall inside the FRP had been bricked over during its construction, except for a metal pipe that ran through the former opening, to provide a means for the Radiac meter's cable to connect to a sensor mounted on the building's exterior. I now have a good sense of the appearance for these two types of FRPs but have yet to see an outdoor, aboveground example. It may be that these ones were more variable in appearance or have more likely been removed over the past six decades.

As for the future of these Fallout Reporting Posts, I am hopeful that a museum somewhere will be receptive to displaying one, especially if the provincial government carries out its plan to disinter them in the name of public safety. I think FRPs are an important reminder of a tense time in mid-twentieth-century history when there was a real chance of global nuclear war.

Directions

Enter these coordinates into a GPS receiver or a map app on your smartphone.

Historic Site	Latitude	Longitude
Fallout Reporting Post GH3 (Devil's Lake)	N52.40471	W98.91156
Fallout Reporting Post JG3 (Beaver Creek)	N51.39922	W96.90737
Fallout Reporting Post KE4 (Moose Lake)	N49.20370	W95.34926
Fallout Reporting Post EE32 (Deloraine)	N49.19184	W100.49419
Fallout Reporting Post KE36 (Piney)	N49.08602	W95.97939

ACKNOWLEDGEMENTS

I thank Elise Watchorn for arousing my curiosity about these mysterious underground structures, Andrew Burtch at the Canadian War Museum for sharing his research on this little-studied aspect of Canadian history (including a map of the approximate locations of FRPs throughout Manitoba), and David Cuthbert at the Winnipeg office of Library and Archives Canada for his support of my research there. I am grateful to Kelly Barnert-Loewen, Teresa Bell, Jim Burns, Grant Cassils, Kyle Daun, Ellen Donald, Tom Farrell, Sheila Grover, Mike Hameluck, Cheryl Kirschman, Allan McKay, David Pankratz, and Darin Smith for sharing their information on FRPs and their equipment. Gilles Messier generously shared his own archival research on FRPs.

NATIONAL HISTORIC SITE 300 - YARDS

Sargenia
Terraces

Manitoba's population is a mosaic of peoples from around the world, many of whom have left visible marks on the landscape. Few such works are so evocative of their origin far away as some stone terraces built over a century ago, on the side of a small hill near Roblin, by Italian immigrant Lorenzo Sargenia.

Lorenzo (or Lawrence, as he was known in Manitoba) is a great example of what drives genealogists crazy. Born at Rome, Italy, his family lore holds that he did not know his birthdate because he had been on his own since an early age. He estimated it as 1838 based on events he remembered but, many years later, after immigrating to Canada, census takers thought he looked far too young for that to be right. So, they made up a year. His birth year was given as 1861 in the 1911 census and 1855 in the 1921 census. His

OPPOSITE A closeup of the stones used by Lorenzo Sargenia to build terraces on the side of a shallow, south-facing slope where he grew fruit trees and other crops. GORDON GOLDSBOROUGH

death registration at Manitoba Vital Statistics has 1858. But Lorenzo prevailed in the end; his grave marker states that he was 98 years old at the time of his death, on his Manitoba farm, in 1936.

Before arriving in Canada in 1903, Sargenia travelled the world, spending several years in Scotland where he apparently learned the trades of stone masonry and bricklaying. Settling in Winnipeg, at an age when most men would be thinking of a relaxing retirement, the 65-year-old bachelor began to think of marriage. Through mutual friends, he learned about Maria Cillis, a widow in Italy (13 to 36 years younger than Lorenzo, depending on the source) whose husband had died suddenly, leaving her to raise their two daughters alone. He sent them the money for passage to Canada and they arrived in 1908. The family resided in Winnipeg for two or three years but, supposedly, Lorenzo's penchant for socializing took him away from home frequently. Maria did not see this as a recipe for successful family

Lorenzo Sargenia, his daughter Mae, and his wife Maria Cillis Sargenia on their farm at Bield, circa 1930. SYLVIA MATWE

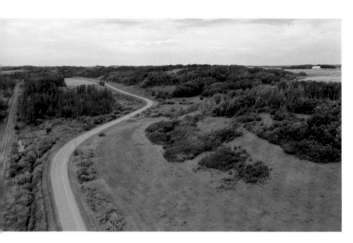

An aerial view of the Sargenia terraces shows the dense foliage that mostly hides the stone terraces. GORDON GOLDSBOROUGH

A grave marker in the Bield Cemetery for Lorenzo Sargenia dates him as being born in 1838, despite census takers to the contrary. ERIC MATWE

life, so she gave him an ultimatum: the parties had to stop. Otherwise, there were numerous other men in the city who would be interested in her. According to a family member,

"Lorenzo told her if she wanted someone else, he would not stand in her way. She told him she had made a bargain with him and that she intended to keep that bargain. However, she wanted to find a quiet place for them to raise their family." Lorenzo agreed and they moved to Bield, a sleepy farming community of fewer than one hundred souls about ten miles east of Roblin. In time, the two daughters brought from Italy were joined by four more children, one girl and three boys.

The farmland at Bield chosen by the Sargenias was hilly, on the side of a gentle south-facing slope in a picturesque valley. Perhaps the terrain reminded them of the land they had left in Italy. Using his skills as a stonemason, Lorenzo built a comfortable home for his family and a barn for his livestock on the side of the hill. In addition to the food he grew on the farm, Lorenzo supported them by doing masonry work for others, including the stone foundation for a school building at Bield.

The foundation of the Sargenia home and the stone manger from its barn were still present in the 1980s, long after Lorenzo's death. A more conspicuous sign of their residence, however, was the landscape itself. Lorenzo was an avid horticulturist, and he began to develop extensive gardens around their hillside home. Around 1918, he began to sculpt the hill in a way pioneered millennia earlier by his Roman forebears. He stacked long rows of stones, neatly fitted together without the use of mortar, to create long, low retaining walls. In so doing, he was able to create level plateaus, or terraces, up the side of the hill where he could plant gardens.

I imagine that Lorenzo grew most of the same crops as other Manitoba gardeners of the time. Two of his descendants, who visited the terraces in 2004, found feral apple, sour cherry, and plum trees, along with clusters of rhubarb and asparagus growing in clearings. But his position nestled in a valley might have enabled Lorenzo to

grow other crops that were not otherwise possible in Manitoba. A history book mentioned that Lorenzo might have grown grapes, which seems entirely plausible to me. Lorenzo's valley was sheltered from harsh prairie winds by the surrounding hills with a south exposure providing abundant sunshine. The site may have the same warm microclimate as areas elsewhere in Canada, such as the Okanagan Valley in British Columbia, where growing grapes has proven suitable.

The Sargenias were legendary for their hospitality. The hillside homestead was near a line of the Canadian National Railway and hobos "riding the rails" would disembark before arriving at Bield and come to the Sargenia home to beg for food. After a meal, Maria Sargenia would invariably send them on their way with a loaf or two of homemade bread.

Lorenzo Sargenia died at home in December 1936, at the age of 78 or 98, and was buried in the Bield Cemetery. Maria and their children moved to the Okanagan Valley where Maria died at the age of 91, in 1965. The Sargenia land in Manitoba has gone through a succession of hands since they moved away but it appears that nobody has maintained Lorenzo's carefully crafted terraces since the 1930s. As a result, they have become massively overgrown.

I visited the abandoned Sargenia terraces in 2019. While I was there, a train passed by, but no hobos disembarked. I found no remnants of the stone buildings that had been visible years earlier, probably because they were concealed by dense vegetation. The hillside was covered by a mixture of mature trees and shrubs, mostly thorny caraganas, that made walking the site very challenging. I bushwhacked around a bit and found a few small sections of stone walls, but I felt that I must be missing a lot. I sent my drone up in the air and, lo and behold, at least two long stretches of stone walls were readily visible. Just as I had been told, the walls were composed of flat stones, fitted together carefully without mortar. They stood about two feet high. I was not able to find a stone chair, set into the hillside, that a Sargenia relative told me he had found during a visit nineteen years earlier. But I can imagine Lorenzo Sargenia sitting in his chair, enjoying the warm summer sunshine as he looked out on his bountiful garden, in this most attractive little valley in western Manitoba.

Directions
Enter these coordinates into a GPS receiver or a map app on your smartphone.

Historic Site	Latitude	Longitude
Sargenia Terraces	N51.22665	W101.13180

ACKNOWLEDGEMENTS

I first learned about the terraces from the late Ed Arndt, a former Bield resident, who was the keeper of all knowledge about this little community. I thank Eric Matwe, a great-grandson of Lorenzo Sargenia, and his mother Sylvia Matwe, for sharing family information and photos, including ones of Lorenzo and Maria Sargenia.

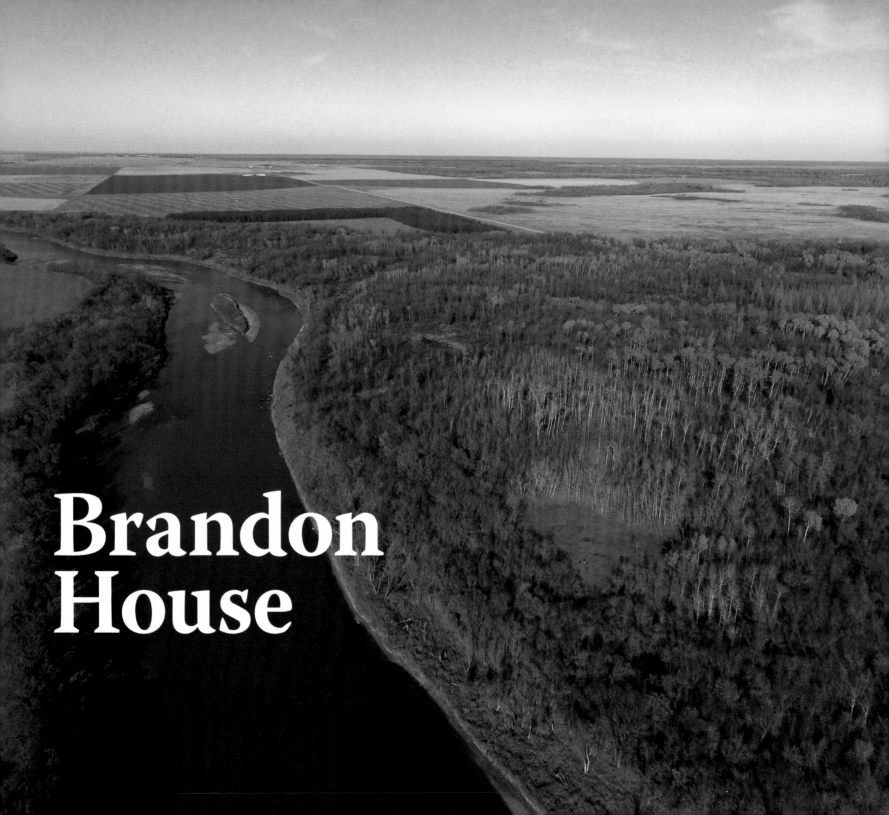

Brandon House

I have long believed that drones costing just a few hundred dollars can provide unique perspectives on historic sites that are unobtainable in any other way. This notion is amply demonstrated by Brandon House that, by virtue of its role as one of the first inland posts of the Hudson's Bay Company (HBC), holds a pivotal place in our understanding of the fur trade on the Canadian prairies.

The first Brandon House was established in 1793 by HBC trader Donald McKay on the north bank of the Assiniboine River, about seventeen miles as the crow flies—twenty-six miles by water—from the present-day city of Brandon (which took its name from the fur trade post). Its purpose was twofold. First and foremost, it was a trading post situated in a strategic spot near the confluence of the Assiniboine with the Souris River. The HBC had established its first post at York Factory, on the Hayes River near Hudson Bay, in 1684. (We visited York Factory in my previous book, *More Abandoned Manitoba*.) There, various goods from Europe were traded for furs delivered by Indigenous peoples in the region. For many years, the fur trade operated out of York Factory. By the 1770s, however, the HBC was facing stiff competition from the North West Company (NWC), XY company (XYC), and private traders, all of whom brought trade goods to the Indigenous customers directly and

therefore did not obligate them to travel great distances. Recognizing that its business was in jeopardy, the HBC established Brandon House, closer to where Indigenous peoples lived and trapped. It was the first time that HBC fur trading was done on the southern prairies from semi-permanent facilities.

In addition to its role as a fur trading post, Brandon House likely served as a provisioning post too. Its location on the prairies meant it was a logical place to manufacture pemmican using bison meat and locally obtained berries. Pemmican was a stable, nutritious food for the voyageurs who transported furs and trade goods back and forth between York Factory and the many HBC facilities that would eventually dot the prairies.

Construction of the first buildings at Brandon House—made from locally cut logs—surrounded by a palisade of vertical wooden poles, commenced in mid-October 1793. Around the same time, the NWC, recognizing the trade opportunities if they could attract customers away from the HBC, built a post nearby. In 1801, the two companies were joined in the area by the XYC. With three fur trading companies operating in close proximity, the area was the hub of prairie commerce until 1805, when the NWC, having absorbed the XYC the previous year, moved downstream several miles. The subsequent history of Brandon House is fuzzy, and various historians—amateur and professional—who have considered it through the years disagree on the dates and locations. They generally agree, however, that in 1811

OPPOSITE A treeless rectangle that was the site of Brandon House #1 two hundred years ago is clearly visible in this aerial view from my drone. GORDON GOLDSBOROUGH

the HBC post moved to what was thought to be a more advantageous, wooded spot about 4½ miles upstream, on the west side of the Assiniboine River. It became Brandon House #2. They were soon joined by an NWC post on the east side of the river.

Noted explorer Peter Fidler was in charge of Brandon House #2 when, in 1816, Métis leader Cuthbert Grant and a group of his men, allegedly at the behest of the NWC, pillaged the HBC post before going on to the Red River Settlement. There, they confronted Governor Robert Semple, killing him and twenty Selkirk Settlers, resulting in what has come to known as the Battle of Seven Oaks. Brandon House #2 was abandoned for a time then reoccupied by Fidler and his men in the fall of 1817. The HBC and NWC merged in 1821 and, in the aftermath, Brandon House was moved across the river to the former NWC post becoming in effect Brandon House #3. It operated there until being abandoned as a post-merger austerity measure in 1824. Four years later, workers were sent out from Upper Fort Garry to reestablish Brandon House at a new site. Misunderstanding their instructions, they began building a post seven miles upstream from the previous one. When the mistake was discovered, in fall 1828, the post was moved once more, five miles by water upstream, to its fourth and final site as Brandon House #4. There it operated—on a high, grassy site overlooking the Assiniboine—until being abandoned for good in 1832. Fur resources in the area had been depleted and bison herds were starting to dwindle. There was not enough

trade in the region to warrant the cost of maintaining Brandon House.

By the 1880s, with the arrival of a transcontinental railway in western Canada, attention turned away from the rivers that had once been the main means of transportation. As a result, knowledge of the trading posts along the Assiniboine River was mostly forgotten. There were occasional attempts to find them, starting in 1890 when geologist and explorer Joseph Tyrrell paddled a canoe down the Assiniboine and found evidence of at least three former fur trade posts. On 9 July 1890, he explored the site of Brandon House #1:

> There is a little grassy prairie of about 4 or 5 acres in extent in the midst of a forest of small white poplar. … The remains of the fort are scattered along the top of this ridge. They consist towards the N.W. of two shallow pits and a deep one that is still 6½ feet deep. N.E. of this last pit is a shallow pit on the side of the hill. Again S.E. of the deep pit are two other large ones 70 feet apart, the N.W. one 22 x 14 ft., and about half way between them is a little pile of boulders representing a chimney.

Tyrrell found several more pits and concluded that they were the cellars from former post buildings.

A copy of Tyrrell's report on his findings ended up in the hands of physician David Stewart. Based at the Ninette sanatorium, where he helped to diagnose and treat people suffering from tuberculosis, Stewart also had an abiding interest in Manitoba history. Spurred by

Tyrrell's findings, Stewart dug into journals and other records of the Hudson's Bay Company and determined the approximate location of what he thought was Brandon House #2 (but was, in fact, Brandon House #4). He enlisted two Brandonites, Sidney Peirce and Charles Baragar, also medical doctors, to help him in confirming the location. Baragar, who was president of the Brandon Rotary Club, persuaded club members that the historical significance of Brandon House was such that it deserved to be marked permanently. Funds were duly raised and, on 7 October 1928, the hundredth anniversary of the post's founding, a fieldstone cairn was dedicated at a well-attended ceremony. Stewart summarized his research in a paper published in 1930 by the Manitoba Historical Society. It contained a detailed chronology of activity in the area and it concluded by saying that:

> This group of trading posts, then, along the Assiniboine River, near the mouth of the Souris, for

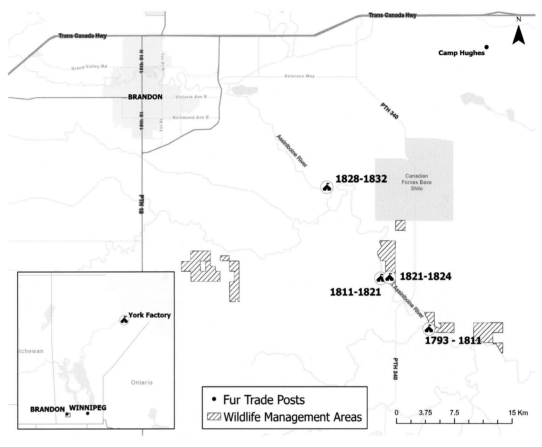

Locations of the four sites occupied by Brandon House between 1793 and 1832, near the junction of the Assiniboine and Souris rivers. PAIGE KOWAL USING INFORMATION PROVIDED BY SCOTT HAMILTON

forty-seven years, from 1785 to 1832, made fairly colorful history that should not be forgotten. Their most distinctive features, perhaps, were the trade relations they began and kept up between Assiniboine and Missouri, and the considerable part they were forced to play in the "Pemmican War" and subsequent troubles. A cairn and tablet to commemorate the whole group has been granted by the Historic Sites

and Monuments Board of Canada, and is to be unveiled at Wawanesa as a central point among them, on 15 July 1930, the sixtieth anniversary of the elevation of Manitoba to provincehood.

Leap forward to the 1960s and we encounter Morley and Alice Brown. Morley's family had farmed land on the banks of a little stream that explorer David Thompson had dubbed Five Mile Creek, less than a mile from the site of Brandon House #1. He had grown up on stories of the fur trade and had told them to his wife Alice, whose family had homesteaded at Souris. Together, they walked the ground where the posts had once been and, although the effects of agriculture had obliterated many of the remains that Tyrrell had seen decades earlier, there was still much to be found. In a paper read to the Manitoba Historical Society in 1961, Alice Brown reported that she and her husband had found "unmistakable evidence of a large post [probably Brandon House #2], and one that must have been occupied for a long time judging by the density and extent of the food refuse in the form of bones and clam shells." In the end, the Browns identified no fewer than five former fur trade sites, and

provided a good basis for thinking there were others yet to be found.

Next up was Roy Brown (no relation to Morley and Alice). As a young man, he had contracted tuberculosis that necessitated convalescence at the Ninette sanatorium. There he met David Stewart, who stoked his interest in Manitoba history generally, and the Assiniboine River fur trade specifically. In 1974, Brown published a slim booklet entitled *The Fort Brandon Story*. Described later as "somewhat inaccurate and unfocused," and containing a lot of unsubstantiated speculation, it nevertheless rekindled interest in the fur trade history of the Brandon region. (Brown would also publish, four years before his death in 1985, the booklet *Steamboats on the Assiniboine* describing his discovery of the wreck of the SS *Alpha* in the Assiniboine, discussed in the introduction to this book.)

The most extensive research on the Assiniboine fur trade posts was carried out in the early 1980s by the Manitoba government. Plans to construct a new highway from Shilo to Wawanesa, crossing the Assiniboine River in the vicinity of the old posts, led to worries that it would disturb these significant historic

The site of Brandon House #1 has been treeless for at least a century, as shown by this photo from the provincial archives, dated tentatively to the 1920s, possibly taken during the work of David Stewart. ARCHIVES OF MANITOBA

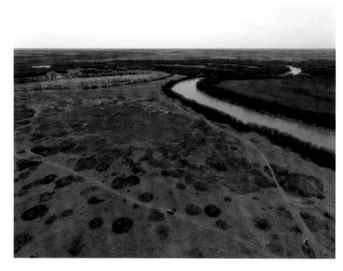

Numerous circular patches of juniper bushes growing at the former site of Brandon House #4 might be reminders of Indigenous tents that were erected around the post. The fieldstone cairn is visible in the lower, right corner of this aerial view. GORDON GOLDSBOROUGH

sites so provincial archaeologists were dispatched. The team was led initially by Scott Hamilton, a fur trade archaeologist now at Lakehead University in Thunder Bay. Among the tools they used to find post ruins was a proton magnetometer, a device that measures small variations in Earth's magnetic field that can reveal iron-containing objects as well as materials in which high temperatures have realigned the iron atoms, buried in the ground. The team had limited financial resources and time to investigate a large and complex archaeological site, but it conducted as thorough a survey as it could. There have been no follow-up studies (although, in 2016, Hamilton flew the area with a drone to make detailed topographic maps) so the group's work provides the best available information to date.

Hamilton's initial survey in 1981 revealed several possible sites of interest, especially what they called DkLv-9, the presumed site of Brandon House #1. He confirmed the observations, made ninety years earlier by Joseph Tyrrell, of several cellar depressions. Although no extensive excavations were made, the magnetometer detected "anomalies" (where metallic objects or other features might be buried) and small test holes dug by shovel yielded a few artifacts. Subsequent archaeological work in 1982 confirmed the initial findings. Small pits excavated by shovel yielded numerous bone fragments, probably the remains of meals eaten at the site, and rocks that had been exposed to fire. They located what they believed were the sites of an icehouse (where ice blocks collected in the winter were stored for use in summer refrigeration), a blacksmith shop, garbage pits, and the post's cemetery containing the graves of at least five people who died while at Brandon House. Other posts, such as one established in 1796 near Brandon House #1 by NWC trader John McDonnell, and Brandon House #4, were also investigated. Other archaeologists took over from Hamilton in 1983 and 1984. I do not know what they discovered because I have not been able to find reports for those years.

Results of the archaeological research at Brandon House #1 have never been disclosed publicly except in summary form many years later by Scott Hamilton. Provincial government officials did not release their

internal reports for the understandable reason that they might encourage treasure-seekers wielding metal detectors to disturb the sites. Today, the Brandon House #1 site is located in a provincially designated Wildlife Management Area. Although intended primarily to protect habitat for wildlife such as deer, land use within a WMA prohibits such destructive activities as gravel quarrying and timber cutting. This restriction should, in theory, also benefit the long-term preservation of an important archaeological site.

In the spring of 2017, retired Brandon University historian and archivist Tom Mitchell invited me to join him for a visit to the site of Brandon House #1. We drove east out of Brandon, veered south on Highway 340, and passed CFB Shilo. Just before crossing the Assiniboine River, we turned off the highway onto a gravel road, drove a mile east, then a mile south. Leaving our vehicles on the side of the road, we walked about a half-mile through mixed deciduous woods, here and there punctuated by a few small swamps. The leaves had not yet emerged on the trees, so it was fairly easy to make out narrow trails leading through the woods.

Arriving at the site—an open meadow of knee-high grasses surrounded by poplars and other deciduous trees—we found it easy to make out shallow pits in the ground that had been seen by Joseph Tyrrell 127 years earlier. Walking down the bank toward the Assiniboine River, we were surprised to see how much of the riverbed was exposed by drought conditions that year.

On what would normally be the river bottom, low water revealed thousands of open clam shells. Like Morley and Alice Brown before us, we think those clams were eaten by the post's occupants and the shells dumped back into the river as a means of garbage disposal. Walking back to the site of the post buildings, I launched my drone to get an aerial view of the overall site. What really struck me was that the post site was regular in outline, a well-defined rectangle defined by the absence of trees. Despite the passage of some two hundred years since Brandon

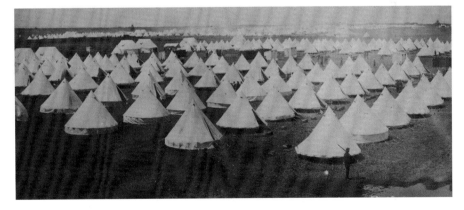

This 1915 postcard of tents used by soldiers training at Camp Sewell (later renamed Camp Hughes), about eleven miles northeast of Brandon House #4, may help to explain how circular patches of juniper plants developed after tents were removed, exposing the area's light, sandy soil. MARTIN BERMAN COLLECTION, WINNIPEG PUBLIC LIBRARY

A few shallow depressions at Brandon House #1 were the cellars of buildings at the site. GORDON GOLDSBOROUGH

House #1 was abandoned in 1811, there are no trees growing on its site.

Why are there no trees? I do not know, but it has been a consistent feature of the site for over 130 years. There were no trees when Joseph Tyrrell was here in 1890 and no trees when Scott Hamilton worked here in the early 1980s. As some readers may know, I am a botany professor at the University of Manitoba and, while I am not a tree expert, I cannot understand why trees have not overgrown the site, as they have done in other abandoned sites. I asked some of my university colleagues and they are just as perplexed. A possibility is that there may be some factor in the soil that prevents trees from growing. The site was an active fur trade post for eighteen years. Maybe there was so much foot traffic in and around the HBC buildings that the soil became heavily compacted, so much so that tree seedlings cannot penetrate it. Yet, trees have managed to grow in some fairly dense soil elsewhere, and the annual freeze-thaw cycle, along with the burrowing of animals, should have loosened up compacted soil over two centuries. Another possible explanation is that there is some toxic material in the soil that inhibits trees more effectively than grass. If they had tanned leather at Brandon House, for example, one of the many methods for doing this involved the use of toxic heavy metals. But post journals do not indicate extensive leather tanning that could lead to the level of toxicity that would have had to occur to prevent tree growth.

I wonder if I have things backwards. What if the absence of trees at Brandon House #1 is not because of some impact of the former fur trade post on the environment? Instead, maybe the site was chosen two hundred years ago specifically because it had no trees due to some as-yet-unknown characteristic of the underlying soil and its hydrology and geology. A treeless site would make it much easier to construct buildings quickly. When work began late in 1793, winter was fast approaching and they needed shelter. With no trees in the way, they could dig cellars and construct log buildings in the open meadow while cutting and bringing logs from the surrounding forest. In the end, I am no closer to an explanation for the absence of trees, but I am reassured that it seems unlikely to be a result of the negative impact of humans on the landscape.

Another biological mystery awaited me at the former site of Brandon House #4, which Tom and I

visited after leaving Brandon House #1. The cairn that had been erected in 1928 was still standing, in the middle of an open field, largely forgotten. Again, I put my drone into the air to take some panoramic photos. In them, I was surprised to see numerous green circles—up to fifty feet in diameter—in an eighty-acre area around the cairn and extending down to the river. They seemed to occur most densely in the area that I imagine had once surrounded the fur trade post. I walked over to a few of the circles and found them to be patches of shrubby junipers, known by the scientific name of *Juniperus horizontalis*. Why were there so many of them, and why were they so strikingly circular? It is likely that juniper seeds were dropped here by wind or animals. The seeds germinated and thrived, especially where the surface vegetation had been lost and the light, sandy soil was exposed where the circular Indigenous tipis had stood. And there is another example of this phenomenon about eleven miles to the northeast of Brandon House #4. There, we find the former site of Camp Hughes, where thousands of Canadian military personnel trained in preparation for going overseas in the First World War. The soldiers lived in bell tents during their training. My friend Glen Suggett, during his work as a land manager for the provincial government, has found numerous circular patches of juniper at Camp Hughes. He thinks that junipers are especially good at colonizing the bare soil left at former tent sites. Based on my observations at Brandon House #4, and especially the insight provided by my drone photos, I agree with him.

As I drove home from my visit to Brandon House, I thought about the legacy of this forgotten spot along the Assiniboine River that, for a few short years over two centuries ago, was the epicentre of the fur trade. Tom Mitchell thinks that without the logistical support provided by Brandon House, and the claim of sovereignty over the land of western Canada that it represented to the Hudson's Bay Company, the founding of the Red River Settlement at the junction of the Red and Assiniboine rivers in 1812, would not have been possible. In short, without Brandon House, the City of Winnipeg might never have existed.

ACKNOWLEDGEMENTS

I have the indefatigable Tom Mitchell to thank for inviting me to accompany him on a visit to the sites of Brandon House in 2017. I am grateful to my friend Glen Suggett for sharing his observations of juniper at the former Camp Hughes military site, and for information about the Assiniboine Corridor Wildlife Management Area. Eileen Trott (Daly House Museum) found a letter in Roy Brown's papers in her care, from Joseph Tyrrell to Stuart Criddle, describing his visit to Assiniboine River posts in 1890. Fur trade archaeologist Scott Hamilton was generous in sharing reports from his Brandon House excavations in the early 1980s and his recent remote sensing work using drones. I encourage those interested in knowing more about the archaeological work at the Brandon House sites to read Scott's 2019 paper "Remote sensing at the Sourismouth forts (Manitoba): Archaeological re-interpretation after nearly 40 years."

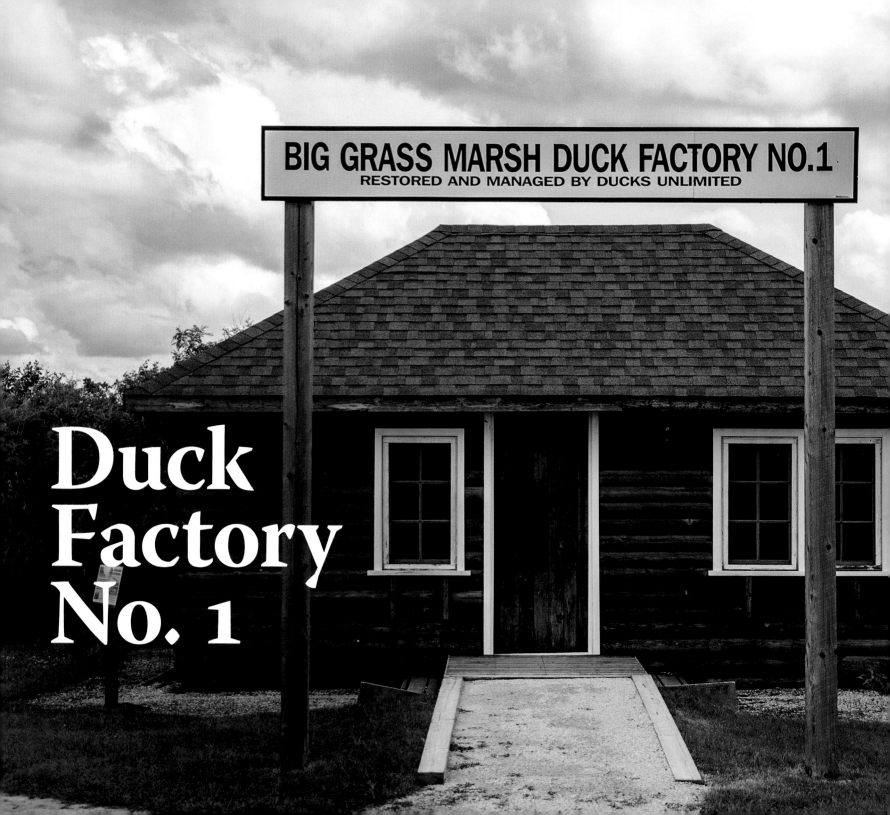

Duck
Factory
No. 1

I doubt that visitors to Manitoba's Oak Hammock Marsh realize, as they walk from the parking lot to the Interpretive Centre, that they pass a brown and green building connected to one of the most significant events in the modern conservation movement in Canada. Once the ranger's cabin for a site called Duck Factory No. 1, this inconspicuous little building is an important link to the 1938 founding in Manitoba of one of Canada's pre-eminent environmental organizations, Ducks Unlimited Canada.

One hundred years ago, a Winnipegger who wished to visit their banker, or their doctor, or their lawyer, in the autumn was just as apt to find them out of the office. Unlike their modern counterparts, who might be found relaxing on the golf course, these professionals would take weeks at a time to sojourn in the marshes of rural Manitoba, avidly seeking migrating waterfowl (ducks and geese) that were flying overhead. Waterfowl hunting was a popular pastime pursued by all strata of society as a way of reconnecting with their humble roots. By the 1930s, however, that pastime was in jeopardy. It was a period of intense economic depression, but the Canadian prairies were also undergoing the worst drought in living memory, with several successive years of "dust bowl" conditions. Many of the shallow lakes and ponds that are fundamentally important to waterfowl and other wildlife were

A view of the restored Duck Factory No. 1 cabin at the Oak Hammock Marsh Interpretive Centre, June 2018. HOLLY THORNE

drying up and Canadian sportsmen were concerned that wildlife populations would be decimated.

In 1936, an American conservationist came to Winnipeg and met with prominent lawyer Edward Pitblado (president of the Manitoba Game and Fish Association at the time), and grain barons James Richardson and Norman Paterson. He came to encourage local sportsmen to establish a Canadian counterpart to a newly founded organization in the United States called "Ducks Unlimited." The name, incidentally, is reported to have arisen when the name "Ducks Limited" was proposed and someone responded, "We don't want Ducks *Limited*, we want Ducks *Unlimited*!" and the whimsical name stuck. A charter of incorporation for the new organization of Ducks Unlimited Canada (which has, by the way, the entirely appropriate acronym of DUC) was received on 17 March 1937. It was operated by a temporary group of directors until the next year when the first formal meeting of members, at the Fort Garry Hotel, occurred on 1 April 1938.

The focus of the new organization can be gleaned from the skill sets of its first employees. For its general manager, the DUC directors recruited Thomas "Tom" Main, a water supply engineer from the Canadian National Railway. He knew where to find water and how to put it to best use, whether for steam locomotives or ducks. His assistant manager was Edgar "Ed" Russenholt, a publicist for the Wawanesa Mutual Insurance Company, who knew how to get public attention. (A genuine

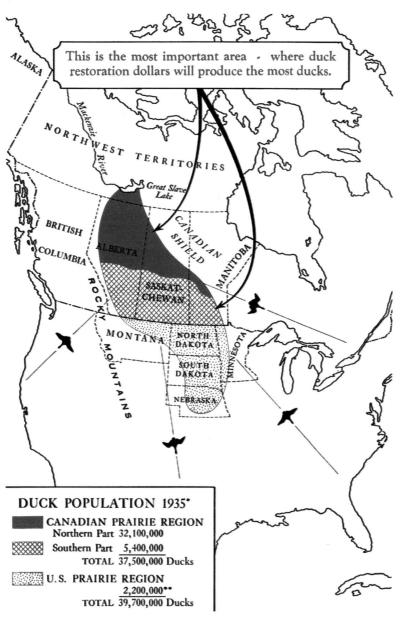

This is the most important area · where duck restoration dollars will produce the most ducks.

DUCK POPULATION 1935*

	CANADIAN PRAIRIE REGION	
	Northern Part	32,100,000
	Southern Part	5,400,000
	TOTAL	37,500,000 Ducks
	U.S. PRAIRIE REGION	
		2,200,000**
	TOTAL	39,700,000 Ducks

A diagram of North America, prepared by Ducks Unlimited in 1935, was intended to show potential investors in the United States that their dollars spent on the restoration of wetland habitat in Canada would repay them with more ducks migrating southward in the autumn. DUCKS UNLIMITED CANADA

raconteur, Russenholt would later gain fame as a CBC television weatherman.) The work of creating the structures needed to hold water was to be done by civil engineer Donald Stephens, who worked at DUC for a short time before moving on to an illustrious career with the provincial government and as general manager of Manitoba Hydro. Finally, to raise awareness of the animals that the organization was aiming to help, biologist Bertram "Bert" Cartwright became its founding Chief Naturalist. Other talents would be added in due course, such as Angus Shortt and his prodigious artistic ability, and eccentric Russian water scientist Alexander Bajkov. The emphasis in those days was always on engineering works—dikes and control structures—that would promote water retention, and secondarily on the biological factors that helped or hindered waterfowl breeding success.

DUC began in earnest to work against the forces of drought, to do for natural wet spaces what groups

such as the Prairie Farm Rehabilitation Administration (PFRA) were doing for agricultural land. In 1938, DUC's first conservation project was to construct a dam, in co-operation with the Province of Manitoba, the Rural Municipalities of Lakeview and Westbourne, and local landowners and lessees, at the outflow from Big Grass Marsh. This project had symbolic as well as practical significance because it was hoped the dam would reverse the decline of what was arguably one of Manitoba's largest wetlands, and one of the earliest targets of land drainage in the province.

The story of Big Grass Marsh, an enormous (40,000 acres) wetland situated on the western side of Lake Manitoba, is not well known outside of waterfowling circles. When settlers arrived in the newly acquired Canadian territory that would become southern Manitoba, they found vast areas of it covered in wetlands. A typical experience was the one of Julius Galbraith, a journalist who arrived at Winnipeg in 1873. His 1881 book *A Sketch of Both Sides of Manitoba* described a gruelling trip from Winnipeg to Morden:

> A few minutes after leaving the trail, I struck swamp, and the remaining twenty-eight miles, did not travel altogether a quarter of a mile on dry land. A mile or two of swamp alternated with a narrow ridge of dry land a few yards across, that is a full description of the country. If I had known at any time before noon what lay ahead of me, nothing could have induced me to continue the journey.

All these wetlands were considered useless for farming; land developers saw them as an opportunity to make money by attempting to turn them into productive farmland. That meant getting rid of the water. In 1882, a consortium of Canadian investors recruited thirty-two-year-old Robert Riley from his Ontario farm to drain Big Grass Marsh on their behalf. Where others had failed, Riley succeeded. He oversaw the construction of ditches and drains to transfer marsh water into the Whitemud River and eventually into Lake Manitoba. Between 1909 and 1916, the peripheral parts of Big Grass Marsh were drained as part of a proposed 100,000-acre land

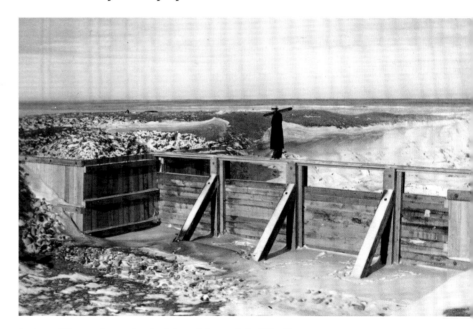

A view of the newly constructed dam at the outlet of Big Grass Marsh, December 1938. DUCKS UNLIMITED CANADA

development project. This would be merely one of Riley's many accomplishments. Another was founding a little company that met some success: Great West Life.

Today, monuments at Gladstone (next to "Happy Rock" on the Yellowhead Highway), Langruth, and Plumas bear testament to the rise and fall (or more correctly, the fall and rise) of Big Grass Marsh. A wooden dam that DUC constructed at Big Grass Marsh in 1938, to reverse Riley's drainage work, had the potential to flood and restore about 10,000 acres (or one-fourth) of the former marsh. In 1939, a thirty-seven-foot observation tower was built along with a field office (called a "ranger's cabin"), and a tool shed. Because the objective of the project was to restore water that would entice birds to stop there during their spring and fall migrations, and breed to produce more ducks, the place was dubbed "Duck Factory No. 1." (In case you are wondering, yes, there was a Duck Factory No. 2, and so on, but DUC records do not preserve all their names.) A famous photo taken that year shows Bert Cartwright at Big Grass with the cabin in the background.

In the early days of DUC, bulldozers were the tool of choice. To create earthen structures that would hold water, it was necessary to plug natural drains that would otherwise allow the water to escape. DUC built thousands of water control structures across the prairies. The funds to do this work came from numerous sources, including the wealthy patrons who had founded DUC in the first place, combined with donations from the general (hunting) public and companies whose executives were avid hunters. However, funding from the south side of the 49th parallel always provided a major part of the DUC budget. The rationale for Americans to donate to a Canadian organization was that waterfowl migrate northward into Canada in the spring, and breeding therefore occurs here. The resulting new ducks and geese fly back to the United States to spend the winter. Consequently, money put into improving breeding conditions in Canada pays direct dividends to American hunters. This successful formula, of American money paying for wetland improvement projects in Canada, defined DUC operations for decades. To raise public awareness about its good works, DUC staff did short radio broadcasts, the first in May 1938, using free airtime provided by James Richardson on his radio network in Winnipeg, Regina, Yorkton, Edmonton, Lethbridge, and Calgary. They published a newsletter that went by several names including *News Flight*, *Ducks and Drakes*, *Duck Doings*, and *Duckological*, and they spoke at meetings of fish and game associations across the Canadian prairies. Ed Russenholt created whimsical and informative cartoons on the adventures of "Jack the Drake" and "Mary the Mallard."

The purpose of public engagement was not merely to create political goodwill and raise funds. The DUC staff was never large so, whenever possible, they enlisted public help with their field work. For example, in the 1930s, DUC followed a long-standing government policy of offering a bounty for body parts (usually feet) from

waterfowl predators such as crows and magpies to alleviate the pressures on nesting waterfowl, especially when there were tasty and tempting young birds in nests. They recruited over three thousand "Kee Men" from across the prairies to provide local observations of waterfowl numbers as well as water and nesting conditions. These numbers were used to compile an annual census of waterfowl populations that provided useful feedback on the relative success of DUC actions.

By the late 1970s, DUC had spent more than $59 million in over 1,400 projects to restore about 1.5 million acres of waterfowl habitat. Many of these projects were small, involving relatively small areas, but some larger ones in Manitoba are worthy of note. Beginning in the 1940s and continuing through the 1980s, DUC undertook a series of projects in the vast inland delta of the Saskatchewan River surrounding The Pas. A control structure—named the Bracken Dam for incumbent Premier John Bracken—enabled the regulation of water levels in Saskeram Lake, upstream of The Pas, for the sake of waterfowl. Downstream control structures built by DUC in the late 1970s and early 1980s allowed water level management for some forty bodies of water in the huge Summerberry Marsh complex there. In southern Manitoba, DUC collaborated with the provincial government, starting in 1973, when eight thousand acres of marginal farmland near Stonewall were purchased and earthen dikes were built to enclose four large areas. The water level inside these cells could be regulated, to stimulate the growth of

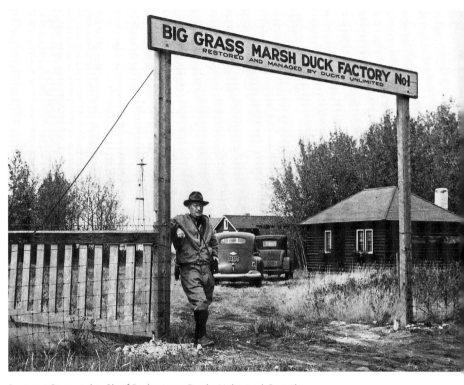

Bertram Cartwright, Chief Biologist at Ducks Unlimited Canada, stands at the entrance to Duck Factory No. 1 at Big Grass Marsh, 1938. DUCKS UNLIMITED CANADA

aquatic plants such as cattails and bulrushes, using water from nearby wells. Waterfowl benefited from sixty nesting islands within these cells. The area, known originally as the St. Andrew's Bog before attempts to drain it for agricultural production proved futile, is today's Oak Hammock Marsh.

A new era at DUC began in the 1970s, when its staff began to realize that a large proportion of the waterfowl

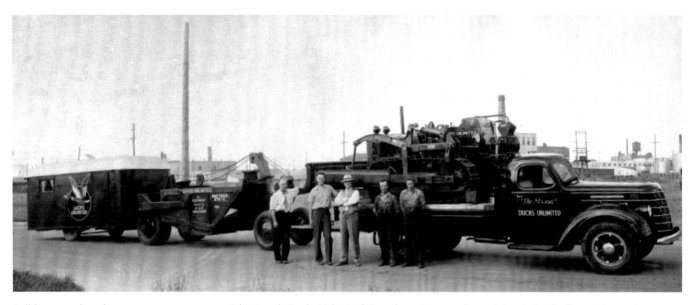

Bulldozers and earth movers were a common sight at early Ducks Unlimited Canada projects on the prairies. A sign indicates the equipment was provided by "a U.S. Sportsman." Gradually, this focus on engineering shifted in favour of more subtle management of landscape practices.
DUCKS UNLIMITED CANADA

they wanted to foster came from the agricultural lands of the prairies, and that some farming practices were both harmful to wildlife and environmentally unsustainable. DUC began working more actively in agricultural extension and public education, with newly hired staff "working at the farm gate, at the coffee shop or at the kitchen table." They were responding to a growing segment of Canadian society that was environmentally conscious and concerned but was not necessarily among DUC's traditional constituency of waterfowl hunters. This entailed moving away from its roots by acknowledging that, although engineering would be a necessary component of some projects, active intervention was not always the preferred option. In

1977, DUC established a Biological Services Group, staffed by people with advanced university degrees. Rather than focusing on waterfowl directly, they began putting more emphasis on the creation of high-quality habitat—the plants and other creatures of a healthy wetland—needed to sustain waterfowl populations. Gradually, DUC moved away from efforts to restore large, single wetlands such as Big Grass Marsh, Summerberry Marsh, and Oak Hammock Marsh, toward working with landowners and the public on numerous, smaller wetlands (potholes and sloughs) all over the prairies that numbered in the millions.

Inevitably, DUC expanded its operations beyond the prairies. At one time, the vast boreal forest of northern

Canada was seen as poor waterfowl habitat, but this attitude changed through research. Now, many of DUC's programs occur there. Regional offices opened in Ontario and the Atlantic provinces and, later, in Quebec and British Columbia. DUC became more actively involved in the advocacy and development of public policy on wetlands. It was an active participant in developing the North American Waterfowl Management Plan (NAWMP, shortened to "NAY-wump") between the Canadian and American governments to address declining waterfowl in the 1980s. The work to be done under the NAWMP was enabled by the passage, in 1989, of the North American Wetlands Conservation Act (NAWCA, pronounced "naw-kuh") in the United States. NAWCA has provided over $1.6 billion in grants to some 2,800 projects throughout North America, acknowledging that waterfowl and other migratory animals do not recognize international borders so neither should natural resource managers.

By the mid-1990s, DUC had reinvented itself again. This change was motivated in no small part by the ongoing decline in the number of waterfowl hunters in Canada. DUC's Institute for Wetland and Waterfowl Research, established in 1990, became its "brain trust" for generating new knowledge about wetland management that could help the group meet a variety of goals. Fundraising became more focused at the grassroots, starting in the mid-1970s with dinners held in communities far and wide. These "DU dinners" were widely respected by other nonprofit organizations for their diverse and clever means of extracting maximum dollars from those in attendance. DUC also evolved in other, more subtle ways. At one time, it was definitely an "old boys' club" that catered to masculine interests. From a time when most of its employees were men—including all its senior administrators—only recently did DUC have a woman as its Chief Executive Officer. DUC is a different organization from what its founders envisioned in 1938, still focused on outdoor enthusiasts but now, increasingly, ones who are just as concerned about clean air, water, and soil as for the availability of ducks to shoot ... with their cameras. Reflecting this focus on conservation, broadly defined, DUC's glossy newsletter is now called *The Conservator*. I think it can justifiably be said that the origins of the conservation movement in Canada has much to do with the founding of DUC and the ethic of environmental preservation that it fostered.

Around 2000, Gary Garrioch, a DUC administrator, wondered if there was anything left at Duck Factory No. 1. During DUC fundraising dinners in the area, he made inquiries of local residents and succeeded in finding the building sitting in a farmyard not far from Big Grass Marsh. He negotiated with the owner to purchase the building and it was moved near the Interpretive Centre (and DUC national headquarters) at Oak Hammock Marsh. There, it was restored by a pair of DUC volunteers. The interior ceiling and walls were fixed, and the roof was reshingled. As the first building linked to DUC's restoration projects in Canada, the cabin is now used in

DUC staff sought to entertain and inform Canadians about waterfowl biology and habitat with cartoons such as this one, drawn by Ed Russenholt with verse composed by Bert Cartwright. DUCKS UNLIMITED CANADA

public programming at the Centre. On a windy day in October 2022, a public ceremony was held in front of it. Hosted by the Historic Sites and Monuments Board of Canada, the attendees saw the unveiling of a plaque to recognize the Manitoba founding of DUC in 1938 as an "event of national historic significance". I am proud to say that I helped to initiate that designation. The members and staff of DUC understand that, to respond positively to the impacts of pollutants, climate change, invasive species, and other environmental challenges, we need sound land management based on good science. We know now that vast Manitoba wetlands like Big Grass Marsh, Delta Marsh, Netley-Libau Marsh, Oak Hammock Marsh, and many others are natural treasures that must be preserved. We need policies—supported financially by the Canadian public—to rehabilitate degraded wetlands, to sustain existing ones, and to create new habitat for the benefit of wildlife and ultimately also their human friends.

Meanwhile, an ending to the story of Big Grass Marsh has not yet been written. In 2014, an agreement was concluded between the provincial government and the Rural Municipalities of Lakeview and Westbourne (two participants in the original restoration project, now united as the Municipality of WestLake-Gladstone), to protect 45,000 acres of municipal and Crown land from future drainage and development. The move was not seen as a positive one by everyone. In 2015, an illegal trench around a water-control structure dropped the level of Big Grass Marsh by as much as three feet. The trench was believed to have been dug by a local farmer who was angry that the project was flooding his farmland. The needs of waterfowl and farming are sometimes in conflict so the struggle between conservationists and farmers continues. Yet, there is growing awareness that water that may be excessive in the spring can become scarce when it is needed to sustain crops in the summer. The mantra of "keep water on the landscape" that DUC pioneered eighty-five years ago is one that is just as pertinent today.

Directions

Enter these coordinates into a GPS receiver or a map app on your smartphone.

Historic Site	Latitude	Longitude
Duck Factory No. 1	N50.17211	W97.13190
Big Grass Marsh Monument (Gladstone)	N50.21959	W98.95280
Big Grass Marsh Monument (Langruth)	N50.38759	W98.67571
Big Grass Marsh Monument (Plumas)	N50.38736	W99.08691

ACKNOWLEDGEMENTS

I dedicate this chapter to the many fine people at Ducks Unlimited Canada (DUC) who, over many years, have supported my scientific and historical work. I want to especially acknowledge my long-time scientific partner, Dale Wrubleski. Others include, in alphabetical order: Parsa Aminian, Mike Anderson, Rick Andrews, Pascal Badiou, Bruce Batt, Greg Bruce, Cal Cuthbert, Dave Dobson, Bob Emery, Shane Gabor, Gary Garrioch, Bob Grant, Karla Guyn, Larry Leavens, Tracy Maconachie, Rhonda McDougal, Henry Murkin, Bryan Page, Robin Reader, Lisette Ross, Don Sexton, Nigel Simms, Chris Smith, and Jeope Wolfe. I benefitted enormously from two books on the history of DUC, by Bill Leitch and Bruce Batt, and access to the DUC corporate archives, which provided several of the illustrations in this chapter. Gary Garrioch told me the story of the rediscovery of the "ranger's cabin" from Duck Factory No. 1. For the past several years, I have tried, with incomplete success, to map the locations of monuments that DUC erected at many of its conservation projects around Manitoba. If anyone knows where some of these markers are located, please let me know.

NEW GRADING

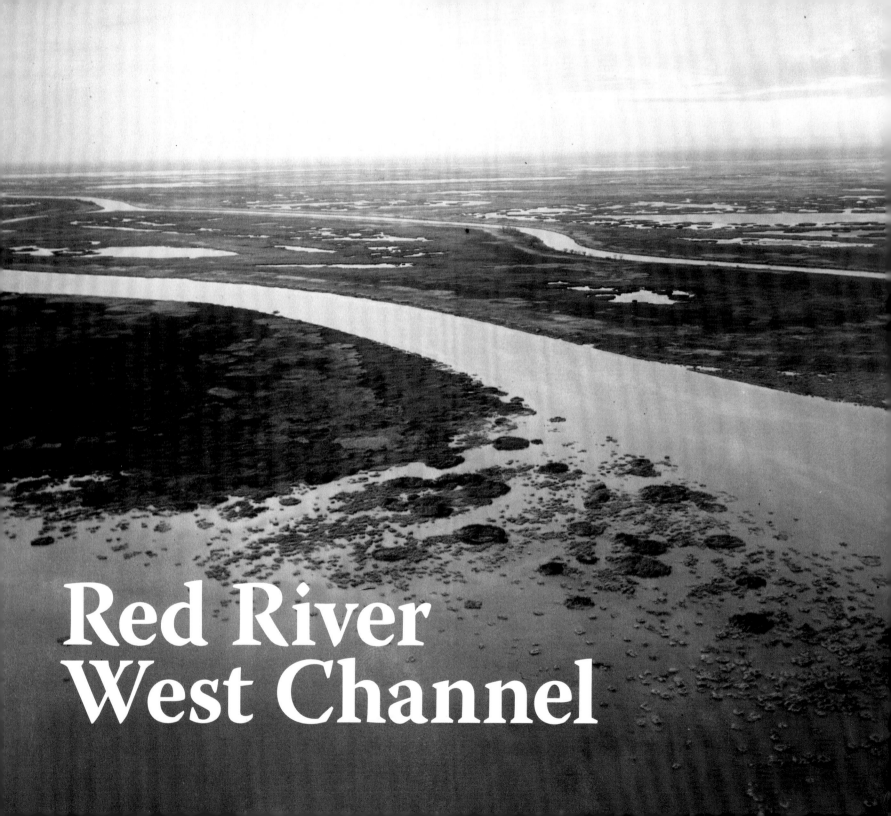

Red River
West Channel

The muck stops here. Something akin to the metaphorical "buck" that passed on and on until it stopped on US President Harry Truman's desk, Manitoba's Red River is the stopping place for much of the mud and silt that erodes from the sides of slow, meandering rivers of the Canadian and American prairies. The Red River often carries what looks less like muddy water … and more like watery mud. It has long been a busy river too: first for generations of Indigenous people, then for fur traders, then for steamboats and small cruise ships, and today for pleasure craft of all sizes. However, due to a profound change to the Red River in the spring of 1893, a portion of it has been abandoned ever since.

During the early fur trade in the area that would become Manitoba, Hudson's Bay Company traders arrived at York Factory, at the mouth of the Hayes River, aboard large, ocean-going ships. From there, in response to competition from other traders who brought their goods directly to Indigenous trappers, freight was transferred to York boats or canoes for transport to far-flung inland posts. (See the chapter on Brandon House.) Trade goods were shipped south and furs returned north for the journey back to England. The river and lake vessels were small, driven by the wind and manpower, so their cargo capacity was strictly limited. When steamboats

An aerial view of the Red River's Centre Channel mouth at Lake Winnipeg looking southwest to the Netley-Libau Marsh in the background, 1923. ARCHIVES OF MANITOBA, FA23.04, C10 BOX 15, 1960-2

began operating on the Red River and in Lake Winnipeg during the 1860s, and especially when railways began reaching southern Manitoba in the 1870s, they vastly increased the quantity of materials that could be carried quickly and cheaply. Commercial vessels began plying Lake Winnipeg, transporting fish, lumber, and minerals to southern Manitoba via the Red River and bringing back supplies to previously remote communities around the lake. Compared to the vessels of yore, these large ships on the Red River required deeper water to operate, and this necessitated dredging the river channel to maintain its depth. Suspended sediment is deposited on the river bottom as the water moves, and sedimentation is especially high where the river slows down, such as at the mouth where it meets Lake Winnipeg.

The earliest dredging of the Red River occurred in the United States. In 1874, US Colonel F. U. Farquhar was dispatched to survey the river and, two years later, Congress appropriated $10,000 to construct a dredge at Fargo. It began working in mid-1879 and by 1885, it had deepened eighty miles downstream of Fargo, as far north as Grand Forks. Canada was not far behind. In 1882, our federal government spent $60,000 (or $1.5 million in today's dollars) to purchase a dredge (to be named the *Winnipeg*), a tugboat (the *Sir Hector* after Hector Langevin, federal minister responsible for infrastructure), and two dump scows (for collecting, then dumping dredged mud) from a shipyard at Lockport, New York. They were shipped in pieces on twenty-six railway cars

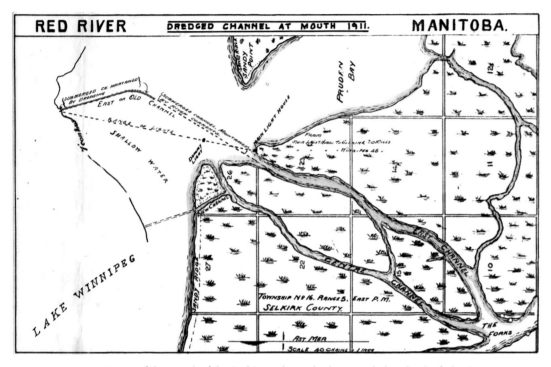

A map of the mouth of the Red River shows dredging work done by the federal government in 1911, labelled "NEW CHANNEL", that bisected Thomas Hardman's farm. The western river channel from The Forks is not shown in this map. LIBRARY AND ARCHIVES CANADA (WINNIPEG), ACCESSION W84-85/493 BOX 31B RED RIVER MOUTH 1911–1920

and assembled on the bank of the Red River upon arrival in Winnipeg in February 1884. The primary purpose of dredging was to ensure the Red River was navigable by commercial ships, by deepening and straightening its channel and removing submersed tree trunks and boulders that were hazardous to ships. There were numerous other uses. The dredge could dig up sand and gravel from the river bottom for use in construction projects around the province. It could assist in stabilizing channel banks by installing piles and rocks. It could excavate new channels and build or improve harbours.

In the period between 1884 and 1925, there were five dredges in the federal fleet in Manitoba. The *Winnipeg* was a dipper-style dredge that lowered a large bucket into the water, filled it with mud from the bottom, then brought it up to drop into a waiting scow. When full, the scow was towed by the *Sir Hector* into deeper water (such as Lake Winnipeg) where its contents were dumped to the bottom. The dredge was designed to work well in the shallow Red River, being able to float in only 4½ feet of water. Powered by steam, the *Winnipeg* was fuelled by coal or, if coal was not available, by wood. When operating, it could excavate up to 300 cubic yards of mud each day to a maximum depth of 20 feet. The *Winnipeg* was used almost every year until being taken out of service in 1909, when it was replaced by a larger dipper, the *Winnipeg II*, with a daily working capacity of 1,000 cubic yards. The dredge *Assiniboine*, used from 1908 to 1922, was a hydraulic type that blended mud with water

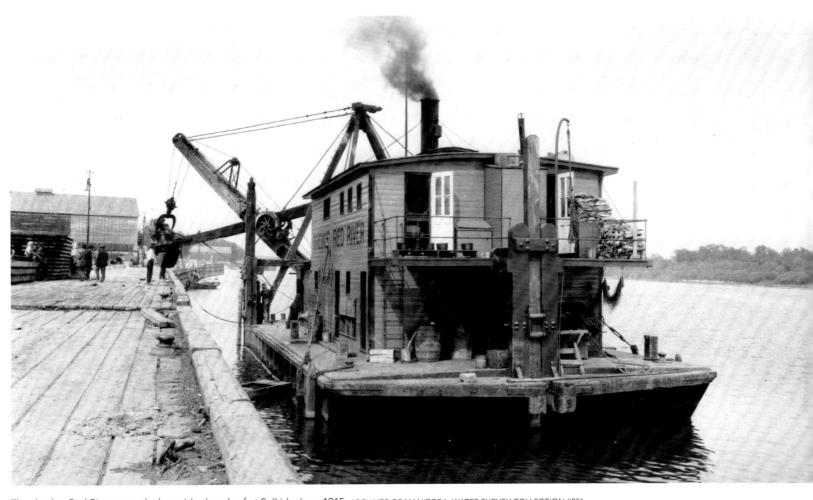

The dredge Red River at work alongside the wharf at Selkirk, June 1915. ARCHIVES OF MANITOBA, WATER SURVEY COLLECTION #251

then pumped the wet mixture from the bottom into a scow. It could move up to 725 cubic yards per day. The dredge *Red River* worked from 1910 to 1930. It functioned something like a wet vacuum cleaner, sucking up bottom mud and piping it into the scow, with a daily capacity of 350 cubic yards. Finally, there was the dredge *Crane*, that began operating in 1911. It was an "orange peel" type, so called because it had a metal bucket that resembled an orange being peeled. Its capacity was 220 cubic yards per day.

Dredges typically had a six-man crew. The captain had overall responsibility for operation of the vessel, a craneman operated the dredging mechanism, a fireman kept the boiler fueled, a deckhand helped anyone who needed extra hands for a particular task, a watchman provided security and sometimes doubled as cook, and a scowman oversaw the transfer of mud into the scows. In addition, the tugboat had a three-man crew: a captain, an engineer, and a fireman. The dredges had small cabins in which the crew lived throughout the work season, which typically started in May and ran to the end of September or early October. In the 1880s, they were paid salaries

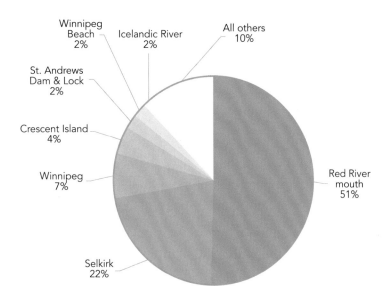

FIGURE 2 The mouth of the Red River represented, by far, the greatest amount of dredging done by the federal government between 1884 and 1925. GORDON GOLDSBOROUGH, USING DATA OBTAINED FROM LIBRARY AND ARCHIVES CANADA

ranging from $30 per month (about $800 in today's dollars) for the lowliest positions to $120 per month ($3,200) for the dredge captain. Most of the dredge crews were honourable fellows but, occasionally, they included a few scoundrels such as A. R. Weare, who, for a time, captained the tugboat *Sir Hector*. In August 1884, the *Manitoba Free Press* reported that:

> A lady sold a ring to a jeweller on Main Street on Wednesday for $5 … After the sale of the ring, a man, representing himself as a detective, called on the lady who had sold the ring and asked her for the proceeds of the sale, saying that the article was stolen. The woman handed over the money, and the man disappeared with it, and has not been seen since. His name, so far as can be gathered, is Captain Weare, who was at one time in charge of the dredging machine at the mouth of the Red River.

Weare was subsequently captured by the police at Morris and sentenced to a month in the provincial jail.

In the *Winnipeg*'s first year of dredging, 1884, it cost the government $10,866 (about $280,000 in today's currency). Half went to salaries, one-third to supplies, and the remainder for food and coal. Over the next forty years, to 1925, dredges were deployed wherever they were needed. About half of all dredging occurred at the mouth of the Red River, where mud accumulated continually. Another third took place at Selkirk, where the dredges were based, with the rest at Winnipeg, St. Andrews Lock and Dam, and at various ports around Lake Winnipeg. Interestingly,

almost no dredging occurred in the Red River south of Winnipeg or on the Assiniboine River (see Figure 2).

Are you wondering where the abandonment part of our story comes in? Readers who have boated on the Red River between Selkirk and Lake Winnipeg will be familiar with an area called "The Forks," not to be confused with the same-named place in Winnipeg. There, the single river channel splits into three, with a West Channel that heads northwest toward Lake Winnipeg, and a Centre Channel and East Channel that parallel each other heading northeast. When dredging began in 1884, the West Channel was the main one used by ships. In the spring of 1893, however, when the river ice broke up, government engineers were horrified to learn that the channel was so thoroughly plugged with sediment that it was far too shallow for ships needing to pass through it. They calculated the volume of mud that would have to be dredged to reopen the channel and concluded it would be faster and cheaper to

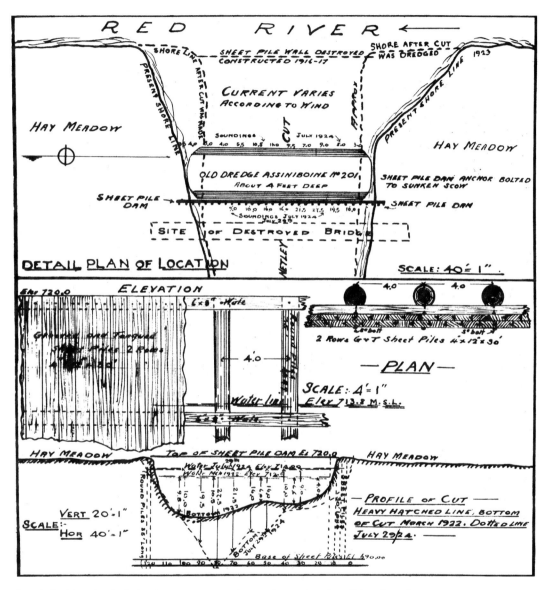

A technical drawing by federal government engineers shows what they did to close the Netley Cut: sink an old dredge and, later, build a sheet pile dam across it. LIBRARY AND ARCHIVES CANADA (WINNIPEG), ACCESSION W84-85/493 BOX 26 NETLEY

abandon the West Channel altogether and dredge to make the East Channel navigable. That is what they did.

From 1893 to around 1903, the East Channel of the Red River became the predominant means of travelling to and from Lake Winnipeg. However, it became shallower over time too so, around 1903, the decision was made to abandon it in favour of the Centre Channel. This has been the main channel for all boating on the Red River ever since. The government engineers determined that the mouth of the Centre Channel would be less prone to sedimentation if it entered Lake Winnipeg in a northwesterly direction, rather than the northeasterly orientation of the original outlet. In 1900, they put the dredge *Winnipeg* to work to create a new channel near the river mouth. Curiously, the land where they dredged was not public land but was owned by a fellow named Thomas Hardman. He had once had a farm there but, on account of prolonged high water, he had moved his home to a site farther south along the river, near St. Peter Dynevor Church. Hardman intended to return when the floodwaters receded. Imagine his consternation when he came back to find that the site where his house had once stood was now cut off from the rest of his property by a newly dug channel. When Hardman complained and sought compensation, the government flatly refused, arguing that, in fact, they had made his land more valuable by making it "river-front property".

At the mouth of the Red River where it meets Lake Winnipeg, there is a vast wetland known as the Netley-Libau Marsh—roughly 100 square miles in area, the largest of its kind in North America. The marsh is a vast complex of shallow waterbodies interspersed with heavily vegetated areas of water-loving plants such as bulrushes and cattails. For eons, the marsh has attracted a myriad of waterfowl (ducks and geese) and, in turn, waterfowl hunters. However, not everyone has seen this expansive natural resource as valuable. As I have said in another chapter of this book, wetlands have traditionally been viewed as worthless by farmers and others who measure worth only in monetary terms. In 1908, a Winnipeg firm proposed that the city could rid itself of a mounting garbage problem by loading the waste onto barges and dumping it into Netley Lake, the southernmost part of the Netley-Libau Marsh. A channel would have to be dredged, from the Red River into the marsh, to permit access by the barges. Eventually, the marsh would be filled in to become valuable farmland. After a leisurely visit by Winnipeg's mayor and members of the city council, in which they were assured by the federal government's engineer that "there would be no objection to using the lake as a dumping-place," the idea was eventually rejected as infeasible, in part because the site would not be accessible year-round but only in the summer when barges could operate.

The dumping of garbage into the marsh was not the only measure for which the federal government was being lobbied to dig a channel. In July 1907, the government engineer at Winnipeg was contacted by a group at Selkirk, who wrote to advise him that:

Netley Lake is separated from the Red River at the closest point, by a narrow strip of land, through which a channel could easily be dredged to permit Netley Lake being entered from the Red River by small boats and flat-bottomed scows. There is considerable cordwood and hay on the shores of and adjacent to Netley Lake, that settlers and others interested experience difficulty in having taken out. An entrance into Devil's Lake from the River had already been dredged out; which has resulted in great benefit to the settlers and public; and it is fully as important, if not more so, that a channel be made affording similar access to Netley Lake. Your petitioners therefore pray: that you arrange at as early a date as possible to give the necessary instructions to have the small dredge that is used for such purposes, sent up to cut out a channel between the Red River and Netley Lake, as herein referred to.

It would take a half dozen more years before the government responded to requests for marsh dredging. Finally, over a period of two weeks in early October 1913, the dredge *Crane* and tugboat *Lisgar* were dispatched down the Red River, adjacent to Netley Lake, at a site just north of where Netley Creek flows into the river from the west. Almost immediately after this new Netley Cut was dredged, it began to widen as a result of erosion by water flowing from the river into the marsh. A small bridge, constructed to enable farmers to reach hay-cutting areas north of the channel, washed away in 1916. A sheet pile dam was built across the Cut during the winter of 1919–1920 but it (and a second bridge) was already damaged by the summer of 1920. By 1924, the Netley Cut was over eighty feet wide and about sixteen feet deep. During replacement of the dam that year, the hull of the former dredge *Assiniboine*, that had been moored lengthwise across the channel to support a pile driver, sank and was abandoned, ostensibly to form part of the dam and a makeshift bridge. Eventually, the Netley Cut closed and remained so until the catastrophic Red River flood of 1950. It re-closed again shortly afterward and remained closed until sometime between 1968 and 1970 when, for reasons that are still mysterious, the Cut opened permanently. By 2001, it was about 1,300 feet wide, broader than the Red River itself at that point, and it has continued to widen in the past two decades. One of my university colleagues estimated in 2009 that between a quarter and a half of the total Red River flow now goes through the Netley Cut rather than through the Centre Channel. This is believed to be one of the factors contributing to the degradation of this once vast wetland. Since we have been studying the marsh and its vegetation, extensive areas have changed from dense stands of cattails, bulrushes, and other marsh plants to open water. Other factors leading to plant loss are excessive pollution entering the marsh from the Red River and the lack of periodic droughts during which marsh plants have an opportunity to regenerate.

Dredges have made channels for other projects on the Red River. For many years, treacherous rapids near Lockport had presented a navigational obstacle to ships.

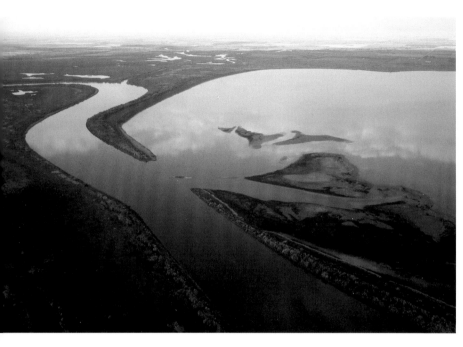

The Netley Cut as it appeared in October 2003, with the Red River in the foreground and the expanse of the Netley-Libau Marsh in the background. GORDON GOLDSBOROUGH

After years of empty promises from federal politicians, the Liberal government of Wilfrid Laurier resolved to finally conquer the St. Andrews Rapids. Work started intermittently around 1902 and began in earnest in 1906. In the spring of 1907, the dredge *Winnipeg* began excavating a channel through which a lock—the only one on the prairies—could allow ships to bypass the innovative Camere-style dam being constructed. The first ship to use that lock was the steamboat *Victoria*, in May 1910. Two months later, Laurier was aboard the steamer *Winnitoba* to officially christen the new St. Andrews Lock and Dam.

The dredging of the Red River's Centre Channel by the government's dredge fleet, based at Selkirk, continued through the twentieth century until 1999 when the last work was done. It stopped because the federal government felt the money being spent on dredging, around $1 million each year, was not warranted by the volume of boat traffic using the river. Despite widespread public criticism, the government held firm. Consequently, no dredging has been done for the past twenty-four years, with the result that siltation of the river channels continues unabated. A friend of mine who boated into the West Channel a few years ago says it is now only a few inches deep in places and remains hopelessly unnavigable. Likewise, we know the East Channel is no longer as deep as it once was. Nobody has suggested that dredging should resume on these abandoned channels but, in theory, it could be. However, it seems to me that dredging *should* resume on the Centre Channel. One of the consequences of sedimentation in the undredged channel is that one of the largest ships on Lake Winnipeg, the research vessel *Namao* that collects water samples around the lake and monitors its declining health, is no longer able to reach a dry dock facility at Selkirk. The Centre Channel is too shallow. Without access to a dry dock, it will not be possible to certify the ship as seaworthy, which will jeopardize our ability to learn about the lake.

Municipal, provincial, and federal governments, along with other stakeholders, are being asked to support a resumption of Red River dredging. I am one of the people

who thinks that dredging is a good idea because it will help to restore the badly degraded Netley-Libau Marsh and it will also help to reduce upstream flooding along the river. The plan takes advantage of the fact that mud accumulates naturally at the mouth of the Red River. In 2021, with permission from the federal and provincial governments, our research group used a pair of Amphibex machines—ones used by the provincial government for years as icebreakers on the Red River—for their original purpose as dredges in a small-scale scientific experiment. An Amphibex can pump mud from the river bottom, with the consistency of thick toothpaste, in a pipe up to 1½ miles away from the point of dredging. In our experiment, the mud was deposited on the bottom of Netley Lake—just north of the Netley Cut—where the water is presently too deep to permit the growth of aquatic plants. The plan is to create shallow areas where cattails and other wetland species can grow. Unfortunately, high water levels in 2022 made it impossible for us to determine if the newly created habitat is serving its intended purpose. As I write this story, we hope that additional monitoring will occur in the summer of 2023. If all goes according to plan, newly grown cattails will provide wildlife habitat, hold nutrients from the Red River that would otherwise contaminate Lake Winnipeg, and in the future may be harvestable as a source of biofuel.

It is too early to predict if the degradation of the Netley-Libau Marsh can be reversed, but we are confident that the sun has not set on one of North America's largest natural wetland resources. But the West Channel of the Red River that passes through it is, I think, a lost cause. The muck has definitely stopped there.

Directions

Enter these coordinates into a GPS receiver or a map app on your smartphone.

Historic Site	Latitude	Longitude
The Forks of the Red River	N50.34990	W96.83958
Netley Cut	N50.31125	W96.83551

ACKNOWLEDGEMENTS

I first became interested in Red River dredging at the urging of Harold Taylor who, at the time, worked for the Red River Basin Commission. Our work on the Netley-Libau Marsh has involved my long-time research collaborator Dale Wrubleski along with Pascal Badiou, Shawn Clark, Richard Grosshans, Paige Kowal, Steve Strang, Elise Watchorn, and many others. Our interest was first drawn to the marsh by the late great waterfowler Frank Baldwin. Financial support through the years came from Ducks Unlimited Canada, Manitoba Hydro, the Province of Manitoba, and Environment and Climate Change Canada, and funding to support our recent efforts to investigate methods of restoring Netley-Libau Marsh has come from numerous sources, coordinated by the good folks at the Commission. I want to recognize archivists David Horky and David Cuthbert at the Winnipeg branch of Library and Archives Canada who have always been exceptionally helpful in my archival endeavours there.

BRIDGE REPAIRS

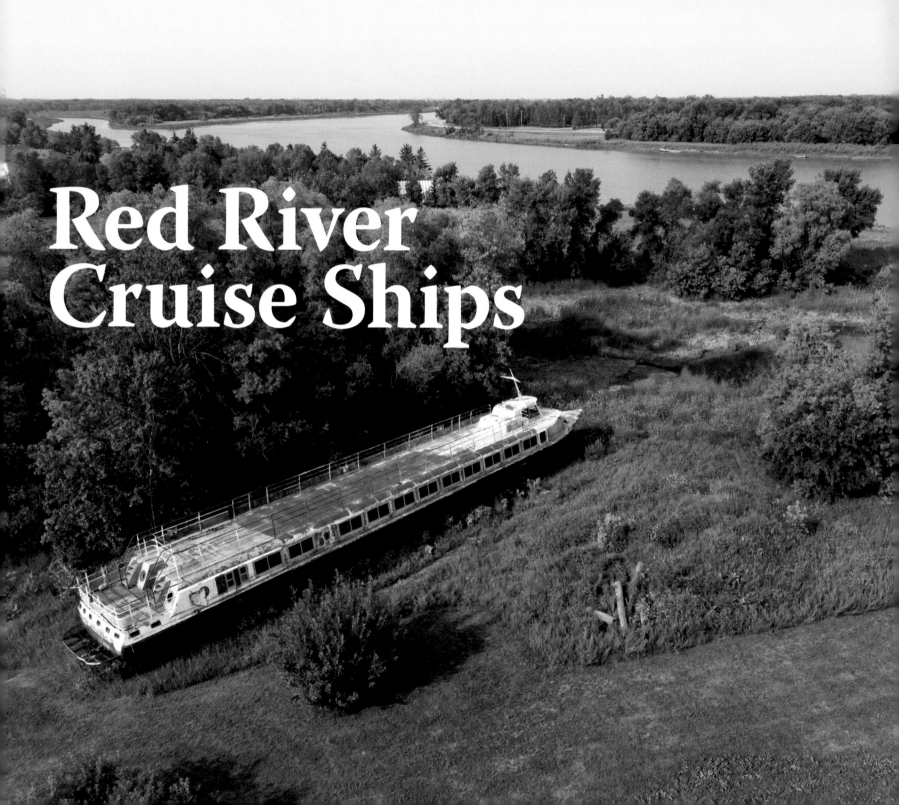

Red River
Cruise Ships

In the 1860s, the vast majority of people arriving in Manitoba from the outside world came aboard a steamboat on the Red River. The first of these ships, the *Anson Northup*, began operating between Canadian and American ports in 1859. Steamboats continued to operate on the river throughout the nineteenth century, but the arrival of the Canadian Pacific Railway put a nail in the coffin of ship-based domestic travel on the Red River. Jump forward to 1965 and that situation changed as, once again, people could see Manitoba from the vantage point of a large ship.

That was the year a semi-retired contractor named Ray Senft, who lived in a house overlooking the Red River near Lockport, was on holiday in Mexico. Inspired by the riverboats that he saw operating there, and the lore of Mississippi steamboats, he decided to build his own replica steamboat. He commissioned Selkirk shipbuilders Bill and Ted Purvis to construct the *Paddlewheel Queen*. In a period of under three months, at a cost of about $200,000 ($1.75 million in today's money), a ship with room for up to four hundred passengers was built. Although described as a sternwheeler, which is a ship propelled by a large, conspicuous wheel on the stern (rear), the *Paddlewheel Queen* was a fake. The sternwheel was merely for show; propulsion came from two large

OPPOSITE The *Lady Winnipeg*, a cruise ship that operated on the Red River between 1972 and 1993, sat beached and rusting beside the Red River when my drone flew over it in early 2023. GORDON GOLDSBOROUGH

Ray Senft inspects the work as the *Paddlewheel Queen* was constructed over a period of 80 days in 1965 at a cost of about $200,000. ADRIAN AMES

propellers on the bottom of the hull, driven by three diesel engines. Like the steamboats of yore, though, the *Paddlewheel Queen* had the remarkable ability to operate in water as shallow as 41 inches, which is essential for a river like the Red that is prone to collecting sediments. (See the chapter on the Red River West Channel.) The *Paddlewheel Queen* was launched at Selkirk in July 1965 and began cruising up and down the Red River.

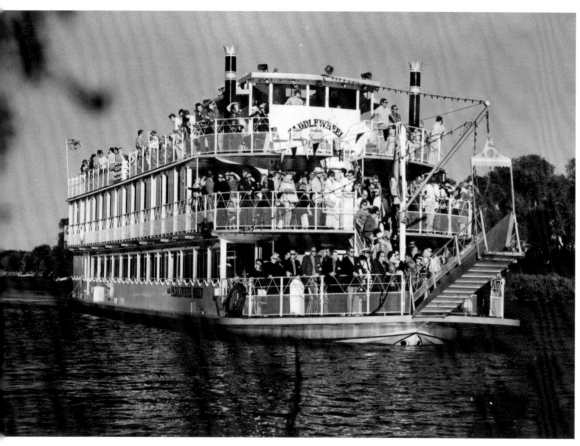

A group enjoys a trip aboard the *Paddlewheel Queen* in this photo published in the *Winnipeg Tribune* in August 1974. GORDON GOLDSBOROUGH

The *Paddlewheel Queen* picked up passengers at the Redwood Docks in Winnipeg and took them north on a three-hour cruise, through the locks at St. Andrews, stopping at such places as Lower Fort Garry. Charter trips on different routes could also be arranged. Essentially, the idea was to relax while sightseeing along the river. The ship was equipped with full dining facilities, snack and sandwich bars, beer and wine service, and particularly important for some groups, a dance floor for dinner-and-dancing cruises.

The ship was so popular that, in 1966, Senft built a second fake stern-wheeler, the *Paddlewheel Princess*. Smaller than its predecessor, with a capacity for two hundred passengers, the idea was to have one ship available for public excursions and the other at the same time for private charters. Soon afterward, a local restauranteur named Dan Ritchie, who provided food service aboard the *Paddlewheel Queen*, decided to get into the riverboat business too. He went to the Purvis Shipyards and asked them to build him one. This four hundred-passenger ship, allegedly built at a cost of a half-million dollars, would feature a more modern, streamlined design. When launched on its maiden voyage in early 1967, Ritchie named it the *River Rouge*, and advertised it as "Canada's largest cruise ship."

Not to be outdone, in late 1967 Senft moved his *Paddlewheel Queen* to a site north of Selkirk where workers sliced it into two pieces and

added 24 feet in the middle, increasing the ship's total length to 116 feet. A third deck, a promenade, was added, increasing its height to 30 feet. A new 90-foot-long dance floor was added too. In so doing, Senft snatched the "largest ship" title from Ritchie who, in retaliation, argued that if his was not the largest, it was certainly the fastest. Ritchie challenged Senft to race the *Paddlewheel Queen* against his *River Rouge*. According to Steve Hawchuk (who I will introduce in a moment), there were many such challenges over the years and they were never taken seriously. But there was definitely no love lost between Senft and Ritchie, or later between Hawchuk and Ritchie.

Ray Senft and Dan Ritchie were the men who built the riverboats, but Steve Hawchuk holds the distinction of having operated them the longest: forty-four years. In 1969, Ray Senft decided that he had had enough. He said that he wanted to return to his first love, the construction industry. But maybe his bitter rivalry with Dan Ritchie had broken him. In any case, he put his two riverboats up for sale, and they were purchased by Steve Hawchuk and his half-brother Joe Slogan of Selkirk. Hawchuk saw the purchase of the ships as a business opportunity; he had no background in the marine industry and was therefore on a steep learning curve. He put in the effort and managed to obtain his Master's papers. This allowed him to captain his ships, something that Dan Ritchie never did, though he was frequently photographed in a captain's uniform.

Between 1971 and 1972, Dan Ritchie built the *Lady Winnipeg*, a smaller counterpart to his *River Rouge*.

Peeling paint and plywood-covered windows reveal the apparent abandonment of the *River Rouge* at Selkirk. HOLLY THORNE

Initially 80 feet long, it was extended by 36 feet in 1974. It was the last of the true riverboats, although the *Lord Selkirk II*, built between 1967 and 1969 by a consortium of businessmen as a replacement for the aging *Keenora* on the Lake Winnipeg circuit, also operated on the Red River in the 1980s. This ship, with room for 450 overnight passengers, was 176 feet long with a draught of 7½ feet. The *Lord Selkirk II* was supposed to be the largest ship ever built between the Great Lakes and the Pacific coast.

Many people have fond memories of cruises on the Red River. Steve Hawchuk's 2022 memoir, co-written with journalist Bill Redekop, is filled with anecdotes and observations about the rowdies, celebrities, and everyday people who boarded his ships … and sometimes disembarked under less-than-ideal conditions. Charters

The *River Rouge* on the Red River in 2005.
GEORGE PENNER

cruises. We would have to restock mid-cruise. They were a wild bunch. We had to call the cops a few times on their cruises, too.

Hawchuk claims that many a marriage occurred as a result of romance, and sometimes outright lust, that blossomed aboard one of his ships. He describes his efforts to bolster ridership with double-decker buses that he imported from Britain in the early 1970s. Dan Ritchie later bought his own double-deckers, and the bright red buses were a conspicuous feature on Winnipeg streets until being retired in 2003.

In 1978, less than ten years after its maiden voyage and having been a money-loser for much of that time, the *Lord Selkirk II* was sold, then re-sold with plans to turn it into a floating casino. In 1990, the ship was mothballed in the Selkirk Slough (a dead-end branch of the Red River that has been long used for winter storage of all sorts of watercraft) where it was subject to numerous acts of vandalism. The bulk of it was

by companies, sports clubs, churches, schools, and other groups provided much of his income. But these events often had a downside:

> We sold a lot of alcohol at some of those events. The biggest liquor sales were the University of Manitoba Engineering student

sold for scrap in 2010, an arson fire in 2012 destroyed what was left. The ship was dismantled in 2015 and its metal was recycled. To meet a dwindling demand, the third deck of the *Paddlewheel Queen* was removed in 1989 so it could pass under the bridges of downtown Winnipeg. In 1986, Dan Ritchie sold the *River Rouge* to businessman Jack Neaman who leased it to Hawchuk from 1993 to 2006, after which it was sold. The *River Rouge* stood alongside the city-owned Alexander Docks until city officials forced it to move in 2014. The *Lady Winnipeg* last operated in 1993 and was sold in 2002. Planned to be renovated into a private yacht, it now sits forlornly on the east side of the Red River north of Selkirk. The *Paddlewheel Queen* was last used in 2013 and was dismantled in 2016. The Selkirk Slough is now a graveyard for two abandoned ships. The *Paddlewheel Princess* last sailed in 2009 and the *River Rouge* was last used in 2014. In May 2017, the *Princess* was heavily damaged in a huge blaze that took local firefighters hours to bring under control. Everything not made of metal was consumed.

Using data in Hawchuk's book, I prepared a graph that shows the number of passengers aboard the *Paddlewheel Queen* and *Paddlewheel Princess* from 1969 to 2013. Figure 3 shows clearly that his passenger numbers were stable through the 1970s, but a marked downward trend began in the early 1980s that culminated in the final retirement of the fleet in 2013. What killed the riverboats? This is a question that fascinates me because it speaks to changing societal priorities. Steve Hawchuk addresses

this question in his memoir, and he puts a lot of blame on rising water levels on the Red River during the 1990s. Higher water made it difficult, and sometimes impossible, for his ships to pass under the bridges of downtown Winnipeg and caused flooding at his dock facilities. But I think the answer is more complex because the decline started a decade earlier.

Hawchuk does recognize that other factors contributed to the end of his business. One was a decrease in international tourist traffic. In the 1970s, he observed that up to 70% of the licence plates in his parking lot were from outside Manitoba, particularly from American states. The impact of the 9-11 terrorist attack on New York

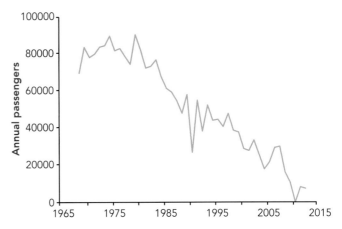

FIGURE 3 Statistics on the combined annual ridership aboard the *Paddlewheel Queen* and *Paddlewheel Princess*, from 1969 to 2013, showed a worrying downward trend since the early 1980s. This is not total passenger traffic on riverboats, however, as it omits those travelling on the other two ships, the *River Rouge* and *Lady Winnipeg*. *WELCOME ABOARD! MY 44 YEAR JOURNEY ON THE RED* BY CAPTAIN STEVE HAWCHUK

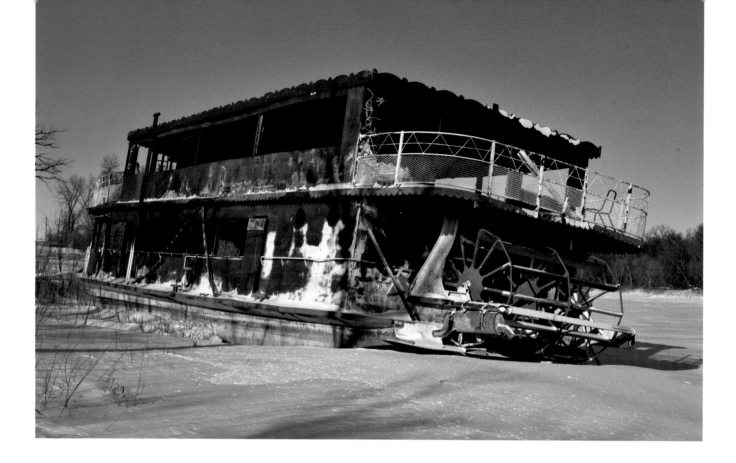

The burned-out hull of the *Paddlewheel Princess* sits in the Selkirk Slough in February 2022. Only the ship's bow and stern outside the main passenger compartment seem to have escaped the fire relatively unscathed. GORDON GOLDSBOROUGH

City made some Americans hesitant to travel, even to friendly countries such as Canada. A further disincentive occurred in 2009 when all Americans had to start carrying a passport to visit Canada, and many of them did not have one or see a compelling reason to get one. From 1974 to 2000, the government of West Germany sent its military troops to Manitoba to train in desert warfare (using the desert-like conditions at CFB Shilo) and, according to Hawchuk, a lot of the soldiers stopped for a river cruise while passing through Winnipeg.

He feels that the City of Winnipeg was not sufficiently supportive of his efforts to promote tourism in the city. He had to move his dock several times, thanks in some cases to broken promises by city officials, making it difficult for tourists to find him. Declining interest rates reduced the discretionary income that people received from their investments and this income was what seniors (a major demographic among Hawchuk's passengers) would otherwise use to pay for cruise tickets. Private charters, a staple that comprised as much as one-third

of cruise income, diminished as the organizations that organized them—churches, veterans' groups, fraternal organizations, and others—experienced declines in membership. Changing attitudes about public drunkenness that once fueled the "booze cruises" also contributed to the decline, as did liability concerns and funding shortfalls that restricted the ability of schoolteachers and their students to come aboard. High school graduation parties, once a mainstay of riverboat business, ended, as Safe Grad (initiated in 1981) meant that graduates partied at hotels where there were tighter controls on bad behaviour.

To Hawchuk's explanations, I add one of my own. A problem faced by most cultural attractions, such as museums, is that they must continually provide something new to attract repeat business from the local community. Otherwise, once you have seen the exhibit— or taken the cruise—what attracts you for a second, third, or fourth visit? Hawchuk did offer cruises aimed at people with specific interests, such as foodies, dancers, history buffs, and music and sports fans, as a way of diversifying his passenger base. There were even cruises for artists and quilters. Yet, there is only so much repeat business available from the local community. I suspect that four cruise ships on the Red River, offering essentially the same service, led to market saturation that, along with the aforementioned problems, ultimately doomed all of them.

In February 2022, I struggled through waist-deep snow on the Selkirk Slough to have a close look at the two cruise ships still sitting there. The *Paddlewheel Princess*

is a burnt-out hulk that is only good for metal recycling. The *River Rouge* is covered in peeling paint, its windows covered in plywood. I think it would require a *lot* of work, and an inspection from the federal government, to confirm its seaworthiness. Yet, as long as they sit on the riverbank, abandoned though they are, these ships remind us of a heady period in the 1970s when taking in the scenery and historic views along the Red River was popular. I think we have seen the last of the Red River cruise ships.

Directions

Enter these coordinates into a GPS receiver or a map app on your smartphone.

Historic Site	Latitude	Longitude
Selkirk Slough (riverboat graveyard)	N50.15965	W96.86361
Redwood Docks	N49.91735	W97.12683
Alexander Docks	N49.89958	W97.13059
Lady Winnipeg	N50.18731	W96.83928

ACKNOWLEDGEMENTS

I encourage anyone wanting to know more of the history behind Red River cruise ships to pick up a copy of Steve Hawchuk's 2022 book *Welcome Aboard! My 44 Year Journey on the Red*. It provides a wealth of information plus many more photos than I can show here. I thank Bill Redekop for a useful conversation.

Winnipeg Canoe Club

If I said that I wanted to swim in Winnipeg, would you assume I was headed to someone's back yard or an indoor public pool? What if I told you that I was going to swim in the river? After all, Winnipeg has two of the largest rivers on the Prairies passing through it. Would you think I was crazy to swim in their muddy and possibly polluted water? Yet, people used to swim in the rivers all the time. Why is so little of our water-based recreation centred on them today? Therein lies a story of the rise and fall of the Winnipeg Canoe Club.

In February 1893, local businessmen George Harris, William Nicholls, and Llewelyn Nares met for lunch in a restaurant on Main Street. During the course of their conversation, they lamented the fact that Winnipeg, despite having the Assiniboine and Red rivers flowing through it, had no social club for recreational paddlers. The Winnipeg Rowing Club, founded in 1881, was intended mainly for competitive rowers. The men resolved to do something about it. In March 1893, they founded the Winnipeg Canoe Club with William Whyte (General Superintendent of the Canadian Pacific Railway) as Honorary President, Hugh John Macdonald (Member of Parliament and son of Sir John A. Macdonald) as President, lawyer Thomas Robinson as Vice-President, and George Harris as founding "Captain" (later retitled

"Commodore" and given overall responsibility as the chief executive officer).

The Club built its first clubhouse on the bank of the Red River near the Norwood Bridge. In 1910, they moved to new quarters on Jubilee Avenue opposite Elm Park, on a loop of the Red River where Kingston Row is now situated. The area was heavily wooded with residential development still years in the future. This second building was used for three years until a new, more substantial clubhouse was constructed at a cost of about $28,000 (around $720,000 in today's currency). It was situated on the east side of the Red River, a short distance south of the second site in what was then the Rural Municipality

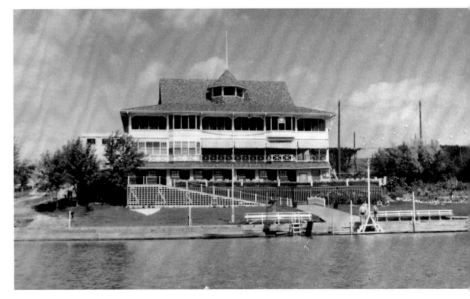

The third clubhouse of the Winnipeg Canoe Club, no date. ARCHIVES OF MANITOBA, WINNIPEG CANOE CLUB FONDS P73034/6, AM

OPPOSITE A few stubby wooden support posts from the docks at the Winnipeg Canoe Club were all that I could see when I visited the site in November 2016. GORDON GOLDSBOROUGH

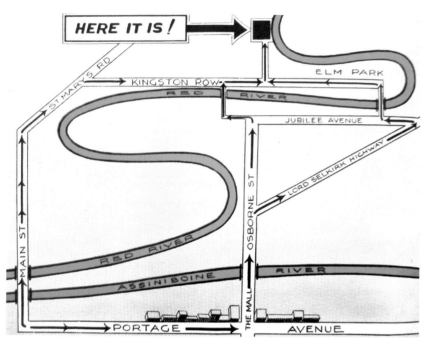

HERE IT IS!

KINGSTON ROW
ELM PARK
RED RIVER
JUBILEE AVENUE
ST MARYS RD
LORD SELKIRK HIGHWAY
RED RIVER
OSBORNE ST
MAIN ST
ASSINIBOINE RIVER
THE MALL
PORTAGE AVENUE

An early map showed several routes to the Winnipeg Canoe Club site. WINNIPEG CANOE CLUB FONDS, ARCHIVES OF MANITOBA

of St. Vital. The Club was becoming a more formal, professional entity. In 1914, it was incorporated formally by an Act of the provincial legislature. Advertising literature encouraged Winnipeggers to view the facilities for themselves. There were several routes to get there. Those coming from Main Street could cross the Red River to St. Mary's Road then turn off onto Kingston Row. People on the west side of the river could walk to the Club across a pontoon bridge located roughly where the St. Vital Bridge now stands, or drive across the newly built vehicle bridge off Jubilee Avenue to Elm Park, near the present-day Bridge Drive-In (BDI).

At first, the Canoe Club was oriented toward outdoor water sports during the summer, mostly recreational canoeing and rowing. Sometimes, canoes would be rigged with sails so members could sail up and down the river. As motorboats became more popular in the early twentieth century, members began storing their motors in the Club's boathouse. Members also enjoyed swimming and diving from the Club's dock. However, the Club was not the only place in or near Winnipeg where river swimming was enjoyed. People all along the Red, including students from the Manitoba Agricultural College (today's University of Manitoba), used it to escape the summer heat. Recreational swimming was also popular on the Assiniboine River. Around 1931, a sixteen-acre site west of Headingley was named Lido Plage by combining the Italian and French words for beach. By the time it closed, in 1953, Lido Plage included, in addition to a man-made sandy beach along a reach of the river, picnic tables, toilets, dressing rooms, eleven cabins, a dance hall, a dining hall, and a restaurant. After it closed, the land was subdivided and private residences were built there. All signs of Lido Plage, except the name of a road that passes by, have been obliterated and, today, one would be hard-pressed to know there had ever been a popular swimming resort there.

By the turn of the twentieth century, the recreational offerings at the Winnipeg Canoe Club began to diversify … and move inland. A nine-hole, par-68 golf course and tennis courts were added. Other outdoor sports hosted at the Club included football, rugby, archery, basketball,

When this photo was taken, sometime in the 1920s or early 1930s, students from the Manitoba Agricultural College (today, the University of Manitoba) were happy to swim in the adjacent Red River. A sign on the diving tower reads: "Notice: Anyone swimming or bathing here without permission will be prosecuted for trespassing. Man. Agric. College." UNIVERSITY OF MANITOBA ARCHIVES & SPECIAL COLLECTIONS

volleyball, and badminton. Initially, a maximum of 350 members was permitted. Many others were unable to become members, either because there was no room or because they were women. Women were permitted to use the golf course as of 1918 and they could also use tennis courts when they were opened in 1919. The Club's Paddling Section, formed in 1925, allowed women to participate in boating for the first time. By 1941, women were admitted as associate members having most, but not all, of the benefits of full membership. They were finally able to become full members in 1966, a mere seventy-three years after the Club was founded. The cap was eventually removed so that, by the mid-1930s, there were 950 members.

Winter use of the Club consisted mainly of snowshoeing and hockey on the frozen Red River. In 1933, several Club members made an expedition to the Pembina Valley near La Riviere that resulted in the establishment of the province's first downhill ski hill there. (I discussed the original La Riviere ski slopes, now abandoned, in *Abandoned Manitoba*.) The Club did not become a year-round operation until 1970–1971 when it constructed indoor courts for badminton, racquetball, and handball, and merged with the Winnipeg Badminton Club.

Disaster struck in March 1954 when the Club's third clubhouse was destroyed by fire. Its replacement opened officially in April 1955. The new two-storey structure

featured lounges, dining and sitting rooms, locker rooms, and a banquet hall. In 1963, the Club faced a crisis when plans were announced by the Metropolitan Corporation of Greater Winnipeg—which oversaw development in the municipalities comprising Manitoba's capital region—to build the St. Vital Bridge linking Osborne Street and Dunkirk Drive, taking much of the Club's golf course for its roadway and approaches. Some members argued the loss of the golf course would be a death blow, a strong indication of how critical its revenue had become to Club operations. A plan to relocate the Club to another site was rejected as prohibitively expensive. Instead, a reconfiguration of the golf fairways was found to be feasible and the Club survived at its existing site. In the aftermath of this crisis, a committee of members made recommendations on how to avoid a recurrence while boosting revenue. They proposed to build a larger boathouse. More significantly, the dining and lounge areas should be enlarged and fitted with air-conditioning to enable the Club to host larger social functions with greater comfort. A heated, outdoor swimming pool with enlarged locker rooms would entice more swimmers to become members. These recommendations were carried out in 1965. Two years later, the Club hosted the tennis events of the 1967 Pan American Games.

In a manner of speaking, members of the Winnipeg Canoe Club went from swimming in the Red River to swimming in red ink. Upgrades to Club amenities in the 1960s, intended to attract more members and external uses, incurred greater operating costs and, symbolically,

began to isolate Club members from the natural world that earlier generations had embraced. Although attempts were made in the late 1960s to revive the Club's moribund Paddling Section with a new, 200-foot-long floating dock and the purchase of new boats and canoes, attitudes about water contact were changing. In the past, Club members swam willingly in the Red River. Now, they wanted crystal-clear, disinfected, heated water in pools. The activities of the Club were increasingly oriented away from the river toward such terrestrial pursuits as golf, tennis, and saunas. By the early 1980s, there were other sports facilities around Winnipeg offering these services and more, often in free or low-cost public venues. Competition took its toll. In 1982, the Club was notified by the City of Winnipeg that it would have to pay significantly more property taxes on its golf course, situated on land leased from the City, and permit some use of the course by the general public. The Club failed to pay its property taxes in 1984. In November 1987, the Club was forced to close for a week because its bank refused to extend more credit. To address a debt of some $1.2 million, the Club carved off a portion of its riverfront property and developed a condominium complex on it. For reasons unknown, the Club realized much less profit from the project than had been predicted. The Club's difficult financial position and the need to attract new members was a recurring theme of the annual reports provided to Club members throughout the period.

The year 1993 was noteworthy in the Club's history, for two reasons. It celebrated its centenary but, more

negatively, its dire financial straits came to a head. The entire board of directors resigned and was replaced. The new board was unable to turn things around during their short time in office. The City of Winnipeg, which was owed $140,000 in back property taxes, seized the facility. In 1995, it turned over management to a consortium of German cultural organizations but, in the end, a City official stated publicly that the group "couldn't run the facility in a financially viable manner," having defaulted on thousands of dollars in property taxes. Although the club was closed permanently in May 2001, the dock and boathouse continued to be used by members of the Prairie Fire Rowing Club while the Dunkirk Tennis Club used the ten tennis courts without access to washrooms or locker rooms. Inside the clubhouse, four glass-backed squash courts, two racquetball and handball courts, five badminton courts, and banquet and restaurant facilities were dormant. In 2004, the Prairie Fire and Dunkirk clubs submitted proposals for continued use of the site in response to a request from the City but neither was accepted because they did not propose to use the entire six-acre property.

In 2006, a Saskatoon-based land developer offered to construct a residential complex for seniors on the site. Tennis fans were outraged because the proposal would destroy "world-class" facilities merely to build a parking lot. Despite their opposition, the graffiti-festooned clubhouse was demolished in mid-2006. Today, photos of the former Winnipeg Canoe Club clubhouses (along with one of the Winnipeg Rowing Club) are displayed inside the seniors' complex and there are at least two other remnants of the Club at the site. Most conspicuous is its nine-hole golf course, known today as the Canoe Club Golf Course. Owned by the City, it is managed by a private company. On the banks of the Red River, when the water level is low, rows of wood stubs poke out of the muddy riverbank, the remains of the piers for the Club's former grand dock. I think it is fitting that this vestige of the Winnipeg Canoe Club commemorates its original function, when Winnipeggers were eager to relax and recreate on the Red River.

Directions

Enter these coordinates into a GPS receiver or a map app on your smartphone.

Historic Site	Latitude	Longitude
Winnipeg Canoe Club Dock	N49.85137	W97.12728

ACKNOWLEDGEMENTS

I thank Michael and Sheila Paddon for inspiring me to learn about the old Winnipeg Canoe Club. I thank whichever member of the old Canoe Club saw fit to deposit its records at the Archives of Manitoba. They provided detailed, if sobering, information on the activities of the Club through the years that benefitted the writing of this story. I thank Wayne Chan for drawing my attention to the photo of student swimmers in the Red River.

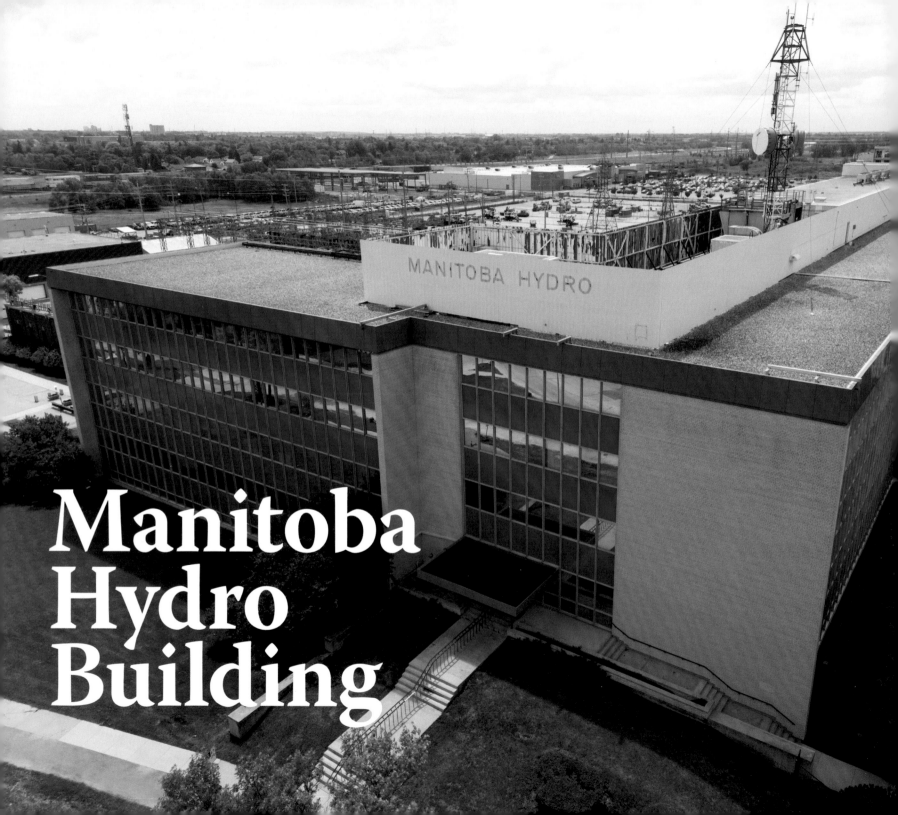

Manitoba Hydro Building

A bandonment is not necessarily a permanent condition. In some cases, an old building may be vacated and never occupied again, becoming decrepit with the passage of time, until eventually it falls of its own accord or someone helps it. But other structures may sit empty until some new use is found, or their owners lose hope and demolish them. One such "building in limbo" is the former Manitoba Hydro corporate headquarters at the corner of Harrow Street and Taylor Avenue in Winnipeg.

Before we can tackle this story, we should review the various players that have contributed to the history of Manitoba Hydro. We start in 1892 with the founding of the Winnipeg Electric Railway Company. It operated streetcars on rails that shuttled people around the city. The "railway" part of its name was dropped in 1924 and it became simply the Winnipeg Electric Company (WEC), providing streetcar, gas, and electrical service to Winnipeg and several outlying rural municipalities. In 1953, the WEC's assets were sold to the Manitoba Hydro-Electric Board (MHEB). The Board had been established by the provincial government in 1949 and was operated by civil servants until, in 1951, the first dedicated employees were hired. Its mandate was to coordinate the development and operation of all electrical generating stations in Manitoba, including those of the former WEC. The Board worked

OPPOSITE After Manitoba Hydro employees began moving into a new office tower in downtown Winnipeg in 2008, the former headquarters gradually emptied. GORDON GOLDSBOROUGH

Through the early to mid-20th century, transmission lines began spreading out across Manitoba, connecting towns, and later rural homes and farms, to a provincial power grid. This line west of Winnipeg, constructed by the Manitoba Power Commission around 1927, is one of the earliest still in service today. GORDON GOLDSBOROUGH

alongside the Manitoba Power Commission (MPC), which had been established in 1919 to "generate, purchase, transmit, and distribute" electricity throughout rural areas of Manitoba; essentially, it promoted rural electrification. If anyone thinks the MHEB and the MPC seem somewhat redundant in function, you have the same impression as me. I can understand why, in 1961, those two entities merged to form Manitoba Hydro although, today, the company is still named in official documents as the MHEB.

The building in question dates from 1957 but its site has a history rooted in hydroelectricity as far back as 1920. The City of Winnipeg was expanding, and newly built areas of the city needed electrical service. To meet the demand, the WEC constructed substations where high-voltage lines from its generating stations would come in and low-voltage power lines useful to consumers would go out. To my knowledge, there are twelve electrical substations still standing in or near Winnipeg. Eight of

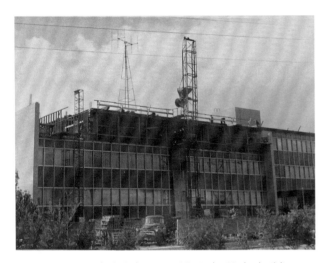

Between 1966 and 1967, the entire Manitoba Hydro building was raised to four floors, bringing it to its present configuration. MANITOBA HYDRO

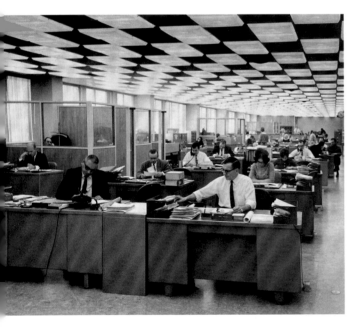

In the age before computers, every desk in the Manitoba Hydro headquarters was covered with papers, telephones were the primary means of communication, and white shirts and ties were the standard business attire. MANITOBA HYDRO

them were built by the WEC, and all are still in use, but only five as power conversion sites. One active substation, built in 1920, is located on Harrow Street, immediately south of our building in limbo. It does double duty as home to the Manitoba Electrical Museum. In 1931, a second power-related presence was established in the substation's vicinity, this time by the MPC.

Although the MPC's work was primarily in rural Manitoba, much of its workforce was based in Winnipeg. In 1931, the Commission bought land at the northwest corner of Harrow Street and Frederic Avenue (renamed Taylor in 1959), immediately north of the building in limbo, and there developed workshops and storage facilities. In 1946, after the Second World War had concluded and the Transcona Cordite Plant (which I described in *Abandoned Manitoba*),

located east of Winnipeg, was being decommissioned, a large metal building from the plant was moved to the MPC site. However, it was only there for six years and, in 1952, the MPC sold their land to the Winnipeg School Board for the construction of Harrow Elementary School, which still stands on the site.

By the late 1950s, the demand for electricity around Manitoba was so high that the MHEB offices in the old WEC building on Notre Dame were overcrowded. The Board hired the architectural firm of Moody and Moore to design a new office building. In 1958, engineers and administrative staff moved into the building, consisting of a two-storey part facing Harrow and a three-storey part along Taylor. When the MHEB merged with the MPC in 1961, more office space was needed. By early 1963, the office building had been extended westward along Taylor and the Commission's former headquarters on Portage Avenue were vacated. Finally, between 1966 and 1967, the entire building was

raised to four floors, bringing it to its present configuration. Originally, the main entrance had faced onto Harrow. In April 1963, it was moved to the north side facing Taylor, as it is today.

In 2003, Manitoba Hydro began investigating options for a new corporate headquarters that would consolidate the workforce from several of its offices around Winnipeg. It sought proposals for possible development sites and most of the ones it received were for sites in downtown Winnipeg. A site on the south side of Portage Avenue was ultimately chosen and a highly energy-efficient structure was constructed between 2005 and 2008. The first employees moved in December 2008 and, as the building filled over the next few years, the old headquarters on Taylor emptied gradually. My sources tell me that Manitoba Hydro has still not completely vacated the building; there is a small contingent of staff still working there, in some sort of backup control centre for the power distribution network that Hydro has not yet seen fit to move elsewhere. However, the building is presently on offer by a corporate real estate firm, at an unspecified price.

If we consider what happened to the former corporate offices of the companies that merged to become Manitoba Hydro, one might predict this building would become office space for the provincial government. I say this because the old WEC offices on Notre Dame are still occupied by government employees. The former MPC offices on Portage Avenue were used for several decades

Aerial view of the roads from the former "utility town" of Sundance, next to the Nelson River with Limestone Generating Station in the left background. GORDON GOLDSBOROUGH

by the Manitoba Motor Vehicle Branch before being sold to the Peguis First Nation. But some people predict that the old headquarters on Taylor will not survive. Two explanations are offered. One is that, in an age of corporate downsizing aided by the move to online work during the COVID-19 pandemic, there is little demand for an office building as large as this one. The other is that, being a product of the late 1950s and early 1960s, the building's mechanical systems, windows, and doors would need upgrading to meet modern efficiency standards. And who knows what nasty surprises, such as asbestos and other once-widely-used construction materials, might be concealed within its floors, walls, and ceilings? Costly

Sundance

The story of our modern hydroelectric power network began in southern Manitoba when the mighty Winnipeg River was harnessed but, as that river's potential was fully exploited by the mid-twentieth century, future development moved northward. Between 1960 and 1965, the Grand Rapids Generating Station was built on the Saskatchewan River and, moving over to the Nelson River, five more stations were constructed between 1958 and 1990. The fact that they were built in remote areas, far from established communities, meant there was a need to accommodate workers near the construction site.

For the first Manitoba Hydro mega-projects in the early 1960s, provisions for workers were rudimentary. The hours of work were long, the pay was low, and living conditions were primitive. The workers lived in tents or in poorly heated buildings with minimal privacy. When it came time to build the Kettle and Long Spruce stations, the technology of residential trailers and prefabricated homes was more well established. When Hydro began building its Henday Converter Station and Limestone Generating Station, it developed two sites to house the workers. For single people, there was a construction camp. Numerous long trailers were delivered to the site

Aerial view of Sundance at its height in 1987. MANITOBA HYDRO

and fastened together, end to end, with a central corridor with bedrooms on each side. There were communal bathrooms with central kitchens and recreation areas.

The other site was Sundance, intended for married couples, including families with children. In 1975, Hydro placed a $1.4 million order with a Winnipeg firm for fifty prefab houses to be put on foundations at Sundance. It was a fully equipped town and, between 1975 and 1976, it acquired a grocery store, liquor store, bank, post office, gas station, theatre, chapel, bowling alley, curling rink, recreation

centre, and hockey rink. Anyone needing a hospital or high school had to drive the 30 miles to Gillam. In the spring of 1976, the Frontier School Division advertised for five teachers to work at the six-classroom Sundance School, the enrollment of which was expected to be up to 125 children from kindergarten to grade 8. One might say there were plenty of "Sundance Kids" but, as far as I know, no Butch Cassidys. It was predicted that the resident population of the construction camp and Sundance would exceed 2,000 people, and Sundance alone had a population of more than 500.

The prediction went unfulfilled when Sundance's life was cut short. In 1978, Manitoba Hydro decided to postpone construction of the Limestone Generating Station and, as a result, there was no immediate need for Sundance. By 1984, its population had dwindled to fewer than 50 people. Then, in 1985, Limestone got the "green light," and Sundance boomed again. By the fall of 1986, there were 572 people (including 200 children) living there. Families rented three-bedroom homes from Hydro, heated by electricity (of course!), and served by running water and sewer. Residents added decks, gazebos, tool sheds, and other amenities. Roads were carved into the forest, with names like Beaver Avenue, Caribou Drive, and Tamarac Bay, and most houses were surrounded by mature spruce and birch trees.

Sundance was built in anticipation of further development downstream of Limestone on the lower Nelson River: Conawapa and Gillam Island generating stations. Perhaps, if they had gone ahead, Sundance might still exist today. However, those plans were shelved pending demand for the electricity they would produce. Trailers at the construction camp were removed and some ended up in southern Manitoba. (Coincidentally, I have lived in some of the Limestone construction trailers while teaching a class at a wildlife field

camp near Minnedosa.) The only thing left at the Limestone camp is the floor of its gymnasium and, as recently as a few years ago, the floor markings were still visible. (There is a photo of it on page 273 of *More Abandoned Manitoba*.) Sundance was removed gradually over a period of years in the mid- to late-1990s, and what items its residents did not move elsewhere were relocated to Gillam. The shopping centre became a church in Gillam. The water treatment plant was sold to the Town of Carman. The recreation centre was one of the last buildings to go, in the fall of 1999. The total cost to build and operate Sundance for about twenty years was estimated to be $20.3 million.

I visited Sundance in 2017 and found that most of its buildings were gone, although water and sewer lines were not removed at the request of a local Indigenous band that might use the site for its future growth. Sundance's former sewage lagoon is gradually turning into a natural wetland. Although the area was used a few years ago as an equipment staging area during construction of the Keewatinohk Converter Station, Sundance's roads are growing over with vegetation. At least for the time being, the sun has set on Sundance.

remediation may have to be done by whomever wants to occupy the building for the long term. In the meantime, I am told it is being used as a movie set, most recently in the 2021 Bob Odenkirk film *Nobody*. So, whether the building returns from limbo, or goes to demolition hell, remains to be seen.

DIRECTIONS

Enter these coordinates into a GPS receiver or a map app on your smartphone.

Historic Site	Latitude	Longitude
Winnipeg Electric Railway Building (213 Notre Dame Avenue, Winnipeg)	N49.89556	W97.14055
Manitoba Power Commission Building (1075 Portage Avenue, Winnipeg)	N49.88509	W97.17767
Manitoba Hydro Building (650 Harrow Street, Winnipeg)	N49.85663	W97.15545
Sundance Town Site	N56.53407	W94.07653

ACKNOWLEDGEMENTS

I thank Bruce Owen, a public relations officer at Manitoba Hydro, for gamely responding to my many obscure historical questions about the company's infrastructure, even if he could not always find an answer.

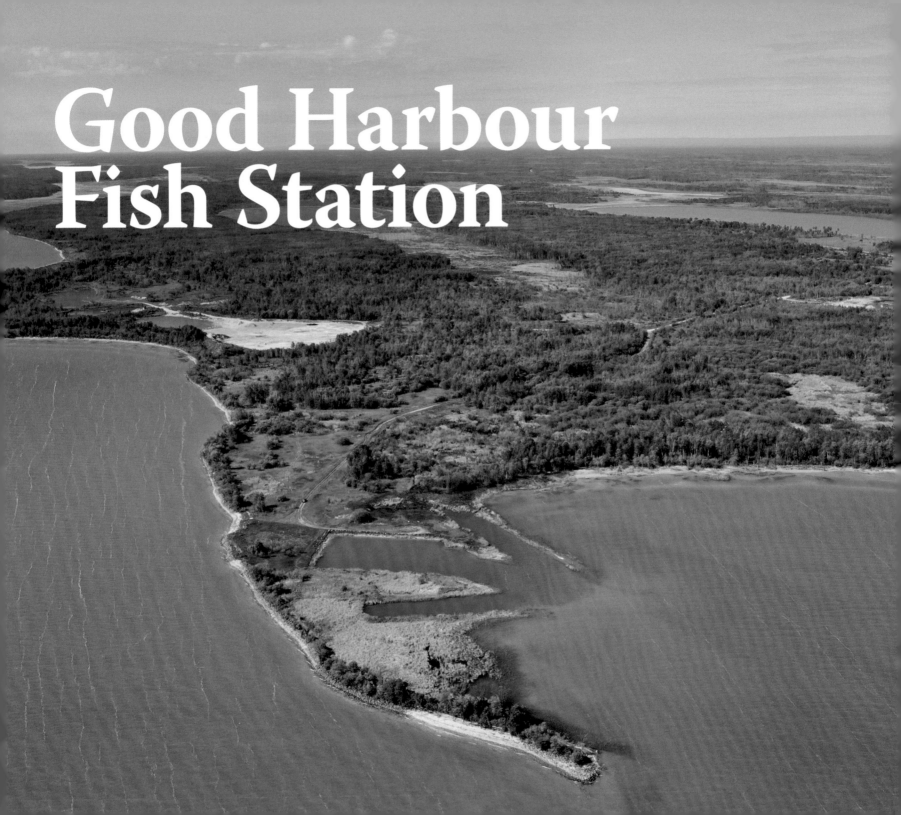

Good Harbour
Fish Station

The practice in Manitoba of catching fish for money—commercial fishing—goes back to a time when European fur traders purchased fish from Indigenous people. By the early 1800s, commercial fisheries were flourishing on lakes throughout the future province, especially on the three largest ones: Winnipeg, Winnipegosis, and Manitoba. Most fishing was done using nets that were set out in the lake, left for a period of a day or less, then retrieved. Traditionally, fishers used sailboats to deploy their nets far offshore but, starting in the 1920s, motors started to replace sails. In the winter, they used horse-drawn sleighs (or sometimes dog teams), later replaced by tracked bombardiers and snowmobiles to get to the fishing grounds. Nets were deployed through holes cut in the ice, using an ingenious rig to pull a folded net under the ice and extend it toward a second hole.

The daily routine of a fisher consisted of setting and retrieving nets then dressing the catch. Dressing meant removing the internal organs (or "guts") and, sometimes, cutting off the head. Unless the fish were dressed on the lake, as might happen during the winter, they were returned to shore in fifty-pound wooden boxes (later, plastic tubs) to be processed at a fish station. From there, the dressed fish were packed on ice or frozen for delivery to

An aerial view, looking southwest, of the former Good Harbour Fish Station surrounded by the windswept waters of Lake Winnipegosis. Dredged channels and an overgrown access road are the only clearly visible signs that the station operated there for thirty-four years. GORDON GOLDSBOROUGH

market by boat, wagon, truck, or train, depending on the station. Fish stations—physical structures with equipment and supplies for dressing, along with accommodation for fishers—were established around the lakes, usually at spots that had good natural harbours and access to transportation networks. On Lake Winnipegosis, there were at least twenty-two fish stations at one time, with the largest concentration near a railhead in the town of Winnipegosis. The subject of this story, the Good Harbour Fish Station, sat on the west shore of the lake, about thirty-five miles as the crow flies northwest of Winnipegosis. Duck Bay, an Indigenous fishing village, is about three miles to the north. Good Harbour was established in July 1962 through the amalgamation of two independent fishing groups comprising seventeen fishers from South Spruce Island and Camperville. They built a state-of-the-art fish-processing plant operated by a company called the Winnipegosis Co-operative Fisheries Limited.

Good Harbour was well named. Its west-facing harbour, augmented by dredged channels, protected fishing boats and gear from harsh winds sweeping off the lake. Wooden docks where boats could moor were built around a main channel, with an electric conveyor to move fish tubs into a 5,000-square-foot metal building with a concrete floor where dressing was done. Next to this building was an icehouse (ice was made by machine or cut from the lake in winter) and a hopper for collecting fish guts. Nearby were reels on which wet nets were draped to dry. Along a road leading away from the fish plant was a

row of small bunkhouses where hired workers lived, and larger bungalows for licensed fishers and their families. Two large tanks stored fuel for boats, trucks, and bombardiers, and the facility was rounded out by a grocery store, a small office building for conservation officers, and, far enough away to dispel the stench, a pile for discarded guts.

I learned about the daily routine at Good Harbour from Shelley Matkowski, who lived there with her family from 1965 into the early 1980s. Her father was one of the licensed fishers at the station and her mother worked hard to keep the fishers fed and clothed. Matkowski recalls there were as many as 40 to 50 people living there during the fishing seasons. Fishers came from diverse backgrounds. Shelley's family was ethnically Ukrainian and other fishers included Swedes, Icelanders, Metis, Cree, and Saulteaux men. Each day from the third week of July to the third week of September (the summer fishing season), at least eight boats, each with a licensed fisher and two or three hired men, would leave the harbour before dawn. Arriving at the site of their nets, marked by buoys, they pulled in the nets and removed the fish, then set the nets again. They returned with the catch by mid-morning and spent the rest of the day dressing and packing fish, drying and mending torn nets, and preparing to repeat the whole process the next day. Conservation officers on the lake checked that they were using appropriate nets to catch no more fish than their quotas permitted. In the fish-processing plant was a manager and at least four workers who weighed and readied the fish for shipment. Daily, a truck and semi-trailer picked up boxes of iced fish for delivery to Winnipeg.

The Good Harbour Fish Station closed in 1996, after thirty-four years in operation and, today, only a few vestiges remain. Around Lake Winnipegosis, there are few other fish stations in operation and many fewer people are engaged as commercial fishers. What happened? In a word, overfishing. Between 1946 and 1964, around five hundred commercial fishers on Lake Winnipegosis were catching a variety of species, including whitefish, tullibee, mullet (aka suckers), sauger, pike, and perch. Their most lucrative catch was known by scientists as *Sander vitreus* but called either pickerel or walleye by fishers (or "yellows" by fishers on Lake Winnipegosis). Each year, the fishers removed an average of one million—sometime over two million—pounds of pickerel from Lake Winnipegosis. Starting in 1964, however, the annual pickerel catch began to decline, to about one-quarter million pounds by the late 1960s, and only 100,000 pounds by the early 1970s, roughly one-tenth of the traditional catch. What is also noteworthy is that the smaller catch was caught by fewer fishers, barely three hundred of them over the whole lake by the 1970s (see Figure 4). In 1975, a provincial task force was formed to examine the basis for the decline and to recommend methods for restoring it.

A key factor determining the number of fish that are caught, besides the number of fishers, is the size of the mesh in the nets being used. A three-inch mesh is one that, when you stretch it out, measures three inches between successive holes in the mesh. (Cotton nets stretch more

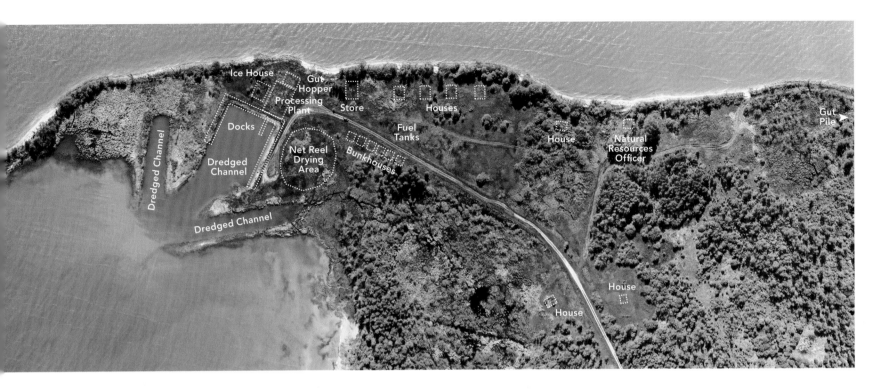

Labels on image: Ice House, Gut Hopper, Processing Plant, Store, Houses, Docks, Dredged Channel, Net Reel Drying Area, Bunkhouses, Fuel Tanks, House, Natural Resources Officer, Gut Pile, Dredged Channel, Dredged Channel, House, House

A site map of the Good Harbour Fish Station as it appeared in the 1970s. North is to the left. GORDON GOLDSBOROUGH, BASED ON INFORMATION PROVIDED BY SHELLEY MATKOWSKI

than nylon ones so the mesh material is also a determinant of catch potential.) The smaller the mesh size, the smaller the fish that it will catch, and vice versa. Smaller fish generally means younger fish; thus, small-mesh nets catch young fish and large-mesh nets catch older ones. Nets smaller than three inches are rarely used because they catch too many young fish on which the long-term sustainability of the fishery depends. Today, fishers on Lake Manitoba use nets with a minimum mesh size of 3¾ inches while those on Lake Winnipegosis use four-inch nets. Mesh sizes on Lake Winnipeg vary geographically, from 3¾ inches up to a maximum of 5¼ inches.

In early 1976, the Lake Winnipegosis Task Force published a list of twenty-seven recommendations for restoring the fishery. Among them was a recommendation to close the summer fishery for three years, starting in 1977, to allow the fish stocks to be replenished naturally. Fishers would be offered alternative fishing opportunities, compensation, and other job income. In the fall of 1976, public meetings were held at Dauphin and Camperville to gauge receptiveness of commercial fishers to the recommendations. Although the fishers were strongly supportive of restoring the fishery, a secret ballot held at Dauphin on the recommendation to close the fishery was resoundingly defeated, with 31 of 32 ballots opposed to

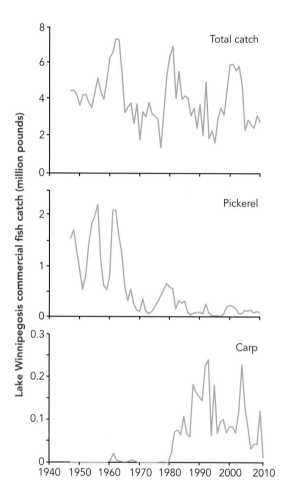

y-axis label: Lake Winnipegosis commercial fish catch (million pounds)

Total catch

Pickerel

Carp

FIGURE 4 Data on the commercial fishery for Lake Winnipegosis, between 1947 and 2010, gleaned from annual reports of the provincial government's Fisheries Branch, show that the total catch (in pounds x 100) has varied considerably over time, having peaks in the early 1960s (when Good Harbour was established), early 1980s, and early 2000s, and valleys at other times. What the total catch data do not reveal is a profound change in the composition of the catch. Pickerel (walleye) were a major part of the catch in the 1950s and early 1960s, but their numbers plummeted in the late 1960s and have remained low ever since. Conversely, the catch of less desirable fish such as carp jumped dramatically in the 1980s. LEGISLATIVE LIBRARY OF MANITOBA, GRAPHS BY GORDON GOLDSBOROUGH

the measure. One fisher went so far as to suggest that fishers should take over management of the fishery from the provincial government, stating that "it is too big a gamble to have some civil servant practice with our lives". The vote was not binding on the government and, ultimately, the Minister of Renewable Resources decided to raise the mesh size allowed on the lake, from 4 to 4¼ inches, thereby allowing more small fish to reach maturity. However, this change would force fishers to purchase new nets, so it was highly unpopular. They would incur costs to catch fewer fish.

In 1986, Lake Winnipegosis fishers agreed to a summer fishery closure for three years, running to 1988. During that three-year period, stocking programs put about two million pickerel fingerlings into

the lake and the government bought back fishing licences from some fishers, reducing their number from 48 to 28, thereby cutting by roughly half how much fish could be taken from the lake. Fishing resumed in the late 1980s and, through the early 1990s, many fish were caught, suggesting the closure had been successful. The government monitored the age of fish being caught during this time, finding that most were three years old.

Ultimately, the Good Harbour Fish Station was doomed by a general decline in the Lake Winnipegosis fishery and the number of fishers involved in it. But there was an additional reason. A final blow, so to speak, came in August 1996 when the facility was badly damaged by a tornado. Fishing boats were hurled through the air and the fish-processing plant was

"almost a complete wipeout". The damage was estimated at about $450,000. It was simply too expensive to repair the station given the diminishing returns. The equipment owned by the co-operative was sold by tender in 1998. Although some of the fishers from Good Harbour moved elsewhere to fish, many of them simply left the industry by the time of the closure and found employment in some other way. In a sense, the closure of Good Harbour was good for the fishery on Lake Winnipegosis because, with fewer fishers operating, there was less pressure on the remaining fish stocks.

The buildings at Good Harbour were removed so efficiently that, when I visited the site in mid-2019, I found no sign that the steel and tin processing building and its concrete floor had ever been there. The wooden docks had been removed from the dredged harbour, and I saw only the concrete foundations for a few buildings and some assorted garbage. The road into the site was barely passable except by four-wheel-drive vehicle.

This story resonates beyond the shores of Lake Winnipegosis. Over the past two decades, numerous fish stations around Manitoba's three large lakes have closed. The commercial fishery is still active but there are fewer people involved in it. One older fisher told me years ago that few young people want to go into commercial fishing because it is hard work for an uncertain economic return. Commercial fishers continue to fight with the provincial government over fishing quotas and mesh sizes. During the past decade, some people have raised concerns that the present levels of fishing are unsustainable, despite recent record catches of fish from Lake Winnipeg. The provincial government is presently buying back quotas and licences from Lake Winnipegosis fishers to reduce fishing pressure. Meanwhile, fish buyers are increasingly interested in dealing with "eco-certified fisheries" that have been shown to be sustainable with fishers catching only as many fish as the populations can bear without decline. To educate consumers, fish from eco-certified lakes can bear a product label in stores. In 2014, Manitoba's Waterhen Lake became the first freshwater fishery in North America to be eco-certified and Cedar Lake followed suit in 2022. Will the Lake Winnipegosis fishery be next?

Directions

Enter these coordinates into a GPS receiver or a map app on your smartphone.

Historic Site	Latitude	Longitude
Good Harbour Fish Station	N52.13063	W100.14934

ACKNOWLEDGEMENTS

I would never have known about the Good Harbour Fish Station had it not been for my friend Shelley Matkowski, whose family lived there seasonally from the 1960s to 1980s, and who read an early version of this chapter to correct my misunderstandings of commercial fishing. I would not have known about "yellows" without Shelley's advice. The resources of the Legislative Library of Manitoba were crucial for providing the data on Lake Winnipegosis fisheries on which this story rests.

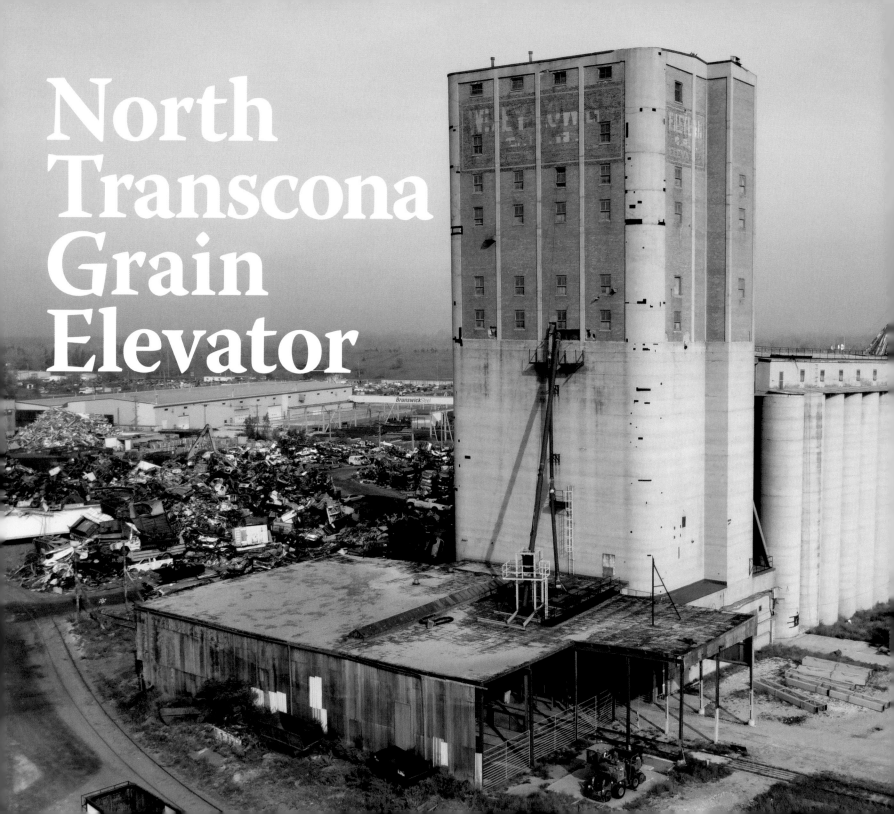

North Transcona Grain Elevator

Winnipeg was (and is) the central hub of the Canadian Pacific Railway (CPR), receiving trains destined for all parts of the country. Through the early twentieth century, the traffic was only expected to grow as people flooded into the prairies and much of the land was carved into agricultural fields. To handle the anticipated growth in its business, the CPR decided in 1912 to build a bypass around Winnipeg, the Bergen Cutoff, and a vast railway yard on the northeast side of the city. Built at a cost of $4 million ($790 million in today's money), the North Transcona Yard was thought to be the largest of its kind in North America. It featured 105 miles of track, with room for over 12,000 cars, and a 106-foot turntable (for turning locomotives) that was the largest on the continent. On the edge of the massive railway yard was an equally massive "transfer elevator", capable of holding one million bushels of grain. To put in perspective the enormous size of this elevator, the average "country elevator" at the time was 31,000 bushels, about 3% the size of the one in North Transcona.

The vast majority of the hundreds of grain elevators that once stood in Manitoba were country elevators; they were the initial receptacles for grain delivered by farmers. Country elevators would load the grain into railway boxcars and, in some cases, those boxcars would be delivered to transfer elevators at key spots in the railway network, such as in the North Transcona Yard. The function of a transfer elevator was to receive grain that had been officially inspected and weighed at a country elevator and then to clean, store, and treat the grain before shipping it on to terminal elevators at places like Thunder Bay and Vancouver.

The transfer elevator in North Transcona had three main parts. On its south side was a large, open shed with railway tracks leading into it where boxcars of grain to be transferred into the elevator, or boxcars to be filled, were moved in and out. Next to the track shed was a tall concrete and brick workhouse, like a skyscraper for grain, that housed the machinery for moving and processing the grain. Finally, on the north side were sixty-five cylindrical, reinforced-concrete bins (in five rows of thirteen; referred to as the binhouse) where the grain was stored, with conveyor belts at the bottom and in a cupola at the top for moving grain in and out.

The North Transcona grain elevator, which stands abandoned today, remains an important lesson in the training of geotechnical engineers. As a result of what happened to the elevator within a year of its construction, the building illustrates the necessity of a properly designed foundation for industrial buildings. Today, when a large building is constructed, a common first step is to drive piles down to bedrock as a solid, unmovable

OPPOSITE This aerial view of the North Transcona elevator shows the neighbouring metal recycling business, the track shed in the foreground where railway cars were loaded and unloaded, the concrete and brick workhouse behind it, and the concrete storage bins at the back. When built in 1912, the tops of the bins were level with the concrete part of the workhouse, an indication of how much they sank in the ground before being put upright.
GORDON GOLDSBOROUGH

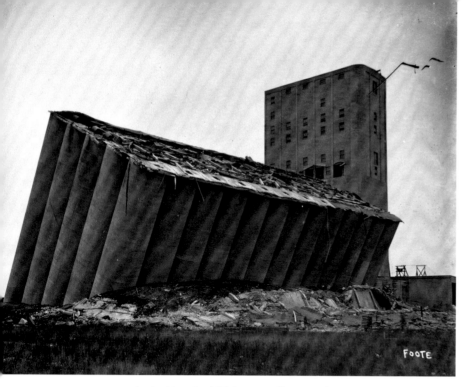

As the bins tilted 27 degrees off centre, the cupola on top of them slid off and crashed to the ground, on top of the mound of soil that had been pushed up as the bins sank into the ground. ARCHIVES OF MANITOBA, L. B. FOOTE COLLECTION #1802

foundation for the building. But this huge transfer elevator had no such piles; it was merely sitting on the surface of the ground. The design engineers had tested the soil and found it capable of supporting twice as much weight as the new elevator would have when fully loaded with grain. They had assumed the clay deep in the ground had the same strength as the "blue gumbo" clay near the surface. This turned out not to be the case. Decades later, in 1951, two deep bore holes drilled around the elevator by geotechnical engineers revealed that strong clay near the surface was underlain by much weaker clay at a depth of about twenty-five feet. As a result, on 18 October 1913, as the binhouse was being filled, the downward force caused the soil to shift in a way that, today, is entirely understandable and preventable. First, the binhouse settled uniformly by about a foot, pushing soil around the elevator upward to a height as much as five feet. Then, the binhouse began to tilt. By the time that it had stopped moving, twenty-four hours later, it was off vertical by almost 27 degrees. Its western side had sunk an incredible 43 feet into the ground. The only reason it did not topple over completely is that the sinking was stopped by a layer of glacial till in the ground. Clearly, the foundation was inadequately designed for the weight of the elevator and its grain.

The process of putting the bins upright was an entirely manual one, with hordes of workmen, huge wooden timbers, and jacks. Note the holes above the wooden beams where grain was removed from the bins. KEN SKAFTFELD

While the bins were moving, there was nothing to be done. When they stopped, the first task was to remove the grain inside them. Workers bored holes into the concrete walls so they could pump out the grain. A company from Montreal that specialized in foundation work was hired to advise the CPR what could be done. They dug underneath the tilted bins and installed jacks, with enormous wooden beams on the west side of the bins. By lifting the jacks slowly and moving the beams ahead as they went, the bins were tilted slowly back until they were vertical, although they were twenty feet deeper in the ground than they had been before the accident. Concrete piles were then installed to prevent a recurrence. The elevator was back in operation by mid-October 1914. Yet, the holes in the bins, now plugged with concrete, are still clearly visible on the west side.

Although the elevator was owned by the CPR, it was leased to grain companies through the

In the cupola above the bins, a conveyor belt similar to the one at the bottom delivers grain into numbered chutes leading to the bins. GORDON GOLDSBOROUGH

Circular holes drilled in the west side of the bins to remove grain from them following the disastrous collapse in 1913 are still readily visible today, although they were closed with concrete. GORDON GOLDSBOROUGH

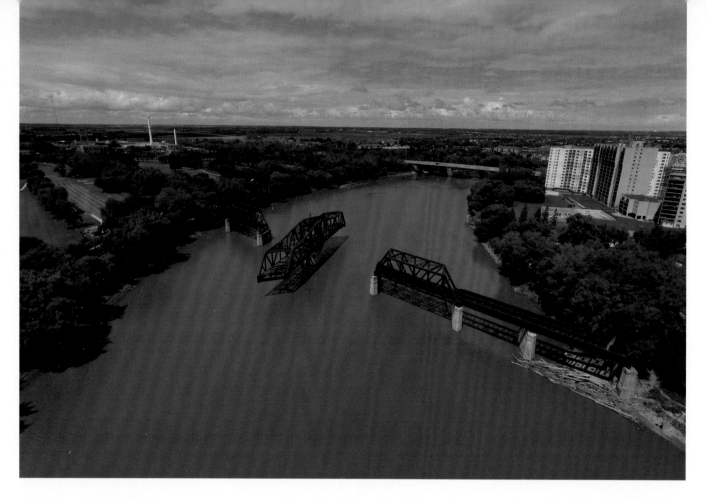

Bergen Cutoff Bridge

I cannot count how many hours I have spent in my car at railway crossings in Winnipeg, waiting for a train to pass, grumbling under my breath about this delay in my busy schedule. Yet, things might have been very different today if the Bergen Cutoff was still in operation.

The Bergen Cutoff is a thirteen-mile-long double railway track of the Canadian Pacific Railway that ran from a station east of Winnipeg, north of the city, and rejoined the main line at a small station called Bergen less than a mile from the present-day headquarters of the Prairie Dog Central Railway. It enabled through-traffic to bypass the city and avoid congestion in the main Winnipeg yard by shunting it through the newly built North Transcona Yard.

In January 1913, the railway began to build a 930-foot steel truss bridge over the Red River. Because there were numerous large ships operating on the river, the new bridge contained a "swing span" to enable ships to pass underneath. Raised, graded approaches extending a quarter mile on each side of the river allowed the railway to cross over Main Street on the west and Henderson Highway on the east without impeding traffic. Underpasses for cars and trucks were constructed at each place.

The first train crossing of the new bridge occurred in May 1914, coinciding with the opening of the North Transcona Yard. Yet, the railway did not use the Bergen Cutoff to the extent that its massive expenditure should have meant. After the Bergen Cutoff was closed in 1943, the rails and ties on the bridge were removed so only the roadbed remained. The swing span was locked in the open position to permit ships to pass, although few if any ships today are large enough to require it. (See the chapter on Red River Cruise Ships.)

Through the years, alternative uses for the abandoned bridge have been proposed. The city government suggested using it as an automobile bridge over the Red River but, by 1955, had dropped the idea in favour of the present bridge on the Chief Peguis Trail to the north. In 1987, a local restaurateur in partnership with a landscape architect proposed a housing development on the east side of the river that entailed converting the bridge into a restaurant and pedestrian corridor. They acquired twenty-two acres of land from the CPR, but the plan was withdrawn within a year when they yielded to public pressure to leave the area undeveloped. Ultimately, the land was sold to the city. The raised approach on the east side is now a peaceful walking trail affording a good view of the abandoned bridge.

Yet, an interesting implication is that, over a century ago, the CPR realized how congested its lines through Winnipeg were becoming and took action to reduce it. Inexplicably, the railway abandoned its Bergen Cutoff bridge in 1943. We are still paying—in our time as well as our tax dollars—for the impact of railways on street traffic. In the past two decades, the City of Winnipeg has spent millions to build two railway underpasses in south Winnipeg. Eventually, it hopes to replace the Arlington Bridge over the main CPR yard in downtown Winnipeg. Would these expensive works be needed if the Bergen Cutoff was still functional?

years. Judging from the conspicuous "ghost sign" on the workhouse, one of those firms was Wiley Lowe and Company. Then, from the 1940s to at least 1965, the elevator was operated by the Eastern Terminal Elevator Company, a subsidiary of the James Richardson and Sons grain firm, and used during the Second World War to store grain that could not be shipped overseas. The elevator was vacant in the late 1960s until being bought in 1970 by the grain company Parrish & Heimbecker (P&H). They installed a modern driveshed, weigh scale, and leg on the north side of the bins to turn the facility into a country elevator where farmers could deliver their grain. In speaking with Bill Parrish Sr, who spearheaded the elevator's purchase on behalf of his company, I realized that he should be recognized as a pioneer of concrete grain elevators in Canada. Today, they are common and, in fact, the norm in the industry. The first purpose-built country elevator made of concrete was built in Swan River, in 1961, but its 146,000-bushel

This aerial view from 2015 shows that the North Transcona Yard is still in use for storage of railway cars but not nearly to the degree that was envisioned a century ago. The one-million bushel grain elevator is visible at the left. GORDON GOLDSBOROUGH

A map of the North Transcona elevator was used to track what was stored in each of its massive bins. By 2017, when I took this photo, several of the bins were marked as being inoperable. Bin #130, for example, was labeled "Bin Dead. Merry X-mas". GORDON GOLDSBOROUGH

capacity was a mere 15% of that in North Transcona. P&H continued to operate the huge elevator until closing it in late 2021.

I suspect that a combination of factors led to the closure. The company had recently built a new concrete elevator a few miles away, closer to farmers, so the need for one in Winnipeg was not so great. The North Transcona elevator was limited in the space it had for railway cars—called the "spot" by railways—compared to modern elevators that have room for over 130 hopper cars. It had limited dust control so indoor air quality was terrible for the people working there, something to which I can attest personally. I toured the elevator in 2017, including in the very dusty cupola above the binhouse, and I took so much dust into my lungs that I coughed for a couple of days afterward. Finally, the elevator is over a century old and would need significant repairs to be fully functional. When I visited, I noticed on a map on an office wall that labeled several of its bins as being no

A conveyor belt below the bins collects grain either for removal from the elevator or for transfer into other bins. The absence of a dust-control system inside the elevator is evident from the heavy coatings of dust over everything. GORDON GOLDSBOROUGH

longer operable, due to either water flooding or significant mechanical or structural problems.

When the elevator was closed, its office—a separate building that stood near the driveshed—was removed and the federal government licence to operate the elevator was withdrawn. The elevator and its surrounding land were sold to the neighbouring metal recycler, which probably wants it as a place to store more derelict vehicles awaiting the shredder. Given the amount of reinforced concrete throughout the facility, it would be a substantial and costly demolition job. Consequently, I predict the North Transcona elevator will be standing, as a reminder of the early history of grain storage on the prairies, with a solid foundation, and a lesson to geotechnical engineers, for years to come.

Directions

Enter these coordinates into a GPS receiver or a map app on your smartphone.

Historic Site	Latitude	Longitude
North Transcona Grain Elevator	N49.92685	W97.01516
Bergen Cutoff Bridge	N49.94687	W97.09807

ACKNOWLEDGEMENTS

I am grateful to Bill Parrish Sr., retired CEO of Parrish & Heimbecker, for enjoyable conversations on the history of the grain industry, and specifically his advocacy for concrete elevators. I thank geotechnical engineer Ken Skaftfeld for arranging a tour inside the North Transcona elevator in 2017 and for sharing a collection of historical photos taken as its bins were being put upright in 1913.

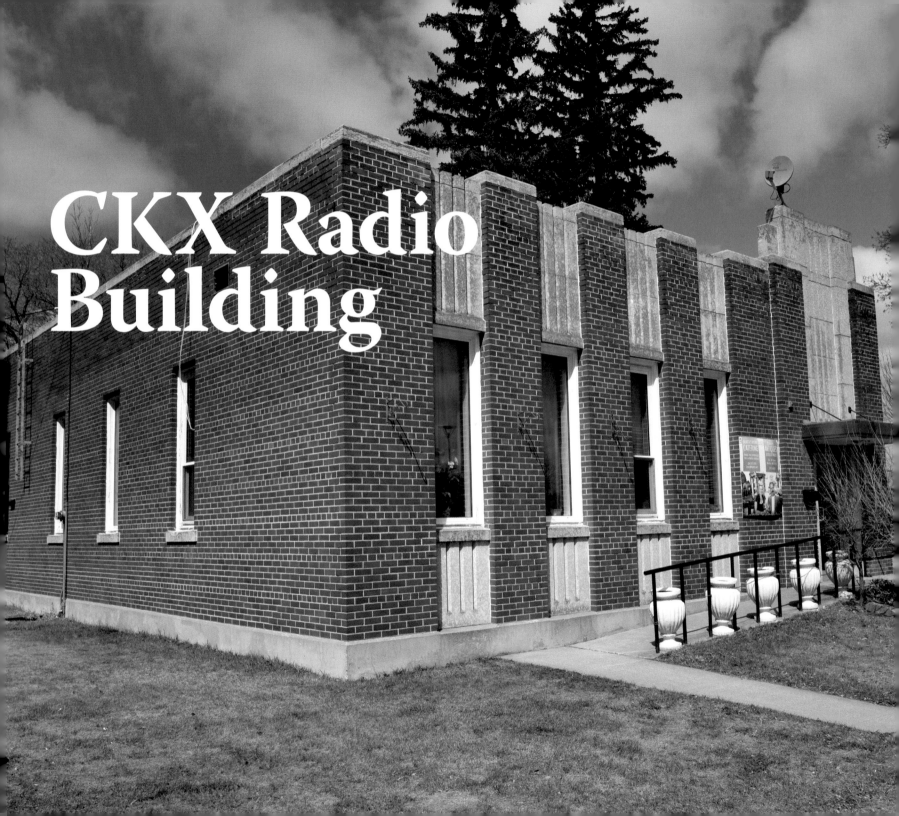

CKX Radio Building

I lived in Brandon for over six years. Yet, I was unaware that a small building in a park on Eighth Street was once at the forefront of public radio broadcasting in Manitoba. For sixteen years in the 1940s and 1950s (before I was born, so my ignorance can be excused), it housed radio station CKX, a sister to station CKY in Winnipeg. CKY had been established in 1923 by Manitoba Government Telephones, a company purchased by the provincial government in 1907 to promote the development of telephone service throughout Manitoba and renamed Manitoba Telephone System around 1921. CKY holds the distinction of being Canada's first publicly owned radio station. Five years later, in 1928, CKX at Brandon began operating. At first, CKX was based in a building on the grounds of the Brandon

City Hall alongside a tall metal tower from which the radio signal was broadcast to the surrounding area.

CKX was on the air only for a few hours each evening, mostly re-broadcasting the programming developed at the larger CKY studios on Sherbrook Street in Winnipeg. But it also had locally produced content. In its first year of operation, 1929, CKX broadcast such things as the inauguration ceremony for a new president of Brandon College, Sunday church services, speeches at the annual convention of the United Farmers of Manitoba (an agrarian political party), a talk by the superintendent of the Brandon Experimental Farm, and musical performances by the Salvation Army band and a vocal group called the CKX Quartette. CKX was an immediate hit, proving so popular that, in 1936, its transmission tower was upgraded from 100 watts to 1,000 watts to permit the radio signal to travel farther, with the station moving to all-day programming. By 1938, the building was facing a

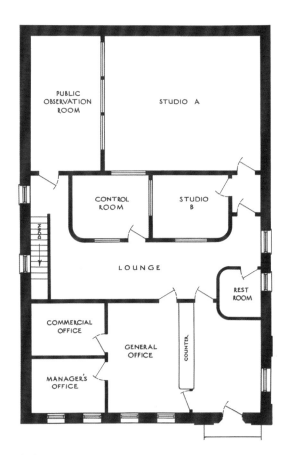

The building's original layout included an office for the station manager, salesman for commercials, and clerical staff; a lounge for staff and guests; a control room; two studios; and a room for audiences. A library of musical recordings on disc was in the basement. *MANITOBA CALLING, MARCH 1942, PAGE 17*

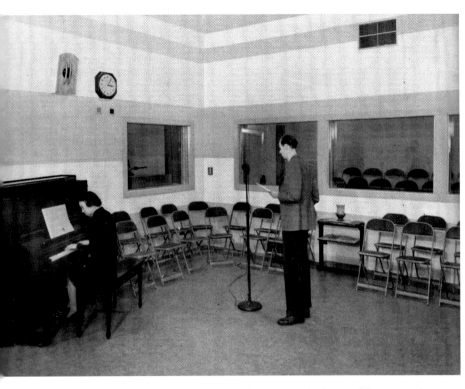

A view of a musical performance in the larger of the two studios in the CKX Radio Building, circa 1942. The control room can be seen in the smaller window at left and the chairs for the audience in the windows at right. *MANITOBA CALLING*, FEBRUARY 1942, PAGE 4.

severe space crunch so the provincial government's radio commissioner, John Lowry, approached the Brandon city council about enlarging it.

Unfortunately, the city council was not receptive. Although the councillors were supportive of the radio station generally, they did not want a radio station on the grounds of the City Hall. They offered CKX some city-owned space across the street. Lowry responded that

if the station had to relocate, its preferred space would be upper floors at the nearby Prince Edward Hotel. The council responded that if CKX enlarged its building, it would have to be capable of moving the structure off the City Hall grounds, if required. Negotiations between the City of Brandon and the provincial government dragged into 1941 when an agreement was finally reached to lease the original studio site to MTS for ninety-nine years at $1 per year, and to construct a new building to replace the original one. The job of designing the new studio was given to an architect named Gilbert Parfitt.

Parfitt had impeccable credentials. Among his architectural works in Winnipeg still standing today are the St. John's Anglican Cathedral and, at the Fort Garry campus of the University of Manitoba, the Tier (Arts) and Buller (Science) buildings. From 1924 to his retirement in 1957, he served as the Province of Manitoba's in-house architect. It was in this capacity that he designed the building for the government-owned radio station.

He designed a 2,400-square-foot, one-storey brick building with a full concrete basement. The exterior is mostly nondescript except for the side facing Eighth Street that is an attractive Art Deco mixture of red bricks and cream-coloured Tyndall stone. As one entered the building from the street, there was a general office. An inner door led into an "artists' lounge" where the on-air personalities and their guests could relax between shows. Doors from the lounge went to a control room for technicians who monitored two studios. A larger "Studio A" was

for groups of performers or perhaps a small orchestra. It had an adjoining "public observation room" with seats for up to forty spectators. A smaller "Studio B" had space for one or two people for interviews and news. In the basement was storage space, mechanical equipment including air conditioning (to keep the facility cool from the heat generated by the electronic equipment), and a record library. Steam heat was provided from the boilers in the adjacent City Hall building.

Initially, CKY and CKX enjoyed a monopoly on Manitoba's airwaves. Any new station would have to be approved by the provincial government which it was unlikely to do given that it would compete with its own stations. However, Manitoba businessmen found creative ways around the monopoly. In 1928, grain merchant James Richardson established radio station CJRW with a transmitter at Fleming, Saskatchewan, just three miles from the western Manitoba border. In 1933, Richardson was given permission to

move his station to Winnipeg where the station's call letters were later changed to CKRC.

On the evening of 11 December 1947, Manitoba Premier Stuart Garson broadcast an announcement on CKY and CKX that the two government-owned stations would soon be closed and their assets sold. The move was in response to new federal legislation that prevented

agencies of provincial governments from holding broadcast licences. A federal entity founded in 1936, the Canadian Broadcasting Corporation, was constructing a new 50,000-watt transmitter at Carman, Manitoba (a photo is on page 72) and it was keenly interested in acquiring CKY. The station was duly renamed CBW and the call letters CKY would later be recycled by a private station. In

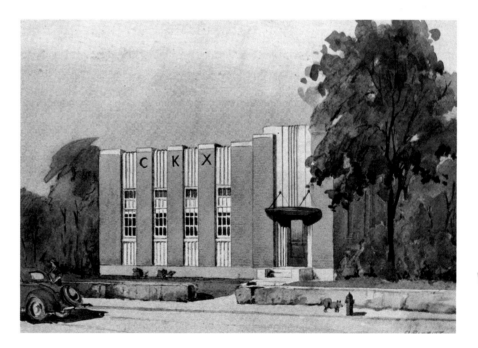

The Art Deco building for CKX Radio as envisioned by architect Gilbert Parfitt, 1941. *MANITOBA CALLING*, AUGUST 1941, FRONT COVER

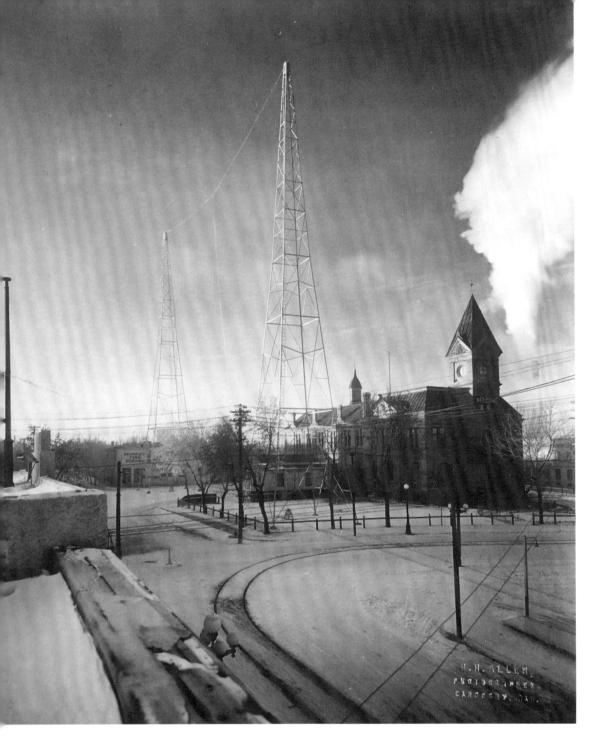

For all its early history, the CKX radio station was hosted on the grounds of the Brandon City Hall, seen here in 1929 before the construction of the present building. A horizontal antenna between two towers helped to distribute the radio signal to listeners in outlying areas.
ARCHIVES OF MANITOBA, MANITOBA TELEPHONE SYSTEM COLLECTION #2

Brandon, the Western Manitoba Broadcasters Limited, a consortium of businessmen led by former CKX employee John Craig, bought the station and the Craig family name would in time become synonymous with radio and television broadcasting across western Canada. CKX continued to broadcast out of the little building on Eighth Street until 1957, when it moved to more spacious new studios on Victoria Avenue. CKX would operate there, as an affiliate of the CBC under various ownerships, until closing in 2009.

Meanwhile, the former CKX building on Eighth Street, owned by the City of Brandon, was occupied

by its public health department until 1971 when the City Hall building was demolished. The building sat vacant until 1975 when a new heating plant was installed to replace the steam no longer available from City Hall. The interior was renovated to be occupied by several social agencies. By the early 2000s, it was being used by the Native Addictions Council of Manitoba. The building was sold into private ownership in 2007 and used by a catering business that also sold restaurant supplies and antiques, and vended barbecued foods during events in the park that replaced the old Brandon City Hall.

In 2020, financial challenges caused by the COVID-19 pandemic led the building's owners to retire and put it up for sale. It remained on the market as recently as early 2023 when, with permission, I was able to see inside. I had expected the interior to be highly renovated in the sixty-six years since CKX moved out. Remarkably, the original layout was almost completely intact. The only substantive changes were that windows that had once enabled radio engineers to see into each of the building's two studios, and windows that allowed an audience to watch a performance in the larger studio, had been covered by walls. A full commercial kitchen occupied the former audience room. As I stood in the old studio, I thought that, if those walls could talk, they would undoubtedly tell great stories about the heady days when the medium of radio was new, along with the possibilities that it created for the information and entertainment of western Manitobans.

Directions

Enter these coordinates into a GPS receiver or a map app on your smartphone.

Historic Site	Latitude	Longitude
CKX Radio Building (220 8th Street, Brandon)	N49.84639	W99.94888

ACKNOWLEDGEMENTS

I thank my friend Christian Cassidy for drawing my attention to the historical significance of this innocuous little building in Brandon, and Brandon city councillor (and one of the producers of my *Abandoned Manitoba* videos) Shaun Cameron for arranging a look inside the building. Owners Susan and Paul Spiropoulos welcomed me on a visit in April 2023.

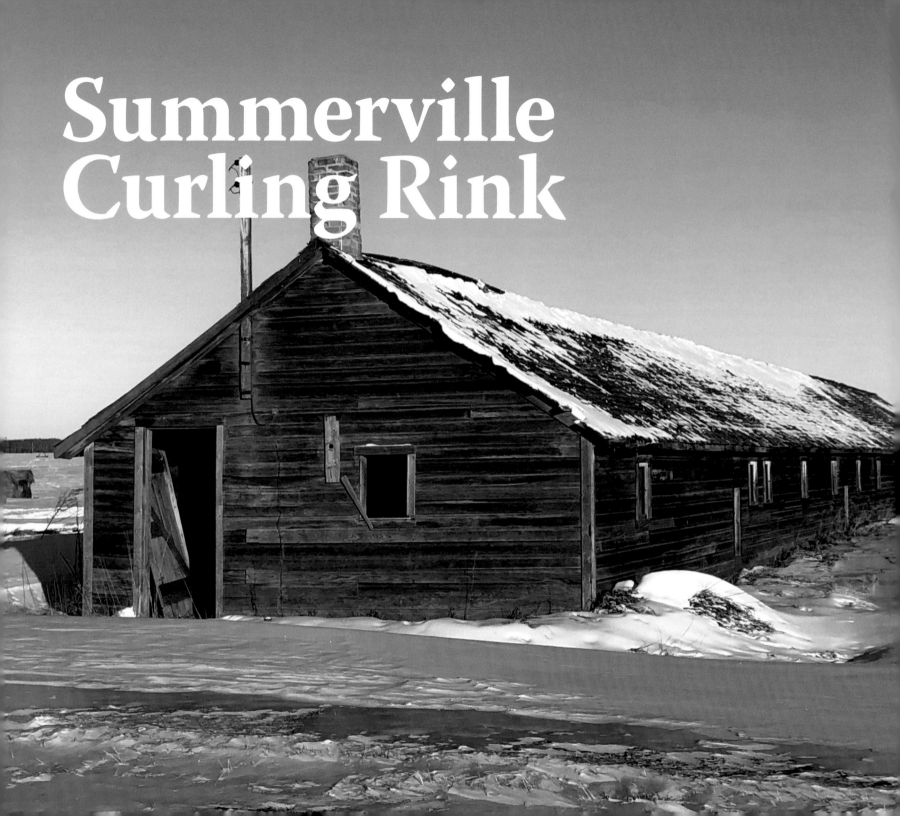

Summerville
Curling Rink

It strikes me as somewhat ironic that a building standing on the edge of a farm northwest of Carberry, whose former function was intimately connected with winter, would have a name like Summerville. Yet, that is the case.

My attention was first drawn to the building by my friend Robert Smith of Edrans who knows my fascination with quirky old buildings. As I drove up to it during the winter of 2020, his suggestion was amply justified. It was strange, unlike any building I had seen before. One of my practices, when I encounter a building for the first time, is to get an approximate idea of its size by pacing out the length and width. In this case, it was just 18 feet wide but a whopping 160 feet long. The interior consisted of just two rooms, a small roughly square room at one end, with a large window looking into the second room that occupied the rest of the structure, about 145 feet long. There were small exterior windows spaced along the length of this second room. Not only was the building narrow and long, but it was very low too, with roof rafters barely eight feet above the ground. What could it be? I wondered.

The dimensions of this curious building should sound familiar to fans of the sport of curling. They almost exactly match those of a curling sheet, the length of ice on which rocks are pushed to the opposing team's end. This was what is known in the curling world as a one-sheet rink. The small room on the west end of the building was

OPPOSITE The abandoned Summerville Curling Rink as it appeared when I visited in February 2020. GORDON GOLDSBOROUGH

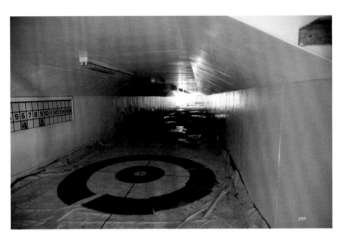

The ice was gone when this photo was taken inside the Roseland Curling Rink, the last active one-sheet rink in Manitoba, in July 2021. GEORGE PENNER

the "waiting room" that was typically heated whereas the room with the ice sheet was unheated. Curlers waiting their turn to use the rink could wait there, along with spectators who watched the games. In places where there was no other public space, the waiting room could also be used for social events such as luncheons, pie nights, and card games. There might have even been a bit of drinking.

Time, weather, and vandals have not been kind to this building. It was in very poor condition with many missing roof shingles and large holes all along its roof and walls. Clearly, it had not been used for curling in a very long time. But, at first, I knew nothing about its identity. To learn its history, I had to find a name. That turned out to be relatively easy. I measured its precise latitude and longitude when I was there and, using these coordinates, I

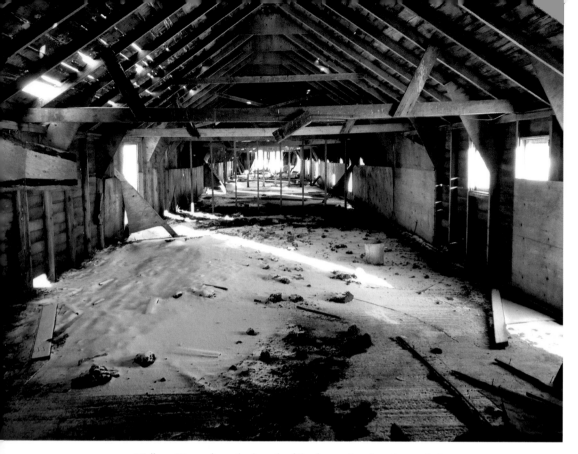

Wall partitions along the length of the former ice sheet betray its later use as a granary.
GORDON GOLDSBOROUGH

was able to determine in what school district it had been. In the early days of Manitoba, people in rural areas often identified themselves as being from a particular school district if there was no nearby town. (My dad's family, for example, came from a place called Ferndale that appears on few maps.) I found that this little curling rink was in the Summerville school district. Turning to a local history book for the Carberry area, I found the answer. The building was the remains of the Summerville Curling Rink. I was stymied, however, in my attempt to learn WHY the place was called Summerville. Typically, the names of school districts commemorate prominent local residents, their places of origin, and the like. But, in this case, the family that pioneered the area, and offered land for use by the curling rink, were the Muirheads. I am no closer to knowing why it was called Summerville. Reader, do you know?

Manitoba's first curling game was played on 11 December 1876, in a new indoor rink on Annie Street in Winnipeg. The Granite Curling Club, established five years later, built its first indoor rink in 1892. It is probable that curlers in rural Manitoba were active by the 1890s. The first curling game at Summerville occurred in 1910 and the Summerville Curling Club was constituted formally in 1911, becoming a member of the Manitoba Curling Association that year. The Club bought a full set of curling rocks at the princely sum of $17 per pair. The rink was constructed in 1928 by volunteers, using locally raised funds, on land provided by the Muirhead family. In 1936, local women organized a Summerville Ladies' Curling Club with sixteen members, and mixed bonspiels were held frequently.

According to the local history book, the Summerville Curling

Rink was last used in 1947, probably because it was becoming more convenient to travel to Carberry, 7½ miles away, to curl in the larger, multi-sheet rink there. I talked to the owner of the property on which the old rink sits. She told me that her family converted the ice sheet into a granary by pouring a concrete floor, adding metal reinforcing rods to make its wooden walls sturdier, and adding doorways where grain could be added and removed. The waiting room had been used as a Sunday School for Summerville United Church, which was once located across the road. She and her family had preserved the waiting room as a sort of time capsule until quite recently when vandals broke in and trashed it. The church was later moved elsewhere and eventually burned down, leaving this small rink as the only visible reminder of the Summerville community. But there is another reminder of the Summerville Curling Club in a more conspicuous place. A pair of the original Summerville curling rocks is on display in the Carberry rink.

The abandonment of the Summerville curling rink is another sign of the gradual transformation of Manitoba's rural landscape. Just as one-room schoolhouses gave way to large multi-room schools in towns, and many small grain elevators were replaced by a few huge ones, the one-sheet rural rinks have mostly closed in favour of multi-sheet rinks in towns. At one time, such buildings must have been commonplace in small communities all over Manitoba. My curiosity was aroused. Is Summerville the only one left standing? The answer is no! There is at least one more. Located in the community of Roseland, southwest of Brandon, the rink was built in 1948, around the time that Summerville was abandoned. Unlike Summerville, the Roseland rink is still in active use, believed to be the only one-sheeter still operating in Manitoba and one of only three left in all of Canada. Now, there is roaring history for you.

Directions

Enter these coordinates into a GPS receiver or a map app on your smartphone.

Historic Site	Latitude	Longitude
Summerville Curling Rink	N49.92344	W99.45320
Roseland Curling Rink	N49.79801	W100.07515

ACKNOWLEDGEMENTS

I thank George Penner and Robert Smith for sharing photos of the Roseland Curling Rink and artifacts from the former Summerville rink, respectively. Robert, a keen Manitoba historian, first drew my attention to Summerville. I thank Arla Shamansky for telling me about her family's repurposing of the former curling rink after its use as a community centre ended in 1947.

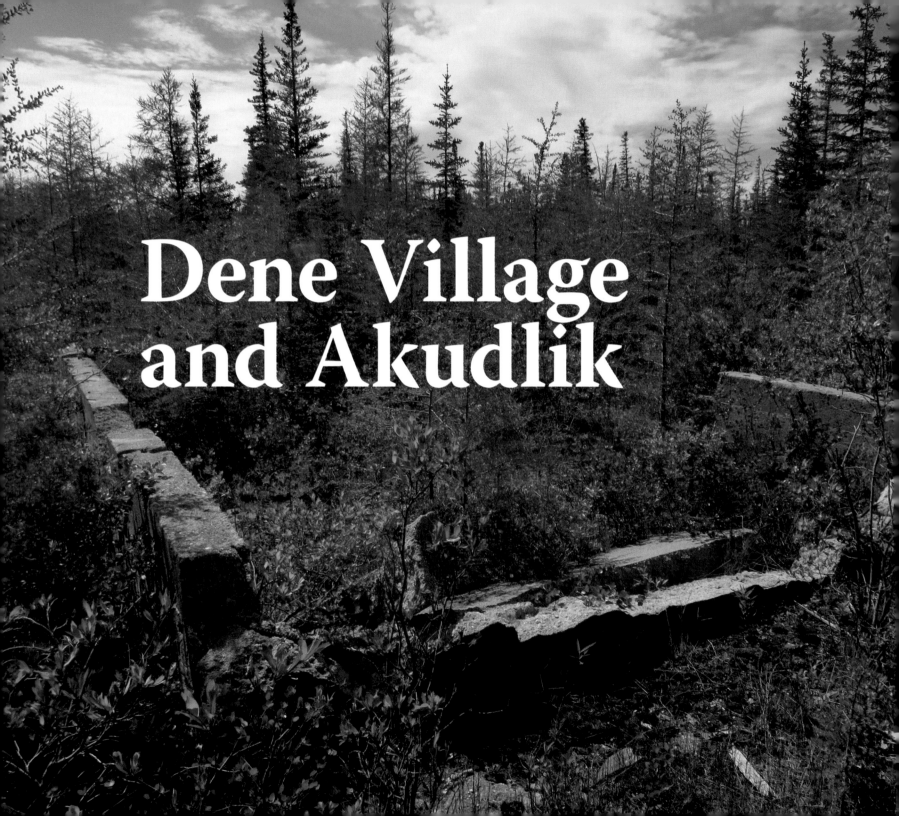

Dene Village
and Akudlik

In this undated view of the Sayisi Dene Village, a wooden crib on the right side of the road held coal used by residents to heat their homes. ARCHIVES OF MANITOBA, MANITOBA GOVERNMENT PHOTOGRAPHS, #69-358

A couple of communities near Churchill are reminders of misguided attempts by the Canadian government to relocate two groups of people, one Chipewyan and the other Inuit, to Churchill in the 1950s. Both communities are now abandoned, and bad memories linger among those who were relocated.

For centuries, the Fort Churchill Indian Band, known today as the Sayisi Dene First Nation, have occupied the transitional area between the forests of northern Manitoba and the open tundra. They followed herds of caribou and hunted them for food and clothing. In 1953, with suspicions that the caribou population was in decline, the Department of Indian Affairs decided to relocate the Dene from their traditional lands around Little Duck Lake and North Knife Lake to Churchill, a community about 100 miles to the northeast. The move occurred in 1956. Initially, the Dene lived in tents near the mouth of the Churchill River and were later moved into small, poorly insulated shacks near the community's cemetery. A report from 1962 included the shocking description of a home where "a mattress and a heap of dirty blankets serve as the bedroom for an entire family."

A sedentary lifestyle, such as the one into which the Dene were forced at Churchill, is generally only feasible when the food supply is stable, such as when people

OPPOSITE The foundations of buildings at the former Sayisi Dene Village, seen here in July 2018, are cracked and broken after being abandoned in the 1970s. GORDON GOLDSBOROUGH

practise agriculture. So, with the benefit of hindsight, it would seem inevitable that a sudden transition from a nomadic, caribou-hunting way of life to non-migratory urban living would have disastrous consequences. Poverty and racism only exacerbated these consequences. The Churchill RCMP detachment reported that 75% of their workload came from the Dene community, involving cases of alcohol abuse, violence, criminal behaviour, and child neglect. In 1966, the Department of Indian Affairs moved the Dene into what became known as the Dene Village. Located about three miles southeast of Churchill, it was a collection of wood-frame bungalows laid out in a pattern reminiscent of modern suburban subdivisions. There was still no opportunity for hunting, fishing, and trapping, and the houses were crowded and unserved by water or sewer. Alcoholism continued and deaths occurred when

The final bungalow at the Sayisi Dene Village, present in early 1984, is now long gone.
MARIA ZBIGNIEWICZ

people who had walked to Churchill died on the way back. Several homes were destroyed by fire caused by improper heating, forcing people displaced by fire to move into neighbouring homes, thereby amplifying the overcrowding problem.

In 1968, some of the Dene began to return to their traditional lifestyle and by 1973, most of the people had moved to Tadoule Lake, about 150 miles west of Churchill. With

a restored ability to pursue their traditional lifestyle, the community has thrived. I visited the site of the former Dene Village in 1984 and found a single abandoned house and many concrete foundations. When I returned in 2018, all the houses were gone, but a monument, erected in 1999, commemorates what has been described by one historian as "one of the most grievous errors committed by the federal government."

Unfortunately, a second case of forced relocation of Indigenous people to Churchill, also on grounds of declining caribou populations, occurred around the same time, in the mid-1950s. This time, it involved the federal Department of Northern Affairs. A group of Inuit people from what was at that time known as the Keewatin district of the Northwest Territories (today part of Nunavut) was moved to a former construction camp near Fort Churchill, the military base about 2½ miles southeast of Churchill. It became known as Akudlik, an Inuit word meaning "The Place Between" because it was between Churchill and Fort Churchill. In 1958, the regional headquarters for the Keewatin district were established at Akudlik, along with a transient centre for people coming to Churchill for medical treatment. At that point, cedar-log bungalows were built. Unlike the houses at the Dene Village, the houses at Akudlik were serviced by water and sewer from the military base. The Inuit were

permitted to hunt, trap, and fish as they had previously done in the Northwest Territories. In addition, men from Akudlik were able to get jobs at Fort Churchill so the standard of living was relatively good. Nevertheless, the Inuit experienced difficulties adjusting to this way of life. An example? Their new homes had large, picture windows on the front that were entirely foreign to them, allowing people to see in as readily as the residents could see out.

The abandonment of Akudlik started in the 1970s when the Keewatin government office was relocated to Rankin Inlet. Although the move would not necessarily have required the Inuit to leave, Manitoba conservation officers informed them that they were no longer permitted to hunt in Manitoba. They could kill a polar bear only if it was on sea ice offshore of Churchill, which was defined as belonging to the Northwest Territories, but not on land around the town.

After Akudlik had been vacated, the buildings became the property of the Manitoba government and most of them were sold to people from Churchill who moved them to sites along the Churchill River to become homes and summer cottages. A few of the buildings remained at Akudlik into the early 1980s because the University of Manitoba had expressed an interest in having a research station in Churchill. A non-profit entity known as the Churchill Northern Studies Centre (CNSC) was established and it was based initially in the former Keewatin office building and a couple of the other nearby buildings. This was where I stayed when I visited

Numerous concrete foundations of houses from the former Sayisi Dene Village were readily visible in this aerial view that I took in July 2018. The Churchill grain terminal is visible on the left horizon in the distance. GORDON GOLDSBOROUGH

The main administrative building for Akudlik was converted into the headquarters for the Churchill Northern Studies Centre, where I slept and took meals during the month that I worked there in 1984. MARIA ZBIGNIEWICZ

Dakota Entrenchments

North of Portage la Prairie is a site known as Flee Island. The site is a roughly circular patch of land surrounded by a shallow ditch so I suppose, in a sense, it could be thought of as an island. Our story begins in central Minnesota, the traditional lands of the Dakota (also known as Sioux) people. Like Indigenous people all over North America, their interests conflicted with those of settlers who flooded onto the western plains in the mid-nineteenth century. Forced onto American reservations, they suffered intolerable living conditions. Then, in August 1862, a white farmer and his family were murdered, starting what came to be known as the Dakota War of 1862.

The US government, busy fighting the Civil War at the time, had no tolerance for the killings and directed the military to deal with the situation. In December 1862, thirty-eight Dakota men were hanged at Mankato, Minnesota in the largest mass execution in American history. In the aftermath, several hundred Dakota fled to what they hoped would be the protection of the "Great White Mother," or Queen Victoria, in British-held territory to the north, in today's Manitoba.

In February 1864, they established fishing and hunting camps near Lake Manitoba, on the edge of what is today known as Delta Marsh. According to their custom, these camps were called ćunkaśke (pronounced "choonkash-kay")—wooden palisades, piles of stones and earthen entrenchments—for protection against the elements, wild animals, and potential enemies. Each camp was enclosed by a circular trench and embankment behind which armed defenders could position themselves. Inside this circle was a ring of pits where the women and children took refuge in the event of an attack.

In late April or early May 1864, the camps were attacked by what were believed to be Chippewa (or Ojibwa or Saulteaux) people from the Red Lake area of Minnesota. Several Dakota were killed. The leader of the Chippewa raiders was a man named Short Bear, known for his wisdom and leadership, and his remarkably short stature. (A photo in which Short Bear appears, taken at Fort Dufferin near the Canada-US border in 1872, shows a standing Short Bear indistinguishable among a group of his people, all seated.) In the aftermath of the 1864 attack, the entrenchments are thought to have been deepened.

Abandoned entrenchments can be seen at two sites: at Flee Island along highway 227 and the St. Ambroise Entrenchments nearer to Lake Manitoba. Both are roughly circular, ranging in diameter from 150 to over 300 feet. Over

A curving trench at Flee Island, excavated by Dakota people in 1864, is barely visible and overgrown by small trees.
GORDON GOLDSBOROUGH

the past 150 years, the entrenchments have filled in, now varying in depth from one to three feet. The area, formerly open grassland, with tree growth prevented by periodic prairie fires, is today overgrown with shrubs and poplar trees. Archaeological digs by the provincial government in the 1970s did not discover any evidence of occupation or spent ammunition after the 1864 construction. It appears the camps were used in battle after the entrenchments were deepened and were probably occupied for a relatively short period. Though the entrenchments are abandoned, some descendants of the people who constructed them can still be found in Manitoba. Dakota people live at several places, including the Dakota Tipi and Dakota Plains First Nations near Portage la Prairie.

Churchill in 1984. Today, the CNSC has relocated to the former rocket range east of town and, when I visited Churchill in 2018, I saw only one of the former buildings at Akudlik, surrounded by a field of derelict vehicles and a host of barking sled dogs.

I think these cases illustrate the paternalistic attitude of the federal government toward Indigenous people at that time. They were thinly veiled attempts to assimilate the Dene and Inuit into mainstream society by moving them into a more urban setting in hopes they would abandon their traditional ways. The abandonment of these communities reveals the "wisdom" of this approach.

By the time this photo was taken in early 1984, some of the buildings at Akudlik had been removed and the remaining ones were in use by the Churchill Northern Studies Centre. I spent a month working out of a brown-coloured building in the centre, a former recreation hall.
MARIA ZBIGNIEWICZ

Directions

Enter these coordinates into a GPS receiver or a map app on your smartphone.

Historic Site	Latitude	Longitude
Sayisi Dene Village	N58.73345	W94.11170
Akudlik	N58.74400	W94.11417
Flee Island Dakota Entrenchment	N50.10549	W98.15575
St. Ambroise Dakota Entrenchment	N50.22673	W98.07728

ACKNOWLEDGEMENTS

Photos of the former Sayisi Dene Village and Akudlik in the early 1980s were taken by my wife, Maria Zbigniewicz, during her scientific research based at the Churchill Northern Studies Centre which, at that time, was located at Akudlik. I joined her there for a month in 1984 but, for reasons I cannot fathom now, I focused entirely on science and took no photos of the abandonment that surrounded us.

WARNING
CLASS
B
HIGHWAY
HIGHWAY TRAFFIC ACT 1936

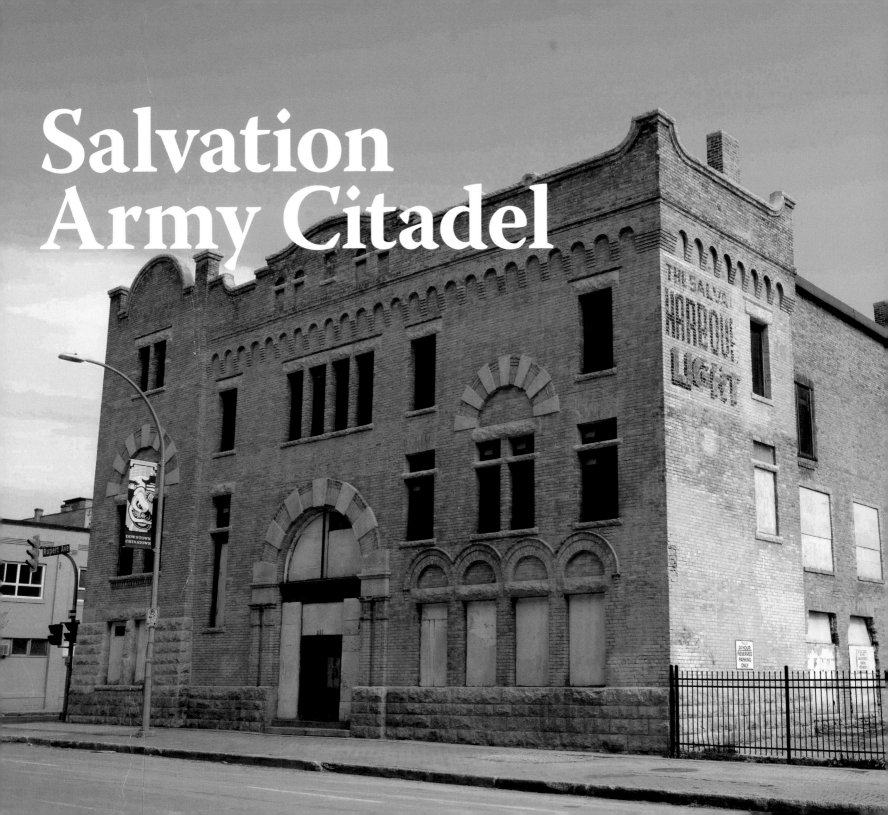

Salvation
Army Citadel

One might say that the former Salvation Army Citadel on Rupert Avenue in downtown Winnipeg is waiting for a saviour to turn an empty shell with an attractive exterior into some new purpose.

Founded in England in 1865, the Salvation Army (SA) —sometimes referred to affectionately as the "Sally Ann" based on the same initials—is well regarded for its good work on behalf of society's less advantaged people. Who among us has not encountered its workers soliciting donations outside businesses during the winter holiday season? Many people looking for bargains patronize its thrift shops. It is worth remembering, though, that the SA is also a Protestant Christian faith in which clergy hold ranks similar to those of military forces. The SA arrived in Winnipeg in December 1886 and immediately began to evangelize. Within weeks, the leader of the six-person group telegraphed back to headquarters in Toronto: "Send more officers over to help us. Thermometer 30 degrees below. Salvation boiling over. The whole North-West a blaze of salvation."

In time, the SA opened satellite facilities in Brandon, Emerson, Minnedosa, Morden, Neepawa, and Portage la Prairie but it was predominantly focused on the large population of Winnipeg. In 1892, it moved into a former Baptist Church at the corner of Rupert Avenue and

OPPOSITE This view of the former Salvation Army Citadel from 2020 still bears a ghost sign advertising its Harbour Light Centre. GEORGE PENNER

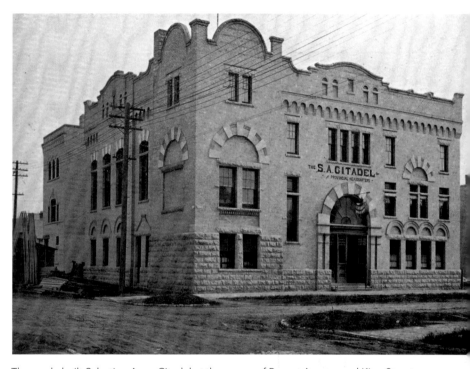

The newly-built Salvation Army Citadel at the corner of Rupert Avenue and King Street, circa 1903. W. A. MARTEL (1903), *AN ILLUSTRATED SOUVENIR OF WINNIPEG*, PAGE 73.

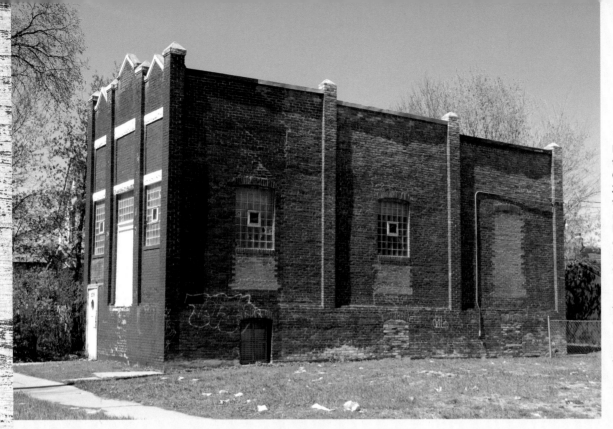

In this view of the former No. 2 Citadel from May 2019, some of the windows on its east side had been bricked over, and the street-facing main entrance at left had been closed permanently in favour of a lower door into the basement. The building appeared to be undergoing redevelopment when I visited it in June 2023.
NATHAN KRAMER

Salvation Army No. 2 Citadel

Like other religious denominations, the Salvation Army consists of distinct congregations that meet for religious services. In keeping with the military nomenclature used by the SA, these groups are called Corps. In 1910, the Salvation Army built a small hall for its No. 2 Corps—referred to as the "No. 2 Citadel"—on Pritchard Avenue in Winnipeg, completed at a cost of about $5,000 (at least $150,000 in today's money). The 3,100-square-foot, red-brick building, with Tyndall stone accents, had an auditorium with seating for 200-250 people on its main level, with entry through street-facing doors that have since been boarded up. The basement had rooms for Sunday School classes and band practices. Opened officially in March 1911, the hall was used by the Corps until around 1925 when the SA moved to a building on Main Street. But this building remained in use as the home for a Jewish fraternal society called the Hebrew Friends Temple until around 1965. The building housed a wholesale glove factory from the early 1970s until being put up for sale in 2010. Today, the former SA hall is classified by the City of Winnipeg as a "warehouse" but, in early 2023, it was listed by a realty company as a "great project for investors, builders and renovators" that might be suitable for a multi-family residential development. My site visit in early 2023 confirmed that some redevelopment seems to be starting.

King Street but, within a few years, that space became too small, and they began making plans for a larger building at the same site. Tenders were called in 1899, and the work was completed in 1900. The new three-storey brick and stone building had two public halls, one with room for 900 people and the other for 250 people. There was also a band room, dressing rooms, and offices for officers and other SA staff. The building accentuated the military theme of the organization, being called a citadel, usually defined to mean a fortress on high ground.

The SA had three main areas of charitable work in Winnipeg. First, it offered care to "fallen women" who were single and pregnant, or whose husbands had abandoned them, and it operated the Grace Hospital—opened in 1906 in the Wolseley neighbourhood as a maternity hospital and later turned into a general-care facility. Second, it assisted newly arrived immigrants in becoming established. Finally, it supervised recent parolees and their families. In the early years, the SA also employed homeless men to cut wood for sale as home fuel. By the 1950s, they began working for the care and rehabilitation of alcoholics. The Citadel became the Harbour Light Centre for Alcoholics, a detox centre with hostel accommodation, counselling, and a soup kitchen. It also offered family services, a suicide prevention line, and a missing persons tracking service. It offered disaster assistance during the 1950 Winnipeg Flood, a Christmas Cheer Board (now a separate agency), and Red Shield campaign to fundraise for the needy.

The beginning of the end for the Citadel occurred in 1961, when a new SA headquarters opened on Colony Street, north of Portage Avenue. Harbour Light continued at the Rupert Avenue location until 1986 (coincidentally, a century after the arrival of SA in Winnipeg) when the facility, now known as the Booth Centre, moved to its present Henry Avenue location. In 2002, the building, along with two other buildings on the same block, were bought by a local businessman and donated to an Indigenous environmental group that planned to redevelop them into "Canada's most environmentally sustainable building." An ambitious $5 million plan was announced in 2004, focused on the old Citadel building. In July 2004, a cleanup project funded by CentreVenture entailed the removal of "vast amounts of pigeon droppings." Unfortunately, the facility was never developed. About $100,000 was spent on cleanup work but, in 2006, the group was told by the City of Winnipeg that it had to spend thousands more to comply with a new by-law aimed at thwarting arson in vacant buildings. (See the chapter on Victoria Court for more information.) They were required to repair its roof, install interior stairs, and cover holes in its floors. The cost of the proposed new facility had risen to $7 million. I suspect the costs were too much for the non-profit group. Both buildings were put up for sale in May 2010 with an asking price of $495,000.

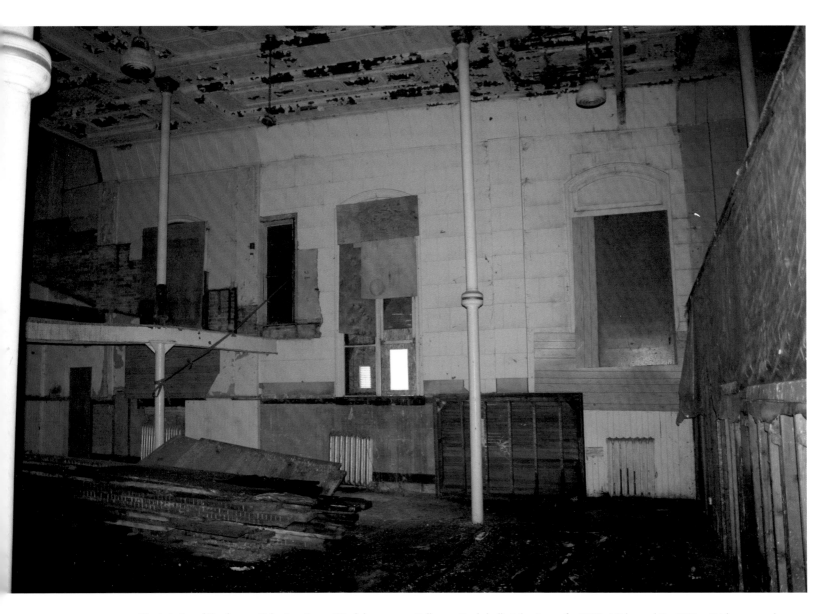

The interior of the former Salvation Army Citadel was essentially a gutted shell at the time of a 2010 visit by architect Wins Bridgman and historian Jim Burns. JAMES A. BURNS.

In June 2010, conservation architect Wins Bridgman and historian Jim Burns toured the building and found the floor of its large meeting room with a large burn hole caused by people who had had a bonfire. Damage caused by the fire, and the water used to extinguish it, was extensive. It was potentially treacherous to move around the building as there was no electricity and therefore no lights. Pigeon poop was everywhere, and the smell was atrocious. The two visitors were required to stay within five feet of an exterior wall because it was not known if the decrepit floors would bear their weight. Although much of the interior had been gutted, most of the walls still stood, and remnants of the two original halls were still visible. A large map of the globe on a wall at the back of a stage in the large hall showed all SA facilities around the world.

Sold in 2011, the former Citadel's present owner has refused to reveal their plans publicly. I am told the interior has now been completely gutted and the building is an empty shell. Its municipal heritage designation protects it from demolition, but it could be another victim of "demolition by neglect" where the owner does nothing to maintain the building and simply waits until inevitable deterioration takes its course until demolition is the only option. So where, I wonder, is that saviour?

Directions

Enter these coordinates into a GPS receiver or a map app on your smartphone.

Historic Site	Latitude	Longitude
Salvation Army Citadel (221 Rupert Avenue)	N49.90122	W97.13854
Salvation Army No. 2 Citadel (229 Pritchard Avenue)	N49.91297	W97.13341

ACKNOWLEDGEMENTS

In 2010, my friend Jim Burns—the skilled copyeditor of this book—accompanied architect Wins Bridgman on a tour inside the former Citadel, and generously shared photos from that visit. Nathan Kramer and Christian Cassidy did helpful research on the former No. 2 Citadel.

DO NOT CROSS SOLID LINE

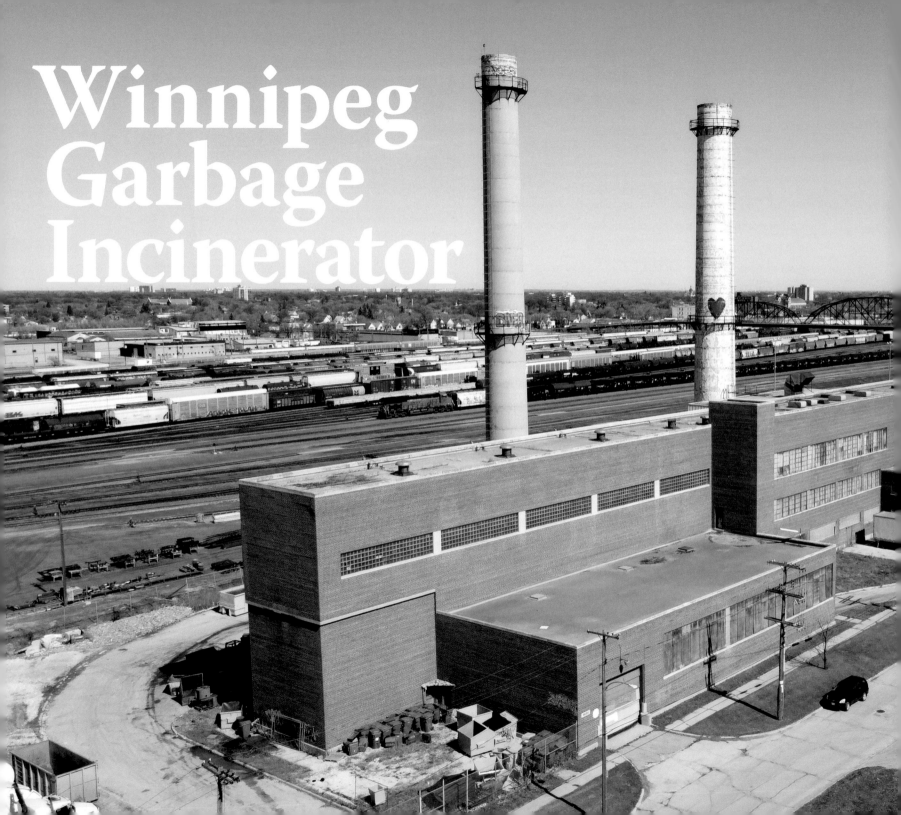

Winnipeg
Garbage
Incinerator

Garbage is an inevitable product of consumption and garbage disposal is one of the many essential tasks performed by municipal governments. Back in the 1880s, the City of Winnipeg purchased a ten-acre parcel of land on the northeast edge of the city, at the intersection of Wellington Avenue and Empress Street, a few blocks north of present-day Polo Park. Over the years, a veritable mountain of garbage was dumped there, along with animal carcasses and manure from wagon-pulling horses that was collected on city streets.

As early as the 1890s, as Winnipeg grew westward, residents of houses near the dump complained about "foul odors, noxious gases and disease-breeding germs" carried on the wind. In 1907, the city hired a US company to build an incinerator to burn 140 tons of garbage each day. But this was only a portion of the city's daily garbage output, so the dump continued to be used. By 1942, during the Second World War, the garbage pile was sixty feet high, and the Canadian Army considered (but ultimately rejected) an idea to use explosives to excavate salvageable scrap metal for the war effort.

After the dump was deemed to be full, in 1948, it was closed and developed as a public recreation space through the 1950s and 1960s by a committee led by city councillor Lillian Hallonquist. Some took to calling the old dump

OPPOSITE An aerial view of the former Winnipeg Garbage Incinerator, April 2021. GORDON GOLDSBOROUGH

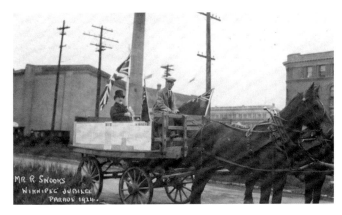

In 1924, Robert "Ginger" Snook, wearing a jaunty top hat, rode in a horse-drawn wagon in a parade celebrating the fiftieth anniversary of Winnipeg's founding. Despite his active role in picking up street trash, the "road apples" dropped by Ginger's horses contributed to the city's mounting street waste problem. MARTIN BERMAN POSTCARD COLLECTION, CITY OF WINNIPEG LIBRARIES

"Lil's Hill" until a public competition was held to select an official name. The suggestions included Jubalation Heights (named for the city's flamboyant mayor, Stephen Juba) and Pioneer Hill in a nod to the early Winnipeggers who started the pile. My favourite suggestion was Snook's Mountain for businessman and raconteur Robert "Ginger" Snook who was famed for his knowledge of the inner workings of city politics. His obituary in 1926 observed that:

> For years his humor and waggish interruptions were a feature of the civic election campaign. Ward meetings would rock with laughter as he pilloried perspiring aldermen or school trustees with alleged derelictions of duty or even with malfeasance in office. To "Ginger" was accorded a

latitude and tolerance that would probably not have been extended to any other citizen. His quick and ready wit and quaint way of putting things always "got by".

Later in his life, Ginger took on the unpaid job of city scavenger, a thankless but necessary task of picking up trash on city streets and taking his collections to the garbage dump. In the process, he helped to build Winnipeg's only mountain.

Ultimately, the innocuous name Westview Park was suggested by city councillor Bill McGarva due to the good westward view that one gets from the top of the pile. This name was formally accepted by the Winnipeg Parks Board in 1961 but Winnipeggers persist in calling it "Garbage Hill". Today, the large mound of refuse is a popular place for tobogganing and skiing in the winter, and cycling, running, and walking in the summer.

By 1944, it was clear that Garbage Hill could not meet the needs of a growing city. Taxpayers authorized a half-million-dollar expenditure to hire a Chicago-based engineering firm to design a new facility on Henry Avenue, about 1.5 miles as the crow flies from the old dump site. Sod was turned in May 1946 at what was to be called officially the City of Winnipeg Mixed Garbage and Refuse Destructor, but which was referred to commonly as the Winnipeg Garbage Incinerator. It opened for testing in February 1948. The following month, Mayor Garnet Coulter, assisted by City Engineer William Hurst and City Health Officer Morley Lougheed, ceremonially lit three large furnaces by tossing flaming torches into them.

When fully operational, four garbage trucks at a time dumped their contents into a 350-ton receiving pit, from which cranes transferred the mixed waste into hoppers emptying into the furnaces. The garbage was burned at temperatures from 1200 to 1400° F (about 650 to 750° C), high enough to convert most organic waste into carbon dioxide and other gases. They were spewed from a chimney

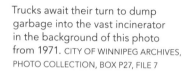

Trucks await their turn to dump garbage into the vast incinerator in the background of this photo from 1971. CITY OF WINNIPEG ARCHIVES, PHOTO COLLECTION, BOX P27, FILE 7

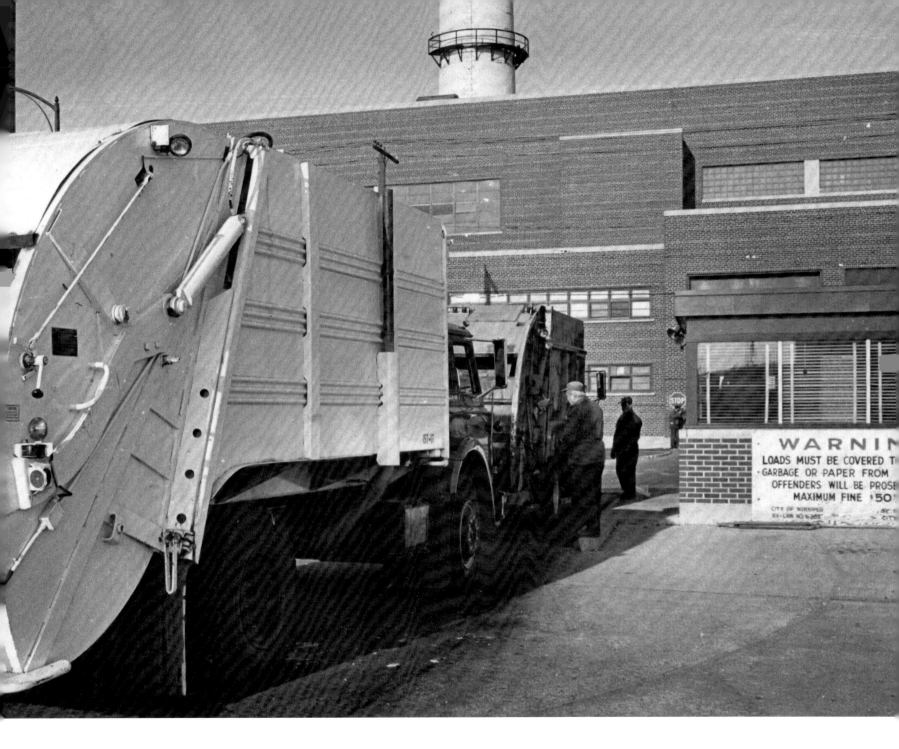

WARNIN
LOADS MUST BE COVERED T
GARBAGE OR PAPER FROM
OFFENDERS WILL BE PROSE
MAXIMUM FINE $50

In this view from August 1946, we see construction workers preparing forms for the concrete parts of the Winnipeg Garbage Incinerator. The base of one of its huge chimneys is at left and the Arlington Bridge over the CPR yards is in the background. CITY OF WINNIPEG ARCHIVES, PHOTO COLLECTION, BOX P27, FILE 79

built 180 feet high in hopes of discharging the gases high enough into the air to avoid smell complaints from nearby residents. Each furnace burned 100 tons of garbage per day, giving a total capacity of 300 tons per day. Whatever ash and unburned waste was left went to a dump in West St. Paul while metal that survived incineration was sold for scrap. The facility was staffed around the clock by twenty-two people working in three shifts.

Within twelve years, the incinerator facility had doubled in size. In 1960, a second chimney was built along

with a 200-ton incinerator containing five furnaces. The expanded facility had unused capacity, so the City of Winnipeg negotiated garbage incineration contracts with the adjoining Town of Tuxedo and City of West Kildonan. By the late 1970s, the incinerator was handling 100,000 tons of garbage of the city's annual production of 460,000 tons, and trucking about 25,000 tons of burned waste to city landfills. In other words, about three-quarters of the garbage handled by the facility was put into the air.

Today, the act of venting vast amounts of carbon dioxide into the atmosphere is seen as irresponsible because it contributes to global climate change. The Winnipeg Garbage Incinerator's downfall came with the increasingly stringent air quality standards that it was expected to meet. In April 1979, faced with a $7 million bill to upgrade the incinerator to modern emission standards, the City of Winnipeg instead closed the facility. Henceforth, unburned garbage was sent directly to local landfills, primarily the massive Brady Road Landfill which had opened in 1973 beside the Perimeter Highway in south Winnipeg and is believed to have enough capacity for at least another ninety years of dumping.

The focus of modern waste management is more on recycling useable materials and less on burying or burning garbage. The former incinerator building on Henry Avenue

was converted into a recycling depot although its two huge chimneys still dominate the skyline as an ongoing reminder of the way that we used to deal with garbage in Winnipeg. In 2013, the Brady Road Landfill was renamed the Brady Road Resource Management Facility in view of its new emphasis on recycling. In 2016, over 36% of the 350,000 tons of material received at Brady was re-used or recycled, and most Winnipeg residents now have a blue box for getting rid of recyclables in addition to a grey box for garbage. In my family, for example, almost all organic materials are composted in our back yard and used to fertilize our garden. On any given week, our blue box put out for curbside pickup is nearly full while our grey box is almost empty. I think Ginger Snook would be pleased.

Directions

Enter these coordinates into a GPS receiver or a map app on your smartphone.

Historic Site	Latitude	Longitude
Winnipeg Garbage Incinerator (Henry Avenue)	N49.91422	W97.16761
Garbage Hill / Westview Park	N49.90356	W97.19292

ACKNOWLEDGEMENTS

I am eternally grateful to Nathan Kramer for his diligent and thorough research on a wide range of historical topics, including on the former "destructor" on Henry Avenue.

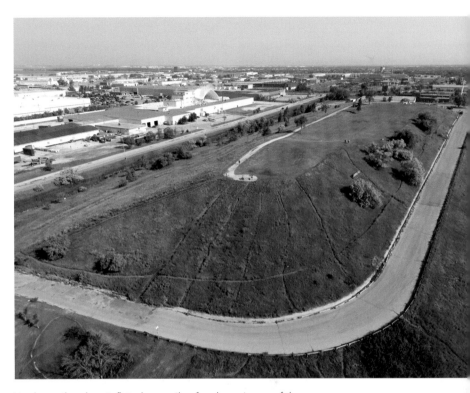

You know the place is flat when a pile of garbage is one of the highest elevations on the landscape. This aerial view of "Garbage Hill" shows the extent of Winnipeg's early-twentieth-century landfill.
GORDON GOLDSBOROUGH

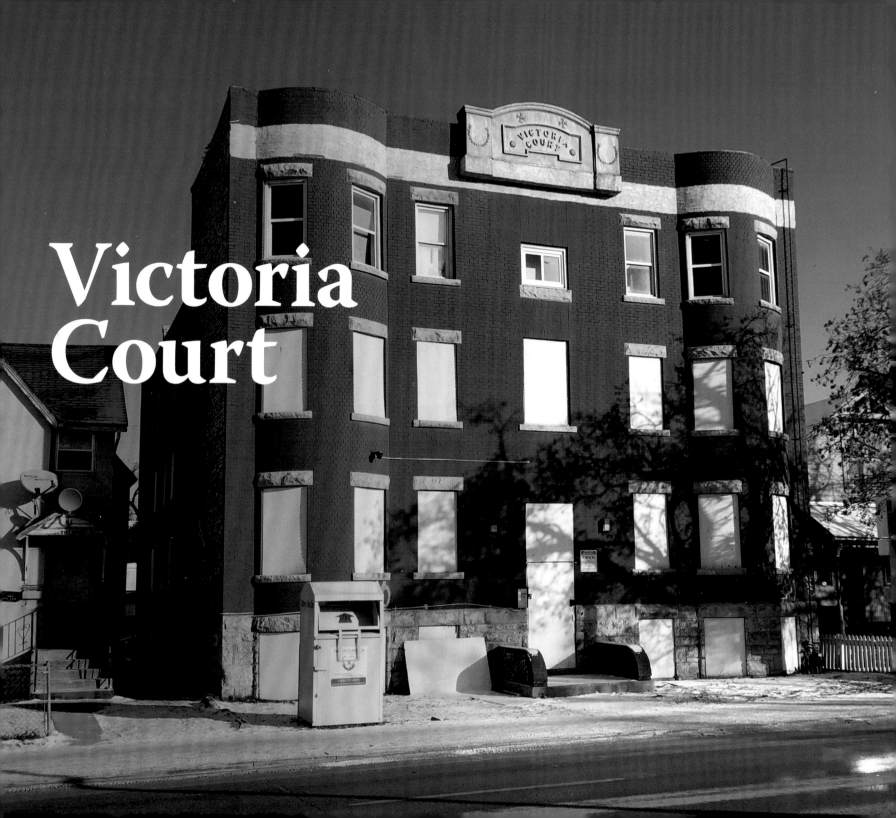

Victoria
Court

The cover for a 1971 record by the Winnipeg rock band The Guess Who shows band members leaning on a red 1957 Chevrolet automobile. Few people knew the basis for the album's title *So Long, Bannatyne*, which relates to the three-storey building in the background: the Bannatyne Apartments, built in 1910. The title track refers to a move by band member Kurt Winter from "a tiny little place" in the Bannatyne to a single-family home on Chevrier Boulevard. It was a move to which many Winnipeggers—who initially lived in the city's core then moved to the "burbs" as their financial fortunes improved—could relate.

By 1910, Winnipeg's population was booming. People seeking opportunities were flooding in from all corners of the world. Two decades earlier, new arrivals had stayed at commercial hotels or in "boarding houses" that provided them with a bed and meals. Winnipeg's architects and contractors responded to a need for longer-term accommodation by constructing lots of single-family homes and "terraces"—several one- or two-storey residential units connected side-by-side. In 1896, the Cauchon Block at the southeast corner of York Avenue and Main Street (demolished in 1981), built as a commercial building in 1883, was converted into the city's first multi-storey, multi-resident apartment block. As a new century

The cover of The Guess Who's 1971 album *So Long, Bannatyne* featured band members gathered around a red Chevy with Winnipeg's Bannatyne Apartments, the inspiration for the title track, in the background. RCA RECORDS. USED WITH PERMISSION OF BAND MEMBERS BURTON CUMMINGS, JIM KALE, GREG LESKIW AND GARRY PETERSON

OPPOSITE When I visited the vacant Victoria Court in late 2019, most of its street-facing windows were boarded up to dissuade people from breaking in. Smoke that had poured from third-floor windows left soot stains visible in a view from the back lane. GORDON GOLDSBOROUGH

dawned, the need for housing of an ethnically and demographically diverse population became critical. In the ten-year period between the 1901 and 1911 federal censuses, the city more than tripled in size, from 42,340 to 136,025 people. It would be difficult to build enough houses for that many new residents and a lot of them were single people or couples without children who did not necessarily want the financial and maintenance burden of a house. For them, an apartment made more sense. So, Winnipeg builders began constructing apartment blocks ... lots of them. In 1911, a city directory listed over four hundred blocks from almost none ten years earlier. In fact, during this decade, Winnipeg built more apartment blocks than any other Canadian city. Today, Winnipeg has one of the largest collections of three- and four-storey apartment blocks in North America, and one of the people who

contributed substantially to this abundance was Pall "Paul" Clemens.

Born at Reykjavík, Iceland in 1870, Clemens emigrated with his family to the United States in 1884 where he was schooled in the architectural hotspot that was Chicago. Seeing opportunity in western Canada, his family relocated to Winnipeg in 1898 where he began working as an architect and building contractor, in partnership with another Icelander and later by himself. At first, he designed single-family houses. As his skill and reputation grew, he turned to apartment blocks, designing and overseeing the construction of at least twenty-six of them (eighteen of which survive as of this writing) between 1908 and 1914, most of them in Winnipeg's core. Compared to the façades of blocks in more affluent, outlying areas of the city—that featured fine materials and intricate details—Clemens' designs were plain and undistinguished, perhaps like the working-class people who occupied them. In 1905, he married Laufey Gudjonsdottir, a fellow Icelander, and they had five children. The family left Winnipeg in 1921, probably for a reason that I will mention later, and returned to Chicago where he continued his architectural work, later moving to Virginia. Clemens died in Missouri in 1966 but was returned to Manitoba for burial near his parents in the cemetery at Ashern.

Among Clemens' architectural legacy in Winnipeg is Victoria Court, a three-storey brick and stone block on William Avenue. Wanting to know more about its history, I visited the City of Winnipeg Archives. It holds a large collection of municipal building permits issued through the years that provide a wealth of information about buildings. Unfortunately, there is no easy way to find a permit for a particular historic building. It often takes searching and detective work—and sometimes a bit of luck—but in the case of Victoria Court, I found its permit quickly. It told me that the three-storey block, 46 feet wide and 110 feet deep, was built by Icelandic contractor Joseph Johnson using day labour. This meant that workers were hired and paid daily, as particular skills were needed. The foundation was made of stone (a common occurrence at that time, before its widespread replacement by concrete) on concrete footings, and the exterior walls were made of red and amber bricks. In total, the construction of Victoria Court consumed 80 cubic yards of concrete for its footings and basement floor, 40 cords of stone, 200,000 bricks, and 5,000 square yards of plaster for its lath-and-plaster walls and ceilings. Excluding the basement, the block contained twenty-one apartments with a total area of about 15,000 square feet (or about 725 square feet per apartment, including public hallways). The apartments were centrally heated by a steam boiler in the basement. Completed in late 1910, at a cost of about $40,000 (or about a million dollars in today's money), the block was named in memory of the recently deceased Queen Victoria. It had no street-facing courtyard so the basis for calling it a Court is unclear. Maybe Mr. Johnson was trying to make his building seem fancier than it was.

Winnipeg city directories and census data for 1911 provide interesting insight into Victoria Court's first occupants. They were a diverse cross-section of the city's population, including a veterinary surgeon, grocer, restaurant manager, bookkeeper, railway conductor, machinist, police officer, tanner, hotelier, journalist, undertaker, saddlery foreman, schoolteacher, garment factory foreman, accountant, and railway clerk. Interestingly, one of them was an architect named Edgar Prain, who was then at the beginning of a long career that included the design of apartment blocks, churches, and schools, including the elementary school that I attended. Of the sixty-seven people (33 females, 34 males) that occupied the block's apartments, ten originated outside Canada, including five from England and one each from Ireland, Russia, Scotland, United States, and Wales. All but two had been in Canada for ten years or less. They were exactly the sort of people who would live in apartments. The individual apartment occupancy ranged in number from two to ten inhabitants. (I cannot fathom how they crammed ten people into one apartment.)

Today, most of the late-nineteenth-century terraces are gone, but a few good examples survive, such as the Queen Terrace (built 1890) in Virden, the Lorne Terrace (1892) in Brandon, and the Glamour Terrace (1902) in Winnipeg. But, I wondered, how many of the early- twentieth-century apartment blocks survive? This was the genesis of a project that I undertook on behalf of the Manitoba Historical Society (MHS): to document Winnipeg's earliest, surviving blocks. To keep the project manageable, we adopted a few criteria. We would include only blocks built up to 1930, at which point economic conditions of the Great Depression squelched new building construction. They would be purpose-built as apartments, mostly (but not entirely) excluding blocks on major streets that had retail shops on their main floor and residential apartments on upper levels.

The original building permit for Victoria Court, held at the City of Winnipeg Archives, contains a wealth of information about the building. GORDON GOLDSBOROUGH

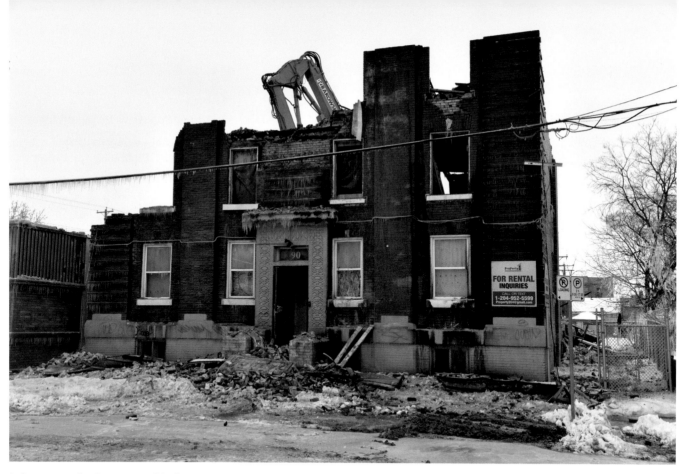

A three-storey brick apartment block on Gertie Street in downtown Winnipeg was built in 1906. Known as the Frontenac Block for most of its life, it was renamed Rizal Apartments around 1980. Destroyed by fire in mid-January 2023, it was one of several century-old blocks around the city that have fallen to fire in the past year. Before the rubble had cooled, a machine set to tearing down the remaining walls. The Frontenac namestone can be seen lying on the ground in front of the entrance. GORDON GOLDSBOROUGH

By consulting decades of annual city directories held at the Legislative Library of Manitoba, we compiled a list of 549 apartment blocks that met our criteria. To learn more about these blocks, researcher Nathan Kramer spent many, many hours combing the building permits at the City of Winnipeg Archives. Meanwhile, volunteer MHS photographer George Penner travelled around the city, going to the addresses we had found for the blocks, taking photos of all the ones he found, and making note of those that he could not find. Nathan helped with this work too, and I photographed numerous blocks during my "pandemic walks" with my wife. It took us about eighteen months to go through the entire list of blocks, and there are about a dozen or so that we are still working on.

Of the 549 apartment blocks built in Winnipeg between 1900 and 1930, about two-thirds are still standing.

For most of them, we know their year of construction, architect and builder, building dimensions and number of apartments (from which we can estimate the area of an average apartment, including proportionate shares of public spaces such as hallways and lobbies), and cost of construction excluding the land purchase (allowing us to estimate the cost of an average apartment). We have street addresses (and latitude and longitude) for every block. All this data reveals some interesting trends. For instance, although the blocks ranged from two to five storeys, 83 percent of them were three storeys. The smallest apartment was 300 square feet and the largest was 2,200 square feet, with an average of 850 square feet. Not surprisingly, the size of an apartment was directly correlated with its cost of construction; larger apartments were more expensive to build. In general, the largest apartments occurred in the wealthier areas of the city, in a cluster around the Assiniboine River: in the Wolseley neighbourhood north of it and in Fort Rouge and Crescentwood south of it.

Some interesting conclusions can be drawn by cross-referencing the average cost of an apartment with a building's architect and contractor. Some architects, such as Max Blankstein, the first Jewish architect in western Canada, seems to have specialized in small, modest buildings. His blocks were mostly, but not entirely, in the North End and their apartments averaged just 689 square feet. Pall Clemens and Bentley Taylor were in the "lower middle end of the pack" at 771 and 840 square feet, respectively. And some architects clearly focused on large

buildings in the upscale market. An example was Cyril Chivers whose buildings were all in Crescentwood with an average apartment size of 1,452 square feet.

A graph of the number of blocks built each year between 1900 and 1930 is illuminating. After a slow start in the first three to four years, the pace picked up considerably through the late 1900s and early 1910s, then plummeted in 1915 (see Figure 5). It turns out that the Great Depression was not the only reason that apartment block construction stalled. The First World War was also a major factor. In 1914, the year the war started, 73 blocks were built. In 1915, the number fell to just two and we found several blocks, started before the war, that were not completed until the early 1920s. In fact, the war had a lingering economic impact on Winnipeg's growth. Between 1919 and 1925, only twelve blocks were built. I suspect the

FIGURE 5 A graph of the number of apartment blocks built in Winnipeg between 1900 and 1930 shows clearly the "boom" in construction that preceded the First World War, then a depression during and for seven years after it. An increase during the late 1920s ended with the Great Depression. NATHAN KRAMER AND GORDON GOLDSBOROUGH

dearth of work was what motivated Pall Clemens to seek greener architectural pastures in Chicago. Finally, in 1926, economic conditions began to improve, with a dozen blocks built that year alone. On the eve of the Great Depression, in 1929, twenty-nine blocks went up. And it was in this period of the late 1920s that we ran into an interesting case that led me to pose the question: "When is an apartment block *not* an apartment block?". The glib answer? When the building's contractor says it is not.

Among the many contractors who built apartment blocks in the 1910s and '20s was Bentley Taylor. He designed and built five blocks, all of which are still standing. Among them was Craigavon Apartments in the Wolseley neighbourhood, whose construction in 1927 was controversial. As Taylor was building the Craigavon, two of his neighbours took him to court, seeking an injunction on construction. They argued that a caveat on the land title allowed only single-family residences, not apartment blocks. The rationale for such a caveat was that at least some proportion of the populace—generally, its more affluent members—believed that the blocks attracted the wrong kind of residents: lower- and middle-class folks who needed affordable housing and who, in the racist and class-based thinking of the day, would breed slums, bringing poverty and crime into the neighbourhood. This was not an uncommon attitude in the early twentieth century. It was responsible, in part, for a concept known today by urban planners as "the missing middle".

The missing middle describes a condition in many cities around North America where there are abundant detached single-family homes at one end of an accommodation spectrum, and tall apartment complexes at the other end, but nothing in between. A lot of cities have no small apartment blocks such as Victoria Court and Craigavon Apartments. In Toronto, for example, the city council passed a by-law in 1912 that explicitly banned the construction of apartment blocks, with the result that there are few early-twentieth-century blocks in Canada's largest city.

Returning to the court case, Bentley Taylor responded to his neighbours that the caveat against apartment blocks did not apply because his building was, in fact, a single-family house. The neighbours responded that the building had a flat roof, just like an apartment block. It had a main entrance that looked like that of an apartment block. And it had five bathrooms. Why would a single-family home need five bathrooms? the neighbours asked. Despite these astute observations, the judge found in favour of Taylor and the work was completed. At first, in keeping with Taylor's assertion, the building was initially occupied by a single family. However, in 1935, it began to be advertised in newspapers as an apartment block. So, Bentley Taylor succeeded in pulling the wool over the eyes of the court and, in so doing, circumvented a zoning by-law that would have contributed, at least on a local level, to a "missing middle" here in Winnipeg.

My family had an experience with one of Winnipeg's many old blocks when we moved to the city in 1996. We needed a place that did not insist on a year-long lease, and we found one in the Harrow Apartments at the corner of Harrow Street and Grosvenor Avenue. Designed by Pall Clemens and built in 1913, the block contained twenty-one apartments in its original configuration. The Harrow must have been an upscale block in its day; it was in a quiet neighbourhood within walking distance of stores and schools. Its apartments featured parquet floors in all rooms except the kitchen. But maintenance and cleaning of the place had been sorely neglected. Most significant to me was that our apartment was served by a single electrical circuit. This might have been perfectly adequate to meet the demand for power a century ago, but it was woefully inadequate for our modern gadget-filled lives. Every time that we turned on two or more appliances, we exceeded the capacity of the circuit. This meant a walk down three flights of stairs to the basement, where the main electrical panel was located, to replace a screw-in fuse. (The building was built before the innovation of circuit breakers and had not been updated.) I recall we had a large supply of fuses at the ready and I took many trips to the basement after we tried to use any combination of the coffee maker, microwave oven, computer, hair dryer, and television at once. Fortunately, our stay in the Harrow was short and, since then, it has been renovated into condominiums. I sure hope they upgraded the electrical service!

Meanwhile, Victoria Court was occupied until around 2014 when it sustained fire damage that caused it to be vacated and boarded up. When I visited the area in 2019 and walked along the back lane behind the building, I saw prominent soot stains above some of the rear windows. The surrounding neighbourhood was not doing so well either, having been in the news several times in 2019. A convenience store within eyesight of Victoria Court closed because of

Built in 1892, the Lorne Terrace on Brandon's Lorne Avenue originally contained four apartments. Terraces, once fairly common around Manitoba in the 1880s and 1890s, were replaced by larger and taller apartment blocks and are now rare.
GORDON GOLDSBOROUGH

rampant shoplifting. An investigative report by the CBC described the vacant block as a local "drug den" and a newspaper story referred to injection needles that littered the grounds. It was sad to see this handsome building in such a state of disrepair and abuse. That is why I am pleased to report that, after sitting empty for around seven years, as of mid-2022, Victoria Court has reopened and is

once again providing needed accommodation in central Winnipeg. Many more buildings around Winnipeg, however, remain abandoned. At least one local journalist has described the situation as a "plague". It is hard to know for certain how many vacant buildings are in Winnipeg. A by-law enforcement officer with the City of Winnipeg told me in August 2022 that, at that time, there were 462 vacant residences and 153 vacant commercial buildings, for a total of 615. According to some community advocates, this total is a substantial underestimate.

Vacant buildings are often subject to acts of vandalism, arson fires, and miscellaneous crimes. In 2022, two vacant apartment blocks—the Kenora Apartments on William Avenue (built in 1914, not far from Victoria Court) and the Tremont Apartments on Sherbrook Street (also 1914)—were destroyed by fires. Some vacant buildings have multiple fires, becoming an undue burden on city firefighters. The Winnipeg Fire Paramedic Service reported that, in the first three months of 2022, it responded to eight fires in vacant structures, and the number of such fires had more than doubled over the preceding four years, from 30 in 2017 to at least 64 in 2021. When firefighters and emergency personnel enter a vacant building that has been neglected for a long time, they may be putting themselves at risk when, for example, there are gaping holes in floors or when stair treads are rotten.

A cynical view is that buildings that have been empty for a long time may be subject to "friction fires" initiated by someone acting on behalf of the owner. (Friction fires occur when the deed or mortgage for a building rubs against the insurance policy.) Sometimes, when the building stands on land that is valuable for redevelopment, failing to maintain an old, vacant building may be a conscious strategy—dubbed "demolition by neglect"—to hasten its downfall. But we should not presume that owners of vacant buildings are all corrupt and dishonest. Fires can be the result of trespassers who force their way inside a building to escape from the cold, or to drink and take drugs.

The Winnipeg Vacant Buildings By-Law requires that empty buildings must be boarded up to discourage people with nefarious intent from getting inside. The by-law was passed by the Winnipeg city council in 2010. Its purpose is to discourage building abandonment and, in so doing, reduce the risk of fires, reduce the risk to city personnel, reduce the extent of illegal activities that may occur in and around such buildings, reduce devaluation of neighbouring properties, and prevent buildings from standing empty for long periods. The objective is to encourage building owners to bring their property up to habitable standards so they can become occupied again or, failing that, to demolish them. Landowners must purchase a Boarded Building Permit, designed to discourage long-term boarding, *before* boarding up their property. A permit for a boarded-up residence costs about $2,500 and increases by almost $2,000 for each subsequent year that the permit is renewed. For commercial buildings, the cost for a boarding permit is the same as for a house, if it is the owner's first permit. The cost rises for each

additional building so that, for example, if the owner has four boarded-up buildings, the fourth permit costs $8,000. If a building owner boards up a building without paying for the permit, there is a $1,000 penalty and it, along with the permit cost, is added to the property taxes for the building. The owner cannot simply ignore the fine. After a building has received a Boarded Building Permit, boarded-up residential and commercial buildings are required to be inspected annually when they have been the subject of complaints from neighbours, when they are visibly dilapidated, or when they have been vacant for extended periods of time. These inspections cost $630 if the building is found to comply with the by-law, or double that amount if not compliant. When a residence has been boarded up, it cannot be reoccupied until an Occupancy Certificate is issued, for which another inspection is required. In short, there are a lot of incentives to prevent vacant buildings. But there's more. In 2020, the Winnipeg City Council amended the Vacant Buildings By-Law to add an Empty Building Fee intended to encourage owners of buildings that have been empty for five or more years to occupy, reuse, or demolish their building. That fee is equal to one percent of the assessed value of the property and it is assessed every year until the building is inspected and reoccupied.

Winnipeggers can be justifiably proud of the city's abundant historic architecture, including hundreds of apartment blocks from the early twentieth century. However, as the urban expanse sprawls outward in all directions, the wealthiest residents who retreat to adjoining rural municipalities might agree with The Guess Who's Burton Cummings when he sang about a move to the suburbs: "I moved out of the city and left my Bannatyne behind. I really like it here."

Directions

Enter these coordinates into a GPS receiver or a map app on your smartphone.

Historic Site	Latitude	Longitude
Victoria Court (471 William Avenue)	N49.90209	W97.14845
Craigavon Apartment (165 Ethelbert Street)	N49.88193	W97.16709
Bannatyne Apartments (545 Bannatyne Avenue)	N49.90208	W97.15237
Harrow Apartments (183 Harrow Street)	N49.86963	W97.16509
Queen Terrace (302 Queen Street West, Virden)	N49.84783	W100.93234
Lorne Terrace (1133 Lorne Avenue, Brandon)	N49.84546	W99.95378
Glamour Terrace (367 Kennedy Street)	N49.89482	W97.14972

ACKNOWLEDGEMENTS

Research for the project on early-twentieth-century apartment blocks was supported, in part, by a Gail Parvin Hammerquist grant to the Manitoba Historical Society. I am grateful to Nathan Kramer and George Penner for their dedicated work on the project, and Murray Peterson and Sarah Ramsden at the City of Winnipeg for their help in completing it.

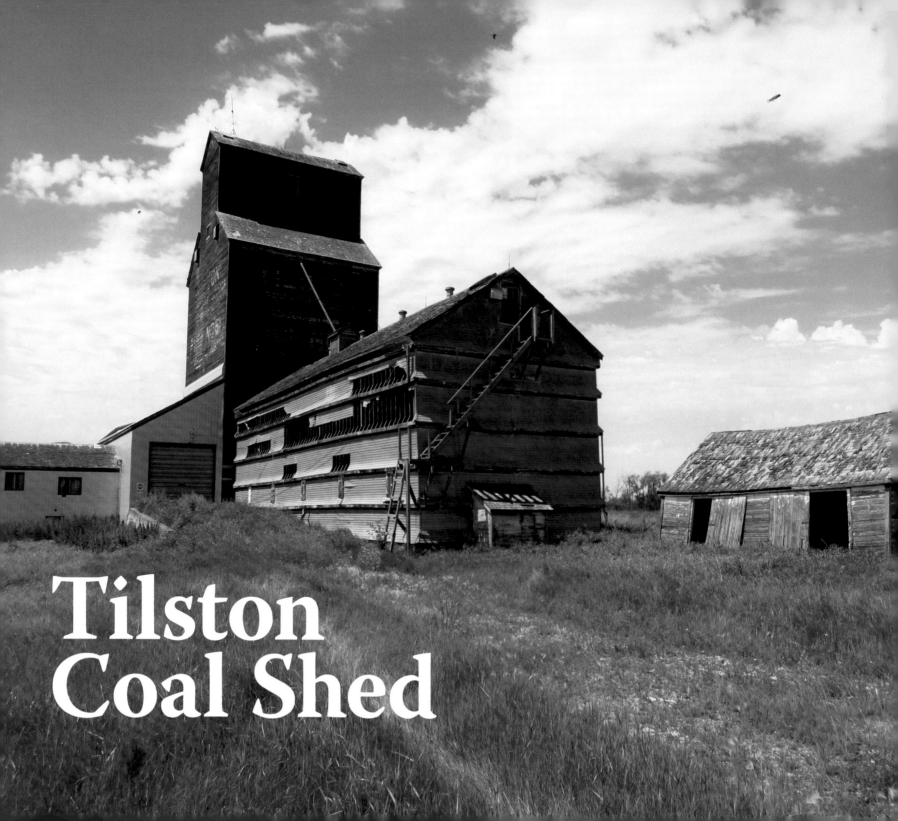

Tilston
Coal Shed

Our sense of smell provides one of the strongest cues for memory, with even a faint whiff causing us to think of a person or event in our distant past. In my case, the smell of burning coal reminds me of visits, decades ago, to the home of my paternal grandparents. A soft, comforting aroma emanating from a coal-fired furnace in the basement filled the entire place. I never asked grandpa where he bought his coal, but it probably came from a mine in Saskatchewan or Alberta. Extensive coal deposits in western Canada were reported by European explorers in the 1700s. By the mid-1800s, coal was being used by blacksmiths to heat their forges and, with the arrival of the Canadian Pacific Railway in the 1880s, coal mining became an essential industry for fuelling the locomotives. In houses across the west, coal was an obvious replacement for wood, whose supply on the open prairies was limited. Here in Manitoba, not so long ago, coal was everywhere. Not only did it heat our homes, but coal also produced our electricity, processed our minerals, and manufactured our products. Today, coal is all but abandoned.

Between 1883 and 1908, and again from 1931 to 1943, coal deposits in southwestern Manitoba were mined

OPPOSITE At one time, country grain elevators were not simply collection places for grain but were also where you bought coal to heat your home. A small coal shed was sitting next to the abandoned Manitoba Pool elevator at Tilston when I visited it in 2016. GORDON GOLDSBOROUGH

For Real Fuel Economy--BURN

MONOGRAM QUALITY COAL

"Keeps You Warm in the Coldest Weather"

BURNS TO THE LAST ASH IN ANY STANDARD FURNACE EQUIPMENT

If you have not already done so, you should get acquainted with **MONOGRAM**—the better Prepared Saskatchewan Lignite, Souris Coal. **ORDER A TON TODAY** and discover for yourself how easy it is to obtain a **SATISFYING, COMFORTING DEGREE OF HEAT** —and maintain an even temperature. **MONOGRAM** is simplicity itself to regulate and control. Knowledge acquired now will put in your pocket many, many dollars as the Winter progresses. Besides you will always have a cheery, warm house in the very coldest weather. Why pay more per ton for similar results?

LOW CASH PRICES
Delivered in Basement

Large LUMP
TON
$4.75

Large COBBLE
TON
$4.50

THESE PRICES FOR CASH ORDERS ONLY

For Cleaner, Better Prepared Coal

PHONE 2-7-5-0

Federal Grain Ltd

ASK the MAN WHO BURNS MONOGRAM

Cartage—Geo. Dinsdale, Phone 2406!

In fall 1931, the Federal Grain company advertised its Monogram lignite coal in Brandon newspapers. Deliveries would be made by former Brandon Mayor, and future Member of Parliament, George Dinsdale. *BRANDON DAILY SUN*, 31 OCTOBER 1931, PAGE 4.

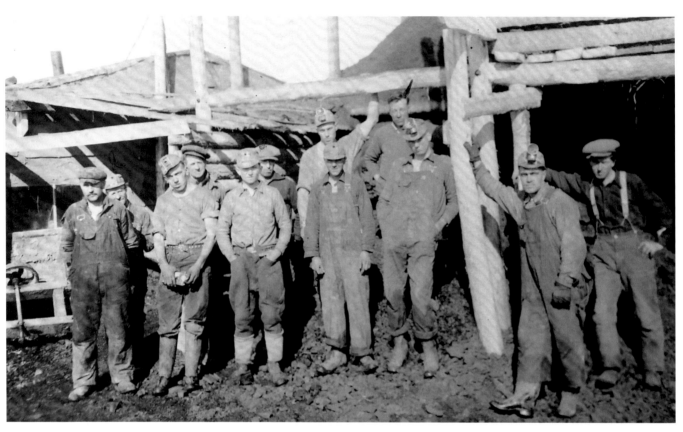

A group of miners at the Salter mine in southwestern Manitoba, including John Nestibo at right, around 1933. ARCHIVES OF MANITOBA, NESTIBO FAMILY COLLECTION 14, N14201.

actively. It was a poor grade of coal, known as lignite or brown coal, with a relatively low heat content on combustion, compared to the higher-grade anthracite mined in Alberta. But it was less expensive than Alberta coal because transportation costs were low. The vast majority of Manitoba coal came from just two mines within a stone's throw of each other, in the valley of a small creek south of Deloraine. The coal deposits there were discovered in the fall of 1931, by brothers John and Ole Nestibo, while digging a water well for farmer George Henderson. Recognizing a business opportunity, Henderson hired the Nestibos to operate the mine and pay him a royalty. With thirty to forty men digging year-round, the mine produced about thirty tons of coal

daily. Sold locally at a considerably lower price than coal from outside Manitoba, most of the mine's output was consumed within a thirty-mile radius. Everything was going fine until, in 1932, Henderson demanded a higher royalty. Rather than pay it, the Nestibos moved across a property line separating Henderson's land from that of his neighbour, Thomas Salter. Henderson then hired another man to work his mine, with the result that, for a few years, two mining operations faced each other across a property line. Ultimately, both mines had closed by 1938 due to "water and subsidence conditions" and they never resumed operation, for the most part ending Manitoba's tiny coal industry.

Coal statistics that I found in federal government reports, issued between 1942 and 1973, show that the vast majority of coal used in Manitoba—over 98 percent—came from Alberta and Saskatchewan, and two-thirds was lignite. The remainder came from the United States and 90 percent was bituminous or black coal used primarily in industrial applications. Not surprisingly, there was a distinct seasonal pattern to Manitoba's coal consumption, increasing in the fall and winter when it was used to keep buildings warm, and decreasing (but not stopping) in spring and summer as industrial use continued year-round. Coal intended for domestic use was delivered by train to cities, towns, and villages around Manitoba. In larger centres such as Brandon and Winnipeg, merchants delivered their product door-to-door and advertised the virtues of their respective wares—with brand names such

as Excelsior, Monogram, and Patsy—in local newspapers. Most homes in older Winnipeg neighbourhoods had a "coal bin" in their basement, connected to the outside by a chute in an exterior wall. A homeowner would order one or more tons of coal, and the desired size—smaller lump or larger cobble—would be poured into the chute. As needed, a resident would shovel coal into the furnace, a job known as stoking. In smaller towns, where there was not enough demand to warrant door-to-door delivery, coal was purchased from a central depot and, in the grain belt of southern Manitoba, this was typically the local grain elevator.

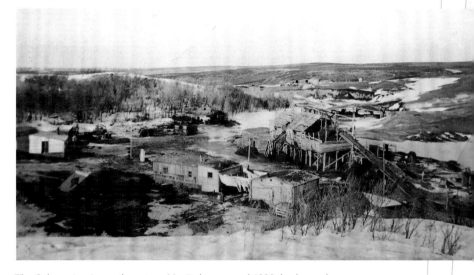

The Salter mine in southwestern Manitoba, around 1933, had a coal-loading ramp (at the right of the photo), with surrounding buildings including an engine house for power, cookhouse, bunkhouse, dining hall, and residence for mine manager John Nestibo. In the distant background, a little right of centre, is the Henderson mine. ARCHIVES OF MANITOBA, NESTIBO FAMILY COLLECTION 1, N14188.

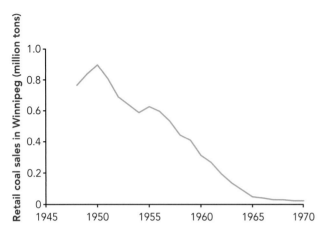

FIGURE 6 Between 1948 and 1970, retail coal sales in Winnipeg plummeted to near zero as homes converted over to other, more convenient methods for heating such as electricity or furnace fuel. GORDON GOLDSBOROUGH BASED ON "COAL IN CANADA" REPORTS, LEGISLATIVE LIBRARY OF MANITOBA

Most people assume that grain elevators did just one thing: buy and sell grain. In fact, they often did much more. They frequently sold fertilizer and farm chemicals. And sitting next to many elevators were small, wooden sheds from which the elevator agent sold coal to whomever wanted it. The railway would deliver a hopper car of coal next to the shed, which usually had several doors facing the railway track, one for each grade of coal. Sales were made from doors on the opposite side of the building. Those wanting to buy coal would come with wagons, sleighs, trucks, or a hand-held scuttle, pay their money, and head home with enough heat for the next week, month, or longer.

Through the mid-twentieth century, the use of coal waned in favour of other fuels (see Figure 6). For example,

retail coal sales in Winnipeg decreased from a peak of about 900,000 tons (about four tons per person) in 1950 to just 24,000 tons (0.1 tons per person) by 1970. This decrease occurred primarily because coal has numerous disadvantages. Lumps of coal are not as easily transportable as oil or gas or electricity, which can be delivered to homes by tank, pipe, or wire. Coal is a very "hands on" product. Daily, you must stoke the furnace then shovel out (and dispose of) the leftover ash. You might have to get out of bed in the middle of the night to feed the fire. Once coal is burning, it burns to completion; it cannot be turned on and off, so a coal-burning furnace cannot be controlled by a central thermostat. And coal is messy, leaving black dust on your clothing. Mid-century homeowners talk about plumes of dust wafting through their house when coal was delivered. "Auto-stoker" furnaces that could automate the process of keeping the furnace fuelled grew in popularity through the 1940s but, moving into the 1960s, coal-burning furnaces were converted to burn more convenient fuels, or were replaced with other heating technologies.

In 2011, according to Statistics Canada, the major sources for home heating in Manitoba were natural gas (61%) and electricity (37%). Use of oil, wood, propane, and other sources made up the remaining 2%. Until recently, though, a small amount of coal was used for home heating, indirectly via the coal-burning electricity generators at Brandon and East Selkirk. But these plants stopped burning coal in 2002 (East Selkirk) and 2018 (Brandon).

As of January 2014, the use of coal as a space-heating fuel is prohibited in Manitoba, due to concerns that burning it puts carbon dioxide into the atmosphere, thereby contributing to climate change. People with coal furnaces who did not submit a plan to convert are subject to a fine, but I suspect the number affected by the coal ban is very, very small.

Today, many older homes still have a coal chute on their exterior, although most have been sealed. Most of the coal sheds that once sat beside grain elevators have been demolished or converted to other uses, such as fertilizer and chemical storage. My friend Jean McManus, who has done a thorough job of locating the surviving coal sheds, has found ones at Holmfield, Kane, Tilston, and Winnipegosis. Unfortunately, the shed at Winnipegosis was demolished, along with the elevator that stood beside it, in 2021.

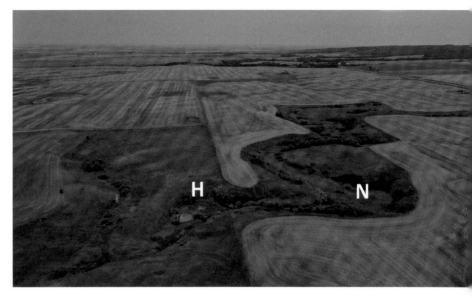

This aerial view from June 2023 shows the shallow, meandering valley where, in the 1930s, nearly all the coal mined in Manitoba was produced. The approximate locations of the Henderson and Nestibo mines are shown by the letters H and N, respectively. GORDON GOLDSBOROUGH

Directions
Enter these coordinates into a GPS receiver or a map app on your smartphone.

Historic Site	Latitude	Longitude
Tilston Coal Shed	N49.39209	W101.31690
Henderson Coal Mine	N49.04082	W100.56708
Nestibo (Salter) Coal Mine	N49.04062	W100.56495

ACKNOWLEDGEMENTS

As with many other chapters in this book, I am deeply indebted to the librarians of the Legislative Library of Manitoba for helping me to find information that I was probably the first person to ever ask for. I thank Jean McManus for drawing my attention to the coal sheds that often stood next to the grain elevators that she and I were visiting. Anyone interested in a more thorough treatment of Manitoba coal mining should read Tony Doerksen's 1971 book *The Saga of Turtle Mountain Coal.*

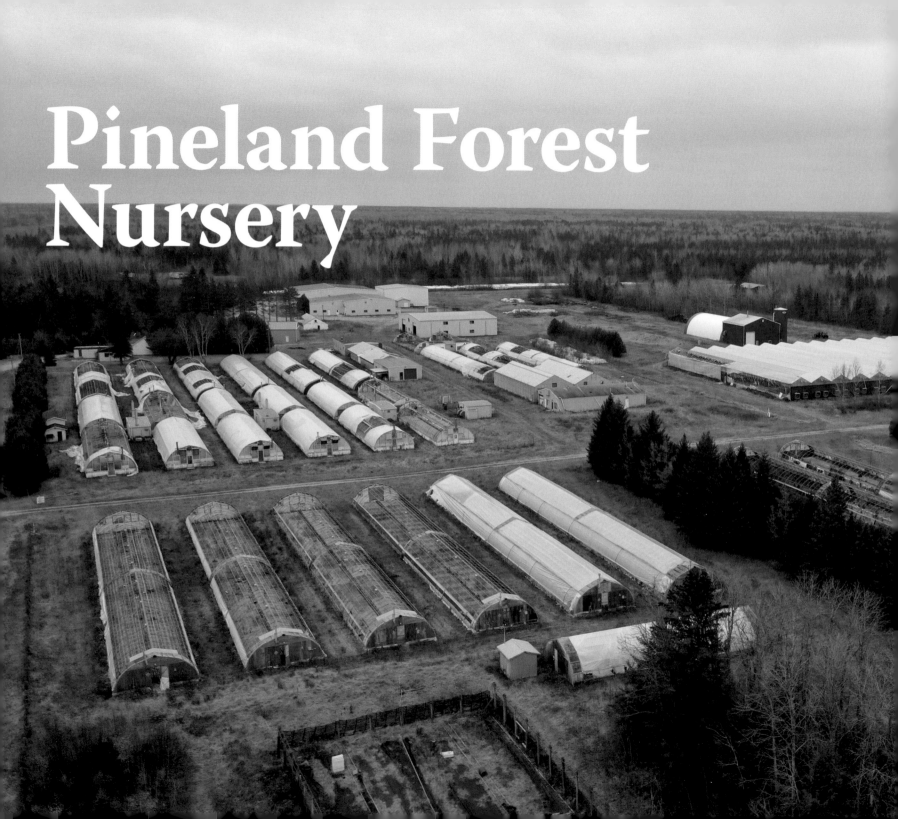

Pineland Forest
Nursery

Abandonment can take many forms and have many causes and consequences. I suspect the theme of this chapter—one of the most recent cases of abandonment that we will visit together—will leave you pining for the past, as it does me. We are talking here about the former Pineland Forest Nursery along the Trans-Canada Highway near Hadashville in southeastern Manitoba.

I love trees. Who doesn't? When you live on the prairies, as many of us do, you are subject to the vagaries of weather and trees afford protection from extremes in temperature, wind, and precipitation. They block the wind and reduce evaporation, thereby conserving critical soil moisture. This was especially important during drought conditions in the 1930s. Trees reduce soil erosion by wind and improve air quality for humans and animals who would otherwise inhale wind-blown dust particles. In a region that is chronically short of water, as is the case on the prairies, trees hold snow and rain in local areas, thereby reducing the extent of flooding after snow melt and rainstorms, and they limit water erosion during runoff. Trees create habitat for beneficial birds and insects such as pollinators and predators of crop pests, and, perhaps most important to those of us who enjoy the outdoors, they provide shade. In times before air conditioning became widely available, shade trees were a major boon during the sweltering heat of summer. Yet, trees

OPPOSITE Aerial view of the abandoned Pineland Forest Nursery, November 2022. GORDON GOLDSBOROUGH

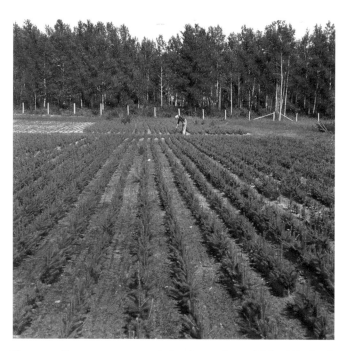

Young coniferous trees are tended at the newly established Pineland Forest Nursery, mid-1950s. MANITOBA FORESTRY BRANCH

are relatively slow growing so they are an investment in a future that the person who lovingly plants and tends them may not live to see. It is reassuring somehow that trees will outlive us and be a source of comfort and enjoyment for those who follow us.

Every day, when I look out at my front yard, I am reminded of the value of trees and the loss that Manitobans have suffered without knowing its full dimensions. Thanks to diligent work decades ago by my in-laws, my home yard is well treed. A large spruce, now mature and over sixteen feet tall, was planted there in the

An aerial view of shelterbelts in the area around Lyleton, Manitoba that were planted from the mid-1930s to late-1950s.
GORDON GOLDSBOROUGH

1970s by my wife's sister. She had received it as a seedling at her school during a visit by staff of the Manitoba Forestry Association. They did not grow the seedling themselves but obtained it from the Pineland Forest Nursery, a large facility nestled along the Whitemouth River. There, they took seeds harvested from trees in the wild and grew them into small seedlings to plant all over Manitoba and beyond. Pineland was one of the finest tree nurseries in Canada, and its history goes back to the early 1950s.

Until 1930, the management of Manitoba's natural resources was handled by the federal government. When the provincial government assumed this responsibility, it began to plant trees in provincial forest reserves using seedlings from four nurseries operated under the auspices of the Forestry Branch in the Department of Natural Resources: at Birch River, Shilo, Carberry, and Marchand, but primarily at the latter two. In 1952, the government purchased a 62-acre site near Hadashville—with light sandy soil that was perfect for growing coniferous and deciduous trees and nearby river water for irrigating them—and transferred a nurseryman from Marchand to the new Pineland Forest Nursery. The following year, the nurseries at Birch River and Shilo were closed. Until 1957, seedlings were started at the Carberry nursery then transferred to Pineland.

The first year of planting at Pineland occurred in 1954. The focus was primarily on hardy coniferous (evergreen) trees such as Jack Pine, Red Pine, Scots Pine, White Spruce, and Black Spruce. Seeds were extracted from cones collected in the wild, kept in cold storage for up to ten years, then grown out-of-doors for two to four years until they were large enough to be transplanted. As demand for trees grew, additional land around Pineland was purchased until it eventually encompassed 400 acres. In 1970, the first greenhouse was built so trees could be grown under more carefully controlled environmental conditions, although it was covered in material that could be drawn back to expose the little trees to natural sunlight

to harden them for their later life outdoors. In the winter, the greenhouse's interior was kept minimally warm by propane heaters, later converted to natural gas in 1996. Additional greenhouses were built through the 1980s. In 1996, the first stage of a massive, high-tech "gutter-connected" greenhouse was constructed at a cost of about one million dollars, and it was expanded in 2008 and 2012. It featured automated watering, heating, and ventilation systems that could be controlled remotely. By 2001, all trees at Pineland were grown indoors in small containers with soil that promoted faster growth and better survivability in the wild, compared to "bare root" seedlings that had been produced in the past.

Seedlings from Pineland went to industrial forestry sites around Manitoba, as well as in Ontario, Saskatchewan, and Minnesota. In addition, Pineland supplied seedlings to other entities involved in tree-planting, such as other provincial government agencies, cottage associations, woodlot owners, Christmas tree growers, retail landscapers, utility companies, mining companies, soil conservation authorities, and the public. And they were superior trees because the seeds were collected from only the best local trees, germinated under ideal conditions, and grown until they were sufficiently hardy to survive and thrive in nature.

At the federal level, the Dominion Forest Nursery at Indian Head, Saskatchewan supplied a wide variety of trees to Canadians starting in 1901. For decades, people all over Manitoba planted shelterbelts around their farms,

schools, and churches using millions of trees provided for free from Indian Head, encouraged by a Dominion Tree Distribution Policy (1901–1944) and Field Shelterbelt Assistance Policy (1954–1969). In 1936, the government collaborated with the Prairie Farm Rehabilitation Administration (PFRA) in a project to test-plant tree hedges in farm fields around Lyleton, in southwestern Manitoba. The Lyleton Field Shelterbelt Association was established and numerous hedges—some running east-west and others north-south—were planted with Caragana, Manitoba Maple, American Elm, Green Ash, Asiatic Elm, and several willow species. The project ended in 1959, by which time 97 farmers had planted 2,386,000 trees into 364 miles of shelterbelts over a 60-square-mile area. It successfully demonstrated the value of shelterbelts for reducing wind erosion and increasing water retention in sandy soils. The Lyleton shelterbelts still thrive today and are an impressive sight when one flies over that area.

During the first forty-three years that the tree nursery at Indian Head was in operation, an impressive 18.4 million broadleaf (deciduous) trees and 0.7 million coniferous (evergreen) trees were planted around Manitoba. From 1954 to 1969, 17.8 million trees from Indian Head went into 3,764 miles of Manitoba shelterbelts. The statistics for Manitoba's Pineland nursery were correspondingly impressive. Over its sixty-five years in operation, Pineland produced about 600 million trees. In 1962, it supplied about two million trees for planting around Manitoba. That number had increased to 3.5 million by 1977.

Sandilands Forest Discovery Centre

In the 1950s, Winnipeg teachers were concerned that their students had no meaningful opportunity to see "real" nature. Surely there is a place in Manitoba that we can go on a day trip, they thought. Enter the Manitoba Forestry Association (MFA). This private, non-profit group was founded in 1971, from the breakup of the Prairie Provinces Forestry Association into three provincial entities, which in turn had been formed in 1946 from the Prairie Division of the Canadian Forestry Association. The MFA's mandate was to inform and educate Manitobans about forests and their many virtues through a variety of programs, mostly aimed at school children.

In 1957, the MFA opened what it initially called the Conservation Training Area, later renamed the Sandilands Forest Centre, and still later the Sandilands Forest Discovery Centre (SFDC). During its first year in operation, it welcomed 300 students. In time, other groups and casual visitors came too. Interest grew so quickly that, by 1965, annual visitation topped 6,000 people and some schools had to be turned away. Between May and October each year, 50 to 100 students at a time—up to 10,000 in a peak

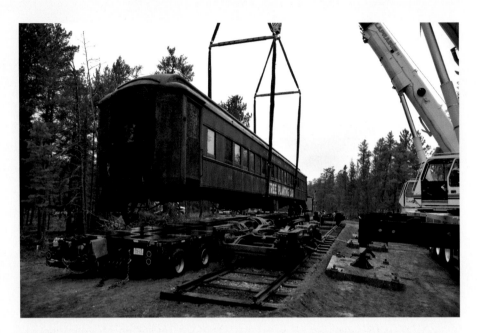

The Tree Planting Car being removed from its former home in the Sandilands in November 2022. GORDON GOLDSBOROUGH

year—would disembark from school buses arriving from Winnipeg and elsewhere to enjoy a day in the forest.

The 300-acre facility consisted of a small museum, a restored forestry cabin that had been built by the Dominion Forest Service in 1926, a former railway car used as a theatre/classroom, outdoor seating and picnic tables, a fire tower, a suspension bridge over the Whitemouth River built in 1963, and walking trails. A bunkhouse and kitchen/dining building for resident staff were added later. Under the direction of an MFA employee, with a

seasonal group of university students and volunteers, sometimes assisted by provincial forest rangers and tree nursery staff, visitors were offered informative programs centred around forest conservation. There were nature walks. There were presentations on tree growth and forest ecology. There were hands-on demonstrations of methods for determining a tree's age and its species, tree planting, and fire detection and prevention. In the early days of the Centre, visits to the adjacent Pineland Forest Nursery were a much-enjoyed supplement to the experience, from

which each student went home with a small spruce seedling. (Nursery visits were curtailed in the mid-1990s over concerns about liability and scarcity of time but spruce seedlings were still distributed to students and other visitors.)

The SFDC was just one facet of the MFA's year-round educational mandate, which was supported by a blend of grants, donations, and in-kind contributions from the provincial government and others. It offered programs in which MFA staff would visit schools around Manitoba and bring some of the same content they presented in the forest. There was an annual fire-prevention poster contest that attracted up to 20,000 entries each year. In later years, the program with which the MFA was most closely identified was Envirothon, in which senior students pitted their general ecological knowledge against those from other schools around Manitoba, across Canada, and in the United States.

Over time, the 90-minute drive from Winnipeg, combined with tight bussing schedules, diminished the meaningful amount of time that school groups could spend at the SFDC, sometimes to as little as an hour or two. Diminishing school budgets and concerns for liability when taking students "into the wild" did not help. In-city educational facilities such as

FortWhyte Alive, although not focused specifically on forests, became more attractive for short visits. All these factors contributed to a long-term decline in use of the SFDC. In the late 2010s, the MFA could no longer justify opening it for anything but special occasions and pre-arranged visits. The final blow was the closure of the Pineland Forest Nursery in 2018. The SFDC closed in 2022.

As I write this in early 2023, the MFA is shutting down, having donated its last remaining records to the Archives of Manitoba, selling its office building in Winnipeg, transferring care of its Tree Planting Car to the Manitoba Agricultural Museum, and dismantling the suspension bridge over the Whitemouth River. Plans to transfer control of the former SFDC site to a group of academic and Indigenous users remain uncertain. The MFA was the last of the provincial forestry associations. The national umbrella group, the Canadian Forestry Association founded in 1900 as Canada's oldest conservation organization, went defunct around 2020. It seems a shame that over 120 years of public advocacy for the benefits of trees will end with the impending death of the MFA. This sidebar may serve as its obituary.

Through the 1980s, annual production of seedings jumped to 7 or 8 million. By 1995, when the nursery went through a major administrative change, about 13 million seedlings were produced in a year.

The impact that the Pineland nursery had on the number of trees planted in Manitoba, from the early 1950s when it became operational, to the late 2010s when it closed, is illustrated by tree-planting statistics provided in reports filed at the Legislative Library of Manitoba (see Figure 7). The number of trees planted annually increased gradually

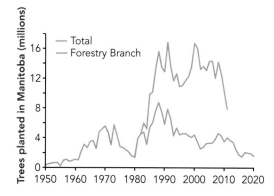

FIGURE 7 Number of trees planted annually in Manitoba, 1950 to 2020. DATA COMPILED BY GORDON GOLDSBOROUGH USING ANNUAL REPORTS OF THE DEPARTMENT OF MINES AND NATURAL RESOURCES AT THE LEGISLATIVE LIBRARY OF MANITOBA

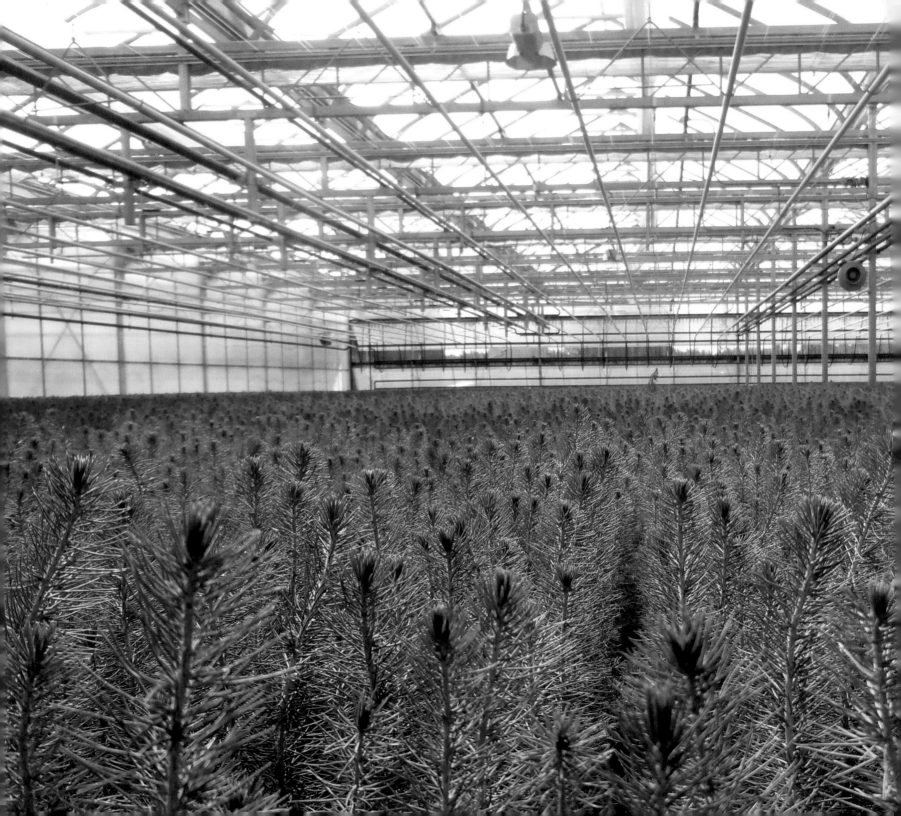

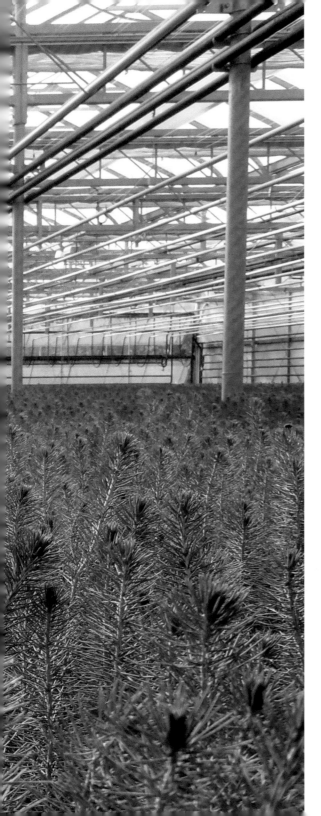

from the 1950s through the 1960s and early 1970s but a huge jump in the mid-1980s really stands out. The explanation, I think, lies in an agreement signed between the provincial and federal governments in March 1984. Its three objectives were "(a) to assist in the development and maintenance of timber supplies sufficient to ensure the long-term viability of the forest industry in Manitoba; (b) to promote the efficient utilization of the forest resource in Manitoba; and (c) to contribute to the economic development of the Manitoba forestry sector, including the improvement of employment opportunities in the sector."

Tree planting, especially by the forestry companies, was a major activity supported under the agreement, with over ten million trees planted each year during what could be called the "Golden Age" of planting in the late 1980s through 2000s. One "employment opportunity" that resulted from the

agreement was that I was hired by the Manitoba government to undertake a scientific study of the possible harmful environmental impacts of spraying herbicides for management of areas where tree planting would occur. I worked on the project for four years and I learned a lot about forestry practices in Manitoba. Another notable trend in the tree planting data was a general, long-term decrease in tree planting by the provincial government, from a peak in 1988 to its lowest value in 2020 (the most recent year for which I found statistics). Corporate tree planting in Manitoba, which had started in 1980 under the terms of a new forest management licence from the provincial government, likewise took a nosedive in 2010 and numbers after this point are not publicly available. I suspect, however, that they are a minute proportion of the millions planted during the Golden Age.

During its first forty-two years, Pineland was operated by the

Tree seedlings in the gutter-connected greenhouse, September 2012 ARIEL BRAWERMAN

The Tree Planting Car

A prominent feature at the Sandilands Forest Discovery Centre was the Tree Planting Car (TPC), a 84-foot-long modified railway car. For 54 years starting in 1919, it had been dispatched by the Canadian Forestry Association (CFA) across the prairies to educate children and adults on the benefits of planting trees. It was a classroom on wheels. At one end of the TPC was a small apartment where the CFA staff who travelled with it could sleep and eat. At the opposite end was a film projection room, and in the middle was a ramped theatre with bench seats for over 100 people. At the roofline along the length of the theatre were specimens of the major tree species that grew well on the prairies.

The costs of operating the TPC were borne by the two major railways, CNR and CPR, along with private sponsors, and the CFA. Being mobile, the car would be moved by the railway, usually by a passenger train but sometimes by a freight train, and delivered to a town somewhere in Manitoba, Saskatchewan, or Alberta (and occasionally into British Columbia). On arrival, residents would be invited inside where they would be shown slides (later, silent films and eventually "talkies") about trees and

hear lectures and pose questions to knowledgeable tree experts. Several towns would be visited during a single tour. For example, a three-week tour of Manitoba in 1973 started on 28 May at Westbourne. The next day, it was at Gladstone. Then it spent two days at Neepawa, followed by two days at Minnedosa. Then a day each at Binscarth and Foxwarren, two days at Birtle, a day each at Shoal Lake and Strathclair, then back to eastern Manitoba for two days at Ste. Anne, and a day each at La Broquerie, Woodridge, and Sprague, completing the tour on 22 June.

If the pace sounds grueling, it was! Alan Beaven, the late Executive Director of the Manitoba Forestry

Association who travelled with the TPC for the longest period of any person, from 1926 to 1946, wrote about a typical day on the TPC. He would wake up with the car sitting in a different town from the night before. Curious visitors would start to arrive before he had finished breakfast. Although there was advance publicity of the TPC's arrival in the form of posters in the local post office and newspaper ads, Beaven would walk over to the local telephone office to have them send out a "general call" reminder to everyone with a telephone. Then he walked over to the local school to invite teachers to bring their classes for a visit that afternoon. Then it was back to the TPC to help local farmers and gardeners to find solutions for their

"Schoolmaster of the Prairies". The Tree Planting Car welcomed thousands of schoolchildren during its glory years in the early-20th century. MANITOBA FORESTRY ASSOCIATION

tree problems. Sometimes, solving these problems would require a visit to a nearby home or farm. Then it was back to the TPC for a quick lunch.

After lunch, classes of students began to arrive. Depending on numbers, there might be a single session or, in larger towns, two or three sessions. Students came from the school in town, as well as rural one-room schools at distances of several miles away, transported in wagons by helpful parents. Excitement was high, as this might be the first time that some students had seen movies with sound. Then, before supper, the "tree doctor" would make a few house calls to diagnose more tree problems. The evening program for adults began at 8:00 and ran to about 10, after which there was an informal Q&A session that could run to midnight or later. Then, fall into bed, and wake up the next morning in a new town, to repeat the entire process. This was a typical day for months at a time, for 54 years.

The final year of operation was 1973 when the CPR donated the TPC to the Manitoba Forestry Association. By that time, the car had travelled over 263,000 miles and had been visited by over 1.5 million people. The TPC was doomed by a couple of factors. First was the decline of railways on the prairies, where there were fewer communities served by railway lines.

Secondly, the novelty of movies in the TPC had worn off. By the 1970s, television was sufficiently widespread that it was a more effective way to deliver the tree-planting message.

In retirement, the TPC was moved by train to Hadashville. There, its metal wheels were replaced by rubber tires and it was towed to the Sandilands Forest Discovery Centre where its wheels were re-attached. It was put on a short section of railway track and covered from sun and rain by an overhead metal roof. It sat there, no longer travelling but still used for educational purposes and surrounded by trees that grew to maturity in the ensuing 49 years. With the closure of the Sandilands Forest Discovery Centre, a new home for the TPC was needed. Fortunately, one was found at the Manitoba Agricultural Museum and, in November 2022, two enormous cranes picked up the car and set it onto a specially designed trailer. Over the course of a day, the TPC was towed to its new home near Austin, Manitoba, where the cranes reversed the action and set the car on newly installed tracks. After sitting for a half-century in the Sandilands, the car needs restoration work but the museum plans to develop it as an exhibit on the history of shelterbelts and tree-planting on farms and elsewhere in prairie Canada.

Manitoba government, meaning that its costs were borne by the provincial coffers. Any profits from tree sales went into general revenue and any shortfalls were borne by the public purse. By the early 1990s, the government of Gary Filmon was looking for savings in its annual budget. In April 1995, Pineland was converted into a Special Operating Agency (SOA), probably to test the waters for eventual privatization, as the government would do with the Manitoba Telephone System the following year. Something like a Crown corporation, an SOA is partially independent of government, which, in this case, gives it the ability to compete on the open market and potentially sell trees to customers who would not necessarily buy from a government-run nursery. At least, that was the idea.

At first, things seemed to be going well. The nursery made a tidy profit in its first couple of years as an SOA. It found new customers in Ontario, Saskatchewan, and Alberta, as well as in Minnesota and Michigan. After incurring capital

costs by embracing new greenhouse technologies, Pineland began losing money, about a quarter-million dollars a year. One major reason was growing competition from a privatized former government tree nursery in British Columbia. Being much larger than Pineland, it could produce trees more economically; essentially, it was the Walmart of trees. Compounding the problem was an ongoing dispute between Canada and USA over softwood lumber that caused the Canadian forest industry to decline. This led to reduced seedling demand for reforestation. And, of course, people were consuming less paper as they switched to online sources of news rather than printed newspapers. As I have discussed in my previous book, *More Abandoned Manitoba*, this trend has doomed many a newspaper around the province, as well as the huge papermaking plant (once a major tree planter) at Pine Falls.

One can draw parallels between the defunct Pine Falls paper mill and the Pineland Forest Nursery. Like Pine Falls, which had just built a state-of-the-art paper plant, only to demolish it nine years later, Pineland was embracing new technology in its final decade of operations. Between 2010 and 2012, it installed an innovative new plant to provide low-cost heat and electricity for its gutter-connected greenhouse complex, supplementing an existing biomass-based heating system. Supplied by Manitoba Hydro,

Tree seedlings in greenhouses at Pineland were kept warm throughout the winter, as seen in this undated photo. DAVID FLIGHT

the new plant burned wood chips, leftover cones, and forest-fire salvage that would otherwise go to waste. After these investments in efficiency, Pineland was considered one of the finest greenhouse facilities in western Canada, visited by growers from around the world who wanted to see its cutting-edge technology. Heck, even King Charles' royal forester toured Pineland. Unfortunately, the embrace of new technology pushed Pineland into a financial deficit for several years running. It was probably never going to be an operation that generated a profit. Yet, we do not expect all aspects of our government to be profit-motivated; it provides public services that are deemed to be contributions to general well-being. Why aren't trees seen as a public investment that need not be produced at a profit?

In 2018, the government closed Pineland, throwing more than 100 permanent and seasonal employees—many from Indigenous communities in the region—out of work and depriving the local economy of about $1.5 million dollars a year. Some of Pineland's tree-growing competitors, recognizing its value, were keen to buy the entire facility. Instead, the government sold the buildings to a cannabis-growing operation for a paltry $1.4 million, despite advice from nursery experts that the greenhouses were not suited to growing cannabis. Their openable roofs would expose the cannabis to weeds and pests. And, of course, open greenhouses, especially ones right next to the busy Trans-Canada Highway, might be seen as an open invitation to those who want to help themselves to the

Seeds collected from coniferous trees in the wild, extracted from cones in a spinning drum, and stored in plastic gasoline cans like these ones at Pineland, can remain viable for decades if properly dried and stored. MANITOBA FORESTRY BRANCH

merchandise. In the end, the unsuitability of the facility for its new purpose did not matter. Since the deal was consummated, the cannabis company has defaulted on its lease payments on the Crown land on which the buildings sit, and the buildings themselves have been abandoned. My sources tell me that the provincial government has taken the company to court to recover ownership of the

The final load of tree seedlings left the Pineland Forest Nursery in early 2019, after which the facility was abandoned. DAVID FLIGHT

buildings. But my request to visit Pineland to see its condition for myself was refused. I was told that the electricity and natural gas supplies have been disconnected. The state-of-the-art heat and power generator installed by Manitoba Hydro was taken back and, instead of being deployed somewhere else where its marvelous technology would continue to benefit us, it was dismantled and its two engines were sold for scrap. The remaining buildings have been badly vandalized and anything remotely of value has been taken. That includes the freon from three giant freezers, capable of holding 20 million tree seedlings, that now pose an environmental hazard. In the fall of 2022, I flew my drone over Pineland and saw the covers of its many greenhouses in tatters, looking quite post-apocalyptic.

After the closure, Pineland's stockpile of tree seeds was shipped to a private storage facility in northern Saskatchewan where they will be stored, possibly for decades, until they are germinated at nurseries in Saskatchewan, Alberta, British Columbia, and Washington state, then shipped back to us as seedlings. But it is not ideal for Manitoba to import young trees from far away, especially when there is an excellent, high-quality facility that could grow them right here in Manitoba. I asked former Pineland staff if they believed that the former nursery could be reactivated under new ownership. They felt that the vandalism and theft the facility has sustained during its short period of abandonment was too severe; the cost of rebuilding would be

prohibitively high for profit-motivated entrepreneurs. In short, a valuable provincial resource has been squandered.

In tandem with this disaster, the interest of the federal government in growing trees seems to be at an end too. In 2013, the Indian Head nursery was closed as a cost-cutting measure by the Harper government. Some of its assets were acquired by a charitable, non-profit organization and a new nursery near Weyburn was opened but on a much smaller scale than its predecessor. The irony is that tree planting is still paid political lip service. In 2023, the Trudeau government announced its goal of planting two billion trees over a ten-year period. Why? Among their many other virtues, trees can offset global climate change because they suck up carbon dioxide, that otherwise blasts into the atmosphere, and converts this greenhouse gas into new growth.

I must say, this is one of the saddest stories that I have presented to you in this series of *Abandoned Manitoba* books, because the abandonment was so short-sighted and unnecessary. Had the closure been better planned, with full consideration of expert advice, the nursery would have been sold into enlightened private ownership and spruced up. Right now, it would still be producing vital trees for a changing world.

Directions

Enter these coordinates into a GPS receiver or a map app on your smartphone.

Historic Site	Latitude	Longitude
Pineland Forest Nursery	N49.64469	W95.89209

ACKNOWLEDGEMENTS

I would have known nothing about the Pineland Forest Nursery, the Manitoba Forestry Association, and the Tree Planting Car had I not met Trevor Stanley, David Flight, and Dianne Beaven. They generously shared what they knew, and Dianne brought to my attention the existence of daily diaries kept by travellers aboard the Tree Planting Car, including those of her father Alan. Anyone interested in knowing more about the TPC should read Dianne's memoir *A Prairie Odyssey: Alan Beaven and the Tree Planting Car*, reprinted in 2023. Other fine people who shared information were Bill Baker and Deny St. George. As usual, the resources of the Legislative Library of Manitoba were critical to increasing my understanding of the province's forest industry, but I readily concede that it is still inadequate. The story of Pineland deserves an entire book.

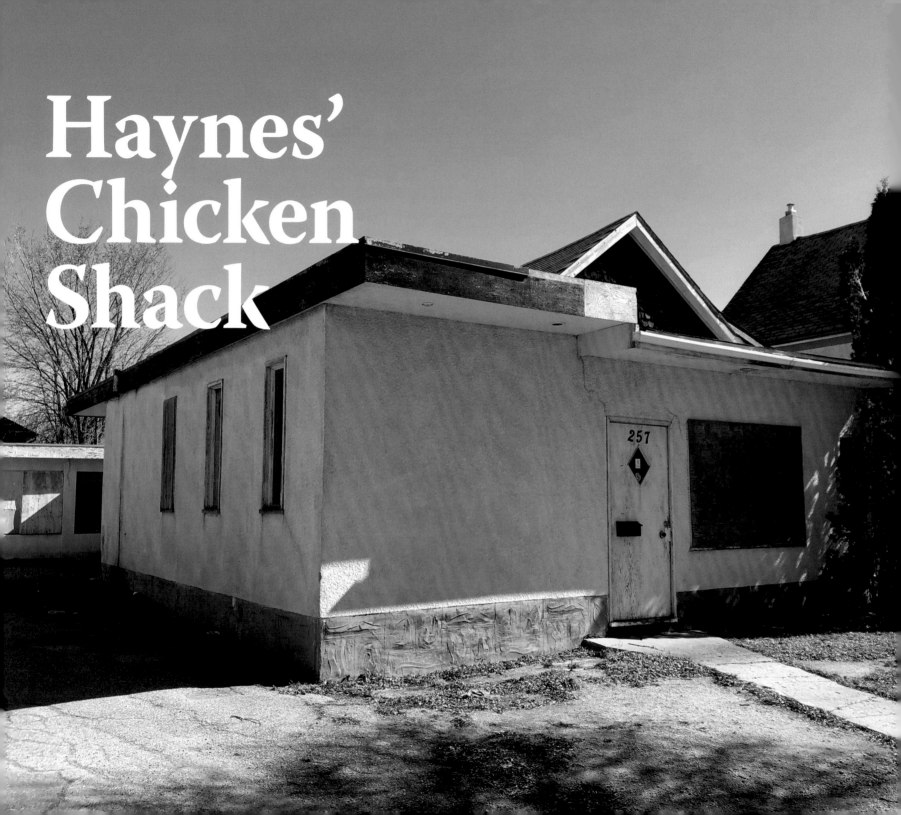

Haynes' Chicken Shack

For many of us, fried chicken is mainstream comfort food. However, combine it with such entrées as chicken tamales, barbecued spareribs, chili con carne, and fried shrimp, then overlay a jazz piano sound-track as you eat, and you have an experience that would have been positively exotic when, in 1952, Haynes' Chicken Shack opened for business on Lulu Street in downtown Winnipeg. Today, this former hotspot of cuisine and culture sits vacant and waiting for demolition.

The story of the Chicken Shack starts in the South American country of Guyana where, in 1911, Percy Augustus Haynes was born. He and his family immigrated to Winnipeg when he was a year old and moved into a small one-storey house on Lulu Street where Percy would live for the rest of his life. As a young man, Percy excelled at sports and played with championship softball and basketball teams. He was Winnipeg's welterweight boxing champ in 1933 and 1934. When the Second World War erupted in 1939, it was natural that Percy would want to enlist in the Royal Canadian Navy to serve his adopted country. They turned him down cold.

Why? Percy—who was Black—was told that visible minorities were not allowed in the Navy on grounds that racism in the close confines of ship life could lead to violence. Percy did not take the racist affront quietly,

Percy Haynes "tickles the ivories" as his wife Zena looks on in their restaurant-home, December 1975. UNIVERSITY OF MANITOBA ARCHIVES & SPECIAL COLLECTIONS, *WINNIPEG TRIBUNE* FONDS

OPPOSITE The former Haynes' Chicken Shack building on Lulu Street in Winnipeg, once home to legendary fried chicken and other comfort foods, was boarded up and awaiting demolition when I visited it in 2021. GORDON GOLDSBOROUGH

petitioning government officials to intercede on his behalf. They did and Percy became the first Black sailor in the Royal Canadian Navy. In 1943, he married Zena Bradshaw, originally from Jasper, Alberta who had moved to Winnipeg in the early 1930s to work as a jazz singer. After his return from military duty, Percy began working as a night porter aboard trans-continental trains of the Canadian Pacific Railway. It was a position that, as far back as the First World War, was held disproportionately by Black men on the mistaken belief that they were naturally subservient. Percy worked for the railway for the next 29 years while his family stayed in his home base of

Percy Haynes watches his wife Zena prepare chicken for frying in their restaurant-home, December 1975. UNIVERSITY OF MANITOBA ARCHIVES & SPECIAL COLLECTIONS, WINNIPEG TRIBUNE FONDS

Winnipeg. In 1952, Zena and Percy decided to supplement the family income by opening a restaurant in their home on Lulu Street. Open seven days a week, late into the evening, with 50 to 60 seats, the Chicken Shack thrived. It offered a unique menu of southern US foods that attracted long lineups. Just as significantly, there was live entertainment. Percy was a gifted jazz pianist and singer so, when he was not travelling with the railway, he performed. Internationally renowned entertainers such as Oscar Peterson and Harry Belafonte patronized the Chicken Shack when they were in town. Even some visiting prime ministers stopped by. Eventually, the entire Haynes home was turned over to dining and music. An addition was built on the back as a residence for Percy, Zena, and Zena's son, Delbert "Del" Wagner, from a prior marriage. Percy's influence may well have led Del Wagner to become a musician too, performing as a drummer, vocalist, and tap dancer at such places as Harry Smith's famed Club

Morocco nightclub on Portage Avenue. Yet, as successful as Percy Haynes was as a businessman and entertainer, he did not fare so well as a politician.

Percy had been active in Winnipeg's growing Black community most of his life and, in the 1970s, he was recruited by the Manitoba Liberal party as its candidate for a North End constituency in the 1977 general election. He launched his campaign at the Chicken Shack where 75 people dined on pork hocks, black-eyed peas, fried chicken, and corn bread while being entertained by a Dixieland band, after which Percy, accompanied by Liberal leader Charles Huband, made rousing speeches about the inadequacy of the incumbent MLA. Percy was especially concerned by the changing nature of his neighbourhood. Older homes were being demolished and replaced by industrial buildings, garages, and gravel yards. A case in point was a large vehicle maintenance facility built by the provincial government a block away from the Chicken Shack. Unfortunately for Percy, the fiery rhetoric offered that day did not translate into success on election day; he finished a distant third place. In 1980, he ran for a seat on the Winnipeg city council but received fewer than half the votes of the other candidate.

There was always the Chicken Shack to fall back on. Fried chicken remained its signature dish, described by a restaurant critic in 1972 as "consistently crisp on the outside, tender and moist on the inside. [But,] the offerings of the rest of the menu are somewhat mediocre." Percy and Zena carried on right up to their deaths, in 1992 and 1990,

respectively. But the blush was off the rose by the time of Percy's political campaigns. By the 1980s, there were many competitors offering the same cuisine—fried chicken, for example, had become ubiquitous from such spots as Oscar Grubert's network of Champs Chicken outlets—and there were more places for enjoying jazz and blues music. The deterioration of the neighbourhood around the Lulu Street restaurant likely also contributed to its wane. After Zena and Percy were gone, a pair of long-time employees bought the business from the Haynes estate, along with the fried chicken and barbecue sauce recipes. They tried to keep it afloat but, having exhausted their life savings, they closed Haynes' Chicken Shack forever in September 1996.

A few months ago, I walked past the old, vacant restaurant on Lulu Street. All its windows were boarded up and the yard was strewn with garbage and abandoned shopping carts. A forlorn realty sign lay on its side in front of the former entrance. Yet, despite the passage of some 27 years since the demise of Haynes' Chicken Shack, my imagination conjured up the delicious smell of fried chicken that would have emanated from it for over four decades. Mmmmmmm!

Directions

Enter these coordinates into a GPS receiver or a map app on your smartphone.

Historic Site	Latitude	Longitude
Haynes Chicken Shack (257 Lulu Street)	N49.90835	W97.15579

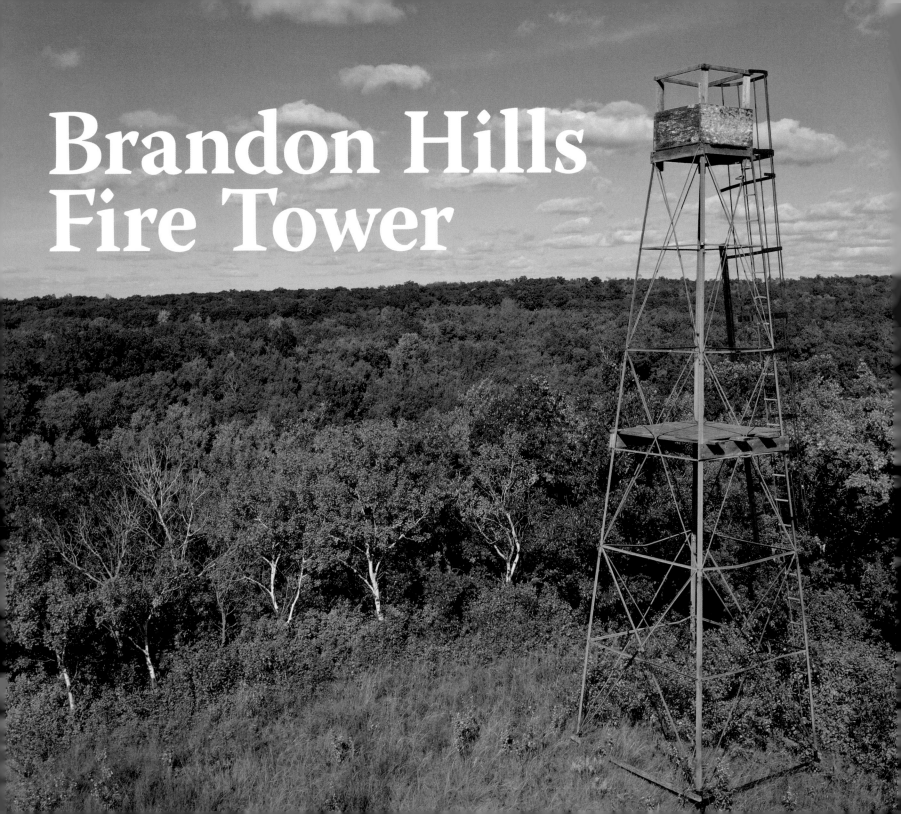

Brandon Hills
Fire Tower

As a child of the 1960s, I grew up with cartoon bears like Winnie the Pooh, Yogi ("smarter than the average ranger") Bear, and of course Smokey the Bear. The bear that probably had the most significant impact on my becoming an environmental biologist was Smokey and his urgent message for forest conservation: "Only YOU can prevent forest fires!" My memories include romantic notions of stalwart men in towers above the treetops, vigilantly looking for signs of trouble. That is how you detect forest fires, I thought, by long hours of tedious observation. So, when I started researching this chapter, I asked provincial government officials how many fire towers exist in Manitoba. None, they replied. The towers were getting old and decrepit and were removed a decade ago in the name of safety. Then I heard from Rod Biggs, a listener to my weekly radio column. There is an old fire tower at Sasaginnigak Lake, he said, on the east side of Lake Winnipeg, about 130 crow-fly miles northeast of Winnipeg. (The tower is mentioned specifically in a 1936 government report, so it is one of the earlier specimens built in Manitoba.) With Rod's encouragement, I went looking and found a few more. And therein lies a story of how forest fires were detected in the "old days" and why those methods have been mostly abandoned today.

A galvanized metal fire tower, erected by the Manitoba government in the southern area of the Brandon Hills, still has a wooden observation box at its top, above the forest canopy. My drone visited the tower in September 2022. GORDON GOLDSBOROUGH

In the early twentieth century, the oversight of forests (and other natural resources) in Manitoba was the responsibility of the federal government. It hired people to work in high-risk fire areas, generally in places close to human settlements where accidental or intentional fires were most prone to happen. It was a labour-intensive process whereby rangers would patrol on horseback, by canoe, or on foot. Covering a large area was essentially impossible but, as of 1921, aircraft were used for regional fire detection. In 1930, Manitoba gained control over its natural resources and thereafter assumed responsibility for fire detection and suppression. In the "settled margins" of forested areas, the provincial government began to erect lookout towers. Made of wood and later of steel, these towers put an observer above the forest canopy, usually at heights ranging from 40 to 80 feet. Given the flat terrain of Manitoba, the distance one can see from a height of 80 feet depends on several factors, including atmospheric conditions, but is generally at least 10 miles. From the top of the tower, a person might detect a fire at a much greater distance because the appearance of smoke rising on the horizon is a pretty good indicator of unseen fire below it.

In 1931, the Manitoba government built 19 fire towers, each equipped with a device called a "Fire Finder" that provided a precise measure of the directional bearing to a fire. By 1936, there were 60 similarly equipped towers. Calculating the location of a fire involved combining and triangulating from the observations of two or more towers. Therefore, rapid communication was essential. I

Smokey's Tree Stump

Sharp-sighted travellers along the eastbound lane of the Trans-Canada Highway between Richer and Hadashville may see, sitting in a cleared area of the forest on the south side of the roadway, an object that looks remarkably like a large tree stump. And when I say large, I mean huge; the stump is at least ten feet in diameter. This would make it one of the largest trees in Manitoba. But there's the rub. The stump is not real; it is made of concrete. Its story goes back to early September 1955 when, after a hot dry summer, a massive forest fire swept through this part of the province, causing the closure of the newly opened Trans-Canada Highway. I had been told that the provincial government proposed to commemorate the fire and the brave firefighters who fought it by erecting a giant statue of Smokey the Bear, standing atop a tree stump, alongside the highway where the fire had occurred. But that did not seem like the whole story to me. My research found that the fire had started in three separate places, which indicated it had been set deliberately. Tragically, three teenage boys (two brothers and their cousin, one of whom had a cast on his leg so he could not outrun the fire) were caught in the blaze and perished. I suspect the senseless tragedy was what motivated the statue of Smokey. However, information about the stump is sketchy. I could find nothing about it in official government documents. Several verbal sources told me that the stump was constructed when the Trans-Canada Highway was being twinned which, according to records of the Highways Department, occurred between 1970 and 1972. Local lore claims that two students working for the provincial government one summer were put to work building the stump. It was supposed to stand alongside the highway but, due to a last-minute decision to relocate the highway farther north, it ended up off the highway. It seemed to be a case of "out of sight, out of mind" as the site was slowly overgrown by the new forest that reclaimed the burned area. By 2010, when a newspaper reporter visited the site, the stump was surrounded by good-sized trees at least 40 years old. A few years ago, gravel was needed for highway maintenance in the area and the government authorized a construction company to establish a gravel quarry near the stump. They cut down a bunch of the trees, thereby revealing the stump, and the government planned to move it to the nearby Sandilands Forest Discovery Centre (discussed in a chapter on the Pineland Forest Nursery). However, that plan met local opposition, for reasons unknown, so it was moved to the side of the quarry and abandoned there. That was where it stood when I had my photo taken standing, like my hero Smokey, atop the stump.

The author standing atop Smokey's Tree Stump, June 2019.
MARIA ZBIGNIEWICZ

was surprised to learn that, even in the 1930s, many of the towers were connected by telephone lines. Ones in remote areas used carrier pigeons donated by the Royal Canadian Air Force. If an observer saw a fire, he would release two pigeons with identical messages—giving the bearing of the fire and its estimated distance—in hopes that at least one pigeon would reach its destination. It was not a sure-fire method because sometimes pigeons could not fly due to heavy smoke or other causes, or they might be intercepted by predators along the way. Eventually, birds were replaced by radios. With a network of fire towers staffed throughout the day, foresters could quickly locate a fire and work to extinguish it. One government report I found stated that a forest fire near Great Falls, on the Winnipeg River, was detected within 30 minutes of ignition by four towers, at distances from the fire ranging from 21 to 35 miles. With rapid communication and action, the burned area was restricted to just five acres.

The provincial network of fire towers continued to grow through the 1940s to 1960s. In 1966, six towers were erected to bring the total network to 132, ninety-three percent of which were 80 feet tall and made of galvanized steel. The following year, five more towers were added but there were signs that a change was afoot. A report noted that "steadily increasing costs for seasonal towermen and difficulty in procuring employees for remote locations has promoted studies of aircraft detection as an alternative to tower lookout systems." No wonder! I can hardly imagine the monotonous life of those poor towermen. Aircraft

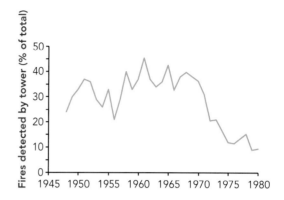

FIGURE 8 Provincial government statistics compiled between 1948 and 1980 show the proportion of forest fires each year that were detected by fire towers. Despite a lot of inter-annual variability, the number seemed to increase slightly in the 1950s and 1960s, then decrease markedly through the 1980s, allegedly because more fires were being detected by aircraft and by the general public. ANNUAL REPORTS OF THE MANITOBA DEPARTMENT OF NATURAL RESOURCES, LEGISLATIVE LIBRARY OF MANITOBA, COMPILED BY GORDON GOLDSBOROUGH

were increasingly prominent in annual government reports moving through the 1960s. In 1970, four chartered aircraft were able to cover an area of 35,000 square miles in northern Manitoba. If you look at statistics on the proportion of Manitoba's forest fires between 1948 and 1980 that were detected by fire tower observers (see Figure 8), there was a precipitous drop over time, from 35% to 40% in the 1960s to just 10% by 1980. One might be inclined to interpret this trend as evidence of the growing role of aircraft. Not so! The proportion of fires detected by aircraft varied a lot from year to year, from 5% to 43%, but showed no trend over time, averaging 23% versus 29% for fire towers over the same period. Yet, government reports through the 1970s continued to glow about the virtues

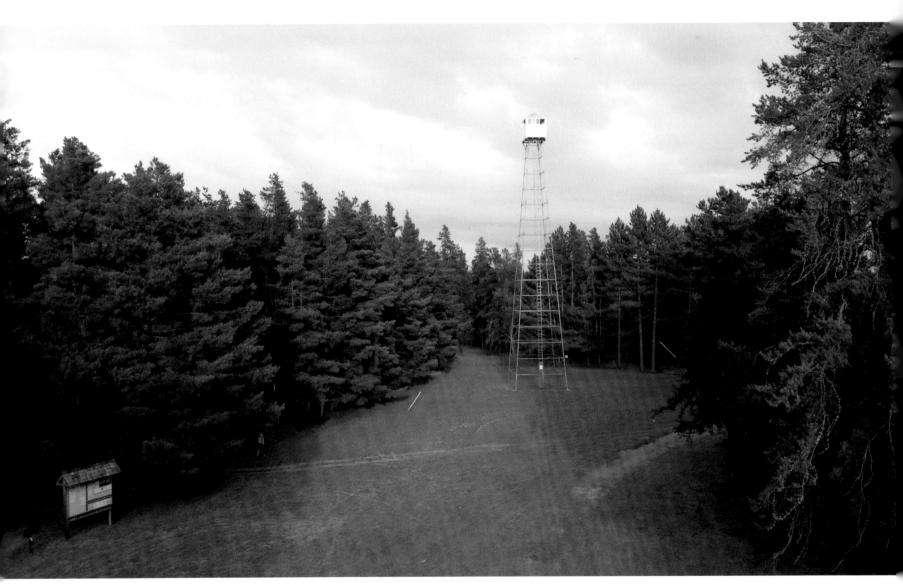

A fire tower in the village of Woodridge, in southeastern Manitoba, still stood when I visited the site in August 2020. Being deathly afraid of heights, I made no attempt to bypass the measure that prevented people from climbing its access ladder. GORDON GOLDSBOROUGH

of chartered aircraft, as 21 fire towers were removed in 1971. (Was it a case of boys and their high-priced aircraft toys?) By 1980, the number of towers had dropped to 58 and, in 1983, a real-time system was installed to detect lightning to assist in early fire detection and suppression. The government acknowledged that, despite the increased use of technology, in many years, the majority of fire reports came from the general public, commercial aircraft, and railway workers. Today, real-time remote sensing from orbiting satellites, combined with people carrying cellular and satellite telephones, has made the detection of fires quicker and easier. And we now take the view that carefully managed fires in remote areas may be desirable because they help to renew the forest. Jack pines, for example, will not release their seeds until the trees are burned in a fire.

Despite what I was told by the provincial government, at least one provincial tower besides the one at Sasaginnigak has escaped demolition. It stands in the village of Woodridge in the Woodridge Provincial Park of southeastern Manitoba. And there are others outside of provincial jurisdiction. For example, I am told there are five fire towers in Riding Mountain National Park. There are two old, disused towers in the Brandon Hills, a few miles southeast of Brandon. One is a stubby, rusty metal tower atop a small hill in the heart of the Hills that, judging from its simple design, is one of the oldest survivors, probably from the 1930s. Its commanding view of the surrounding area probably explains why someone

has attached solar-powered telecommunications equipment to it. A much taller, galvanized metal tower that I suspect is of newer vintage, at the edge of private property, has a makeshift wooden platform partway up, and a rickety-looking observation box at the top. I have never been fond of heights and, in consideration of the towers' advanced age, I made no attempt to climb to their tops. I was perfectly satisfied with the view from my remotely piloted drone. Just saying.

Directions
Enter these coordinates into a GPS receiver or a map app on your smartphone.

Historic Site	Latitude	Longitude
Brandon Hills Fire Tower (short)	N49.71231	W99.86805
Brandon Hills Fire Tower (tall)	N49.70907	W99.89602
Sasaginnigak Lake Fire Tower	N51.60048	W95.67231
Woodridge Fire Tower	N49.28968	W96.14726

ACKNOWLEDGEMENTS
I am grateful to Rod Biggs for making me aware of the old fire tower at Sasaginnigak Lake, igniting my interest to learn more about the history of fire detection in Manitoba. It is too bad that I did not start looking a decade ago when more of the towers were still standing. Annual reports from the Manitoba Department of Natural Resources (also known by other names through the years), held at the Legislative Library of Manitoba, were helpful in illuminating the history of Manitoba's fire towers.

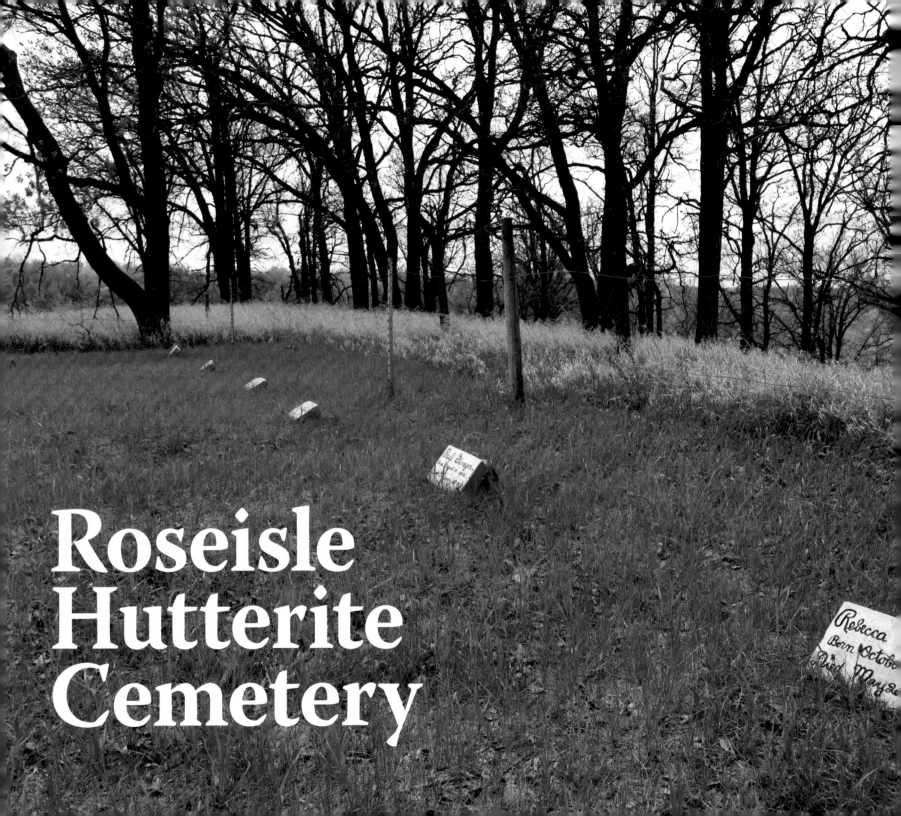

Roseisle
Hutterite
Cemetery

One might imagine the public consternation a century ago when a group of German-speaking Christians arrived in Manitoba. Unlike previous immigrants, this group dressed and lived conservatively, eschewing many pleasures of modern life in the name of piety. They were Anabaptists who, like Mennonite and Amish people, experienced baptism later in life rather than as infants. However, unlike other Anabaptists, they believed in collective ownership of worldly goods and lived in communal colonies, or Bruderhofs. They were Hutterites.

In November 1918, Hutterites moved to Manitoba from South Dakota after suffering persecution during the First World War for their pacifist beliefs. They bought farmland around the village of Benard, roughly halfway between Winnipeg and Portage la Prairie, and established six colonies that adopted the names Bon Homme, Huron, James Valley, Maxwell, Milltown, and Rosedale. All of them were Schmiedeleut (pronounced SMEE-de-light), one of three main branches in the Hutterian faith, the others being Dariusleut and Lehrerleut that are found today primarily in Saskatchewan and Alberta. My friend John Lehr, a retired historical geographer at the University of Winnipeg, tells me there is a largely unknown dimension to this origin story. The first Hutterites in Manitoba

Hutterites were quick to embrace improved technology for farming, as shown by this photo of a group of men at the Huron Colony trying to start a "new-fangled" Aultman & Taylor 30-60 gasoline-powered tractor, circa 1924. ROY WARD

had actually arrived twenty years earlier, but the details are fuzzy because this early group did not stay. About thirty Dariusleut Hutterites from South Dakota came to Canada in 1898. Worried about being conscripted by the American government for military service during the Spanish American War, they established Canada's first Hutterite colony on two square miles of land near Dominion City. They built a grist mill to turn grain into flour—for themselves and as a commercial enterprise for other farmers in the region—and it thrived. Because the milling process took time, the Hutterites provided

OPPOSITE Several grave markers in the former cemetery of the Roseisle Hutterite Colony, southwest of the village of Roseisle, which is tended by extended family members of those buried in it. GORDON GOLDSBOROUGH

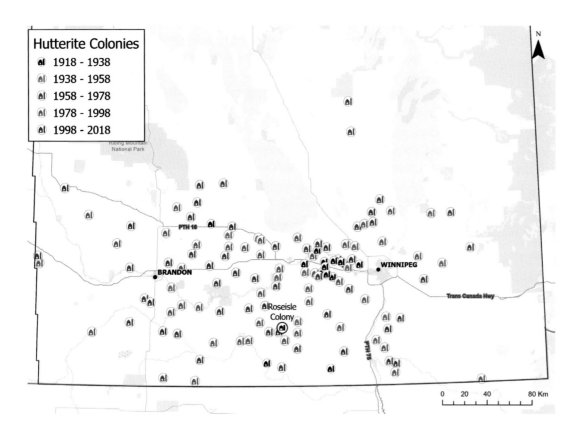

Locations of Hutterite colonies in Manitoba. PAIGE KOWAL, USING INFORMATION FROM *ELIE, MANITOBA: HUTTERITE DIRECTORY* BY JAMES VALLEY HUTTERIAN BOOK CENTRE, 2018

accommodation for non-Hutterian farmers who came to the colony to have their grain milled. This drew business away from merchants at Dominion City. Facing anger from the merchants, the Hutterites sold their land and returned to the United States in 1905. Their mill was taken over by a local resident but was later destroyed by fire. According to

Lehr, there are no residual signs of this abandoned Hutterite colony, but I would be interested in hearing from a reader who knows otherwise.

Unlike the first Hutterite colony from 1898, the ones established in 1918 all exist today and have all spawned a handful of daughter colonies. When the population of a colony grows to a certain size, usually in the range of 100 to 200 people, it divides to form two colonies. All the assets of the parent colony are divided and some of its members move to the new colony, sometime located near the parent but often at a considerable distance. From those original six colonies, today there are 120 colonies around Manitoba. Unfortunately, not all the daughters prospered. One of them, Thorndale Colony, had been established in 1924 on rented land four miles southeast of Manitou, as a daughter of the Huron Colony. Five years later, it relocated to a picturesque site, alongside a small creek, four miles southwest of the village of Roseisle and renamed itself the Roseisle Colony. However, that

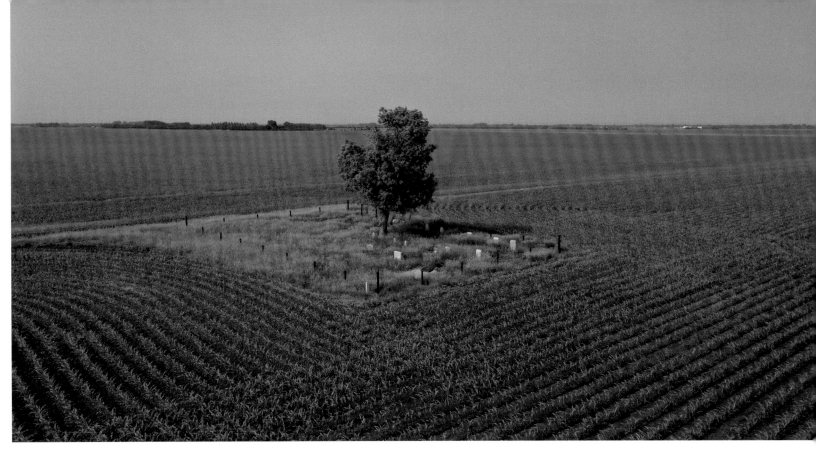

The Enns Family Cemetery, southeast of Winkler, is located far out in an agricultural field and the access road to it has been removed. It can only be accessed by visitors and family members in the spring or fall. GORDON GOLDSBOROUGH

colony was short-lived, being abandoned in 1936, apparently after suffering several consecutive years of crop failure. I was told that banks would not advance the colony any money to buy food and seed grain. Its members returned to South Dakota and established the Jamesville Colony, which is still in operation today.

As the Roseisle Colony existed for just seven years, I expected there to be little left at the site. So, I was surprised to learn from John Lehr that there was a cemetery where deceased members were buried during the colony's short life. He did not know its exact location, but I had no trouble finding it. The cemetery was situated a short distance off a municipal road, on a site overlooking the creek valley, nestled in the shade of mature oaks. Someone has clearly been maintaining the cemetery because its grass was neatly mowed and there was metal wire serving as a boundary. Six graves, each marked with a small concrete tablet, provided the name, full birth date, and full death date of the person buried there. Three males and three females—with the surnames Glanzer, Waldner, and

Wurtz—ranged in age from 5 to 79 years. One of them, David Glanzer, was identified as a Reverend, suggesting that he had been the colony's leader. But there were details about the cemetery that confused me. Three of the deaths had occurred in 1936, 1937, or 1938, supposedly after the Roseisle Colony had moved back to South Dakota. A second confusing detail was that the grave markers all looked identical in size and style and did not look old enough to date to the 1930s, suggesting they were put here more recently. By whom? And who was tending the long-abandoned cemetery?

Linda Maendel solved these mysteries. In early 2019, she contacted me, having read my first two *Abandoned Manitoba* books. She was researching the history of the

A group of young women at the Huron Hutterite Colony, circa 1925.
ROY WARD

Thorndale and Roseisle colonies, where her two grand-mothers—Susanna Glanzer and Anna Waldner—had lived while in their teens, and wondered if I could help. It turned out that Reverend David Glanzer was her great-grandfather. During her research, Linda had spoken with family members about their recollections of the abandoned colonies and had found documents scattered here and there. Among them was a letter written in 1930 by colony member Eberhard Arnold to his relatives in Germany in which he described the new colony:

> In Roseisle I found a Bruderhof of such outstanding scenic beauty that it quite overwhelmed me, and I felt a great longing for home—woods like those in Sannerz and the Rhön Bruderhof, with valleys and ravines as at the Wilde Tisch.

Linda clarified that the new colony could not keep up with the payments on its mortgaged land. In 1936, the ten Hutterite colonies existing at that time, including Roseisle, agreed to pay an equal share of the debt owed to the mortgage holder, Icelandic grain merchant Peter Anderson. In time, Roseisle members were supposed to pay back the other colonies but there is no record that this was ever done. They relocated to South Dakota over a period of three years, explaining the death dates in the cemetery up to 1938. They took possession of a former Hutterite colony that the state had intended to turn into a retirement community but had abandoned because the site was too far from hospitals. Their leader, David

Glanzer, was left behind because he had supervised the evacuation of the Roseisle Colony and had contracted pneumonia while travelling in an unheated truck during the winter. By this time, Linda's grandmothers had married and moved to other Manitoba colonies, so they were left behind when their families returned to the United States. In 1998, five people who had died at the short-lived Thorndale Colony were disinterred from an abandoned and overgrown burial site southeast of Manitou and moved to the cemetery of the parent Huron Colony. But the graves from the former Roseisle Cemetery were not moved. Instead, this little cemetery is lovingly tended by members of the Oak Bluff Colony, near Morris.

The story of the Roseisle Hutterite Cemetery has a mostly happy ending, but I have a grave concern for other cemeteries around Manitoba. Over the past few years, the public has heard much about potential burial sites associated with former Indigenous residential schools.

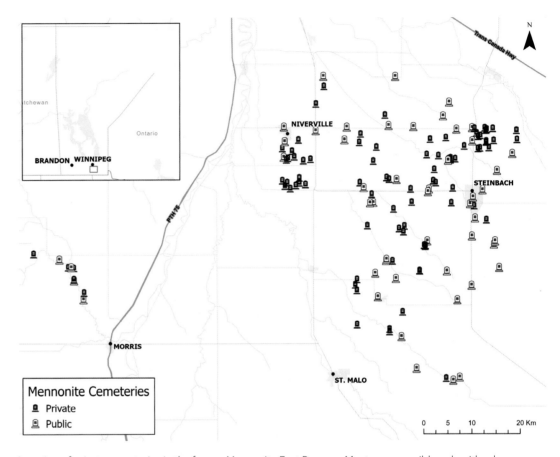

Location of private cemeteries in the former Mennonite East Reserve. Most are accessible only with advance permission from the landowner. PAIGE KOWAL AND GORDON GOLDSBOROUGH USING DATA FROM *HISTORICAL ATLAS OF THE EAST RESERVE* EDITED BY ERNEST N. BRAUN AND GLEN R. KLASSEN, 2015

The concern is that some children died while living at the school and, instead of being returned to their home communities, their bodies were buried in unmarked graves on the school grounds. Grieving communities are using the technology of ground-penetrating radar to find places where the soil was disturbed in the process of digging a grave. Yet, the problem is not confined to residential schools. People who

died in tuberculosis sanatoria or in institutions for those with intellectual disabilities were buried anonymously in common graveyards too. There are two large cemeteries associated with the former Brandon Mental Health Centre, for instance, but at least lists exist of those buried in them.

It seems to be a common Anabaptist practice to bury one's kin on family-owned property rather than in a public, communal cemetery. Burial sites exist on farms all over southern Manitoba where Mennonites settled. Time passes and now some of these farms are no longer owned by the same family. The new owner does not see the value in setting aside potentially farmable land where graves are located. I think, for example, of a very visible burial site on the edge of Highway 30, about a mile north of Altona. There we find five graves, marked with stones, closely encroached by agricultural land, that were put there in 1890. But agriculture is not the only factor threatening private cemeteries around the province. My friend Ernie Braun, who has done a great job at mapping the locations of many early burial sites east of the Red River, in what was known as the Mennonite East Reserve, says that burial sites are threatened by urban sprawl too. He was contacted recently about a possible grave site in the village of New Bothwell. They are planning to use ground-pene-trating radar to determine if graves are indeed present there. Ernie says there is a similar situation in Steinbach, where graves are known to exist in the area south of McKenzie Avenue, one of the city's main thoroughfares. Of the 116 cemeteries and burial sites in the former East Reserve, Ernie says 76 of them are on private land and therefore at risk. And he acknowledges that his burial site survey may have missed some of the obscure private ones so the percentage at risk could be even higher.

In the Municipality of Rhineland, the Manitoba Genealogical Society has catalogued cemeteries and burial sites and lists 191 of them in its database. Of these, 90 of them are family burial sites on private land. The situation is essentially the same in the Municipality of Stanley next door, with 42 out of 80 burial sites being private family ones. In late 2021, an article in the *Winkler Voice* newspaper, written by retired teacher Henry Wiebe, drew attention to the Enns family cemetery southeast of Winkler. Burials there are believed to have begun in 1876. The property was sold out of the family in 1952. The new owner demolished all the buildings in the Enns family farmyard and, more significantly, he ploughed up the road used to access the site. The small cemetery is now surrounded by a corn field. It was maintained by a family member until his death in 1978 and, when Mr. Wiebe visited in 2018, the cemetery was in what he called a "state of gross neglect." He and a cousin cleared the site and were able to find grave markers of 20 people with another 11 suspected but which had no grave marker. The landowner lives outside of Manitoba and has rented the property to a local farmer who, while sympathetic to the people who wish to visit and maintain their family's cemetery, has made clear to Mr. Wiebe that nobody is to go there when the crop is growing. Family members can visit the site only in the early spring before crops are planted, or

in the late fall after they are harvested. A result is that the cemetery quickly becomes overgrown during the summer.

What can be done to address this insidious problem? In addition to the use of ground-penetrating radar to identify graves sites, Ernie Braun suggests two courses of action. First, we need to impress on landowners where known or suspected graves may exist of the need to do something, especially if they are elderly and the land may change hands in the near future. If the graves sites are known, they should be marked conspicuously or, better yet, encircled with a perimeter fence or barrier. Second, we need to ensure that young landowners who have purchased long-held family lands are alerted to the potential problem before they do damage. People like Ernie Braun, who are mapping these abandoned cemeteries, are happy to share their findings with municipal governments who, in turn, can inform landowners.

Meanwhile, Henry Wiebe, along with his wife Ada, are trying to raise awareness among provincial government officials. They note that public cemeteries in Manitoba are subject to the Cemeteries Act. It prescribes that public cemeteries must be surrounded by a fence 4½ feet tall, sufficient to keep animals out, and the cemetery must be maintained. Unfortunately, the private cemeteries are not subject to this Act. The Wiebes suggest that the Cemeteries Act be amended to require all burial sites in Manitoba to have perpetual care and year-round public access. The Wiebes observe that many of the family burial plots were established on the inside of a quarter-section, which means

they are not directly accessible by road. Farmers who plant crops around these burial plots are understandably reluctant to permit access. Yet, without legal protection, these burial sites will eventually be ploughed under and forgotten. Ultimately, there needs to be basic respect shown to the people who preceded us, whether that means at the sites of former Hutterite colonies and residential schools, on the edges of expanding cities, or in the middle of farm fields.

Directions

Enter these coordinates into a GPS receiver or a map app on your smartphone.

Historic Site	Latitude	Longitude
Roseisle Hutterite Cemetery	N49.45076	W98.38759
Enns Family Cemetery	N49.15575	W97.87681

ACKNOWLEDGEMENTS

This chapter would not have been possible without the help of Linda Maendel who researched and wrote a memoir about the long-forgotten Thorndale and Roseisle colonies. I am grateful to Roy Ward for sharing photos taken by his late father Charles Ward while he taught at the Huron Hutterite Colony in the mid-1920s. The originals were lost when Roy's house burned down. Fortunately, my high-resolution scans made years ago preserve this exceptionally rare collection. Finally, I thank Dr. Jock Lehr for sharing his voluminous knowledge of Hutterite history in Manitoba and for gifting me a copy of the useful *Hutterite Directory* published by the James Valley Colony, one of the original six colonies established in 1918.

TRACTORS WITH LUGS PROHIBITED

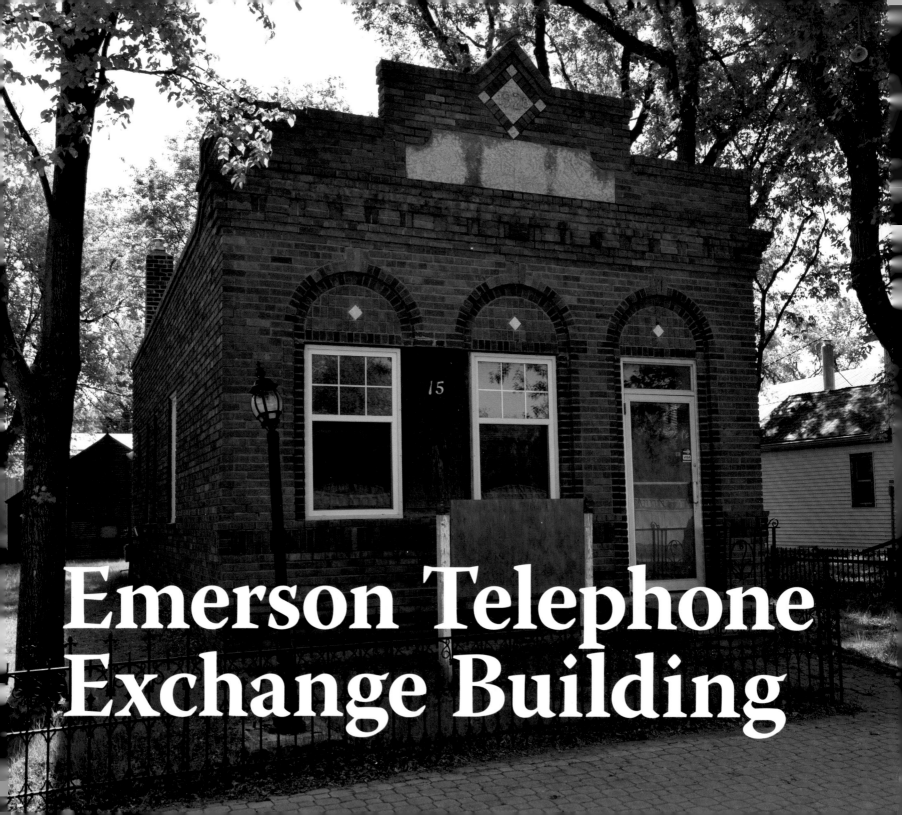

Emerson Telephone
Exchange Building

Who can forget comedian Lily Tomlin's portrayal of Ernestine, the telephone switchboard lady, with her snorted, nasal intonation of "one ringy dingy"? A telephone exchange, where women like Ernestine worked, was essentially where the linkage between two telephone users was made. When telephones first arrived in Manitoba, in 1878, a person wishing to make a phone call picked up their telephone receiver, told an operator to whom they wished to be connected, and the operator made the connection. In comparison, an automatic exchange enabled a person wishing to make a call to simply dial a number and the machinery made the connection without the intervention of a human. The first automatic exchange in Manitoba was installed at Brandon, in 1917, and Winnipeg telephones began to switch over to automatic service in 1920. Winnipeg was the first large city in Canada to have a fully automatic service, by 1926. In time, and especially after 1949, all communities around Manitoba would have automatic exchanges but, for decades in the early- and mid-twentieth century, the need for human involvement necessitated the construction of buildings where the circuitry and switchboard operators could be housed. One such building, now vacant, stands at Emerson.

OPPOSITE The exterior of the vacant telephone exchange building at Emerson, May 2022. At some point in its history, the two front windows were replaced by a single, wide window but, more recently, the separate windows have returned. The wrought iron fence along the sidewalk is not original. GORDON GOLDSBOROUGH

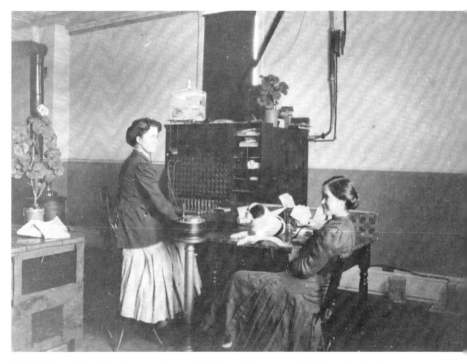

The interior of the telephone exchange building at Emerson might have looked something like this view at Medora, circa 1915, with switchboard operators (usually women) connecting callers with their destination. ARCHIVES OF MANITOBA, MANITOBA TELEPHONE SYSTEM COLLECTION #62

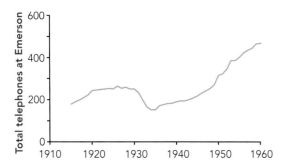

FIGURE 9 The number of telephones served by the Emerson Exchange Building showed a slow, generally increasing trend between 1915 and 1960. GORDON GOLDSBOROUGH USING DATA FROM MTS ANNUAL REPORTS AT THE LEGISLATIVE LIBRARY OF MANITOBA

In 1928, the Manitoba Telephone System (MTS) hired architect Alexander D. Melville to design telephone exchange buildings for towns around Manitoba. Born in Scotland, Melville trained in architecture and civil engineering at Aberdeen before moving to Winnipeg in 1903. He practised with his brother William, who had arrived two years earlier, and together the Melvilles designed all sorts of public buildings around Manitoba. There are at least twenty-eight telephone exchange buildings making up the Melville architectural legacy, among which are seven designed for MTS in 1928. Modest, wood-frame structures, commensurate with a small number of telephone users, were built at Baldur, Crystal City, and Roland. The building at Crystal City is still standing. Emerson, Roblin, Souris, and The Pas apparently warranted more space and therefore got a larger, more substantial building made of bricks. The ones at Emerson and Roblin were nearly identical in appearance but made of different coloured bricks, red and yellow, respectively. The buildings at The Pas and Souris were similar but slightly wider, probably because they were intended to serve larger communities with greater numbers of telephone users, therefore requiring more circuitry. All four of these buildings survive.

To construct these telephone buildings, Alexander Melville issued a call for tenders in July 1928, and in early August, it was announced that the building for Emerson had been awarded to Winnipeg-based contractor Alfred H. Bears. Within a week, Bears was hard at work. The one-storey brick building on Main Street would be 20 feet wide and 40 feet deep, with a concrete foundation and a crawlspace. The front façade had a door and two windows, each with a decorative half-circle of bricks above them. The original configuration of the interior is unknown because, through the years, it has been extensively renovated but I speculate it contained a general office for record-keeping, a room for the switchboard and other miscellaneous circuitry, and a storeroom for equipment. Each side of the building had four windows along its length. A rear door provided access to a single-storey, corrugated metal building—perhaps a garage for utility vehicles—at the back of the site. A two-storey wooden building beside the telephone exchange, dating from 1882 and still standing, had four bedrooms on its upper level that housed telephone operators, most of whom were single women.

In the early twentieth century, telephone use in Manitoba grew dramatically. In the 25-year period from

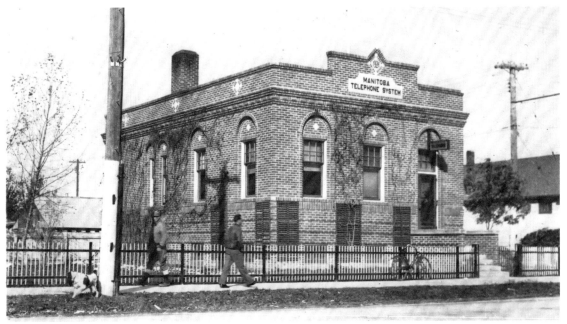

The telephone exchange building at The Pas, seen in this undated postcard, shared a pedigree with the one at Emerson, both having been designed by architect Alexander Melville (1873–1949) and built in 1928. The building at The Pas was slightly wider than the one at Emerson, as revealed by the different amounts of space between their two front windows. Today, the building at The Pas is still occupied by MTS but its front façade has been sufficiently renovated as to be unrecognizable.
GORDON GOLDSBOROUGH

1908 to 1933, the total number of phones went from 14,042 to 59,180, an increase of over 400%. About 60% of the telephones were in Winnipeg. In the Emerson area, the trend was not so dramatic (see Figure 9). In 1915, there were 179 telephones in service, but the total had declined to 165 by 1933, mainly due to a precipitous drop among rural subscribers in the early years of the Great Depression. Subscribers in Emerson itself during the same period increased slightly, from 105 in 1915 to 110 in 1933. But the number of phones was still trivially small compared to today. I calculated that, by the mid-1920s, there were about ten people for every telephone in Manitoba. By 1981, that statistic had dropped to just two people per telephone. Today, I suspect the ratio is close to one telephone per person, as many of us carry a mobile telephone and no longer have a landline in our homes. Some people even carry two or more mobile phones to separate their working and private lives.

In 1950, telephone service in Emerson was disrupted when a catastrophic flood from the nearby Red River forced the exchange building to be evacuated. Its operators were transferred to Morris and later to Winnipeg. A photo of the building shows water lapping

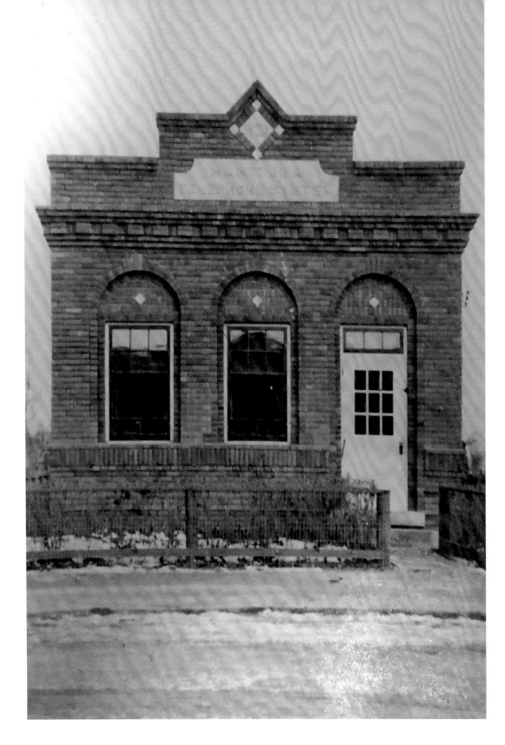

A view of the telephone exchange building at Emerson around the time of its construction in 1928. ARCHIVES OF MANITOBA, MANITOBA TELEPHONE SYSTEM COLLECTION #24

at the bottoms of its front windows. Eventually, the operators returned and service resumed. Automated calling finally came to Emerson in 1968 when a new exchange building was constructed a few blocks away from its predecessor. Emersonians joined the 91% of Manitobans who enjoyed automated telephone dialing by this time. The old building was stripped of its telephone equipment and neon lighting, then sold into private hands before being acquired by the local credit union. When the credit union built a new office next door, the former exchange building was occupied successively by a barber shop, art studio, and several hair salons that, at times, also hosted catalogue sales and a community newspaper in a back room. The

present owner, my friend Wayne Arseny, has had the building since the early 1990s but the last hair salon moved out in 2019. The interior is still configured as a salon, with hair-washing sinks around the perimeter of the main room but, it seemed to me when I visited in early 2023, that the building could be turned easily into something else. The prolonged COVID-19 pandemic has not helped in finding a new use. Meanwhile, the next-door dormitory for telephone operators is still used as residential space although the bedrooms on the second floor have been merged into a single apartment.

In 1993, as a part of an $800 million network upgrade by MTS, 115 telephone users in the Emerson area finally received individual lines to replace the party lines they had had for decades. Not only did the change give callers more privacy from nosy neighbours, but it also became possible to connect fax machines and computers to a phone line in Emerson, opening the door to the soon-to-arrive internet and vast new possibilities for communication. Telephone exchange buildings are still needed to house the local circuitry that makes global telephone calls possible, but few of the ones from the early twentieth century serve their original purpose. And to what extent will bricks-and-mortar structures be necessary as an increasing number of us "cut the cord" on our landline and switch to a mobile telephone? So, the next time that you are in any of the 32 places around Manitoba where an old telephone exchange building still stands and make a call on your cell phone, give some thought to the many hard-working operators who made phone calls possible in the 95 years since a little building in Emerson was constructed. Ernestine would be pleased.

Directions
Enter these coordinates into a GPS receiver or a map app on your smartphone.

Historic Site	Latitude	Longitude
Emerson Telephone Exchange Building	N49.00646	W97.21541
The Pas Telephone Exchange Building	N53.82430	W101.25073

ACKNOWLEDGEMENTS

I thank Wayne Arseny for allowing me to see the interior of the former Telephone Exchange Building at Emerson and for generously sharing information on its history.

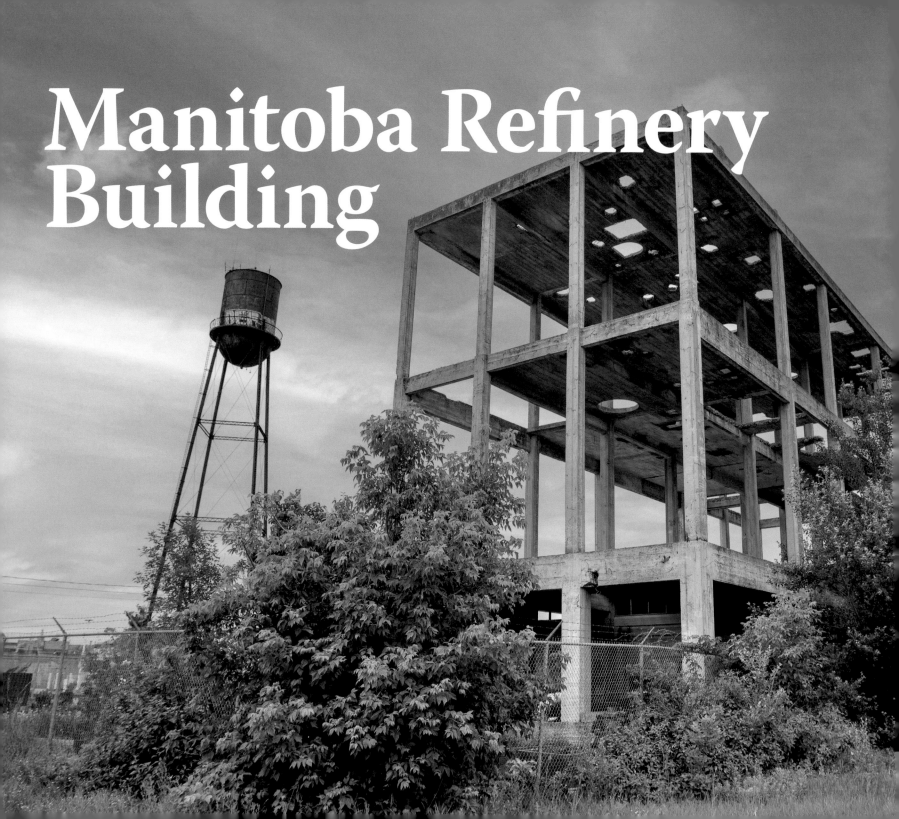

Manitoba Refinery Building

There are only a few abandoned buildings around Manitoba whose history I have not been able to uncover. Yet, one that eluded me for a long time was a multi-storey structure at the corner of Plinguet and Archibald streets in Winnipeg. Every time that I passed it, I wondered what the building had been and what had caused it to end up as an open concrete skeleton with no roof and no interior and exterior walls. Fortunately, one of the faithful researchers who volunteer their time for the Manitoba Historical Society broke the case. To my discredit, I had not considered all the clues that were evident at the site: a long, low building immediately beside the skeleton, along with a squat little grain elevator. Now that I know the history of the site, it all makes sense.

Anyone who has seen a modern, high-rise building under construction knows that it typically involves a steel or reinforced concrete frame to which floors, roof, and exterior walls are attached. This building method made possible the skyscrapers that began to dot Winnipeg's skyline in the early twentieth century. But the building on Plinguet Street is no skyscraper, and the normally concealed skeleton is readily visible. The stout concrete construction, combined with the fact that the floors in the building are perforated by numerous, variously shaped holes, suggested to me that the building had some industrial use. My initial research had indicated that, in the mid-twentieth century, the site had hosted a facility that made and sold livestock feed. So, in error I jumped to the conclusion that the skeleton had been built as a mill where grain was crushed. I was partially right. It turns out, it had been a whisky distillery that played a role in Manitoba's conflicted past with alcohol.

Humans have been making and drinking alcohol for thousands of years. What some people find objectionable are the social ills that frequently accompany excessive consumption: inappropriate behaviour, domestic violence, and loss of income and family support, among others. Through the years, some have advocated for temperance, in which a person does not drink alcoholic beverages voluntarily, or outright prohibition that enforces a legal ban on everyone. In the late nineteenth and early twentieth centuries in Manitoba, temperance and prohibition were hot political topics. Not surprisingly, members of the clergy encouraged their congregations to abstain, and middle-class reform groups such as the Women's Christian Temperance Union and Royal Templars of Temperance were formed. Prohibition was

OPPOSITE A concrete skeleton, along with its maturation warehouse and grain elevator, with water supplied by St. Boniface's municipal water tower in the background, is a reminder of Manitoba's first, and short-lived, post-Prohibition whisky distillery, constructed in 1924. HOLLY THORNE

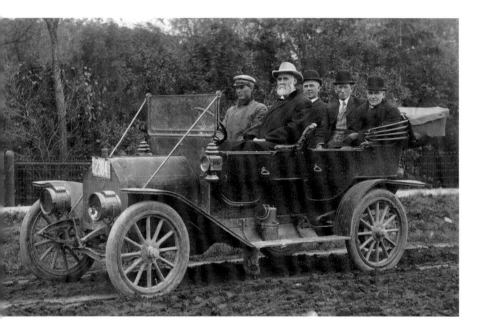

The Royal Templars of Temperance (RTT) took their abstinence message to the voters of rural Manitoba through a series of automobile tours. This postcard, entitled "Banish the Bar", reported that a 72-day tour in June, July and August 1911. They covered over 3,000 miles on what I can only assume were primitive country roads to hold 232 public meetings pushing for temperance. Several notable temperance advocates were in this car, including RTT Provincial Superintendent William Wallace Buchanan (1854–1915) in the front seat beside the chauffeur, and in the back seat, from left to right, RTT Grand Councillor Charles Francis Czerwinski (1863–1936), Reverend Andrew Moffat (1866–1939), and RTT Grand Trustee Herman Telke (1853–1936). GORDON GOLDSBOROUGH

favoured by working-class organizations such as the Trades and Labour Council and the Socialist Women's League. The most strident advocates were typically white, Protestant, middle-class women who perceived a linkage between alcoholism and poverty, mental illness, and crime. These women saw themselves as performing a public service to improve society and alleviate the suffering of poor women and children at the hands of alcoholic husbands and fathers. In many ways, the temperance movement was linked with the growing influence of the women's suffrage movement.

By the late nineteenth century, there seemed to be a broad cross-section of support for prohibition in Manitoba. However, the provincial government wanted to ascertain that support was truly widespread and not the result of a vocal minority. In July 1892, it conducted a referendum on prohibition, the first of its kind in Canada. It coincided with the 1892 provincial general election. In each constituency, voters were asked to vote YES or NO on whether or not they supported Manitoba-wide prohibition. Of the 40 electoral constituencies, four did not participate. Of the remaining 36, two voted against it and 34 voted in favour. Of all the votes cast, 72% were YES, a decisive show of support to ban the bottle. However, the government declined to implement the will of the people, allegedly on grounds that it was concerned about the constitutionality of imposing prohibition. Some suspected a more practical motive, that the government did not

want to lose significant tax income that it derived from the sale of alcohol.

Prohibition crusaders redoubled their efforts and continued to press the government on the issue. A second referendum was held in late 1898. This time, it was held at the national level. Only 20% of votes overall favoured prohibition and, notably, Quebecers were overwhelmingly opposed. On the other hand, 81% of Manitobans voted YES. Once again, questions about the constitutionality of prohibition arose to prevent it from being enacted. By 1901, the Manitoba government of Rodmond Roblin put the question before the courts and was told that prohibition would be legal. So, in April 1902, Manitobans voted a third time. If the two previous referendums were anything to go by, it should have passed easily. But advocates were so enraged by Roblin's waffling that they boycotted the vote. Consequently, the referendum was defeated by a small margin: 59% NO, 41% YES. A new provincial government came to power after the Roblin government fell in a scandal over construction of the Legislative Building. The government of Tobias Norris held another referendum, in March 1916. All but three of the 46 constituencies voted in favour of prohibition, with a resounding 66% YES vote. This time, the government passed the Manitoba Temperance Act and prohibition was declared on 1 June 1916.

During prohibition, it was not illegal to possess alcohol, only to buy and sell it. Fines for the illegal sale of booze replaced tax revenue in provincial coffers.

A newspapers advertisement for "Black Watch" whisky made at the Manitoba Refinery Building, circa 1927. *MANITOBA FREE PRESS*, 31 DECEMBER 1927, PAGE 10.

Although sales of booze were curtailed officially, there were numerous ways of bypassing the rules, especially for "medical reasons." Local production of "moonshine" was rampant, especially in rural areas, as I discussed in my previous book, *More Abandoned Manitoba*. Ultimately,

OPPOSITE The letter "K" on its chimney was the clue that helped me to identify this brick building as the former home of the Kiewel Brewing Company, the first post-Prohibition brewery in St. Boniface. Constructed in late 1924, it began brewing in early 1925. The brewery was taken over in 1929 by the Brewing Corporation of Canada and sold in 1936 to Shea's and Drewry's. It was acquired by Labatt's in 1961 and its name was changed to the Kiewel Pelissier's Breweries in 1969. Finally, in August 1976, the facility was closed and production moved to a Labatt's plant on Notre Dame Avenue in Winnipeg. At the time I visited in 2020, the building was occupied by several small businesses, none related to brewing or distilling.
GORDON GOLDSBOROUGH

prohibition would last for seven years in Manitoba.

The sale and importation of beverages containing over 2½ percent alcohol, roughly half of the amount in ordinary beer today, was banned. But there were numerous ways to acquire beer during prohibition, including brewing it yourself. Or you could buy low-alcohol "temperance beer". Made from the same ingredients as other beers—malted barley and hops—a temperance beer called Maltum was available in Winnipeg as early as 1908. Available in bottles and kegs, Maltum sold at the same price as regular lager beer, allegedly because it cost more to produce.

The short experiment with prohibition convinced Manitobans that changes were needed. A fourth referendum, held in July 1923, supported amendment of the Manitoba Temperance Act to permit beer and wine sales under controlled conditions. Sale of alcohol resumed under tight government control, and I am sure that readers of a certain age will recall the strictness of government

liquor stores and "beer parlours" in the old days. Local municipalities could vote to remain "dry" and this was especially common in the Anglo-Saxon-dominated areas of southwestern Manitoba. In all but the last of four votes on prohibition, however, residents of St. Boniface swam against the provincial tide, by voting against it. If there was any place in 1920s Manitoba that favoured relaxed access to alcohol, it was liberal-minded St. Boniface. It made sense that the first post-prohibition brewery was built there and, it turns out, also the first post-prohibition distillery.

With the repeal of prohibition in 1924, breweries that had stayed afloat, so to speak, on temperance beer and other "soft" products, ramped up production of full-strength beer. By 1925, the Winnipeg capital region had eight breweries. One of them was the Kiewel Brewing Company, established in early 1924 by brewer Charles Kiewel from Crookston, Minnesota. In mid-1924, he constructed a state-of-the-art brewery

on St. Joseph Street in St. Boniface. By June 1925, it could make and store 30,000 barrels of beer a year—about 1,000,000 gallons, or 1½ gallons for every man, woman, and child in Manitoba—of a brew called White Seal. At this time, total annual beer consumption in Manitoba was about 2,000,000 gallons.

Through the 1950s and early 1960s, there was a period of consolidation of breweries. In 1963, there were 52 breweries in Canada, owned by ten companies. Most of those breweries were owned by the "Big Three": Labatts, Molsons, and Carling O'Keefe. They controlled 96% of Canadian beer sales by 1989, when Molsons and Carling merged, leaving just two major breweries. In 1961, St. Boniface's Kiewel was taken over by Labatts, but it continued to operate until closure in August 1976. Today, the big breweries have become multinational conglomerates, none of which brew in Manitoba. The four-storey former Kiewel Brewery is occupied by several small businesses, none related to brewing. However, a growing number of microbreweries—over thirty at last count—carry on our province's proud brewing tradition.

Now that we have established the proud history of St. Boniface brewing, let us now return to the concrete skeleton on Plinguet Street. In January 1925, several noted Winnipeg businessmen, with financial support from American interests, incorporated the Manitoba Refinery Company to carry on a business of brewing and distilling. They hired Winnipeg architect George Northwood to design a complex next to the CPR tracks on Archibald Street, and the construction firm of Carter Halls Aldinger to build it. Construction started in March 1925 and was expected to be completed by June.

The distillery at Archibald and Plinguet consisted of three buildings. Malted barley, needed to start the brewing process, was stored in a grain elevator. It stands vacant at the site today. Grain from that elevator would be transported into the main distillery. There, the first step in whisky-making turned the barley into beer then the alcohol content was raised. This was achieved using tall distilling apparatus that passed between levels in the building through holes in the concrete floors. The resulting colourless and flavourless liquor was then transferred in special wooden barrels that were carried into the long, low building that still stands beside the skeleton. There, the barrels were set on their sides to begin the slow process of maturation where liquor seeped into the wood and extracted colour and flavours, developing complexity as it matured over several years.

As far as I can tell from advertisements in local newspapers of the time, the Manitoba Refinery Company made three products. The first was a Scotch-type of whisky, made from barley, that was marketed under the name of "Black Watch". The second, a bourbon-type of whisky called "Clearbrook", was made with corn as the major ingredient. The third product was a gin named "Blackfriars". Unless someone has squirreled away bottles of Black Watch, Clearbrook, and Blackfriars, we will never know if they were any good. (Given the short

lifespan of the distillery, and therefore a short maturation time, I am doubtful.) A company official was quoted in a newspaper as saying he thought the distillery's products were equal, if not better, than those of Scotland. Would anyone expect him to say otherwise? Whether or not the hooch was good, it was certainly plentiful. When at full production in mid-1926, the distillery employed seventy people and produced 1,500 gallons of alcohol a day. Does that sound like a lot of booze to anyone besides me?

Unfortunately, the Manitoba Refinery Company's life was short and tumultuous. In late 1927, it was sold to a Montreal-based company called National Distilleries. In mid-1931, it was sold again, this time to another Montreal company called Mid-West Distillers. And in late December 1933, the business was sold yet again, to a company from Boston, Massachusetts. The American company was interested only in the state-of-the-art distilling equipment, not the buildings or land. I theorize that, in the name of efficiency, they removed the exterior walls of the distillery building to simplify removal of its equipment, packed everything in railway cars, shipped them east, and reassembled everything in Boston. The buildings and land in St. Boniface were sold to the McCabe Grain Company. It continued to use the grain elevator of the former distillery, now for holding grain to be blended and ground (possibly in the skeleton) into animal feed, which it stored and sold from the former whisky maturation warehouse. My guess is that the gutted distillery building remained exactly as the American company left it, and it stands that way today. If I am right, that concrete skeleton had eight years of active life as a distillery and ninety years as a mostly abandoned building.

Today, there is a large alcohol distillery in Gimli and three micro-distilleries in or near Winnipeg. Attitudes and access to alcohol have relaxed considerably in the past century although the impacts of excessive consumption remain with us. So, I hope you will be moderate when, the next time you are enjoying an alcoholic beverage, you raise your glass in tribute to the residents of St. Boniface. For a few short years nearly a century ago, as the concrete skeleton demonstrates, they voted for a unique connection with whisky-fueled *joie de vivre*.

Directions

Enter these coordinates into a GPS receiver or a map app on your smartphone.

Historic Site	Latitude	Longitude
Kiewel Brewery Building (690 St. Joseph street)	N49.89331	W97.12288
Manitoba Refinery Building (542 Plinguet Street)	N49.89266	W97.10272

ACKNOWLEDGEMENTS

The "case of the mysterious concrete skeleton on Plinguet Street" was solved by Jordan Makichuk, a young Winnipegger with great detective ability for historical research. The indefatigable Nathan Kramer filled in other important details, although a few facts about the building's post-distillery life remain elusive.

STOP
HIGHWAY TRAFFIC
WEIGH SCALES

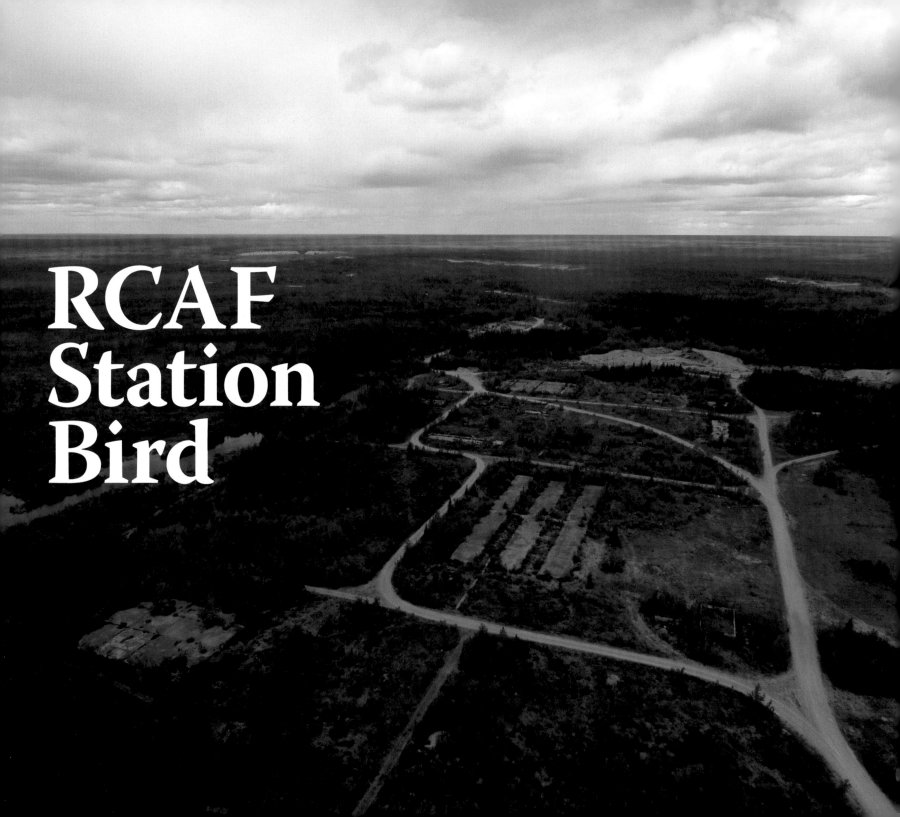

RCAF
Station
Bird

Three hundred and forty-nine miles northeast of The Pas on the Hudson Bay Railway, near the mighty Nelson River, is the home of Fox Lake Cree Nation (FLCN). Tracks pass right by the community and, immediately north of it, there is an airfield that looks to be used only occasionally. A short distance west of the airfield, if one looks down from above, is a large square delimited by gravelled roads. Scattered around the square, inside and outside of it, are concrete rectangles that appear to be the floors of buildings that are slowly being reclaimed by the surrounding boreal forest. The airfield, rectangles, and square are all that remains of an entity known by an incomprehensible string of acronyms (of which the military seems inordinately fond) as RCAF MCL SCS 600 Bird.

OPPOSITE In July 2017, I sent my drone to get a panoramic view of the former RCAF Station Bird. The concrete floors for its three parallel barracks can be seen in the centre and the large floor for a former recreation hall is at lower left. GORDON GOLDSBOROUGH

Fully expanded, it stood for Royal Canadian Air Force Mid-Canada Line Sector Control Station 600 Bird. Abandoned for more than fifty years, it was once part of an early-warning system that operated during the Cold War.

The late 1940s to 1960s were a tense time politically when Americans and Soviets were threatening each other with nuclear annihilation. (Remember the story on the Fallout Reporting Posts?) Fears of Soviet bombers and missiles flying over the North Pole to rain devastation on North America spurred the American government, with Canadian participation, to develop sites across northern Canada to increase our ability to detect and protect against such threats. One component of this "northern defence net" was the Distant Early Warning Line, or DEW Line, a series of American-run posts in the High Arctic intended to give an initial warning of invasion. Once an invader had been detected, another component of the system was the

A young telecommunication technician works on instruments at RCAF Station Bird, 1963. STAN SUMMERHILL

Canadian-run Mid-Canada Radar Defence System (MCL), a series of eight Sector Control Stations (SCS) south of the DEW Line, along the 55th line of latitude. They spanned from Dawson Creek in British Columbia to Hopedale in Labrador, including two in Manitoba: SCS 700 (Cranberry Portage) in the west and SCS 600 (Bird) in the east. A third line of defence, the joint US-Canada Pinetree Line, was established

Interior of the gymnasium at RCAF Station Bird, 1963.
STAN SUMMERHILL

aircraft and be detected at one or more smaller Doppler Detection Sites (DDSs) positioned roughly every thirty miles in an east-west line between the SCSs. When relayed to the continental defence facility in Colorado, this information could be used to estimate the potential target of an invader.

Planning started in late 1953 and the MCL Line was approved by the Canadian federal cabinet in June 1954 at an estimated cost of $120 million, although this figure would balloon to nearly $300 million ($2.7 billion in today's currency) before the network was completed. The seventeen stations in Manitoba (two SCSs and fifteen DDSs) were surveyed in July 1955. The site for RCAF Station Bird—that took its name from a siding on the Hudson Bay Railway commemorating former Member of Parliament Thomas Bird—was chosen by surveyor Fletcher Linklater to be on the bank of the Limestone River near its confluence with the Nelson River, about 65 miles from Hudson Bay. It

at the 50th line of latitude, with Manitoba stations at Gypsumville and Beausejour.

MCL stations were equipped with Doppler radar technology, developed by Trans-Canada Telephone of Montreal, that could determine the speed and direction of objects entering North American airspace. They were essentially like the speed traps used on highways today. They measured the time needed for radar waves emitted by one of the SCSs to bounce off Soviet

was the most northerly of the MCL stations. Construction of SCS 600 (Bird) by Claydon Construction of Winnipeg began in December 1956, using materials brought from Gillam using tracked tractors pulling large sleds, and was completed in April 1957. Among its steel-clad buildings were three large barracks (each with about twenty, two-bed rooms and a communal bathroom), mess halls and lounges, administration building, garages, and water and sewage treatment plants. Electricity to run the facility came from a diesel-powered generator. Nearby was a landing pad for large Sikorski helicopters used to transport maintenance crews and barrels of fuel to DDSs in the vicinity, as well as large fuel storage tanks, and steel towers used as antennas for the Doppler radar system. Gravelled roads ran all around the facility and to a gravelled runway long enough for DC-3 aircraft to take off and land. There were 100 people—all male, including the nurse—on the station's staff. Eleven military personnel did the aircraft detection work in

an operations building where security was strict. The majority were civilians. Technicians who maintained the equipment were recruited from across Canada as well as England and Australia. Other workers were mechanics for the aircraft and other vehicles, ran the kitchens, cleared snow in winter, and did routine maintenance. The men worked long hours, ate well, and were paid well. Most went home after one, two, or three-year deployments with a considerable bankroll, because there was nothing to spend their pay on at Bird.

Even though it was a communications station, links between Bird and the outside world were primitive. There was no telephone to the outside world, but some workers had ham radio equipment. Workers wanting to contact their families typically did so by letters carried in and out by aircraft. American and Soviet radio stations were audible but the Soviets typically broadcast propaganda. Occasionally, the workers would be entertained by visiting USO-style troupes that included a rarity—women—or by a children's choir from the nearby FLCN community. Downtime was mostly spent in the recreation hall, playing basketball, volleyball, or billiards; in vigorous and frequent card games where participants lost some of their hard-earned pay; or outside playing hockey or softball, target-shooting, or fishing in the Limestone River. Liquor was available at the mess hall for Non-Commissioned Officers.

While researching this story, I corresponded with several elderly men who, in their 20s, had worked as

civilian technicians or as members of the Canadian military at RCAF Station Bird. The experience of Don Lapchuk, now living in retirement in Saskatchewan, was typical of what they told me. He was a civilian working with Trans-Canada Telephone when he joined the MCL staff. In January 1957, he was sent to Montreal for four months of technical training on the Doppler radar system. He almost got kicked out of the program when it was discovered that someone by the same name as him, living in Regina, was active in the Communist party. The RCMP pulled him out of class and interrogated him until

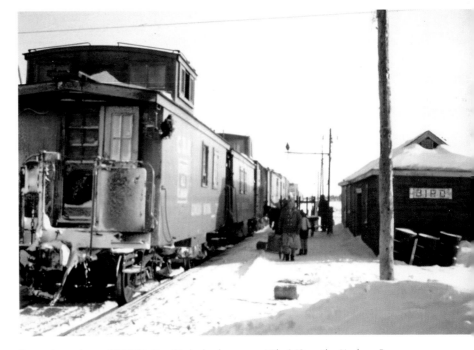

The train station at RCAF Station Bird, also known as Mile 349 on the Hudson Bay Railway, 1963. STAN SUMMERHILL

The concrete foundations for military buildings at the former RCAF Station Bird, no date.
MANITOBA HYDRO

The story of RCAF Station Bird is a short one. Improvements in radar technology and jet engine design in the early 1960s rendered the MCL obsolete. Despite opposition from the Americans, the Canadian government decided to abandon the line, arguing that the range of radar stations on the new Pinetree Line could extend beyond the 55th parallel of the MCL. Station Bird ceased operation, along with three other western stations, in January 1964, less than seven years after it opened, and the four eastern MCL stations closed in April 1965. Their military crews were dispersed across the country. SCS 700 at Cranberry Portage was turned over to the Manitoba government for civilian use. It is now a high school for students from across the north. Manitoba Hydro bought the power-generators from the DDS so they could be used to generate electricity for northern communities. The contents of buildings at Bird were sold at auction and the bulk of the proceeds were donated to the University of Manitoba to establish

he could convince them that he was no threat. Arriving at Winnipeg in early May 1957, he was tested to determine his psychological suitability for remote deployment. Then he was posted at a DDS near the Manitoba-Ontario border. He and another man, a middle-aged former US Navy sailor, were the only people there. Lapchuk was then transferred to Bird, where he maintained the radar and microwave systems for the remainder of his deployment. He recalls that the food was plentiful and excellent, but the isolation was hard to take. He compared the experience to being in jail except he was there of his own volition. He left Bird in mid-1958 and took a job doing telecommunications work with SaskTel in southern Saskatchewan. He was glad to leave Bird but realizes now that it was a formative experience in his life.

the MCL Station Bird Bursary to be given annually to a deserving Indigenous student. In August 1964, the federal government put up some 1,100 acres of land and thirty buildings at Bird for sale and they were bought by the provincial government. At least one of the larger buildings was disassembled and moved to Thompson where it was turned into a hockey arena. (It was renovated recently but its roof and steel beams are original.) Other buildings at Bird might have been re-used but some were simply demolished and buried at the site. However, there are still plenty of remains of SCS 600 within sight of the FLCN buildings south of the railway tracks. The site is accessible year-round by good gravel roads or using the old RCAF airfield so we can readily remember that, at one time, nuclear war weighed heavily on the minds of Manitobans.

At least one of the buildings from the former RCAF Station Bird was moved to Thompson in the mid-1960s where it continues to be used for public recreation. CHARLIE AND VIVIAN CLARKE FAMILY

Directions

Enter these coordinates into a GPS receiver or a map app on your smartphone.

Historic Site	Latitude	Longitude
RCAF Bird	N56.50506	W94.21220

ACKNOWLEDGEMENTS

I am immensely grateful to Jim Anderson, Don Lapchuk, Al Mergel, and Stan Summerhill for sharing memories of their time at RCAF MCL SCS 600 Bird. Mr. Summerhill also provided several photos taken during his stay there. Mr. Anderson kindly tracked down and sent me a rare copy of the late Jack Webb's book on the MCL that was an invaluable source for this story. Brian Jeffrey shared information he obtained from MCL historian Larry Wilson. I thank Robin Clarke for providing photos from his family collection of the former Bird buildings at Thompson, and Stan Barclay and Volker Beckman for sharing memories of the site.

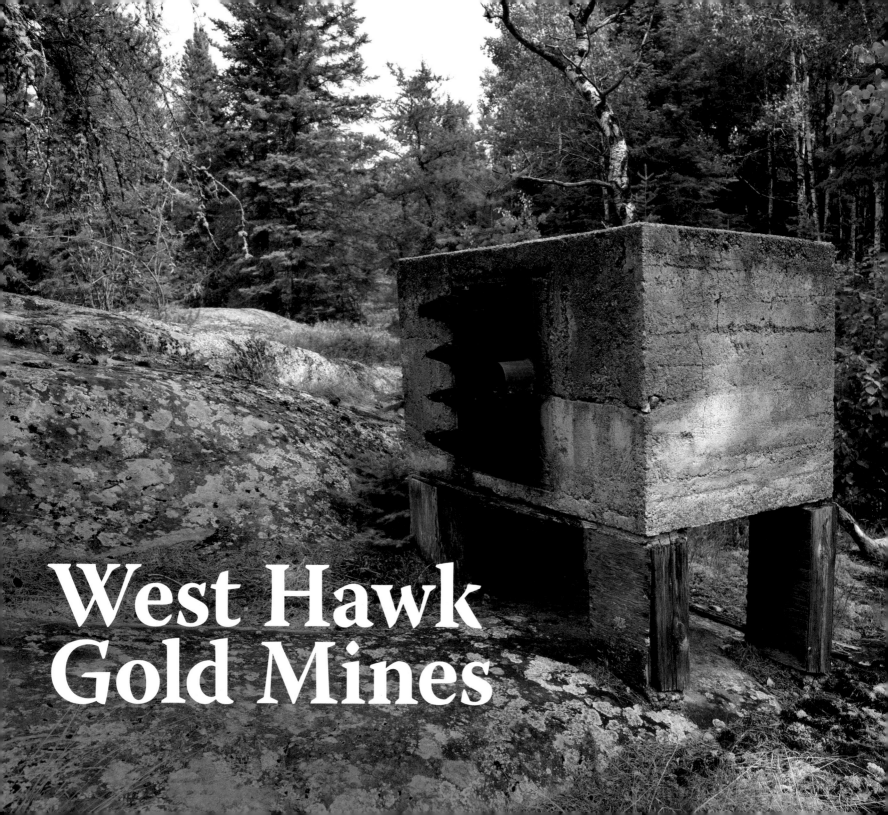

West Hawk Gold Mines

Many people think of the Whiteshell area in southeastern Manitoba as an idyllic playground of pristine forests and lakes. We may not realize that it was once the centre of a "Gold Rush" that saw prospectors and miners descend from around the globe. Some reminders of the area's early mining history are the focus of this final chapter.

In 2021, at the invitation of long-time Whiteshell cottager Kyle Daun, I spent an enjoyable day in Whiteshell Provincial Park. Kyle wanted to show me several abandoned structures he had found during his explorations over the years. A highlight of my visit was several sites on the west side of West Hawk Lake where, according to local lore, prospecting for gold started in the 1890s and active mining began as early as 1910. Keep in mind that this was a difficult place to reach in those days. There were no roads. To reach the gold mine, one had to take a train to Ingolf, Ontario, about a mile east of the Manitoba border, then boat across Long Pine Lake, portage about a half-mile to West Hawk Lake, and paddle to the west side to reach a small bay called Penniac. James Hicks, an executive with the company that established the mine, had given the bay that name because he thought it looked a lot like one he had seen at Penniac, New Brunswick. In turn, the mining company, Penniac Reef Gold Mines,

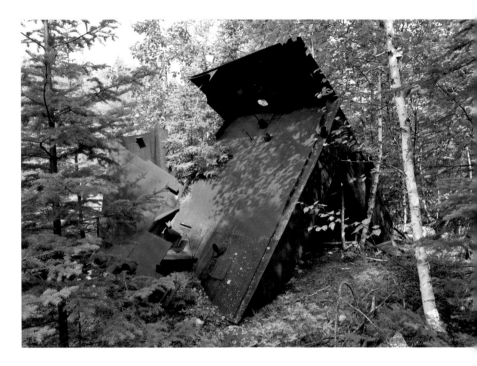

OPPOSITE AND ABOVE RIGHT The remains of an early twentieth century gold mine, including a concrete box used for safe storage of explosives, and a large metal object believed to be a boiler, litter the forest near West Hawk Lake. GORDON GOLDSBOROUGH

took its name from the bay, and it also operated as Star Lake Gold Mines Limited, named for a smaller, nearby lake. And these were not the only mines. In a short time, over a hundred mining claims were registered in the area around Star Lake, with prospectors coming from as far away as Nevada, New York, and South Africa.

Unfortunately for the majority, success was elusive. Penniac Reef spent $100,000—the equivalent of $3 million in today's money—to dig a 70-foot-deep shaft and build several buildings to process ore and house its miners. From 1911 to 1914, the company milled about 270 tons of ore. It was Manitoba's first operating gold mine, and it produced the province's first gold bar in 1913. A second bar

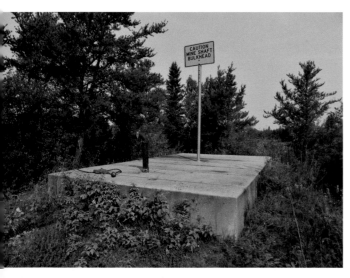

A capped former gold mine south of Star Lake in the Whiteshell Provincial Park. GORDON GOLDSBOROUGH

was made in 1915. At that time, an ounce of gold was worth about 20 bucks, and a gold bar contained 400 ounces, so two bars would be worth about $16,000 in 1913 dollars. As you can see, the operation was far from being a break-even proposition, much less a money-maker.

Like a lot of speculative enterprises, the mine closed at the onset of the First World War when it became nearly impossible to hire workers. Jump forward to the 1930s. The Trans-Canada Highway (today's highway 44) now ran through the area, and access was much easier than in the past. In 1934, Star Lake Gold Mines sold its claim to Sunbeam Kirkland Gold Mines. This company began major mine development south of Star Lake, at what they called the Sunbeam and Waverly mines. By 1938, a vertical shaft over 400 feet deep had been dug. In 1940, ore shipped to a mill near Kenora produced about 800 ounces of gold. At a fixed international price of $35 an ounce, it was worth about $27,000. Again, not a huge windfall, and no further ore shipments were made. The mines were sold in 1941.

It appears the Second World War did not interrupt operation of gold mines the way the First World War had because mining in the Whiteshell continued into the mid-1940s, with drilling crews working twelve hours a day, seven days a week. It was a tough job, but they were paid excellent wages, $1.25 and $2.00 per hour where other workers at the same time might get 50 cents. But the mine shut down in 1946 due to continuing financial difficulties. The mines were simply not producing enough gold to be economically viable. Nevertheless, gold exploration in the area continued into the early 1960s.

Other minerals were mined around West Hawk Lake too. Early prospectors had found high-grade deposits of iron ore on the west side of the lake and uranium was found near Bear Creek, northwest of it. But the main mineral that continued to draw attention was gold. Exploration around Star Lake resumed in the mid-1970s, and active mining took place into the mid-1980s. Kyle Daun drew my attention to an Ontario company that actively advocated for mine development at Star Lake as recently as a dozen years ago. Recognizing the richness of the geological deposits in the West Hawk area, the Department of Earth Sciences at the University of Manitoba operated a field camp there for many years to train students.

During my visit in 2019, Kyle took me to the site of the mines

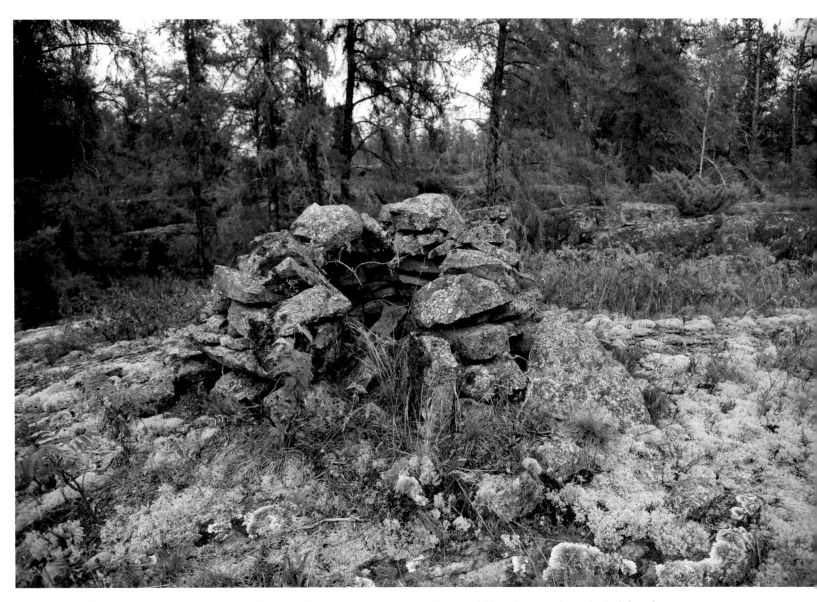

An innocuous pile of jagged stones along a railway line through the forest of eastern Manitoba would have been easily overlooked if not for knowledge that similar piles have been found in British Columbia and throughout the western United States near old construction camps for railway workers. GORDON GOLDSBOROUGH

Hoctor Bake Ovens

In 2017, I visited a construction camp in northern Manitoba where workers for Manitoba Hydro's new Keeyask Generating Station were accommodated. I was impressed by the modular complex that was designed to be disassembled when the project was completed. Eventually, no sign will remain of what was once a massive facility, used by thousands of workers, that included private bedrooms and bathrooms, dining rooms, a bar (with a strict two-drink limit), a gym, and a small theatre. Clearly, the workers were not "roughing it" to work in this remote location, quite different from ones at a former construction camp that I visited in southeastern Manitoba.

That camp was located along the Canadian National Railway main line at the siding of Hoctor, near the present-day western boundary of Whiteshell Provincial Park. The railway was constructed around 1907 or 1908 and remnants of the camps where its workers lived are still visible today in the form of bake ovens made of stacked, large stones. I have a vivid mental picture of workers living in rough tents, baking their own bread and cooking their own meals, and eating while sitting on rocky outcrops of the Canadian Shield, swatting away hordes of mosquitoes and black flies.

Unfortunately, my mental picture is all there is. No historical photos or documents about the Whiteshell construction camps exist, and what little we know about bake ovens associated with construction camps comes from academic studies elsewhere. The oldest known railway bake oven in Canada is in Yoho National Park. It was built in 1884 during construction of the Canadian Pacific Railway across Canada. Several other stone ovens stand near Naramata, British Columbia, believed to have been built between 1911 and 1915. We know that the railway construction crews there were ethnically diverse, being from Scandinavia, China, and

elsewhere. The practice of using stones to make a bake oven is widespread around the world.

The bake ovens at Hoctor are dome-shaped piles of grey stones located about 400 feet north of the CNR main line. One oven that I visited in 2021 was roughly five feet in diameter, and perhaps three feet high, with a small opening on one side. It sat on top of a rock outcrop. The individual stones were very angular. My guess is they were dislodged by explosives when the construction crew was making a level grade for the new railway line.

The ovens worked like bake ovens elsewhere. A wood fire would be lit inside the dome of stones and allowed to burn long enough to heat the oven walls. When the fire had burned down, the hot rocks would radiate heat long enough that one could insert bread dough inside and it would bake. I found just one oven during my visit to the site but my friends George Penner and Morgan Turney, who have explored the area more carefully than I have, say there are at least six ovens scattered along the main line between Rennie and the Ontario border. I presume the camp would have moved as construction of the railway progressed, and new bake ovens were built at each successive campsite. So, it is possible there are many such ovens throughout the area. Some of the ovens are apparently intact but the one that I found had a collapsed roof.

Anyone finding one of these old bake ovens would be hard-pressed to know what it had been, and I worry that people may not recognize them as important artifacts from over 100 years ago and disassemble them. The ovens deserve to be preserved. If nothing else, they illustrate the improve-ment in living conditions for workers in remote areas far from home and family. If my visit to the Keeyask construction camp taught me anything, it was how much working conditions in Manitoba have improved in a century.

south of Star Lake. There was a small, shallow lake where I presume the overburden of soil had been stripped away to enable drilling activity. We found the shafts for two abandoned mines. At some point in the past, the provincial government had covered them with concrete caps to prevent berry-pickers and others from falling in. One of the caps was substantial and intact. The other cap was surrounded by a metal fence, which was good, because there was a large gaping hole in one side of the cap that would not keep people out if they were determined to get in. We also explored a second former mine site about 3½ miles as the crow flies from Star Lake, immediately adjacent to Highway 44. There, we found evidence of surface mining, with large chunks of jagged rock that had been blasted from the exposed granite of the Canadian Shield. There were at least two reminders of the former mining activity. One was a huge, rusty metal object that we suspect might have been the remains of a steam boiler. Perhaps it had been used to produce power for a mining operation? More intriguing, we found a small, concrete box on stubby wooden legs, with a metal door, fastened to the bedrock. Kyle told me it was a safe where miners had stored their explosives to protect against accidental detonation.

I am told the foundations of some early mine buildings are still visible at other places around West Hawk. Many people think of this area as a scenic place for recreation. Hopefully, this short chapter has revealed that quite a lot of industrial activity occurred there too. And, clearly, I will have to spend more time there to fully appreciate the history of local mining and its abandonment.

Directions
Enter these coordinates into a GPS receiver or a map app on your smartphone.

Historic Site	Latitude	Longitude
Gold Mine Explosives Safe	N49.78071	W95.22346
Hoctor Bake Oven	N49.87022	W95.66374
Star Lake Gold Mineshaft	N49.73273	W95.25186

ACKNOWLEDGEMENTS
I offer profuse thanks to Kyle Daun for taking me on a fun-filled, day-long tour of little-known abandoned sites in the Whiteshell. Explorers Samantha Silvester, George Penner, and Morgan Turney first drew my attention to the stone bake ovens along the railway line near Rennie.

Conclusion

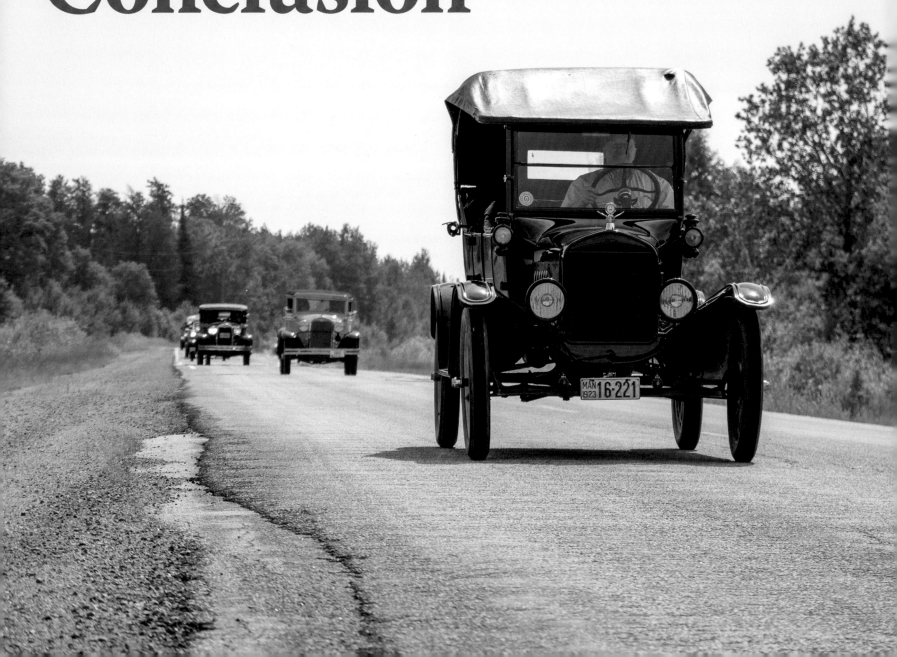

Relic Run Review

The Pine to Prairie Relic Run began with a bridge. I am fascinated by old bridges because, in providing efficient means to cross Manitoba's many rivers, they made possible the road network that we enjoy today. In trying to find surviving bridges from nearly a century ago and hoping to avoid a lot of unproductive driving, I was using satellite images to follow rivers. I found a prospective candidate in western Manitoba, near the border with Saskatchewan. It *looked* like a bridge, but the fuzzy quality of the image made it impossible to be sure. I would have to check it out for myself.

I drove to the site in early 2016 and immediately had my answer. It *was* a bridge … a big steel, through-truss one! Yet, I was confused because it was situated on a minor country road, not the major highway that such an impressive bridge would usually imply. What had motivated the construction of such a bridge here? In time, my research determined that the bridge had been built in 1928 to enable Provincial Trunk Highway #4 (today's #16), that ran from Portage la Prairie to Saskatchewan, to cross the Assiniboine River. Around 1966, the highway was rerouted to its present location so this once-important bridge was relegated to conveying only local traffic. This led me to wonder about what other bridges might be found on former sections of major highways

OPPOSITE "Pine": The five antique cars head out through the forest of southeastern Manitoba. HOLLY THORNE

This steel through-truss bridge over the Assiniboine River northwest of Russell was constructed in 1928 to enable Provincial Trunk Highway #4 (today's highway #16) to cross the river. Around 1966, the highway was rerouted to the south so this bridge is now used primarily for local traffic to the Wolverine district. It led me to wonder about abandoned portions of other old highways which, in turn, motivated us to drive antique cars on the former Trans-Canada Highway. GORDON GOLDSBOROUGH

and, in turn, to reconstruct the original routes those highways had taken.

Finding this information was not easy. I used a combination of digitized highway maps from the 1930s that had been put online by the Manitoba government, some very detailed engineering maps prepared by the Manitoba Highways Branch (to which I gained access through the help of retired highways engineer Chuck Lund), and the same satellite imagery that enabled me to find old bridges. Although the imagery was modern, it was surprising how

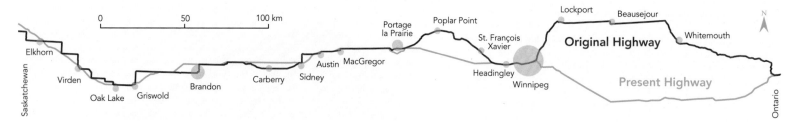

The route of the Trans-Canada Highway through Manitoba as it was in 1932 (dark green line) compared to the modern highway (teal line).
GORDON GOLDSBOROUGH

many clues about former highways could be found in faint remnants visible from space. For example, "speed turns" on former highways—where an abrupt 90-degree turn was made more amenable to high-speed traffic by making it into a graceful, banked curve—are still remarkably easy to see, even when they are abandoned and overgrown. There were abandoned portions of old highways that were still visible here and there along the modern-day route. In some cases, entire sections of former highways still existed but had been "demoted" in the hierarchy of highways; good examples are Highways #26 and #44 that were formerly part of Highway #1, the Trans-Canada Highway. In time, I was able to reconstruct the original routes of most of the Provincial Trunk Highways and I learned about their history. For example, Clint Cannon's excellent 2018 book *Exploring the Old Trans-Canada East: Canada's Route 66* told me about an old monument that still stood along the original highway near the Manitoba-Ontario border. I went out to see it for myself and found that it sat beside a few hundred feet of abandoned pavement. (See the photo in this book's Introduction on page 23.)

The next step to the Relic Run was taken when, in 2022, I attended the Threshermen's Reunion and Stampede at the Manitoba Agricultural Museum, near Austin. There, I chatted with history and antique vehicle buff Don Wadge. I told him about my reconstruction of Manitoba's old highway routes and suggested that I might try to drive some of them to see if it was possible to do so. "How about driving the highways in an antique car?" he suggested. "That would be great," I replied. "Do you know someone with one?" With a grin, Don said, "I do, a 1923 Ford Model T." What route would we take? I suggested the original, meandering Trans-Canada Highway that goes through numerous towns bypassed by the modern highway in the name of speed and efficiency. Could we drive Don's old car (the one featured, by the way, on the front cover of this book)—that would mark its hundredth birthday in 2023—from the Ontario border to the Saskatchewan border on the old Trans-Canada? It was a route that the car might have driven when it was new. Don was game to try.

Later, I told my friend David Rourke about our new plan and he replied "I have a 1928 Ford Model A. May I

come along?" Now there would be two cars, which was probably a good idea—we would have a backup ride in case one of the cars pooped out along the way. Word spread and, before long, there were three more cars ready to go: another 1928 Model A, along with 1930 and 1931 Model As. As we talked, details were fleshed out. We would call our adventure the Pine to Prairie Relic Run from the pine forests of Ontario to the prairie grasslands of Saskatchewan. It would be a three-day tour because we thought the cars, being old and frail, would be damaged if driven too hard and fast. Our merry band of adventurers, accompanied by a few passengers and three support vehicles towing trailers (in case of unfixable mechanical failure), would drive from the Ontario border to Winnipeg on the first day, from Winnipeg to Brandon on the second day, and from Brandon to the Saskatchewan border on the third day. We would stop at museums along the way to give the cars and drivers a bit of rest, chat with people, and raise funds on behalf of the Agricultural Museum to build a protective roof over the Tree Planting Car (see the chapter on the Pineland Forest Nursery). So it was that, on Monday, 3 July 2023—as I was putting finishing touches on this book—five drivers and five antique cars met near the Ontario border to begin an epic 545-kilometre (340-mile) drive.

Driving a hundred-year-old Model T is a radically different experience from driving a modern car. It lacks most of the amenities expected by drivers today. There is no radio or music player, no power steering or brakes,

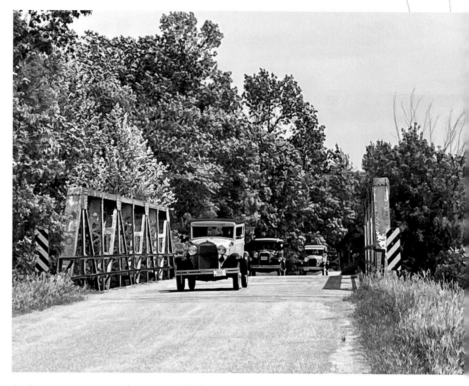

Antique cars cross a steel pony-truss bridge over the Brokenhead River on an original section of the Trans-Canada Highway east of Beausejour. GLEN COOK

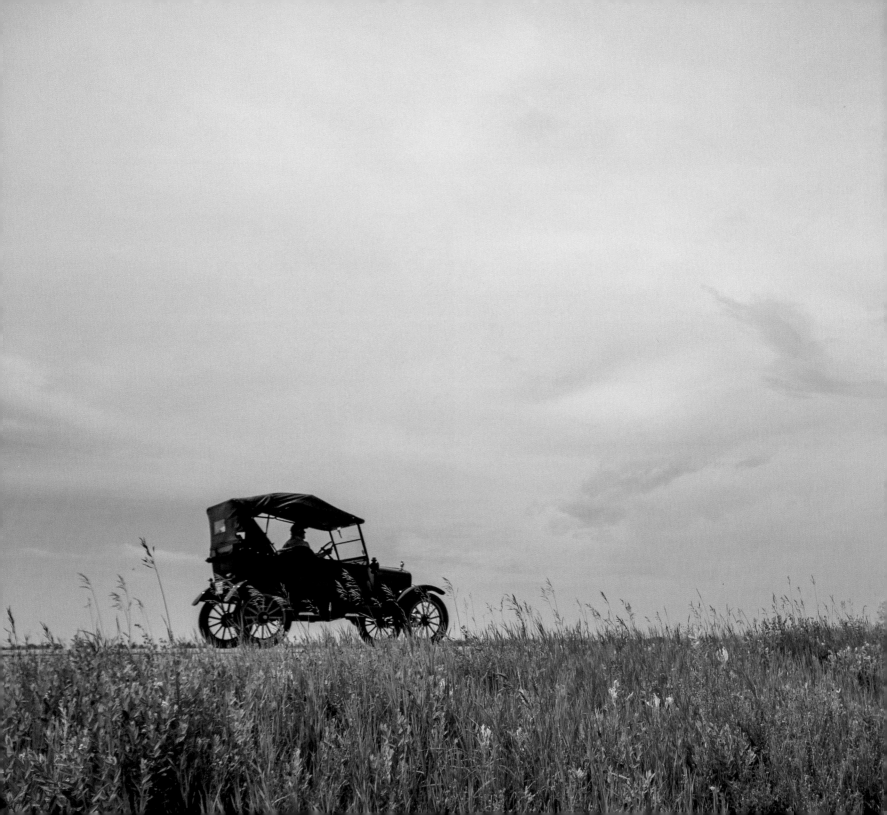

no comfy adjustable seats with lumbar support, and no heating or air-conditioning in the cabin. The instrumentation is basic; it has just one meter that monitors the charge on its battery. To tell if your car may be overheating, there is a thermometer mounted on its radiator cap that protrudes above the engine compartment. There is no speedometer, so you have no idea exactly how fast you are travelling. Want to know how far you have driven on a trip? You are out of luck because the vehicle has no odometer. There is no gas gauge either, so you must lower a calibrated wooden stick into its gas tank, located under the driver's seat. And there is no dipstick to determine the amount of oil in the engine's crankcase, just a pair of small valves that you must slide under the car to check.

Operation of a Model T is different from modern cars too. It was not originally equipped with turn signals but, by law, they must be retrofitted. Don's car has a two-way toggle switch mounted on the edge of its driver's seat that controls lights for left or right turns. The windshield wiper is a small, hand-operated crank that covers a tiny area at the top of the windshield, barely enough to give the driver any vision at all. Getting into a Model T requires an act of contortion from the passenger side because the steering wheel's position makes it nearly impossible to climb in through the driver's door. Perhaps most confusing is that the Model T sports a two-speed transmission controlled by the driver using three floor pedals. The right pedal is a brake (which operates on the transmission, not the wheels), the middle pedal puts the car in reverse, and

A 1923 Model T passes a sign identifying the modern-day Highway 44 as the former Trans-Canada Highway. HOLLY THORNE

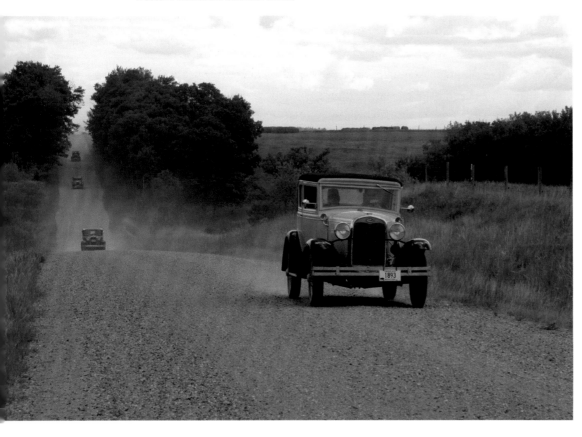

"Prairie": The five antique cars on an unpaved section of the former Trans-Canada Highway west of Alexander in western Manitoba. GEORGE PENNER

the left pedal shifts speeds—not gears, because the car has what is essentially a manual automatic transmission, if you can wrap your head around such a concept. There is no gas pedal; the four-cylinder engine's speed is regulated by a lever on the right side of the steering column. On the left side of the column is a second lever that controls the spark advance—the point at which a spark plug ignites the fuel relative to the piston's position—something that is done automatically on modern cars. In essence, the driver of a Model T must advance the spark to match the engine's speed, but knowing what amount is optimal to make the car run smoothly, is something of a black art. The tires are much narrower than those of modern cars, with simpler tread patterns, and they are pumped to roughly double the pressure, about 60 pounds per square inch.

Despite its many primitive features, a ride in a Model T is unexpectedly smooth compared to modern cars. This is due to the

transverse mounting of its front and back springs; having the chassis mounted in the centre of the suspension means that a wheel hitting a pothole, for example, does not cause the vehicle to lurch like it would a modern car. On the other hand, the ride is not entirely comfortable. If you drive on dry, gravel roads, expect to be inundated with billowing clouds of dust because there are no side windows. Passengers are open to the elements except for a cloth roof. No wonder the riders in these old cars wore goggles. All in all, an old Model T provides a unique and, dare I say, enjoyable driving experience. For one thing, given its slow speed— supposedly a maximum of 68 km/ hour (42 miles/hour)—it gives you more time to appreciate your surroundings than is possible in a modern car zipping past points of interest at 100+ km/hour.

How fast could our little motorcade travel? As we planned the trip, I wanted to know so that I could estimate when we would arrive at stops along the way. The five car owners thought that a speed of 40 km/hour would be prudent. As we began our journey and found that the cars were perfectly content at that speed, we gradually increased the pace. Surprisingly, the Model T, which I expected to be the slowest car, briefly reached 70 km/ hour on a smooth stretch of the modern Trans-Canada, although it was happiest at 50 to 55 km/hour. One of the Model A cars started to overheat, probably due to a failing water pump, when we exceeded 50 km/hour. So, we settled on an average speed of 50 km/hour, reduced to 45 when we were on gravel.

The Relic Run began in the boreal playground of the Whiteshell Provincial Park, near West Hawk Lake, and we passed through Rennie on the way to our first stop at the Whitemouth Municipal Museum. There, we were received enthusiastically. Refreshed, we headed out again and discovered that we were not popular with everyone. The old highway (now #44) was narrow and winding, with few shoulders or places to turn off. This was the final day of a long weekend, so we accumulated a long line of vacationers who were unable to pass our slow-moving cavalcade. When we reached the straight, open portion of the highway east of Beausejour, we turned onto a service road that paralleled the highway. Numerous impatient drivers zoomed past us. That service road turned out to be a little-used remnant of the original Trans-Canada. Its roadway was pitted and scarred, and exceptionally rough. At least, I thought so, in the modern truck that I drove at the front of the tour. Speaking later to the antique car drivers, it appeared the narrow tires and transverse suspensions of their cars were better suited to the rough road conditions than that of my vehicle. After a stop at the Brokenhead-Beausejour Pioneer Village Museum and the classic Skinner's restaurant at Lockport, we ended the day at the Legislative Building in Winnipeg. I had sought permission for a photo op at the front of the

building but was told that was not possible. At the last minute, an MLA who came out to see the cars intervened on our behalf and we capped the day with photos by the steps of this grand building. The cars had all performed magnificently, with no major mechanical problems, so we ended the day on a high note.

In any great story or play, the second act is where challenges occur, and that was the case with the Relic Run. The second day started at Jim's Vintage Garages, a perfectly appropriate museum venue for our old cars, and we were greeted by a large group of motorheads. A photo was taken of the hundred-year-old Model T sitting next to a brand-new electric car. What a change in a century! However, when Don Wadge went to start his Model T, the electric starter motor spun but would not turn over the engine. The car resolutely refused to start. What to do? Here is where the car's "limitations" became advantages because, unlike modern cars, the Model T has a crank handle on its front. Don got out of his car, slid the crank inward to engage the crankshaft, gave it a quick half-turn, and the motor roared to life. This manual start was needed for the rest of the Relic Run but it was the only major problem that the car would suffer. After another enjoyable museum stop, this time at the Fort la Reine Museum in Portage la Prairie, the group decided it was time for lunch. Someone suggested that we take the cars into the drive-through lane at a fast-food restaurant where they attracted a lot of surprised stares.

The weather, which had been generally cloudy for much of the morning, became progressively worse into the early afternoon. A light drizzle turned into a steady rain but it did not dampen our enthusiasm or cause any problems for the cars. Even the Model T, with no side windows, stayed dry inside because the wind was in the right direction to keep most of the water away from Don Wadge at the wheel. The drive west of Portage turned out to be the most challenging of the entire trip because we had no alternative to the modern Trans-Canada Highway, which followed the original route. When one is cruising along at the same speed as other vehicles, one tends not to notice the density of traffic. On the other hand, when one is driving at less than half the speed of huge, semi-trucks and trailers, the loud roar and wind gust as they pass are downright scary! Turning left off the Trans-Canada, across traffic, to reach the Agricultural Museum was particularly nerve-wracking and we were all glad to return to the comparative safety of smaller highways and country roads. At the museum, we had photos taken of the five cars in front of the Tree Planting Car. As we departed, we were joined by Clint Cannon, who lived nearby and whose book had been an inspiration for the Relic Run. He rode with us to Carberry, stopping briefly along the way at the farm of one of our sponsors and at the wonderful old general store at Sidney where we were greeted warmly, albeit wetly. By this time, it had become clear that my original estimate of thirty-minute stops at museums and for lunchbreaks was hopelessly unrealistic, and we were

The Relic Run cars, drivers, and passengers at the Manitoba-Saskatchewan border. GEORGE PENNER

running nearly two hours behind schedule. As a result, our planned stop at the Carberry Plains Museum was regretfully cancelled, and I offer my sincere apologies to the folks there. Finally, we pulled up in front of Brandon's General Museum and Archives at 6:30 p.m., where we met more supporters before moving on to the Brandon City Hall to end the day. Fortunately, the kindness of a local businessman allowed the old cars to spend the night indoors in his warm, dry workshop. He even came in early the next morning to make a few minor tweaks to one of the cars.

The weather was much improved for the final day's drive although the road would be poorer than those of the preceding two days, which had mostly been on pavement. Heading westward from Brandon, the road went straight through Kemnay to the Sioux Valley Dakota Nation, then south to Griswold and on to a stop at the Oak Lake Museum. From there, the road was a pattern of zig-zags on gravel: a few miles west, then north, then west again, and so on into Virden where we enjoyed the hospitality of the Pioneer Home Museum, complete with people in period costume. Then we were back on gravel for more northward zig-zags through Hargrave and a final stop at the Manitoba Antique Automobile Museum in Elkhorn where there is what I believe to be one of the best collections of early automobiles in North America. Our cars

sitting in front of the main museum building seemed right at home with the many contemporaneous cars inside. It was with regret that we left Elkhorn for the final push to the Saskatchewan border.

In 1928, farmer Thomas Noble established "Noble's Tourist Camp and Auto Cabins" on his property southwest of Kirkella, beside the newly established Trans-Canada Highway, about three miles east of the border. Along with overnight accommodation and restrooms, Noble operated a service station selling White Rose gasoline, motor oil, and other vehicle consumables as well as refreshments and snacks for the motorists. Noble was likely responding to a trend in the 1920s that saw many more cars—many of them driven by visitors from other provinces and the US—appearing on Manitoba's roads. I thought of him as our band of five classic cars turned west on the final leg of their journey, passing the former campsite that has long ago reverted to an agricultural field. Once again, our schedule was blown by the effusive greetings we received along the way, so we arrived at the border at 6:00 p.m., two and a half hours later than I had originally estimated.

There was no conspicuous sign that we had arrived in Saskatchewan because it was an innocuous country intersection. Only the different system of markings on road signs gave away its location in another province. We took photos then drove 2.5 miles north to reach the present-day Trans-Canada. There, we took more photos at a now-abandoned Saskatchewan visitor information centre. We ended the Relic Run in the parking lot of the Manitoba visitor information centre at Kirkella. We gathered around a plaque that commemorates Arthur C. "Ace" Emmett who I mentioned in this book's Introduction and who is widely considered the "Father of Manitoba Automobiling" for his role in championing the embrace of motorized vehicles. The drivers with trailers then loaded up the cars and headed off, while others got back into their old cars for the drive home.

In retrospect, I realize that I underestimated two aspects of the Relic Run. First, I did not fully realize the fortitude and capability of the old cars which, despite all being nearly a hundred years old, showed how well they had been built and lovingly maintained over the ensuing years. We completed the entire Relic Run without any mechanical breakdowns. There were just a few minor tweaks to brakes and carburetors, and a bit of dirt in a gas line that caused misfiring in one of the Model As. Indeed, we did not even have a flat tire! My second underestimation was the incredible support that we encountered along the way, not just at the museums where we stopped, but also in towns through which we passed slowly to waves and cheers from folks sitting in lawn chairs. Media attention far exceeded my expectations too, with coverage in local and provincial newspapers, radio, online, and television. We even made the national news on the final day of our journey. Best of all, we raised several thousand dollars in support of the Tree Planting Car. It was so gratifying to recreate this little bit of history in a way that

was lucrative, engaging, and lots of fun. I offer sincere thanks to all the participants in the Pine to Prairie Relic Run—who ranged in age from 4 to 93 years and included four generations of one family—and all our supporters. The route of the old Trans-Canada Highway across Manitoba is very scenic, if challenging in places, and I encourage you to follow our lead.

End of the Road

Why am I fixated on abandonment? This is a question that I have often asked myself. I think that abandoned structures prompt us to be observant about our surroundings and to ask questions about them. Why was that structure built in the first place? What purpose did it serve? What events or circumstances caused it to become abandoned, and why has it remained so? The answers to these questions weave together into a story that gives meaning to the abandonment in a way that photos alone cannot do. This is why, personally, I find books containing nothing but photos of abandonment, no matter how artfully presented, ultimately unsatisfying. If there is a common thread to all the stories that I have presented to you in this book, I suppose it is that abandonment—whether a building or even a natural object like a river course, illustrates a fundamental aspect of life: everything changes. And humans are often reluctant to embrace this change. We find comfort, maybe even safety, when conditions remain constant. Change implies uncertainty and, being inquisitive beings, humans want

to know *why* something has changed so we can be better prepared to resist it. Abandonment may evoke feelings of sadness because we regret the injustice that it implies in the changes it symbolizes. Whatever the psychology behind my interests, it is a deep, abiding passion that I aspire to convey to you through this book and its two predecessors. I hope these stories have sparked a similar curiosity and fascination in you, as we explore the lessons that abandonment can teach us about the evolving nature of life and our place within it.

As I conclude this book, you might wonder why it had an "on the road" theme? The reason is simple—I hope it has inspired *you* to get out and explore your surroundings. Whether it is done behind the wheel of an automobile—vintage or otherwise—or, at least for some of the places featured in this book, on a bicycle, skis, horseback, or on foot, there are numerous nooks and crannies around Manitoba that await discovery. In my opinion, all it takes is a little nudge to get out and see them. Consider this your nudge. Am I finished searching for the abandoned parts of Manitoba? Heck, no! Every day, I learn a little more about fascinating, long-forgotten places across our province and I have no intention of stopping. However, I do not know if I will put any of these new discoveries into another book. So, for now, this marks the end of our journey. I hope that you have enjoyed our shared drives, the places that we have visited, and the stories that we have experienced together ... on the back roads of abandoned Manitoba.

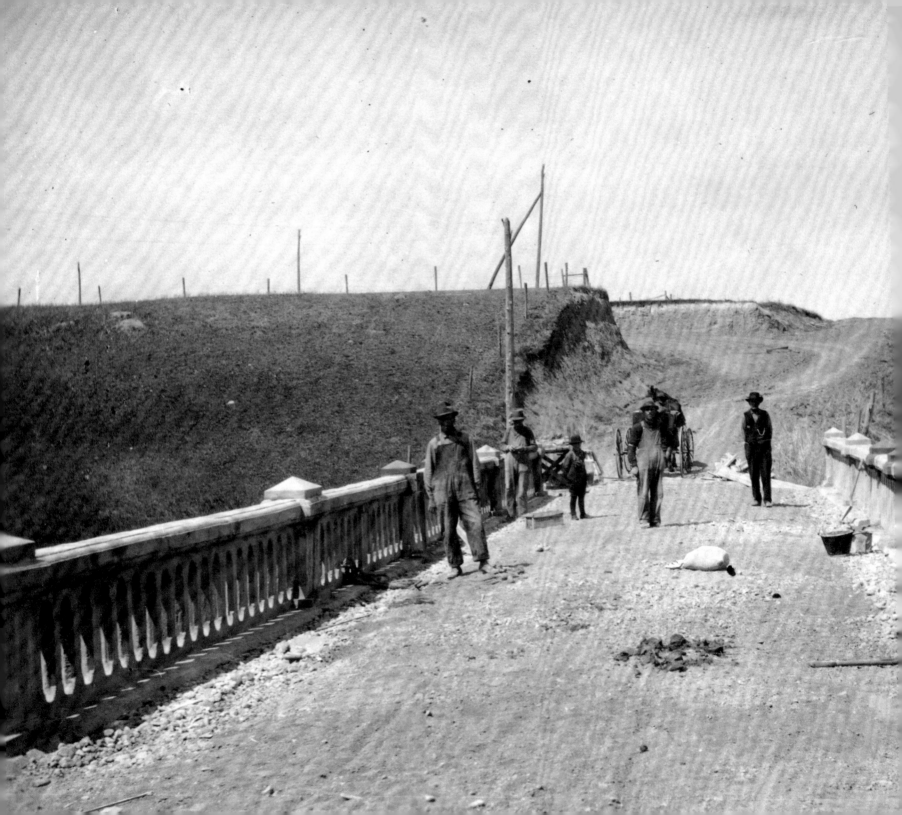

Directions

Enter these coordinates into a GPS receiver or a map app on your smartphone.

Historic Site	Latitude	Longitude
PTH #4 Steel Through-Truss Bridge	N50.81006	W101.43560
Brokenhead River Pony-Truss Bridge	N50.06213	W96.46549
Margaret Concrete Arch Bridge	N49.41345	W99.85637

ACKNOWLEDGEMENTS

I commend the drivers, passengers, and support people of the Pine to Prairie Relic Run for their enthusiasm and stamina. They were, in alphabetical order, David Allinson, Charlie Baldock, Kane Gervin, George Legare, John Olver, Stella Olver, David Rourke, Diane Rourke, Carman Tufts, Pat Tufts, and Don Wadge. Photographer Holly Thorne accompanied us on the first day, and George and Linda Penner were there for the full three days. I thank the kind museum folk who hosted us at stops along the route, and friends who came out to see us at various places. Your support made the Relic Run the success that it was. Above all, I extend my gratitude to Don Wadge for his eagerness to drive his antique car across the province—a distance farther than he had ever driven it before—and for helping me to unravel the intricacies of a Model T.

In closing, I thank numerous people who helped in diverse ways to produce this book, including the good folks at CBC Manitoba who, for over eight years, have given me a weekly radio platform to explore Manitoba abandonment and its implications for our province's history. I will not list them for fear that I will inadvertently omit someone. I would be remiss, however, if I did not give special shoutouts to my "history widow" wife Maria Zbigniewicz, the first reader of every chapter, and to my good friend Jim Burns, who copy-edited the entire book and whose thoroughness makes me seem like a better writer than I am.

OPPOSITE This photo from around 1917 shows construction workers at a concrete arch bridge near the village of Margaret. ARCHIVES OF MANITOBA, HIGHWAYS COLLECTION B144

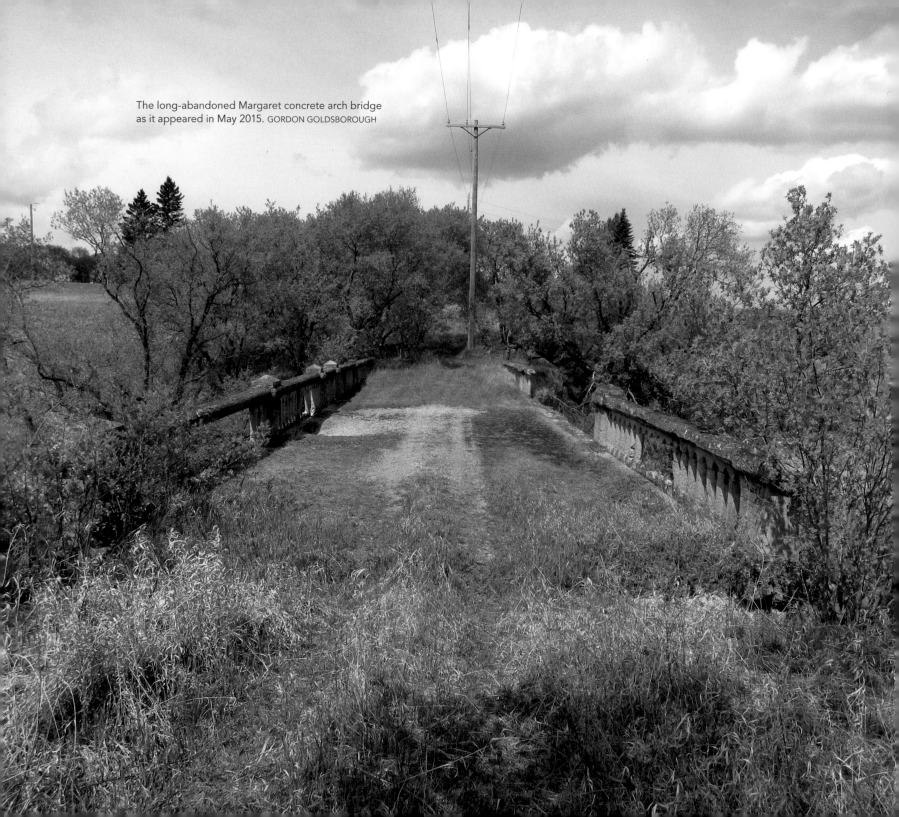

The long-abandoned Margaret concrete arch bridge
as it appeared in May 2015. GORDON GOLDSBOROUGH